BECOMING GUANYIN

Premodern East Asia: New Horizons

Premodern East Asia: New Horizons

Sun Joo Kim, Dorothy Ko, and Haruo Shirane, series editors

This series is dedicated to books that focus on humanistic studies of East Asia before the mid-nineteenth century in fields including literature and cultural and social history, as well as studies of science and technology, the environment, visual cultures, performance, material culture, and gender. The series particularly welcomes works with field-changing and paradigm-shifting potential that adopt interdisciplinary and innovative approaches. Contributors to the series share the premise that creativity in method and rigor in research are preconditions for producing new knowledge that transcends modern disciplinary confines and the framework of the nation-state. In highlighting the complexity and dynamism of premodern societies, these books illuminate the relevance of East Asia to the contemporary world.

Becoming Guanyin

Artistic Devotion of Buddhist Women
in Late Imperial China

YUHANG LI

Columbia University Press
New York

Columbia University Press gratefully acknowledges the generous support for this book provided by Publisher's Circle member Chün-fang Yü.

Columbia University Press
Publishers Since 1893
New York Chichester, West Sussex
cup.columbia.edu

Support for this research was provided by the University of Wisconsin–Madison Office of the Vice Chancellor for Research and Graduate Education with funding from the Wisconsin Alumni Research Foundation.

Publication of this book has been aided by a grant from the Millard Meiss Publication Fund of CAA.

This publication was made possible in part by a grant from the James P. Geiss and Margaret Y. Hsu Foundation.

Library of Congress Cataloging-in-Publication Data
Names: Li, Yuhang, author.
Title: Becoming Guanyin / Yuhang Li.
Description: First edition. | New York : Columbia University Press, 2019.
Identifiers: LCCN 2019021927 | ISBN 9780231190121 (cloth) | ISBN 9780231548731 (e-book)
Subjects: LCSH: Buddhist women. | Women in Buddhism. | Avalokiteśvara (Buddhist deity)
Classification: LCC BQ4570.W6 L5 2019 | DDC 294.3/4440820951–dc23
LC record available at https://lccn.loc.gov/2019021927

Cover design: Milenda Nan Ok Lee
Cover image: Courtesy of the East Asian Collection. University of Chicago Library.

Contents

Figures

CHAPTER 3

CHAPTER 4

CONCLUSION

Acknowledgments

This project would not have come to fruition without the help of many friends, mentors, colleagues, and institutions. It is with great pleasure that I express my indebtedness to some of the many people and institutions who have facilitated the intellectual and practical aspects of this book. Judith T. Zeitlin and Wu Hung, my doctoral advisers, showed confidence in the intellectual value of my work that provided me the strength to finish this book. Additional mentors during the various stages of writing this book, Paul Copp, Dorothy Ko, Chün-fang Yü, have constantly inspired me. The seed of this book was planted when I first read Chün-fang Yü's book on the feminization of Guanyin in the beginning of my graduate work. Since then, her book and her unfailing support have accompanied me throughout these years. I am extremely fortunate to have intellectual support from Dorothy Ko, whose scholarship in gender and material culture laid the foundation of this book.

Many friends and colleagues have offered suggestions, resources, and conversations. I would like to thank Katherine Alexander, James Benn, Aurelia Campbell, Jill Casid, Lang Chen, Sun-ah Choi, Jessey Choo, Liu Cong, Dai Yun, Jacob Eyferth, Grace Fong, Ping Foong, Anne Feng, Beata Grant, Phyllis Granoff, Anup Grewal, Janet Gyatso, Charles Hallisey, Donald Harper, Marsha Haufler, Jonathan Hay, Xi He, Hua Wei, Shih-shan Susan Huang, Rania Huntington, Fumiko Joo, Xiaofei Kang, Tom Kelly, Yu-chih Lai, Hui-shu Lee, Seung-hye Lee, Wai-yee Li, Nancy Lin, Weicheng Lin, Mia Liu, Tina Lu, Lu Yang, Mei Mei, Julia Murray, Michael Naparstek, Susan Naquin, Lynn Narasimhan, Zhange Ni, Bill Nienhauser, Sally M. Promey, Gil Raz, Dagmar Schaefer, Angela Sheng, Koichi Shinohara, Rachel Silberstein, Maya Stiller, Susan Strauber, Catherine Stuer, Xiaosu Sun, Tao Jin, Melissa Vise, Cheng-hua Wang, Eugene Y. Wang, Wang Yudong, Xu Peng, Christina Yu Yu, and Tobias Zürn. In particular, I would like to express my deep gratitude to Wendi L. Adamek, Lynne Gerber, Rivi Handler-Spitz, Ann Waltner, Peggy Wang, and the two

anonymous reviewers for Columbia University Press for offering invaluable comments on revising this manuscript. Rivi Handler-Spitz also provided tremendous help with my translation.

As a research associate in the Women's Studies in Religion Program at Harvard Divinity School during the academic year of 2015 to 2016, including an intensive exchange of ideas with Ann Braude and fellow residents Susanna Drake, Lynne Gerber, Spetemmy Lakawa, and Grace Nono, I had a most productive year and was able to write two new chapters of the book. In bringing this project to completion, I received generous support from my home institution, the University of Wisconsin–Madison. Both the Department of Art History and the Deans' Office of the College of Letters and Science provided moral and financial support. Summer research funding from the Graduate School allowed me to complete new field research in China in 2014 and 2015. My residency at the Institute for Research in Humanities in UW–Madison in the fall of 2017 enabled me to fine-tune the manuscript. I couldn't have published this book in its current form without generous subventions from the Office of the Vice Chancellor for Research and Graduate Education at UW–Madison and the Wisconsin Alumni Research Foundation, the Millard Meiss Publication Fund (College Art Association), and the Geiss Subvention Awards (James P. Geiss Foundation).

Many individuals in China helped me locate certain objects that have not been published and secure image copyrights. Especially deserving of credit are Fang Hui, Li Qingquan, Liu Wentao, Sun Jiangong, Wei Wenbin, Yang Ling, Zhiyan Yang, Yu Hui, Zhang Shuxian, Zhang Zong, Zhu Lishuang, and Zongxing fashi.

I have worked with a patient and efficient team of editors and designers. I am particularly indebted to Su Tong for creating line drawings, Wang Ji's timely assistance, Terre Fisher's critical editing of the first draft of the manuscript, and my editors at Columbia University Press, Wendy Lochner and Lowell Frye, who not only showed enthusiasm for my project but also guided a novice through the process that turned a manuscript into a book.

I want to thank my parents Li Zhou and Han Min, my parents in-law Prema Murthy and Pavaman Murthy, my brother Li Daxue, my sister in-law Chen Can, and my sister Li Jinhang for their warm support through all these years. My mother in-law passed away in 2011, but I believe that she is happy in heaven to see my book in print. Finally, I cannot express adequately my gratitude to my husband Viren Murthy, who always encouraged me to pursue my interests and has constantly stood by my side. He persistently introduced me to Carnatic music, which often drove me back to write more intensely as a form of escape.

Introduction

Gendered Materialization of Guanyin

This book asks a straightforward question: What did Buddhist laywomen in late imperial China actually *do* to forge a connection with the subject of their devotion, the bodhisattva (Guanyin 觀音)? This question, however, is more complicated than it seems at first blush. For one thing, neither "laywomen" nor "Guanyin" are stable categories. I do not seek to define or delimit these two categories so much as to consider them as mutually constitutive, with the relationship between them being established through comportment and practice. That is, although the connection was obviously constructed through religious practices, in the case of lay devotees, these practices were notably based in a shared gender identity. Women connected with the Buddhist deity Guanyin by reproducing her image using specifically female skills, parts of their bodies, and performance.

Guanyin (Perceiver of Sounds) began in India as the bodhisattva Avalokiteśvara (Bodhisattva of Compassion), originally a male deity. This bodhisattva gradually became indigenized as a female deity in China over the span of nearly a millennium. By the Ming (1358–1644) and Qing (1644–1911) periods, Guanyin had become the most popular female deity in China.[1] Scholars have tried to explain the gender transformation as it was manifested in various texts and iconographic variations.[2] This scholarship provides an overall picture of how various indigenized manifestations of Guanyin took shape and attracted believers, especially women, but these discussions tend to prioritize textual sources and largely fail to consider practice. Although texts contain invaluable information, women's experiences usually fall through the cracks in sources produced mostly by men.[3] Even when the writers were women, the texts they produced often did not exceed the limits of literati discourse. Much can be learned from reading against the grain and being attentive to the silences in such texts. To help the unsaid in texts speak to and about women's experience, I will turn to intimate religious practices by women.

To gain a clearer understanding of the influence of Guanyin on women (and vice versa), we must turn to material culture in the form of practices and things. Material culture is a vast and convenient category that can encompass every aspect of religious practice.[4] I concentrate on how laywomen expressed Buddhist devoutness to Guanyin by reproducing the latter's image and restaging her presence using their particular skill sets, labor, and bodies.

The relationships that developed between Guanyin and her worshippers did so through processes of self-, object-, and world-making. I examine how this feminized deity complicated the gender identities of her believers. Guanyin's "sex change" in China, I argue, established a new framework for religious practice whereby the production of the devotee's identity was interwoven with the ideologies and material practices that accompanied the reproduction of gender hierarchy.[5] One way of investigating the difference that gender makes is by thinking through the things that worshippers produced and used to forge connections with the deity. I focus on secular women's unique and imaginative ways of making Guanyin images using skills such as embroidery or mimicking Guanyin by adornment and performance. These kinds of making point to a worldview that differed from yet fit within the Confucian patriarchal system. I show how women were able to synthesize the conflicting symbolic frameworks of Buddhism and Confucianism through the production of material culture and performative practices.

Our present understanding of women in the Ming and Qing periods can be summarized in two perspectives: First, because of the adoption of Neo-Confucian mores among Ming-Qing China's elites, female chastity was widely exalted. The social roles of filial daughter or daughter-in-law, virtuous wife, loyal concubine, chaste widow, and diligent mother were promoted as ideal forms of womanhood. Second, the work of scholars over the past three decades in the fields of Chinese women's literature and women's history has revealed the Ming-Qing period to have been a time in which many women achieved advanced literary and artistic accomplishments.[6] Women's literacy and the companionship (among literati men) of cultivated women were highly valued. Some scholars have viewed these images as competing, with the former representing oppression and the latter standing for women's agency.[7] This dichotomy has identified a contradiction, the opposition of virtue and talent, which, as Dorothy Ko has argued, generated tensions that only intensified in the mid- to late Ming in reaction to the new visibility of talented women.[8] Indeed, women's various talents often helped them to more perfectly perform their roles as exemplars. By examining the religious practices of women during this period, we find that, in many ways, they helped reconcile what appeared to be conflicting demands.[9]

One way of understanding the dynamic between virtue and talent is to study women's lives at the intersection between Confucianism and Buddhism. Although Buddhism and Confucianism are intimately connected in practice, I separate them for heuristic purposes to shed light on the relationship between social construction and self-fashioning.[10] Following in the footsteps of many scholars, I argue that although women's lives were shaped by Confucian patriarchal expectations, Buddhism provided a space in which women could express themselves in alternative ways.

One of the major threads running through this project is how women negotiated their social roles and religious beliefs through material practices. I consider how women fashioned meaning in their lives through the creation of powerfully evocative symbolic objects. When dealing with a premodern society, we must recall that meaning was often, if not always, inextricably linked to religious or cosmological frames of reference. In the Chinese context, that frame was Confucianism, which inscribed women in a patriarchal hierarchy that featured, among other things, specific distinctions between inner and outer realms.[11] This book demonstrates that women could participate in the Confucian worldview as they pursued a Buddhist one. They created space within the rigid Confucian framework by expanding their personhood through the creation and use of objects dedicated to Guanyin. Hence, many cases discussed in this book show how women united the conflicting symbolic frameworks of Buddhism and Confucianism and manifested that synthesis in material culture. Here, I concentrate on cases that address the dialectical relationship between Buddhism and Confucianism, but I am aware that in certain regions and periods, women's struggles were not confined to these two systems but often involved other religious traditions as well.[12]

GUANYIN'S FEMINIZATION AND GENDER POLITICS

The reasons behind Guanyin's gender transformation are not crucial to this book, which instead focuses on the social effects of the already feminized Guanyin. A brief review of the issues around the bodhisattva's transformation, however, will lay the groundwork for our understanding of how it affected late imperial believers in terms of their own gender identities.

Among the many deities in the Buddhist pantheon, Guanyin alone possesses the distinctive sacred powers of openness and self-transformation. Since the appearance of two early Chinese translations of the *Lotus Sutra*, the first by Dharmarakṣa in 286 CE and the second by Kumārajīva in 406 CE, the "Universal Gateway Chapter" (*pumenpin* 普門品), part of this scripture, which is dedicated solely to Guanyin, has been popular.[13] The "Universal Gateway Chapter" contains three sections: The first

FIGURE 0.1 *Guanyin*, dated 453. Bronze with gilding (23 centimeters high, 11.9 centimeters wide, 6.8 centimeters deep). The collection of Freer Gallery of Art and Arthur M. Sackler Gallery, Smithsonian Institution, Washington, D.C.: Gift of Charles Lang Freer, Catalog F1909.266.

The inscription on the base of this statue indicates that this icon was offered by a female devotee named *Zhao Luyuan* 趙路原 of *Quyang* 曲陽, for her departed grandparents.

declares Guanyin's name and its sacred power, the second narrates how Guanyin can appear as the transformation form imagined by practitioners during his or her preaching, and the last relates how Guanyin can rescue people from the disasters of everyday life.[14] Thus, Guanyin is a unique deity with various roles, known as the "thirty-three manifestations." These manifestations range from appearances in the celestial world to the secular world, from divine being to human being, and from male to female. By transforming himself into roles that encompass all hierarchical and gender differences, Guanyin was worshiped as a universal savior who could respond in time to people's cries for help.[15]

Guanyin's feminization was a long and gradual process. When Buddhism first took root in China, Guanyin was often represented either as a male deity with clearly masculine features, such as robust muscles and a moustache, or as a gender-neutral deity (figure 0.1). Evidence of his feminization, however, can be found as early as the Northern Qi period (550–577).[16] By meticulously examining Guanyin imagery in various media, such as indigenous scriptures, literature, miraculous stories, art, and ritual performance, Chün-fang Yü has concluded that Guanyin had become firmly female by the Ming dynasty.[17] Yet Guanyin's feminine forms—such as the White-robed Guanyin, Guanyin of the South Sea (known earlier as Guanyin of Potalaka Mountain), Fish-basket Guanyin/Malangfu Guanyin (also known as

Mr. Ma's Wife), and even the idea of the Child-giving Guanyin—had already appeared in the Tang to Song periods.[18] In late imperial China, these manifestations were feminized more widely with respect to their rhetorical and iconographical dimensions. Guanyin was a female deity not only in various narratives and miraculous dreams and testimonies but also on stage. In miraculous stories and the literary imagination, Guanyin's sacred power operated like a surgeon to help devotees change sex from female to male or vice versa, but Guanyin's bodily sex change was never explained or imagined.[19] A typical *dehua* 德化 ceramic Guanyin figurine from the Ming period reveals the peculiarly female divine body that combines utmost femininity in facial expression and hairstyle with a neutrally gendered torso (figure 0.2).

FIGURE 0.2 *White-robed Guanyin*, Ming dynasty. White-glazed ware, Dehua kiln (12 centimeters high, 5.5 centimeters wide). Excavated from the aboveground crypt of the Fahua Pagoda, Jiading District, Shanghai in 1996. The collection of the Shanghai Museum. *Source:* After Shanghai bowuguan, ed., *Guta yizhen* (Shanghai: Shanghai shuhua chubanshe, 2014), pl. 118.

Various terms, including feminization, gender transformation, sexual transformation, and even "sex change," have been suggested to explain Guanyin's womanly appearance. This transformation is not explicitly sexual in nature but rather is a shift in gender, which implies differences in the way the deity is perceived.

Although Guanyin's anatomical body is never explicitly explained in terms of a sex change, Guanyin is objectified as a woman with sexual appeal. Guanyin subsequently became a symbol of exceptional beauty. Some new iconographies of Guanyin evoke Guanyin with a soft and tender body as shown in the widely circulated Guanyin painting manual the *Thirty-two Manifestations of Guanyins* (figure 0.3).[20] Simultaneously, the feminized Guanyin form was used

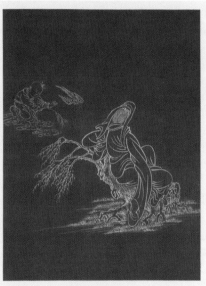

FIGURE 0.3 Qiu Zhu, *Thirty-two Manifestations of Guanyin* (one leaf from the album), Ming dynasty, second half of the sixteenth century. Album leaves, gold ink on paper (image: 29.4 by 22.1 centimeters; sheet: 37 by 55.9 centimeters). Acquired through the generosity of Judith Stoikov, Class of 1963, supplemented by the George and Mary Rockwell Fund, and gift of Warner L. Overton, Class of 1922. Photography courtesy of the Herbert F. Johnson Museum of Art, Cornell University, 2002.012

This is one of the twenty-four portraits of Guanyin. The painting on the right was created by Qiu Zhu and the poem on the left leaf was likely inscribed by Tu Long. Guanyin is seated facing backward on a willow tree. Riding on clouds, Sudhana seems to swing a willow branch to draw the parrot's attention. Guanyin's body rests on the oblique willow trunk following the contours of the tree. Her right sleeve dangles behind her back. The elegant long sleeve parallels the weeping branches and emphasizes her feminine appeal. In literary discourse, a willow personifies a beauty's slim and soft waistline, which is often associated with romantic and erotic meanings. This personification is explicitly visualized through juxtaposing Guanyin's swaying back and slanting willow.

to represent the supersensuousness of secular beauty. Guanyin supposedly transcends the world but is physically beautiful and evokes desire. *Du Liniang* 杜麗娘 in the *Peony Pavilion*, *Yingying* 鶯鶯 (Oriole) in the *Romance of the Western Chamber*, and *Jin Mudan* 金牡丹 in *Record of Guanyin's Fish-basket* are fictional characters compared with Guanyin, sometimes assigned to a specific iconography such as the Water and Moon Guanyin of the South Sea or Guanyin of the South Sea.[21] In one illustration in a scene from *Romance of the Western Chamber* from the late-Ming period, Yingying wears a maiden's dress but is rendered in a pose evocative of Guanyin (figure 0.4).[22] Certain of Guanyin's gestures and postures, such as the royal-ease pose, were assimilated into visual vocabularies to represent beautiful women or courtesans.[23]

The second phenomenon is that male scholars are derisive about the feminine appeal of Guanyin. In popular literature, these scholars express a snide attitude toward any of Guanyin's manifestations that could be linked to sensual appeal. For instance, in chapter 49 of the *Journey to the West*, Guanyin uses a fish basket to capture a golden-fish spirit—evoking the manifestation of Fish-basket Guanyin. The text emphasizes that Guanyin is improperly dressed. She wears only a small waistcoat. Both of her arms are wholly bare and the rest of her body is only barely covered.[24] The scantily clad and makeup-free Guanyin allows the Monkey and readers to gaze upon an inappropriate Guanyin in her domestic setting. Elsewhere we see evidence that male scholars in a monastic setting even mock an icon depicting Guanyin as an attractive woman (figure 0.5).[25] Later adaptations of such a sarcastic attitude toward Guanyin's icon explicitly affirm Guanyin's statue as an object of sexual desire. A strange story in *Dianshizhai Pictorial* from the late-nineteenth century depicts that a go-between robbed a wooden Guanyin statue from a nunnery, substituted it for a bride, and married the statue of Guanyin to an old man (figure 0.6).[26] It may be common that the indulgence in this kind of salacious irreverence often manifests as the counterpart to piety in different cultures; however, such attitude also demonstrates that male scholars believed that their literary prowess gave them a license to play with Guanyin's gender and consequently to place themselves in a higher position.

Given the gender politic embedded in representations of Guanyin, it is telling that the masculine and neutral-gendered Guanyin forms did not completely disappear in the Ming-Qing period. Some male painters continued to depict Guanyin in masculine guise, either to revitalize an archaic style or to seek their own religious salvation through Guanyin's male form.[27] The thirty-three manifestations mentioned in the "Universal Gateway Chapter" were often visualized as a group to explain the scripture, but in late imperial times, some of the male forms

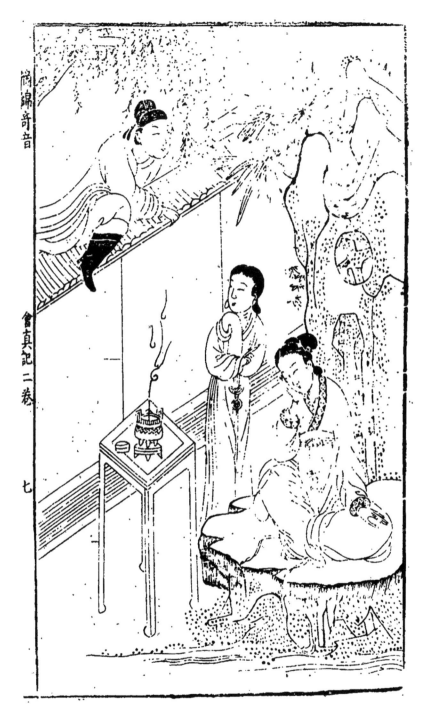

FIGURE 0.4 "Jumping Over the Wall," a scene from *Romance of the Western Chamber*, 1611, woodblock illustration. *Source:* After Wang Shifu, *Huizhenji*, 1611 edition. In *Shanben xiqu Congkan*, edited by Wang Qiugui (Taibeishi: Taiwan xuesheng shuju, 1984) 3:81.

Yingying, who is normally depicted in this scene with her back turned to her lover Student Zhang, sits with two legs crossed on a raised rock with a flat surface. With her cheek resting on her hand, her eyes are closed in a meditative state. Her elevated body is further enhanced by a giant rock and bamboo at the back. These visual elements allude to Guanyin iconography.

FIGURE 0.5 Zhen Longyou inscribes a poem on the wall of Guanyin Hall in Tianzhu Temple in Hangzhou. Ming Chongzhen period, woodblock print. Zhou Ji, *Xihu erji sanshisi juan, Xihu qiuse yijuan*, juan shou, 7. The collection of National Central Library of Taiwan.

This late-Ming illustration is based on a widespread anecdote of the poet Zhen Longyou 甄龍友 who was active in the Southern Song (1127–1279) period. Zhen visited Tianzhu 天竺 Temple in Hangzhou and inscribed four lines from the *Shijing* (詩經 *Classic of Songs*) on the wall of Guanyin Hall to praise the exquisiteness of the statue of Guanyin: "Her winsome smile dimpling, Her lovely eyes so black and white! O that gorgeous lady, That lady of the west!" 巧笑倩兮, 美目盼兮; 彼美人兮, 西方之人兮. "*Meiren*" refers to a male dancer in the poem of "Jianxi" 簡兮 in *Shijing*, but by the time of Southern Song, it is perhaps limited to mean beautiful woman. The illustration that accompanies the text presents this hilarious moment by juxtaposing Guanyin's statue in an altar, a young fellow, and the poems praising beauty (Guanyin in this case). The young man jokes with Guanyin as he inappropriately expresses his feelings for Guanyin in the place for asceticism.

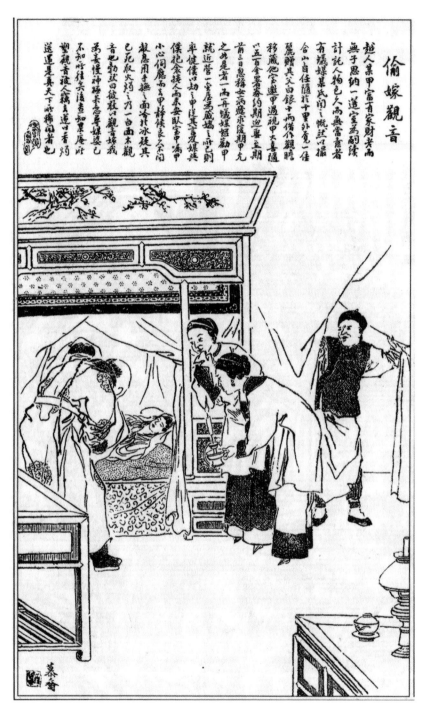

FIGURE 0.6 Zhou Muqiao, *Secretly Marry off Guanyin*, 1884–1898, lithographic prints. *Source:* After Wu Youru et al drew, Qiming Zhang ed. *Dianshizhai huabao: Daketang ban*. (Shanghai: Shanghai huabao chubanshe, 2001), 40:54.

The inscription explains that the older man wanted to marry a concubine because he did not have a son. The color of the wooden statue is explicitly mentioned as white, which draws a connection with the White-robed Child Giving Guanyin. As a deity who has fulfilled people's request for a son, Guanyin herself was forced into playing a role of procreation and was rendered as a passive woman laying on the bed.

of Guanyin, such as Buddha, Pratyekabuddha (Pizhifo 辟支佛), Arhat, layman, and official forms, were singled out and depicted in individual icons and even in bronze statues.[28]

The reasons behind the deity's sexual transformation are complicated and are still being debated. There have been two ways of approaching this question. The first is to regard compassion, Guanyin's most acclaimed power, as a feminine attribute and to link this inner religious quality to the transformation of the deity's outward appearance. Compassion is intimately related to the mother image in Chinese culture and because Guanyin epitomized compassion, he gradually metamorphosed into a universal mother. This approach has been challenged by José Ignacio Cabezón's explanation of the symbolic meanings of mother and father in Mahayana Buddhism. There, he points out, compassion is understood to be a paternal characteristic, whereas the mother has the symbolic meaning of wisdom.[29] Thus, a clear difference exists between the indigenous Chinese view of compassion as feminine and the Mahayana Buddhist view of compassion as masculine. As the cult of Guanyin was adapted to local traditions over the course of its development in China, Buddhist doctrinal symbolism may well have fused with indigenous symbolism. Guanyin's dual gender may be a hybrid formation of the Indian feminine symbol of wisdom and the Chinese value of maternal compassion.

A second approach draws a connection between the gender of the worshipers and the gendered transformation of the worshiped. Some scholars suggest that the various feminine forms of Guanyin mirror the different stages of a woman's life cycle—from a teenage girl like Princess Miaoshan to a middle-age woman like White-robed, Child-giving Guanyin and White-robed Guanyin.[30] According to this view, the gender of believers reshaped the appearance and inner nature of the deity. Some scholars go even further to argue that the paintings of Guanyin produced by female Ming artists contributed to a more feminine Guanyin iconography.[31] Because most women who were painters still followed the painting manuals created by male literati painters and the circulation of their paintings was confined to certain circles, the impact of their paintings on Guanyin iconography seems unlikely. When female practitioners established a connection with Guanyin through brush and ink or other material practices, they identified with the feminized icon, just as certain male literati painters tried to reassert Guanyin's male manifestations to more closely associate with the deity.

Still, any generalization of the reasons behind a feminized Guanyin may lead us down the wrong path. We need to contextualize and historicize the transformation of each feminine incarnation. The driving force behind transformations may not have been gender congruence between worshiper and worshiped. As Yü alerts us, both men and women were avid followers of the cult of Guanyin in her

female forms; therefore, it seems too one-dimensional to assume the gender transformation only fed the needs of women.[32] Clearly, not only women practitioners worshiped the White-robed, Child-giving Guanyin, but also men sought divine aid in producing an heir.[33] Historians have demonstrated that male generativity was a major concern for men during the Ming-Qing period.[34]

In short, men and women may have worshiped the same icon and disseminated the same scripture, but their social roles differed. Consequently, their life experience in relation to the icon and the way they connected with Guanyin likely varied.[35] Both men and women would have chosen a medium for devotion that was suited to their respective social identities.[36]

BUDDHIST LAYWOMEN IN LATE IMPERIAL CHINA

Buddhist laywomen's practices are of interest for two reasons. First, the material practices of reproducing the image of Guanyin grew out of the life experiences of secular women, which in turn were embedded in their social roles as daughter, wife, concubine, mother, and lover. Second, these practices were personalized through the materials used in their devotional works, as when they used their own hair to embroider a Guanyin image, or when they adopted items that women used and wore to mimic the deity's iconographic attributes. Remember that the term "Buddhist laywomen" refers not only to women who lived in a familial space but also to courtesans who resided in social and physical spaces outside the marriage system and encountered different life predicaments.[37] Unlike ordinary women who used Buddhism to facilitate their roles as filial daughters, chaste wives, and dutiful mothers, courtesans practicing Buddhism had to straddle the contradiction between a defiled profession and the purity proper to Buddhist belief. Although we can observe certain patterns in women's religious lives in late imperial China, it is still difficult to present a complete picture because of geographical, historical, and individual variations. For instance, James Robson's research on the hand-copied scriptures hidden in the wooden statues of local gods and ancestors from Hunan Province reveal that the Confucian doctrinal order of women as being inferior in the ancestor worship was not followed in actual practice during the Qing period.[38] Even so, striking a balance between Confucianism and Buddhism was a crucial issue among the women from Jiangnan whom I have studied.

To grasp women's attraction to lay Buddhism in late imperial China, we need to consider Confucian ideology of the era and its restraints on women. Many people are familiar with the Confucian ideal of segregating women and men into inner and outer domains and the promotion of female virtue through "thrice following" (submission to the social superiority of paterfamilias) and the "four virtues"

(womanly morality, womanly speech, womanly manner, and womanly work). Confucian orthodoxy viewed Buddhism as a threat to the foundation of the Confucian family order.[39] As Ko has shown, the practice of thrice-following deprived women of their formal and social identity but not of their individuality and subjectivity. The abstract framework of thrice-following does not subsume the various aspects of women's cultural and psychical life.[40] I expand on Ko's insight by showing how women's subjectivity emerged in both their uses of Buddhism and their creation of material objects. In other words, women created things for reasons that cannot be reduced to male domination. By examining the objects they created, we can reconstruct aspects of late imperial Chinese women's subjective worlds.

Primarily on the basis of textual sources, scholars have described basic patterns of women's Buddhist practice in relation to Confucian doctrines. Women were specifically prohibited from contacting clerics, participating in religious associations, and going to temples in certain regions. Virtuous women were portrayed first and foremost as devoting themselves to ancestral rites and, according to the dictates of filial piety, to their parents-in-law. Women were expected to keep their distance from Buddhism.[41] Even in biographies of Buddhist laywomen, filial piety is always listed above their devotion to Buddha.[42] Nonetheless, a variety of evidence reveals that women from different social strata did leave their domestic space and visit nunneries, temples, and pilgrimage sites.[43] Especially when women entered the postparenthood phase and had finished all the duties required of filial daughters-in-law and virtuous wives around the age of fifty, which is also the age of menopause, they started to face the issue of death and pursue immortality through Buddhist, Daoist, and other religious practices.[44] Other Buddhist women, from the very beginning of their lives, also struggled with the conflict between their religious beliefs and their social roles.

Some Buddhist laywomen seriously pondered gender inequality and rejected their gender identity as a result. Tao Shan 陶善 (1756–1780), who lived later than most women discussed in this book, struggled with her identity as a female Buddhist: she experienced a sharp tension between her actuality and her desire—between who she was and who she wanted to be—as she struggled within the restrictions of both Confucianism and Buddhism.[45] In the Confucian system, women cannot worship ancestors the way men do and, according to Pure Land Buddhism, the female body cannot be reborn in the Pure Land. So Tao Shan practiced Chan Buddhism during her life, but her gender still raised many dilemmas for her to face. Beata Grant insightfully points out that "Tao Shan is trying to emphasize non-gender-specific inner qualities like filial piety, as opposed to the gender-specific ways in which these qualities may be expressed."[46] That means to achieve the same qualities as men, women had to erase their gender identity and think of all humanity as *sons*.[47] Tao Shan was trapped between two gender identities. Buddhism

was supposed to enable her to transcend this double bind, but instead it pushed her more deeply into it, because Buddhist practice made her identify with both male and female ideals. Notably, as Grant reminds us, Tao Shan's female awareness emerged most fully as embarrassment and shame, which likely grew from that gap between her actuality and her desire.

Unlike Tao Shan, most Buddhist laywomen simply accepted the gender hierarchy and negotiated their religious identity within the confines of Confucian ideology. They searched for a way both to accomplish their filial roles in the family and to pursue their religious faith. Guanyin in particular offered religious refuge for women. Worshiping Guanyin enabled laywomen to fulfill their various responsibilities. This practice is illustrated in the case of the exemplary widow Luo Baizhou 羅柏舟 from the Ming dynasty: a Guanyin statue that she worshiped every day came to life and appeared to her in a dream as she napped by the sickbed of her mother-in-law (figure 0.7).[48] Guanyin endorsed her virtuous deeds and comforted her by assuring Luo that her mother-in-law would recover soon.

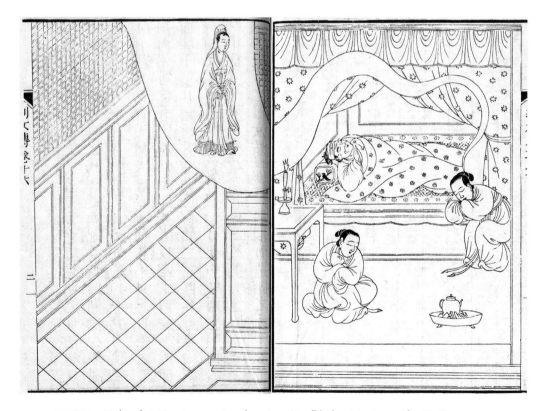

FIGURE 0.7 *Mother of Luo Maoming*, seventeenth century. Woodblock prints. *Source:* After Liu Xiang, Qiu Ying painted, Wang Geng comp. *Huitu lienü zhuan* (Taipei: Zhengzhong shuju, 1971), juan 16, 1b–2a.

Lay Buddhism in the late Ming exemplified religious pluralism, commonly known as *sanjiao heyi* (三教合一): three teachings merged into one. Although one can perceive doctrinal differences among Buddhism, Daoism, and Confucianism, people's lives often combined these different beliefs and practices.[49] The cult of Guanyin in particular blends the various traditions. For instance, Tanyangzi 曇陽子 or Master Tanyang (1558–1580) was a female visionary who claimed to be a reincarnation of Tanluan Bodhisattva (*tanluan pusa* 曇鸞菩薩.) A Guanyin devotee from childhood and a chaste virgin widow, she was deified as a Daoist immortal who advocated the three teachings of Buddhism, Daoism, and Confucianism.[50] Her icon was enshrined with those of Guanyin and other Buddhist and Daoist deities in women's boudoirs.[51] Leading Buddhist monks of the late Ming, such as Yunqi Zhuhong 云棲袾宏 (1535–1615), also promoted syncretic practices and placed great emphasis not only on the cardinal Buddhist virtues of wisdom and compassion but also on the cardinal Confucian virtue of filial piety. Moreover, Zhuhong promoted the joint practice of Chan and Pure Land Buddhism, writing that both Chan meditation and *nian-fo* 念佛 (calling Buddha's name) could lead to enlightenment. He also advocated the method of *yixin nianfo* 一心念佛 (Buddha invocation with one mind). Ordinary people could become Buddhas by holding fast to the Buddha's name in their minds and thus achieve enlightenment and salvation.[52] Some methods of practice, such as meditation and mentally reciting the Buddha's name, as well as the joint practice of filial piety and Buddhism, pervaded society and hence influenced women's devotions. In Buddhist hagiographies from the late imperial period, *yixin nianfo* is combined with the Confucian mandate for household labor ("womanly work") to create the image of the virtuous woman and sincere Buddhist. This new way of promoting devotional practice provided women with a convenient and practical way of achieving salvation and simultaneously fulfilling their wish to be a filial daughter or daughter-in-law, diligent wife, compassionate mother, and chaste widow.

A testimonial entitled "Zhijing zuotuo" 織經坐脫 (seated liberation while weaving sutras) exemplifies this combination. Lady Zhang made a habit of chanting the *Diamond Sutra* while weaving cloth on the loom. She recited about ten *juan* of the scripture during the production of a single bolt of cloth. On July fourth in the *gengshen* year of the Wanli era (1620), Lady Zhang was weaving and chanting when she suddenly stopped the shuttle, put her palms together, and passed away. She had not suffered a single day from the turmoil of illness. Wang Qilong 王起隆 (active late Ming to early Qing) comments that when Lady Zhang chanted sutras while weaving, the cloth itself carried *prajna* or wisdom. Thus, when people weave cloth the way that Lady Zhang did, they are actually weaving sutras.[53] Lady Zhang's commitment to the *Diamond Sutra* and the words emerging from her mouth were transformed into bolts of cloth, the product of her embodied labor and devotion. In this case, a certain length of cloth became a measure of the number of sutra volumes she chanted, the

cloth itself a material manifestation of her devotion.[54] Precisely because her body engaged in focused labor as both textile weaver and sutra chanter, she was able to transmit the potency of the incantation to the product of her labor.

Women's domestic space thus became a multifaceted center in which women could develop womanly worldviews through a combination of religious, ritual, and sentimental activities.[55] Yü has insightfully identified two ways in which women's religious life shifted after Guanyin was feminized. First, women used the home as a space to practice Buddhism, primarily the Pure Land variety, which involved repeatedly calling Buddha's name, chanting Buddhist sutras, worshiping Guanyin, meditating, and keeping a vegetarian diet. These Buddhist women may not have followed monastic religious leaders, but they were similar to nuns, and some even demonstrated the elevated level of spirituality possessed by renowned monks.[56] Second, domestic space was the central site for the practice of filial piety; in this context, women maintained a chaste widowhood and observed the dictates of purity.[57] Here I would like to underscore that I use the term *domestic space* not to refer merely to physical boundaries, but as an analytical tool to grasp the manner in which these women's practices were constantly mediated by concerns related to the household. Clearly, we are dealing with a period before bourgeois domesticity and the nuclear family. Consequently, the lines between the domestic and nondomestic spheres were often blurred and shifting. The women whom I discuss have all encountered the spaces outside, whether religious or non-religious, but their actions were often mediated by concerns related to the home.

This book not only examines women's religious devotions in the home but also investigates religion in the domestic sphere from the perspective of material practice. By "domestic sphere" I refer first to women's family homes, where they lived their lives; second, I extend this idea to women's tombs or their underground eternal homes after they had passed away; and, third, I identify other spaces deemed domestic because of their association with women, namely, places where courtesans lived and worked. Unlike other women, courtesans lived a more transitory life. They could conduct daily rituals at home and also could perform frequent religious dances in brothels and at private banquets as well as at temples with their literati friends. Courtesans were even portrayed as heavenly beings in the literary imagination.

GENDERED MATERIAL PRACTICE AND THE CULT OF GUANYIN

Belief itself is a bodily experience.[58] People's religious subjectivities are forged through practices that combine body and mind. This is seen in the routine bodily behavior promoted in lay Buddhism during the late Ming, including chanting

Buddha's name, keeping a vegetarian diet, burning incense before an icon in the morning and evening, and bowing and praying with folded hands. Through such practices, people manifest their belief. This book, however, focuses on people who forged their belief through bodily expressions that went beyond such daily rituals.

To understand how female Buddhists have creatively performed their belief, we must be attentive to the problem of gender. In recent years, many scholars have studied Chinese women's history to grasp women's experience. Ko and others have correctly alerted us to the fact that women's identities are always already constructed in ways that are almost inevitably linked to male discourses.[59] Grant's investigation of female Chan masters from the seventeenth century further illuminates how monastic women's, and many laywomen's, religious lives were either stripped down or only selectively included in accounts by male authors.[60] In this study, I attend to the dynamic relationship between socially constructed roles and the practices of self-fashioning. In particular, I focus on material objects created and used by women to gain insight into the ways women gave shape to their subjective selves. Sometimes, however, as in the case of Buddhist courtesans, the ability to get to the women's voices remains difficult because of layered discursive reconstructions and a lack of surviving material objects.

The study of material culture emphasizes a dialectical relationship between people and things, "how people make and use things and how things make people."[61] John Kieschnick illuminates that people's religious identities and sentiments are directly constructed through things they used on a daily basis.[62] In the cases discussed in this book, "things" mainly refer to icons of Guanyin and various other artifacts that helped women emulate Guanyin. A material perspective enables us to grasp the complexities of how women made and used religious objects, and how religious objects in their style and media not only reflected women's social status but also their desires. The image of Guanyin played a major role in the construction of women's purity, but each woman who created a painting, embroidery, or embodiment of the deity was different. We need to look at each practitioner in relation to her individual experience.

By investigating the processes of making and using things, we can better understand how women felt connected to and through religious icons. We need to investigate how raw materials became cultural artifacts and moved from "the profane into the sacred."[63] How, for example, did a mundane hairpin worn a certain way enable transcendence? The process of transformation is gendered in the Chinese context, because the material, skill, subject, motivation for making, and function of the object can all be directly linked to the creator's body. Objects carried a number of symbolic meanings linked to social and religious worldviews that women appropriated for their own particular projects. In short, women made things as a way to remake themselves or to be remade by the things they created.

The category of "women's things" has been recently proposed as an analytical tool by scholars in women's history.[64] They approach women's things from three perspectives: function (as they are used by women), conditions of production (as they are made and consumed by women), and decoration (as feminine motifs or styles).[65] If we follow Judith Butler in thinking of gender as a performative category, we may say that women's identity is in part assembled and expressed by the things they make and use. In other words, turning our attention to those things allows us to historicize the lives and practices of women. Specifically, my project works from an insight by feminist historian Joan Scott. Approximately twenty-four years after the publication of her essay "Gender: A Useful Category of Historical Analysis?"[66] she revisited the question in "Gender: Still a Useful Category of Analysis?" She urges readers to historicize the very category of "women." She writes:

> Paradoxically, the history of women has kept "women" outside history. And the result is that "women" as a natural phenomenon is reinscribed, even as we assert that they are discursively constructed. To put it another way, the sex/gender binary, which defined gender as the social assignment of meaning to biologically-given sex differences, remains in place despite a generation of scholarship aimed at deconstructing that opposition.[67]

Scott observes that the biological category of women remains naturalized even as we tout various theories, such as deconstructive feminism and Lacanian psycho-analysis. My answer to Scott's challenge is to turn our gaze to women's things. Things are not static; they have a history and they point to practices often invisible in male discourses, previously our main window into "women's" history. I consider the significance of Scott's more recent reflection to be not just whether gender is a useful category of historical analysis, but whether historical analysis can discuss gender without taking it for granted. Can historians think about the category of gender historically? My answer is yes, through the analysis of women's things.

In the context of late imperial Chinese society, "women's things" can be defined as whatever characterizes and assigns a person's role as a woman. These are intimately related to women's time or history, space, and body. Women go through different time cycles from childhood to adolescence and menstruation and from marriage and childbirth to menopause and post-parenthood.[68] Each of these may be associated with particular things and those things enable women to fulfill their social roles. Thus, by studying these things, we can glimpse that temporal process from the perspective of those who experienced it. In particular, we should not think of time in imperial China as an abstract category; it was intimately tied to human activities and those activities in turn involved things.

Both things and processes marked women's time. Guanyin accompanied women daily and helped them move through different stages of their life cycle. For example, at seven or eight, a girl would get her feet bound. One week before she started the footbinding process, her mother would offer a pair of votive shoes, that she had made, to Guanyin's icon in the nearby Guanyin Nunnery. Guanyin was the patron saint of footbinding in many regions.[69] During childbirth, Guanyin's icon and scriptures were widely used to safeguard mother and child, a process Francesca Bray refers to as gynotechnics. Bray includes spiritual devotions regarding childbirth within the scope of gendered technology.[70] Taboos also restrained women from worshiping and making Buddhist icons at certain times. For example, in Buddhist discourse, women's menstrual blood is considered to be polluted. Therefore, during a woman's menstrual cycle, she was not to visit a temple or make any religious icon, including Guanyin.[71] Things thus emerge as markers of biological time and its social implications. Moreover, women's worship followed a different seasonal schedule than men's worship. Many rituals were created to reconfirm womanhood. For example, during the festival rites of the seventh month, women prayed for skills in weaving and embroidering.[72] Seasonal rituals and activities were practiced using various objects, such as images of deities and ritual implements.

The two main categories of women's things in this book are painted or embroidered Guanyin icons, and hairpins and other accessories worn in imitation of the deity. Of the two categories, painting may be considered the more provocative, because painting was traditionally conceived the domain of the literary man. To claim Guanyin painting as women's things is not to say that only women created images of Guanyin. Indeed, many female painters claimed to follow the linear drawing style of Northern Song master Li Gonglin's 李公麟 (1049–1106) or copied from the Guanyin painting manual attributed to Ding Yunpeng 丁雲鵬 (1547–1628), one of the most established painters of Buddhist subjects in the seventeenth century. Using women's things to discuss female Buddhists' paintings means thinking critically about how female practitioners created those images and, by so doing, helped to define the role of women in late imperial China.

Women's things also provide an important window into women's spiritual and political agency. Having limited access to spiritual and secular authority, women creatively manipulated the objects consigned to them and used these objects to gain access to experiences of transcendence that were key to religious authority.[73] Still, their intentions in using these objects and material practices are often not explicit in Buddhist doctrinal texts, scholars' writings, or even in the women's own writings. Given this lack of textual evidence, we cannot know definitively the meaning of the many objects discussed in this book; nonetheless, their existence reveals more than the mere illustration of words. Studying women's *things* precisely challenges

our obsession with research based on texts and our distrust of the logics imbedded in material objects. In short, this book encourages us to rethink how we understand evidence. I switch my gaze from the abstract mode of textual evidence, which has dominated the study of history, to the complex world of practice, where knowledge and assumptions are often tacit and must be inferred from practice.[74] Rather than studying women as they have been objectified in texts, I examine them in action, and the objects that women created and used provide a window into this moving world.

This book contributes to our understanding of the authority and capacities of female subjects in contexts in which their agency was conditioned by the possibilities of the object. Although a thing may be part the finite world, in specific historical and cultural contexts, material things are also used to bridge the secular and the transcendent or divine, potentially linking even subjects with no sovereign authority to the sacred. Focusing on the use of material objects as a bridge, this book demonstrates how women exploited immanent possibility of things not just to gain access to the transcendent but also to transcend the limitations imposed on women as religious and political actors. I show how they struggled to break through the gendered division of spiritual labor by using their own things to directly connect with deities.

GUANYIN XIAN, DEVOTIONAL MIMESIS, AND DIFFERENT MODES OF BECOMING GUANYIN

Earlier in this introduction, I mentioned the "Universal Gateway Chapter," in which Guanyin is portrayed as a universal savior. The text says s/he can appear in any form according to wishes of the worshiper. *Xian* 現 (to become visible) is Guanyin's way of bestowing his/her miraculous power. The efficacy of this divine manifestation is not necessarily attached to a certain place or to a particular manifestation.[75] Eugene Wang reminds us that "the Guanyin iconography highlights certain fundamental dialectical relationships between transcendence and immanence, between world-renouncing and world-affirming; it also exposes the murky relationship between omnipresence and presence, the two concepts which are conceptually and categorically related yet in fact not entirely exchangeable in the domain of visual representations."[76] The dynamic relationship between transcendence and immanence is central to this book. By focusing on laywomen's restaging and reproducing Guanyin imagery, however, we go beyond the dichotomy between transcendence and immanence in visual representation. Throughout this book, I argue that laywomen's various material practices locate a liminal space between transcendence and immanence, and their very bodies become the medium by which they manifest immanent transcendence.

When the cult of Guanyin reached its zenith in late imperial China, the presence of the deity was enacted through a wide range of visual forms. *Guanyin xian* 觀音現 (Guanyin appears/manifests) or *Guanyin shixian* 觀音示現 (Guanyin demonstrates manifestation) encouraged the re-creation of both still images and live performance. Such multimedia representations blur the boundaries of monastic and secular, sacred and profane, and permanent material and temporal performance. These visual practices allowed the abstract notion of the deity's omnipresence to be perceived through a variety of media connected to people's quotidian activities. The interest in bringing Guanyin to life informed the conventions for portraying her; those conventions almost universally emphasized her mobility. For instance, the visual representations of the thirty-three Guanyin manifestations from the "Universal Gateway Chapter" shift from emphasizing Guanyin's appearances of a wide range of social and religious roles to depicting various feminized Guanyin forms in animated attitudes or postures of walking, sitting, and reclining.[77] I propose that such pictorial variety allowed Guanyin to be part of people's everyday life.

As Guanyin was worshiped in a feminine form, female practitioners developed new modes of devotion and were empowered with new skills and devices to invoke Guanyin's presence. Instead of worshiping from afar, Guanyin's followers pursued an ever more intimate relationship with the deity, and eventually *embodied* her. The condition that made this intimate relationship possible was the congruence of gender identity. That shared gender encouraged a mimetic relation between the deity and the worshiper in which the presence of Guanyin was conjured by or through the practitioners' own bodies.

As I suggested in the outset, the materiality of gender difference positions subjects in different ways with respect to their symbolic universe. A female subject's relation to a female deity is conditioned by her gender. Butler, however, has famously denaturalized the category of sex, claiming it to be a "regulative ideal."[78] She explains, "What constitutes the fixity of the body, its contours, its movements, will be fully material, but materiality, will be rethought as the effect of power, as power's most productive effect."[79] This point is well taken. In this case, how are we to understand the gendered body of deities in relation to their worshippers? The gender of a deity must be conveyed through signs, symbols, and icons. Guanyin's gender transformation comes with certain normative changes as well, which bestow her with a certain power. As Guanyin became a woman, she became oriented toward mercy and compassion in different ways. As she took on a normative role related to female identity, the material practices of female worshipers manifested *differently, too*. The various cases discussed in this book demonstrate how women used the power or efficacy of their own bodies to echo that of Guanyin.

A seemingly nonmaterial phenomenon, namely the transformation of a deity's gender, effected a change in the material practice of very real female worshipers.

The concept of "devotional mimesis" unpacks this development. Bringing together "devotion" and "mimesis," it suggests that a devotee's physical likeness to a deity can facilitate her transcendence of the finite world. The power of imitation, a means of practice that can be observed in many religious traditions, facilitates the imitation and assumes some power of the original.[80] The new mode of mimetic devotion that emerged with the feminization of Guanyin reveals that female worshipers' imitations were full-scale embodiments, including metaphysical, ethical, and material dimensions. Assuming likeness to a deity changes the nature and relationship of dependency. The ultimate goal of devotional mimesis is through merit-making to reach religious salvation.[81] In Mahayana contexts, generosity is understood to be one of the excellences performed by bodhisattvas on their path to Buddhahood, and both lay and monastic devotees can achieve this path.[82] Unlike Buddhism's usual devotional practice in which practitioners donate money to the temple, repetitively chanting sutras to fulfill their worldly wishes, such as having a child or ascending to the Pure Land, laywomen found new ways to use their bodies to express their generosity through various ways of making and using things to gain merit. By merging the bodies of the worshipped and the worshipper, women devotees not only create a semblance of Guanyin's presence but thereby also become the very agents by which to secure their wishes.

This book explores four modes in which laywomen expressed mimetic devotion to *become* the female deity Guanyin. *Becoming Guanyin* thinks critically about just how they created that bodily connection. Their devotions must be understood in light of the distinction between becoming and being. Becoming Guanyin was always a process that never culminated in being Guanyin. Still, women's determination to approach Guanyin gave purpose and direction to their lives. Through four different modes—drawing and painting, embroidering, mimicking through jewelry, and dancing—women used their bodies in different ways to create Guanyin's presence.

The mode of drawing, associated with educated elite women, uses two material elements—ink and paper—external to both Guanyin's body and the practitioner's body, but was projected onto Guanyin's body by the practitioner. Both bodies must be transcended. More precisely, the worshipper through practice transcends the image and becomes an exemplary woman. Guanyin's form was often represented in *baimiao* 白描 (plain drawing) style, a symbol of ethical purity that transcends mere physical form.[83] In this way, unlike courtesans and other women we will encounter in discussion of the other modes, the gentrywoman's identification with Guanyin was abstract because it was not merely based on physical likeness. Rather, it embodied Guanyin's virtuous qualities, such as motherly compassion and purity, carried out in the act of drawing Guanyin and the stylistic choice of *baimiao*

painting. This practice often involved a kind of yogic or meditative preparation. As William LaFleur explains it, "If the human being's body is its own ready-made canvas, it is also its most readily attainable altar or temple. The yogi and *Chan* practitioner insist that the whole of religious practice can be carried out within the domain of the epidermis."[84] The process of creation has a meditative focus that enables practitioners to embody Guanyin while making images of her. For instance, in one of the cases studied in chapter 2, Fang Weiyi 方維儀 (1585–1668) contemplated Guanyin and internalized her image before applying brush to paper.

The second mode involves a physical trial that echoes such practices as gegu 割股 (flesh cutting) and other self-mutilating practices of virtuous women. In particular, I examine the phenomenon of female practitioners plucking out their own hair and using it to embroider an image of the deity. Although they first suffer physical pain, the female practitioners create a tangible image of Guanyin using an item from their body.[85] It was possible for men to use their hair to embroider; however, by the late imperial period, embroidery was long established as a womanly practice. The hair was used as thread and feminized the image more intensively. Pulling out one's hair strand by strand was recognized as a gendered practice of self-mutilation, a counterpart to men's writing scripture using their blood as ink. The act of plucking hair is often mentioned in the inscription on these Guanyin icons.[86] The practitioner's physical experience of pain is transferred onto a divine space, just as the hair represents the literal merging of a woman's body with Guanyin's body.[87]

These first two modes demonstrate how women try to become Guanyin through the production of icons, whereas the third and fourth modes reveal how women embody Guanyin by means of adornment and movement. The significance of the body in the cult of Guanyin is evoked directly in the female body of the deity. Women wore hairpins similar to Guanyin's to invoke her presence. That most of these hairpins have been excavated from tombs indicates that women's bodies were seen as key to securing their rebirth. Although the hairpins are dated to the Ming period, this mode of becoming Guanyin continued to be practiced in the late-nineteenth and early twentieth centuries. The practitioners theatrically identified with Guanyin using a gamut of costumes and hair decorations. Empress Dowager Cixi 慈禧 (1835–1908) dressed up as Guanyin and had herself painted and photographed in this guise to propel her into a religious space.[88] Here we see how the gender of a deity invites, or at least may encourage, a worshipper to make significant changes in her attire to transform herself spiritually and politically.[89]

The fourth mode is the ecstatic experience of becoming Guanyin through dance. Unlike assuming similitude through adornment, courtesans performed something called the "Guanyin dance" to evoke the deity through movement. Creating a physical likeness to Guanyin iconography was not really important; instead, the dancer became Guanyin through dance. This mode of embodiment combines the abstract

and the concrete. The identification with Guanyin is abstract because we are not dealing with likeness; instead, the practitioner became the deity through ecstatic motion,[90] as if there was no mediation between the deity and the devotee. For the duration of the dance, the practitioner *was* Guanyin. If we can talk of mediation in this case, the dancer is mediated by movement. In the specific steps associated with this dance, along with the attire that signified or invoked Guanyin, we must imagine something like theatrical identification. The dancer, like an actor, takes on the character of the deity and the space in which she dances becomes a stage. But that stage was not merely the setting for a fiction but rather was a liminal space between the religious and the secular spheres. We cannot understand the spiritual world of late imperial China based on contemporary presuppositions. Practitioners of the Guanyin dance channeled the deity in ways both appealing and sacred. I argue that these women created a space in which the sexual could be sacred.

This book contains four chapters that closely examine these four different modes of becoming Guanyin. Moving from textual to material sources, chapter 1 begins with a discussion of dance, for three reasons. First, it opens up questions of the gender politics of Guanyin in late imperial China: Guanyin provided gender fluidity to both women and men, but the power to invoke Guanyin in discursive and material practice was not equally accessible. Second, in a book largely focused on making and using objects, this chapter offers a contrasting example of devotion. Dance, although ephemeral, is essentially a material practice including many elements—bodily movements, music, costumes, props, the reciprocal relationship between dancer and audience, and the context of the performance. Many of these elements could not be or were not preserved. Even writings about dance tend to follow conventional forms rather than offer close description. Third, male scholars pursuing various agendas recorded the accounts of courtesans' religious practice, so they are constructed within a male discourse.

The first chapter demonstrates both the virtues of reading against the grain and also the limits of the textual approach, which become even clearer in light of the following three chapters on painting, embroidery, and jewelry. Chapters 2–4 on women's things reveal worlds of women's experience usually obscured in the male discursive universe. From this perspective, they contribute to the growing literature attentive to subaltern voices by turning to practices and things rather than focusing exclusively on texts. The conclusion of this book makes a final remark that suggests how the narrative that I have developed here could go beyond domestic space to include various related spheres, such as temples, courts and other arenas.

Dancing Guanyin

The Transformative Body and Buddhist Courtesans

Wu Zhensheng 吳震生 (1695–1769), a dramatist from the early Qing dynasty (1644–1911), wrote *The Glory of Switching Bodies* (*Huanshen rong* 換身榮) in which he explores the fantasy of having a sex change and the possibility of gender transformation on multiple levels.[1] This short play shows the bodhisattva Guanyin helping a desperate young male scholar change into a beautiful woman. Eventually, that woman becomes empress and successfully takes revenge on the person who had plundered all of her (previously his) property. In the fifth act, "Transforming Into a Woman" (*hua nü* 化女), the young female lead dresses up as Guanyin in a white hood and robe, exposing her chest and neck in an image that blends the White-robed Guanyin with a sexy siren.[2] In her opening monologue, after stating that she has manifested as a hundred billion beings, she reveals some perplexity at her/his gender identity. She says,

> People do not know that my dharma king's body can be male or female, or not male and not female. Nonetheless they forcefully pile black hair on top of my head and pull it into a high bun, then sculpt me on the wondrous lotus platform. Even more absurd, in order to defraud [people], Daoist nuns have recently chopped my feet to fit into women's tiny shoes. They steal [my] name and appearance and call it a living Guanyin. There is a prostitute named Xu Jinghong who choreographed new dance moves and called it a Guanyin dance. Foolish men and women then say that I, the World-Honored One, know how to really dance. I want to transcend all sentient beings so I cannot be stubborn. Only the intolerant ones are called sentient beings. If I follow their manner, how I can be a Great Being? Skillful means is the essence of our Buddhist thought and true words. If they ask me to pull my hair up into a bun, then I have a bun; if they make me bind my feet, then I will

just bind my feet. If they fancy that big tall woman who can do a soft dance, I might just as well perform the dance on Jinshatan [Gold Sand Beach] for several turns. Why not?[3]

This opening remark clearly ridicules the feminization of Guanyin. At the same time, however, it mentions bodhisattva in relation to a courtesan dancer, Xu Jinghong 徐驚鴻 (mid-sixteenth century, before 1610), also known as Xu Pianpian 徐翩翩 (courtesy name Feiqing 飛卿). Xu was celebrated in the late Ming, in the pleasure district of Jinling (today's Nanjing), for both her Guanyin dance and her Buddhist faith. But in Wu Zhensheng's play, Xu's dance is treated as a supreme mockery of this intensified feminine Guanyin form. Although the Guanyin character expresses hopelessness with regard to Xu's dance, she tries to convince herself to tolerate Xu's dance by looking at it as an *upaya* (skillful means), a concept referring to the various ways that bodhisattvas help practitioners on the spiritual path. Through Guanyin's mental struggle over how s/he wants to be seen and how "the sentient beings" wish him/her to look like and behave, the author lays out the politics of gendering the deity. Consequently, we must tackle two sets of questions: those relating to Xu's embodiment of the bodhisattva and those relating to men's attitude toward that embodiment. The two are inseparable. It is perhaps the male gaze that makes Xu's embodiment of Guanyin possible.

The Glory of Switching Bodies was written almost one hundred years after Xu Jinghong's death, but the play preserves the ambiguity of her Guanyin dance. Did Xu ever use dance as a form of religious practice? Did her Guanyin dance and the act of viewing her dance count as Buddhist merit-making? How do we understand the phenomenon of reproducing a deity by a set of bodily movements? Why was a courtesan's religiosity constructed by male writers using Guanyin as a catalyst, especially because Guanyin's statement in the play points to the contested nature of the bodhisattva's feminization, even in the seventeenth century?

Conflicting representations of courtesans in relation to religion were common in early modern Chinese culture. In Buddhist texts, bodhisattvas who took on the bodily form of courtesans used sex as a way to lead men toward enlightenment, but from the perspective of female sexuality, a courtesan's desire was considered antithetical to her attaining enlightenment. Xu Jinghong and other leading courtesans of the time are interesting cases because they were able to be courtesans and devout Buddhists simultaneously. It was the male literati's imagination that drew the boundaries of inside and outside, and it is only from this perspective that the labels "pure" and "defiled" could both be attached to these women. By conflating the two, male scholars could desire what existed in a defiled space and then purify it with theory.

The identification with Guanyin could shift from Xu Jinghong to the male writer. Take for instance the figure of Wang Daokun 汪道昆 (1525–1593), who would monopolize Guanyin's status and persona. Wang, a vice minister of war and scholar-official from a merchant family in Anhui Province, wrote a pseudo-Buddhist scripture "A Chapter on the Heavenly Being Huiyue" (*Huiyue tianren pin* 慧月天人品) and several other long poems that envisioned Xu in the Buddhist Heavenly Realm, but paradoxically, also attempted to establish his own identity as the Great Being. By this textual move, Wang excluded the possibility of Xu becoming Guanyin. In this case, the problem of "becoming Guanyin" depends on written representation and narration. One became Guanyin by the words of those who had the power to express their views and thus could transport themselves beyond the mundane realm.

COURTESANS MIRRORING GUANYIN THROUGH THE SEXUAL BODY

To better understand the stories of Xu Jinghong's Guanyin dance and other courtesans' religious practices, we must grasp the complex relationship between courtesans and Guanyin, and between the erotic and the sacred, from a historical perspective. In Tang (618–907) and Song (960–1279) literary discourse, writers frequently eroticized immortal women and immortalized courtesans.[4] When courtesan culture again flourished in the late-Ming period, this theme reemerged. Guanyin's manifestations as a courtesan, such as the Woman of Yanzhou (Yanzhou Fu 延州婦), or as a beautiful woman, exemplified by the Fish-basket Guanyin, or subtly implied by the Water and Moon Guanyin, came to replace other female immortals and gained popularity as figures that evoked erotic desire.[5] Eroticism was viewed as a skillful teaching device to help the laity, particularly agnostic men, reach goodness.[6] Simultaneously, to legitimize courtesans' spirituality, male scholars constantly drew comparisons between the courtesans and eroticized manifestations of Guanyin.[7]

In the story of Mr. Ma's wife, Guanyin is visualized with a beautiful woman's face, humbly dressed, in bare feet, and holding a basket of fish (figure 1.1). She promises to marry the winner of a competition for the memorization of Buddhist scripture. After she successfully lures her admirer Mr. Ma to learn the scriptures by heart, on their wedding day, she dies of a sudden illness. Not long after her death, her remaining bones are found linked together by a gold chain, a sign that reveals her divinity. Therefore, she is also referred to as the Chained-bones Guanyin (*suogu guanyin* 鎖骨觀音).[8] Mr. Ma then follows her wishes and becomes a sincere Buddhist.[9] Although Mr. Ma's wife, as a Guanyin manifestation, is no prostitute,

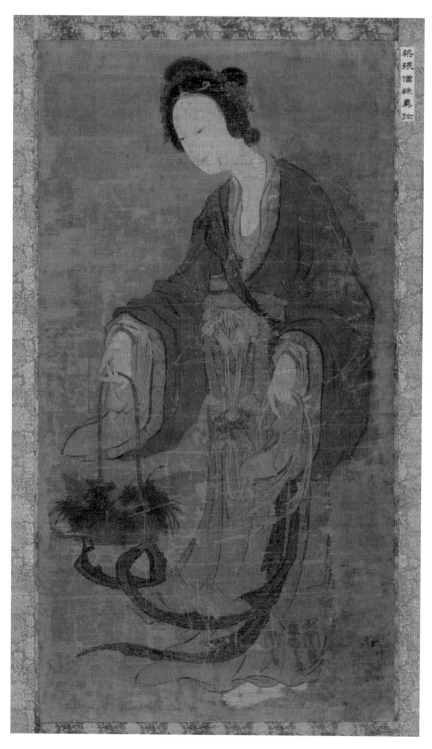

FIGURE 1.1 Anonymous, *Fish-basket Guanyin*, Ming dynasty, fifteenth century. Ink and color on silk (140.3 by 75.0 centimeters). Freer Gallery of Art and Arthur M. Sackler Gallery, Smithsonian Institution, Washington, D.C.: Gift of Charles Lang Freer, Catalog F1911.297.

she does use her appearance to stir male desire and transform that desire into longing for enlightenment. In the popular account of Lady Yanzhou, Guanyin does manifest as a prostitute, and any man who has intercourse with her is freed from sensual longing.

Buddhism displays contradictory tendencies: it gestures toward both purity and impurity with respect to courtesans who were transgressive and marginal social figures. As Bernard Faure elucidates, the transgressive elements of courtesan life threatened orthodox Buddhist ideology, but at the same time, they reinforced it. Buddhist discourse did not just purify or idealize the courtesan, it also debased her.[10] Therefore, Guanyin and courtesans play two extreme roles in representing sexual desire.

A courtesan's sexual identity was part of Buddhist rhetoric that male scholars deployed as a teaching device to "demonstrate illusion" (*shihuan* 示幻). This tactic was used before the Ming era, but interest in it among both lay and monastic writers grew during the Wanli period. One of the driving forces was the popularization of the *Śūtaṅgama Sūtra* (*Leng yan jing* 楞嚴經).[11] The sutra opens with a sermon about Buddha's disciple Ananda going to a brothel to beg for food. The prostitute Matangi succeeded in performing magic on Ananda and seduced him into touching her body. Before Ananda could lose his virginity, however, he was rescued by Manjusri under orders from the Buddha.[12] Eventually, Matangi overcame her desire for Ananda and was ordained a *bhikkhunī*. The difference between Matangi and Lady Yanzhou is that the former renounced her desire by understanding the imperfection of the world. As enlightened but also sacrificial bodhisattvas, Mr. Ma's wife and Lady Yanzhou transform male desire, not themselves.[13] It is no coincidence that several scholars renowned for promoting courtesans' spirituality also wrote and even published commentaries on the *Śūtaṅgama Sūtra*. An adapted version of this story is listed as the first chapter in the *Record of the Lotus in Black Mud* (*Qingni lianhua ji* 青泥蓮花記, ca. 1600) by Mei Dingzuo 梅鼎祚 (1549–1615).[14] That chapter, "The Former Life of Matangi's Daughter" (*Modeng qienü yuanqi* 摩登伽女緣起), promotes the idea of courtesans as the lotuses in black mud, emerging untainted from an unsavory world. Similar accounts can be found in a wide range of literary genres, such as play texts and vernacular novels.[15]

A woodblock illustration from *Wusao ji,* 吳騷集 an anthology of *sanqu* 散曲 (free-standing arias) from the Wanli period, fuses Guanyin and a courtesan into a visual riddle (figure 1.2).[16] The lady's upper-body posture and an aromatic burner in the shape of a lion or *hou* mythological animal make the connection with Guanyin.[17] The delineation of the draped banana leaf mimics the curve of a reclining female body, explicitly evoking eroticism.[18] The banana tree was used as a device for contemplating emptiness in Chan Buddhist doctrinal texts because there is nothing

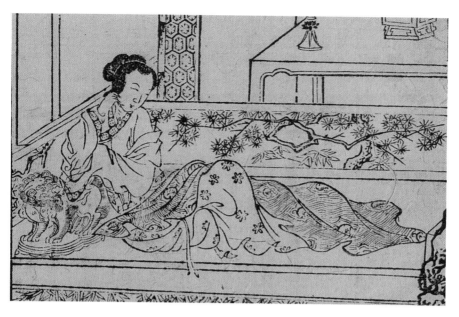

FIGURE 1.2 "Abed with a Green Coverlet, Leaning Idly on a Golden Beast" (detail), Ming dynasty, Woodblock prints (Original leaves 20.7 by 50.0 centimeters), Wang Zhideng, comp., Zhang Qi, ed., *Wusao ji sijuan*, juan 2, 5a. The collection of National Central Library of Taiwan.

left after one peels the leaves off the tree.[19] In this case, the banana leaf implies both the courtesan's unfulfilled desire when her lover is away and a material object to blur the boundaries of dream and reality.[20] In particular, when the courtesan contemplates the banana leaf in a manner of Guanyin's bodily gesture, a contradiction emerges between the extreme desire to possess the interior of the body and the negation of the object of desire—the realization that the interior and exterior are both empty.

Courtesans were often referred to as "living Guanyin" (*huoguanyin* 活觀音) in late imperial times. This term retained the connotation of the bodhisattva as a beauty but extended it to women who were sexually active, and this conception was supported by the popular stories around the Fish-basket Guanyin and Lady Yanzhou.[21] Several well-known female protagonists in *chunqi* opera, such as Du Liniang, Yingying, and Jin Mudan, are all allegorically compared to Guanyin for their exceptional beauty, and they all long after men whom they love but are not lascivious. These two analogs to Guanyin differ, however, from a living Guanyin. The latter could be called virtuous examples—they are beautiful and involved in romantic relationships but are not frivolous. Both in terms of appearance and ethics, this type of character conforms to men's ideals of respectable women.

But the living Guanyin is just the opposite. She not only lusts after romantic relationships but also seeks sexual pleasure for its own sake. The figure of the living Guanyin represents female desire out of control and is often associated with courtesans.

We might consider both these images as products of or at least mediated by male fantasies. We have Guanyin as the ideal woman for conservative men, a young woman who is lovely, decorous, and relatively monogamous. She experiences extreme longing, but she knows how to channel such desire into social and moral structures, even if it means meeting a tragic end. Conversely, the living Guanyin is a negative example perhaps used to contain women's sexuality, because it represents sex without love. This persona could also be manipulative and is Guanyin only in appearance. She has the power to control men, which to some extent relieves men of culpability because they are lured into her trap. The fact that such women often do not have families suggests that they are on the margins of society and may threaten the social order.

XU JINGHONG: THE SHORT BIOGRAPHY OF A COURTESAN

Xu Jinghong is perhaps the only individual who achieved a name for performing a Guanyin dance. Perhaps unsurprisingly, in the literary discourse on Xu Jinghong as a Buddhist, her Guanyin dance is almost invisible. Xu Jinghong's only biography is a short piece written by critic Pan Zhiheng 潘之恆 (1556–1622) in 1610, presumably not long after her death.[22] Xu was born into a family of actors and her younger sister Xu Tingting 徐亭亭 (professional name Ruohong 若鴻) was also a courtesan in Nanjing.[23] Xu Jinghong, like many courtesans of the late-Ming period, accepted the professional name given her by a scholar-client when she was sixteen years old. Inspired by her elegant gestures, Xie Bi 謝陛 (1546?–1615), working from the literary phrase "moving gracefully like a startled swan" (*pianruo jinghong* 翩若驚鴻), gave her the name Jinghong. This name also alluded to another well-known Tang dynasty dancer, Lady Mei, who was the inspiration for the female lead in the popular play *The Startled Swan* (*Jinghongji* 驚鴻記) in the Wanli period. In the play, the female lead invents a dance of the same title.[24] Just after Xu Jinghong received her professional name, she started her artistic training with four different scholars in calligraphy, poetry, singing, and the musical instrument *qin* 琴.[25] Although Pan Zhiheng elsewhere described being amazed by Xu's Guanyin dance when he first saw her perform in Nanjing's pleasure district, he never mentions it in her biography.[26] On the contrary, he emphasizes how Xu disdained singing and playing instruments, and instead she possessed greater talents in composing poems and writing calligraphy.[27] A brief biographic excerpt on Xu in *Ming shi zong* (明詩綜 *Survey of Ming Poetry*) confirms Pan's account of Xu's attitude toward music, but explains it

as incompetence. "She tried to learn the *qin*, but she could not pluck the strings properly. When she tried to learn singing, she could not follow the rhythm of the clapper, so she switched to learning poetry."[28] If this was the case, then Xu's choice of dance as her specialty may have been a decision by default, as each courtesan had to have a signature skill by which to promote herself. Her choice of dance may have been one of last resort, but what she performed might have reflected her own wishes. Xu achieved fame as a Guanyin dancer and as a Buddhist practitioner simultaneously; hence, it is hard not to correlate her dance with her spiritual life. The failure in any Buddhist or official sources to mention the Guanyin dance, performed by Xu or her contemporaries, suggests a complicated view of her religious practice. Dance, more than calligraphy and composing poetry, drew attention to her profession as a courtesan.

Pan Zhiheng's account did not describe Xu Jinghong's religious practice in great detail, but rather it emphasized her love relationships with several members of the literati and included his own admiration of Xu.[29] Apparently, she was desperate to leave the pleasure district through marriage. Xu was once infatuated with a Mr. Mei 琴 from Wanling 宛陵 (today's Yangzhou) and moved away from the pleasure district, but she was soon abandoned with no financial support. She was determined, however, to wait for her lover even if she starved. Her contemporaries laughed at her infatuation with the man, but they also applauded her loyalty. Wang Duanshu 王端淑 (1621–after 1701), the renowned female gentry poet and compiler of *Mingyuan shiwei* 名媛詩緯 (*Classic Poetry by Renowned Women*) from a later period, gossiped about Xu's painful breakup with her betrothed Mr. Mei. Wang said that after Xu found out that Mr. Mei had fallen in love with a younger courtesan during a visit to Suzhou, she rushed to Suzhou in a boat, confronted Mr. Mei, and bit his arm until it bled. She then invited many guests, and in front of everyone, she burned all the jewelry and clothes Mr. Mei had ever given her. Ultimately, she burst into tears and left.[30] After this dramatic event, it is likely that she visited Jiaoshan 焦山 where she had first encountered Wang Daokun in 1586. At this point, Xu's fame as a Buddhist courtesan had spread widely.

Eventually, Xu Jinghong married Yu Wenshu 郁文叔 (?–1595), an elder fellow-townsman from Chengjiang in Jiangyin, probably in 1589.[31] Yu was a good friend of literatus Wang Zhideng 王稚登 (1535–1632) and published Wang's letter collection *Mouyeji* 澄江.[32] Xu hoped to accompany Yu for the rest of her life. Unfortunately, his other concubines were jealous and blocked Xu's plan to follow Yu to his post as the county magistrate of Changle in Fujian Province.[33] Yu was also unhappy about the absence of his newly wedded concubine's companionship, which directly resulted in his sudden death in Fujian in 1595. Xu then said farewell to Yu's principal wife and returned to her natal home in Nanjing. Ten years later, in 1605, Yu's son built

a nun's residence (*anju* 庵居) at Lianziying 蓮子營 in the Qinhuai pleasure district of Nanjing for his late father's beloved concubine.[34] Xu then shaved her head and lived there as a nun there until her death, likely in 1610. Yu's principal wife had Xu buried in Changgan, a place close to the pleasure district. As a woman who had duel identities of courtesan and nun, she could not be entombed in the Yu family cemetery. In the spring of 1610, Yu's son Yuanzhen 元禎 asked Pan Zhiheng to compose a biography to commemorate Xu. It is perhaps for this reason that her practice of dance is omitted from her biography.

DANCING GUANYIN AND GUANYIN MANIFESTATION

Xu Jinghong's Guanyin dance reflects the fascination with staging Guanyin's magical power through live performances in the sixteenth and seventeenth centuries. *Guanyin xian* or Guanyin's manifestation was staged on various occasions and in such spaces as religious festival processions and theatrical performances at the temple Guanyin's manifestation all appeared on other stages during rituals related to Guanyin and shamanistic healing rituals as well as at banquet settings in individual households. In both public arena and private domain, Guanyin as *icon* or *character* in a ritual, an opera, or a dance was enacted by a human agent.[35] Each role had its own performance tradition, ritual, and entertainment function.

Both the history and repertoire of the Guanyin dance (Guanyin *wu* 觀音舞) or dancing Guanyin (*wu* Guanyin 舞觀音) have been occluded as a result of limited textual sources; they can be retrieved only through vague and scattered descriptions from the Ming period.[36] The Guanyin dance was also referred to as *pusa wu* (菩薩舞) or the bodhisattva dance.[37] Both of these terms, at least in Ming sources, refer to representations of Guanyin through choreographed movements accompanied by music or percussion produced by certain props.[38]

An encyclopedia from the Ming period provides a brief explanation of a type of bodhisattva dance that was often performed in rich households in both Nanjing and Beijing: "When a person performs the Great Being, she affixes a bowl to her forehead and holds a bowl in each of her hands, so she uses these to beat out the rhythm."[39] The shape and material of the bowl are not specified. A ceramic bowl, however, has been used as a symbol for hell, with eighteen ceramic bowls representing the eighteen levels of hell in Chinese theatrical tradition. In the Mulian opera, for instance, the title character uses a staff to beat ceramic bowls as a way to emblematically break through hell. This suggests that "beating a ceramic bowl" might have become a theatrical gesture and may have been assimilated into the repertoire of *pudu* 普渡 or rituals of universal salvation.[40] Because Guanyin plays an important part in the Mulian drama, and her main responsibility is to help people

transcend, it is likely that such bodily movements incorporated into the Guanyin dance were used to mark her divinity and powers.

The late-sixteenth-century *chuanqi* drama *Play Script on Promoting Kindness: Mulian Rescues His Mother* (hereafter *Mulian Rescues His Mother*) shows that Guanyin's power is demonstrated through the ability to appear in manifold manifestations. The stage direction indicates that every transformation is signaled dance moves (*wujie* 舞介) or dance-like moves. A comic act (*chake* 插科) known as "Guanyin's birthday" also stages the ability to take on a transformative body (*bianhuashen* 變化身). Each time a new transformation takes place, the character of Guanyin announces, "This is to manifest my miraculous power."[41] The transformations go from bird to beast to human beings, each entering the stage one after the other: a crane, a tiger, a military officer signifying a martial hero, a Taoist representing a scholar, a tall person, and a short person standing for a monk.[42] They are acted by the male role types—*jing* 淨, *chou* 丑, *wai* 外, and *mo* 末.[43] An actor in the female role type *tie* (占) performs the feminized Guanyin forms, such as Fish-basket Guanyin and Thousand-handed Guanyin. The stage direction provides details that help us understand the techniques of stage presentation. For instance, when the Fish-basket Guanyin transforms into the Thousand-handed Guanyin, the actor first changes his (or her) props from the previous manifestation, namely, a fish basket for a willow sprig. Then s/he sits covered with a white bedspread. Several armholes have been cut in advance. Two to three actors hide beneath the white spread. As soon as Guanyin claims, "I now transform into Thousand-handed Guanyin,"[44] all of the actors stick their arms through the slits and move their arms and hands while holding various props. The gender fluidity of Guanyin is presented as Guanyin's efficacious power, but at the same time, it creates a comic effect.

Different from such dance like moves/gestures accompanying acting and singing, Xu Jinghong's Guanyin dance seems belong to a full-fledged dance, in which the dancing body creates a powerful presence through a sequence of movements accompanied by music.[45] A solo female dancer usually performed this dance, but also in some examples, male dancers dressed as women to perform Guanyin dances. Both the banquet entertainments described in the encyclopedia and dance moves in the Mulian drama follow a prescribed code such that an audience would recognize them as representing Guanyin iconography. These involved some mimicry, just as other channelings did. Ming-era (and later) women attempted to approach or embody Guanyin by wearing Buddhist hairpins or by using a combination of costumes, body gestures, and settings, such as when Empress Dowager Cixi dressed up as Guanyin for a photo portrait. In the case of Guanyin dance as phenomenal performance, however, the dancer embodied the bodhisattva through choreographed movements. As William Yeats's poem "Among School Children" describes, "O body

swayed to music, O brightening glance, / How can we know the dancer from the dance?"[46] In the case of the Guanyin dance, the problem is not just becoming the dance, a process that goes beyond the body, but also becoming a divine figure. The dancer becomes Guanyin in the course of the dance. Key to this transformation is that it happens not only in the mind of the dancer but also in the mind of the viewers who witness the transformation.

The fascination with live performances of Guanyin manifestations in dance and the communal recognition of it can be seen in a *ci* poem entitled "Watching A Guanyin Dance" (*Guan guanyin wu* 觀觀音舞) written by Shi Jian 史鑑 (1434–1496), a scholar from Suzhou. He vividly describes the dramatic transformation, as follows:

翠袖低垂	Jade green sleeves hang down,
湘裙輕旋	Long silk skirt swirls delicately.
地衣紅皺弓彎倩	Her tiny feet look lovely on the wrinkled red carpet.
曉風搖拽柳絲青	Her arms sway like pale green willow branches in the dawn breeze,
春流蕩漾桃花片	Her skirt is carried along like peach petals floating on a spring stream.
矯若遊龍	When she dances vigorously, she resembles a dragon surging into the air,
翩若飛燕	When she moves gracefully, she is like a soaring swallow.
彩雲揮毫華燈炫	Colorful clouds brush the sky as decorated lanterns shimmer,
海波搖月晚潮生	The moon's reflection bobs on ocean waves as the evening tide comes in,
大家齊道觀音現	All at once, everyone exclaims Guanyin has appeared.[47]

The dancer in Shi Jian's poem does not evoke any signs of Guanyin until the last two lines, when Guanyin's manifestation is the instantaneous communal experience of all present. This is quite different from the Guanyin dance described in the banquet and play, which rely on costume, props, and gestures drawn from relevant iconography. In this poem, Shi's references to green sleeves and long skirt, likely in crimson, were almost clichéd poetic tropes for a dancer.[48] Similarly, a set of allegorical expressions of a beautiful female dancer's delicate body and the pace of movements described through a willow branch, spring stream, dragon, and swallow are also reiterated in the lyrics. An illustration of a dance performance based on a set of *sanqu* entitled *An Ode on Dancing* (*Yongwu* 詠舞) helps us to envision how a Guanyin dance as described in Shi's poem might have been staged in a garden setting (figure 1.3).[49] What is unusual in this poem is that a seemingly generic dance leads everyone

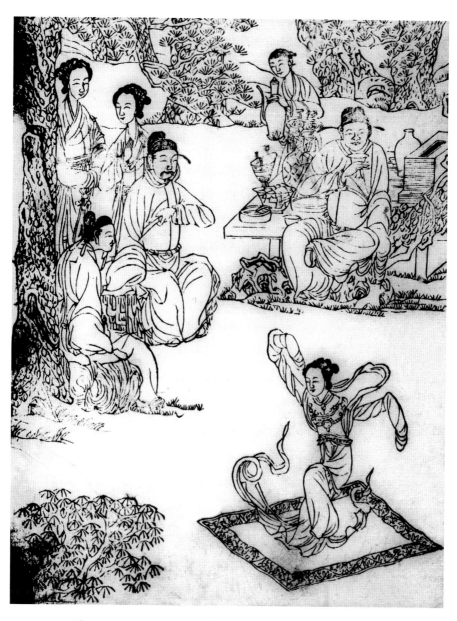

FIGURE 1.3 *An Ode on Dancing. Source:* Gu Zhongfang, *Bihualou xinsheng*, between 1573–1620, (University of Chicago Library, East Asian Collection), microfilm, juan 1, 15 a.

watching to apprehend a manifestation of Guanyin. The last two lines, which unite the moon's reflection, the evening tide, and the manifestation, seem to allude to the Water-Moon Guanyin of the South Sea.[50]

In Ming times, both ceremonial and nonceremonial dances were what we might consider elaborate and often scripted material practices.[51] Ritual dance manuals from the Ming court provide objective and precise instructions on movements, facial expression, steps, the location of each dancer, props, music, instruments, and costume.[52] Additionally, the lyrical and visual vocabulary used to describe a performance in poems or represent a dancer in illustrations relied on literary and visual conventions. Guanyin dances, however, were not standardized.

The general formula for describing and representing a Guanyin dance reveals the impossibility of regulating its movement, music, and costume. Whether it was performed at a private banquet or a public procession, the dance always involved two parties—the performer and the viewers. Dance as performance intensified the drama of witnessing a manifestation of Guanyin. How did the viewer see Guanyin in the dancer? When a courtesan, a living Guanyin, performs a Guanyin dance, mimicry is not executed merely through costume, props, and moves. The embodying dancer evokes a connection with an eroticized Guanyin.

XU JINGHONG'S GUANYIN DANCE

The different Guanyin dance performance traditions presented thus far provide a historical context for Xu Jinghong's Guanyin dance. Here I pursue an in-depth exploration of Xu's specialty. Pan Zhiheng and his friend Zhang Youyu 張幼于 (also known as Zhang Xianyi 張獻翼, 1534?-1601?) both claimed that they watched Xu's Guanyin dance in the Qinhuai pleasure district, but only Pan Zhiheng has described her dance along with that of another courtesan. He wrote,

> [I saw] Yang Qiuji performed a dance on carpet and Xu Jinghong performed the Guanyin dance. When Yang bent her body, [she was cloaked in a] priceless embroidered counterpane; when Xu raised her wrist, [she was adorned with] countless strands of pearls. They take gleeful pleasure in themselves, but they also curry favor with men by evoking pity. Can it be said that they still possess the virtue of feeling shame?[53]

Pan stresses the women's luxurious dance costumes and jewelry. He describes only one gesture in Xu Jinghong's Guanyin dance—that is, raising the wrist, a last flourish to the movement of lifting the arms. In both Chinese literary and visual tradition, the female dancer's hands and wrists are typically hidden inside long

sleeves and their arm motions accentuate the movement of the sleeves. By exposing her wrists weighted with strands of pearls, Xu created an unusual attraction. This vignette, written in the unconventional vocabulary of dance, may suggest a unique feature of Xu's dance, and this allows us to speculate about Xu's creativity in her performance of Guanyin. Bracelets, although a common female adornment, were not often associated with worldly dancers in the late-Ming period. They often appear, however, on icons of bodhisattvas and Devas and on images of famous beauties. Moreover, in the theatrical tradition of Guanyin performance and in religious processions in Ming times, the costume of the White-robed Guanyin was so prominent that it not only represented that manifestation but also stood for a universal Guanyin. The voluminous robe would have concealed the femaleness of the performer's body, but Xu seems not to have followed the fashion of the sleeve dance or the performed tradition of the White-robed Guanyin. By wearing strands of pearls and displaying a wrist or both wrists adorned with fine ornaments, she borrowed moves from the sleeve dance but altered the outfit; the accessory of a sensuous body was more enticing.

The sensuality of Xu Jinghong's Guanyin dance is echoed in the Guanyin dance performed in Wu Zhensheng's *The Glory of Switching Bodies.* In the play, Guanyin claims that she can dance as if she were at the Gold Sand Beach, where the Fish-basket Guanyin converted men into Buddhists. Wu Zhensheng does not explicitly indicate that the dance was an emulation of Xu's version, but it is surely meant to evoke the style of dance a courtesan would perform. In the play, in a break from her performance, Guanyin comments: "The heavenly body has no sense of shame!"[54] This self-ridicule calls the audience's attention to the fact that her dance moves are alluring.

The stage direction specifies the sequential steps, in perhaps the most detailed choreography for the Guanyin dance so far: "Guanyin should move her body forward and turn back, open her arms (sleeves) and swirl, stamp her feet, use a hand to reveal her foot/feet, bend her body forward and show her foot again, stand up and present in a *xiaowu* 小舞 (small dance) gesture."[55] Interestingly, Wu's description is typical of ritual dance and ends with a term that often refers to a category of Confucian ritual dance, but this term is unclear when applied to a specific dance move.[56] Wu incorporates three typical moves in this stage direction: manipulating the sleeves, swirling, and bending the body. These consecutive moves contrast with Guanyin dance-like moves that follow standard Guanyin iconography in the play *Mulian Rescues His Mother* and the Guanyin dances for night banquets recorded in *Lushu.* As we observed in Shi Jian's poem "Watching Guanyin Dance," the first two gestures do not necessarily have religious meaning, but they can still generate in the viewer a recognition of Guanyin when the dancer is a courtesan.

Nonetheless, the gesture of bending the body forward may have a Buddhist connotation. When Wu Weiye 吳偉業 (1609–1672) praised the male dancer Wang Zijia 王紫稼 (1622–1654), he described Wang's dance as "Chained-bone Guanyin manifested in the present body, bending over backwards and touching the floor like a blooming lotus flower."[57] It is unclear whether Wang Zijia was performing a Guanyin dance, but his profession as a male courtesan, and his presumed cross-dressed appearance invoke the Chained-bone Guanyin, who manifested as a prostitute who cured men of sexual desire. In his play, Wu Zhensheng manipulated the two transgendered bodies, Guanyin and the cross-dressing actor, and directed Guanyin to repeatedly reveal the male actor's artificially bound feet.[58] In both visual and textual sources, Guanyin is always depicted with unbound feet, so this move must have functioned as a visual punch line to make audience laugh.

Pan Zhiheng and Wu Zhensheng lived a century apart, but both responded to the dancing body using the moral term "shame" (*xiu* 羞). The shame lies in the sensuousness of bodily movement, whether it was Xu Jinghong performing the Guanyin dance or the character of Guanyin imitating a courtesan's dance. Wu Zhensheng categorized Xu Jinghong's dance as *ruanwu* 軟舞 (soft dance), a term that contrasts with *jianwu* 健舞 (energetic dance).[59] Soft dance implies slower rhythmic movements. In ritual dance, every gesture, costume, prop, and expression is encoded with meaning, and the performer is constrained by the choreography. Unlike ritual dance, in banquet dance, the less coded movements allow the dancer to be more expressive through improvisation. The performer communicated with viewers using space and the flow of movements and emotions through space. This fluidity evokes the idea of becoming rather than the fixed idea of being.[60] As Pan Zhiheng stressed, when Xu Jinghong performed her Guanyin dance, she appeared full of joy. But by questioning the dancer's sense of shame, he also challenged Xu's freedom to charm audiences.[61]

In contrast to Guanyin dance in plays and public processions, the versions performed by courtesans such as Xu Jinghong seem to have combined sexual and spiritual dimensions with respect to both performer and the performed subject. Guanyin has been seen as enticing men through sex, but then channeling their desires into a religious desire for enlightenment. When the same is done by an actual dancer, who is often a courtesan or a male prostitute, "they take gleeful pleasure in themselves, and they entice people through tender loving feeling."[62] Their very allure reveals a kind of vulnerability that invokes in the audience at once pity and desire. In religious experience, the courtesan transcends her existence as a courtesan and becomes divine, and because the divine is channeled through the courtesan, the desire for the courtesan becomes a desire for Guanyin. Does one still need to feel shame in this case? Normally, one might say that being

a courtesan involves feeling shame. If, however, the transformation into Guanyin takes place, suddenly, the base becomes holy. This shifts the viewer's desire from physical to spiritual. The courtesan, who is usually seen as marginal to respectable society, turns exclusion into transcendence. Her actions can be a pathway to the divine.

This passion for elevating courtesans to spiritual figures probably existed among only some members of the literati, such as Wang Daokun, Wang Zhideng, and Mei Dingzuo. The compiler of *Rhymes from a Brothel* (*Qinglou yunyu* 青樓韻語) cited a phrase from the *Classic of Whoring* (*Piaojing* 嫖經) that expressed a rather ironic attitude toward courtesans becoming nuns. He asserted that "after a length of time, prostitutes would turn to pursue the Dao; long-time dandies would become female procuress's husbands (turtles)."[63] This reflects the feeling of a courtesan's client to the exclusion of the courtesan herself. The compiler made a short comment with a spiteful tone, "Prostitutes who have done evil cannot escape that; they become nuns as a pretext for putting it all to rest."[64] This commentator viewed entering a nunnery as a common and unfortunate solution for the aging courtesan who has failed to land a man to marry. This points to a special connection between courtesans and Buddhism, both in their eyes and in the eyes of male writers.

The two poems listed under the theme "Entering the Dao" (*rudao* 入道) are both related to Xu Jinghong's pursuit of Buddhism. One is written by Xu with the title "Chan Words" (*Chanyu* 禪語) and expresses her regrets about being a courtesan. She wished to detach herself from life in the brothel by pursuing religiosity.

誤落風塵已有年	By mistake, I fell into the world of prostitution many years ago,
每思探道叩金仙	I often think of seeking the way and worshiping the golden spirit.
羞將鳳髻重臨鏡	I am ashamed to see my phoenix hairstyle doubled in the mirror,
獨挽牛車好着鞭	Alone, I steer the ox cart and crack the whip with ease.
夢裡巫山空二六	Wu Mountain has always been an empty dream,
悟來法界遍三千	I have awakened to the dharma world that extends to three thousand universes.
傷心歌舞難重覩	It is difficult to watch again those heart-wrenching songs and dances,
矯首長辭玳瑁筵	I raise my head and bid farewell to the lavish banquets forever.[65]

This poem, written late in Xu's life, provides a window onto her own subjectivity or at least the possibility of a late subjective transformation. It also shows the shallowness of the narrative of the courtesan turning into a spiritual figure. Reflectively, Xu notes in her poem that the transcendence can never be complete. The courtesan's actual body, she knows, can never be transformed into Guanyin no matter how alluringly she dances. The social nexus that fixes the courtesan and the client, as indicated with the reference to banquet in the last line of her poem, leaves an indelible mark. Notice that the poem begins with an image of a fall. She fell into the world of prostitution.

In my analysis of Pan Zhiheng's account of Xu Jinghong's Guanyin dance, I consider whether there was a place for shame and explain why there would be no shame if the transformation actually took place. In this poem, however, we see the fact of the shame that Xu actually felt when she looked in the mirror. To her, the whole dance was merely something that signaled failure, her inability to transcend her past and her defiled body. Transcendence requires a moment of radical negation. This negation could be accessed by another practice, namely, meditation on nothingness. One might say that the practices of dance and meditation have much in common, because in both cases one must transcend one's everyday body. In the end, Xu said farewell to the banquets, which she ultimately recognized as the opposite of becoming Guanyin and Buddhist liberation.

BUDDHIST DANCE AS A FORM OF THE JOY OF *CHAN*?

The discourse on dance in Buddhist canonical texts is complicated. There are at least two conflicting tendencies. On one hand, musical performance, including dance, acting (*wuxi* 舞戲), singing, and playing instruments, is considered a type of offering. It is listed as a material gift along with other gifts, such as incense, flowers, and jewels.[66] Such performances usually are conducted during routine Buddhist rituals at court and at Buddhist festivals. They also are performed at special rituals, such as the rite for repenting the deceased souls *jianfohui* 薦佛會.[67] On the other hand, according to monastic discipline, monks and nuns were prohibited from performing or even watching musical performances.[68] The cleric Yunqi Zhuhong, a contemporary to Xu and from the same city, clearly defined the terms of singing, dancing, and playing instruments; the functions of these performances; and their potential dangers.[69] In *Essential Rules and Ceremonies for a Novice* (*Shamen lüyi yaolue* 沙門律義要略), he explained, "To dance is to use a dancer's body to perform a dance."[70] As part of musical performance, it can be offered only to Buddha but is not to be consumed by monastic people except in the rituals

conducted for the laity. Although Zhuhong's definition of dance sounds tauto-
logical, what he highlights is the danger associated with subjecting the bodies of
performers to any viewer's gaze. Specifically, he sees menace in the performing
bodies of women who could evoke sensuous experiences and disturb the minds of
those seeking the way.[71]

 These contradictions are part of the vibrancy and complexity of the late-Ming
world. Many scholars have demonstrated that the late Ming was a time of daz-
zling commercialism and popular culture.[72] When religious opera, singing, and
dance performance became part of quotidian life, destroying the old binaries of
monastic–nonmonastic and religious–nonreligious, entertainment in a nonmo-
nastic space became an important channel for lay people seeking religious sal-
vation.[73] Literatus Tu Long 屠隆 (1542–1605) wrote on the redemptive quality of
drama performances in his preface to *Tanhua ji* 曇花記 (The Story of Udumbara),
a play written in 1598: "Is it possible to use opera to conduct Buddhist rites?
It is said: The ten thousand circumstances in this world are illusory. Opera is
illusion within illusion. We understand that all circumstances are illusory from
the illusion within illusion, therefore opera can be beneficial, not harmful."[74] Tu
Long asserts that the theatrical medium has a structure that mimics the logic
of Buddhism. In particular, Buddhism claims that the various relations of life
are illusory. The doubling of illusion created by opera actually leads to a type of
enlightenment, because by its creation, one realizes that all circumstances are
illusory. What takes place on the stage permeates real life.[75] The opera becomes
upaya or a skillful means to enlightenment. Tu Long only refers to *xi* 戲 (opera),
but to the extent that dancers also play a role, a great overlap exists between
the Chinese concepts surrounding opera and dance. Dance, and Guanyin dance
in particular, was not merely movement synchronized with music, it invoked a
role and a world along with this movement. Dance contains an implicit narra-
tive that can then have the same function with respect to illusion and reality.[76]
Moreover, the dancer's body, particularly the female performer's body, becomes
a teaching device under the rubric of *chanyue* 禪悅, or the joy of *chan*. *Chanyue*
was originally used to describe the Buddhist layman Vimalakirti: "Although he
ate and drank like others, what he truly savored was the joy of meditation."[77]
Gradually, this term came to refer to the enjoyment derived from comprehend-
ing intellectual *chan*, but it also was used in connection with musical perfor-
mance. *Chanyue* was borrowed to refer to an aria about the joy of *chan* (*chanyuequ*
禪悅曲) that accompanies a dance. During Ming times, it was held that when
the aromas of food and drink blended with the visual and acoustic feast of
Buddhist dance and music at meals or a banquet, the visualization of a Buddha
land became a sensuous reality.[78]

A poem entitled "Watching a Play at Wang Wenzhi's Residence" (*Wang Wenzhi jia guanju* 王文治家觀劇) by Zhao Yi 趙翼 from the Qianlong period (1736–1795) may help us conceptualize that experience:

廿載清齋禮佛香	I have kept a vegetarian diet, burned incense and showed respect to Buddha for two decades,
翻將禪悅寄紅妝	but (now) I express the joy of *chan* in red cosmetics.
始知十六天魔舞	I just came to realize that the Dance of Sixteen Heavenly Goddesses,
別是僧家一道場	Is another monastic place along the Way.

The first couplet begins with quotidian Buddhist practices but turns toward the performance space by siting the pleasure of *chan* in rouge, which implies watching female performers. Starting from the Yuan period, the *shiliu tianmo wu* 十六天魔舞 (Dance of Sixteen Heavenly Goddess, hereafter the *tianmo* dance) was performed at court as part of the ritual *zanfo* 讚佛 (Eulogizing Buddha). By the Ming and early Qing periods, however, it was performed in a wide range of social spaces, such as the temple and even private households.[79] Performing and watching a Buddhist dance was comparable to Buddhist daily rituals. The joy of *chan*, which previously the practitioner might have experienced internally through activities such as meditation or composing a hymn, is projected onto the performance.[80] In the second half of this quatrain, the dancer of the Sixteen Heavenly Goddess and the dance occupy a liminal space between theatricality and ritual. There is the split-space of theatricality in the distinction between performance area and audience, fiction and reality. The dancer is expected to become the celestial being and the audience, along with the dancer, experiences this transformation. Consequently, the final line states that this is another form of monastic ritual space.

Given that during the late Ming and early Qing, Buddhist dance and music already had been assimilated into daily life to accompany each day's three meals, religious practice not only approached theatricality but also eventually inhabited a liminal space in which banquet space and ritual space became one and the same.[81] This notion of the liminal space can help us contextualize Xu Jinghong's Guanyin dance and other Buddhist dances that were performed in a secular context.

THE BUDDHIST COURTESAN

Courtesans' mobility in the practice of Buddhism is different from that of gentry and aristocratic women.[82] Courtesans resided outside the Confucian familial system and architectural space. Domesticated religiosity as discussed in the subsequent

three chapters (with the tomb also regarded as an underground home) did not apply to courtesans. As a transitory social group, courtesans appear to have had more freedom than did wives to visit different public and private temples and to engage in material practices like the Guanyin dance.[83] Their low social status, however, also limited their access to religious space. If courtesans went to a monastery as a group in which they represented their own social status, they would be able to visit only certain temples close to or inside the pleasure district.[84] According to *Records of North Alley* (*Beilizhi* 北里志), starting in at least the Tang dynasty, the courtesans visited and listened to scriptures on the eighth day of every month at Baotang Temple, (Baotang si 宝唐寺) which was well-known for its nuns' sermons. Courtesans' devotional efforts focused on paying the madam to get out of the brothel for that one day.[85] During the Ming period, the Zhengjue Temple, (Zhengjue si 正覺寺) which was close to the pleasure district in Nanjing, always received prostitutes, especially on Guanyin's birthday on the twenty-ninth day of the sixth month. For this occasion, the courtesans would follow the rituals of keeping a vegetarian diet and wear plain dresses.[86] Famous courtesans, as companions of literati, could visit a much wider range of temples and private shrines.[87]

Courtesans were not required to confine their religious practice to their home spaces, but to conduct daily rituals, many erected private shrines in their residence to host Buddhist icons. For instance, Ma Shouzhen 馬守真 (1548–1604) could afford to place a large bronze statue in her inner chamber.[88] Similarly, Xu Jinghong is portrayed as a practitioner and as a Buddhist courtesan in her inner chambers in *Caibi qingci* (彩筆情辞 *Lyrics of Stylistic Brilliance*), an anthology of songs published almost a decade after her death (figure 1.4).[89] Wang Daokun once composed a southern-style *sanqu* entitled "Dedicated to Madam Xu Pianpian Meditating on Chan" (*Zeng Xuji Pianpian canchan* 贈徐姬翩翩参禪). An anonymous artist carefully designed an illustration based on a couplet from one of Wang's arias.[90] The illustration includes the two lines: "Surrounded by thousands of tall bamboo, she is destined to live behind red balustrades and venerate the Buddha from her bedside."[91] A lady, presumably Xu Jinghong in this context, is depicted in three-quarter view seated on a couch-bed. A statue of Guanyin with elaborate halos is set in the middle of the altar table. Before her stands an incense burner and a flower vase for veneration. The open chamber is surrounded by bamboo as described in the poem, which evokes a subtle allusion to Guanyin's residency.[92] Xu Jinghong on the couch-bed and Guanyin on the lotus base are juxtaposed. In the coda to this set of arias, Wang Daokun states, "I see you as an enlightened being on the lotus flower."[93] Xu's transcendence is then confirmed in Wang's final statement. As a courtesan well known for her religious practice, she is illustrated confined in a domestic space, yet this is not an ordinary laywoman's ritual space. Her identity as a Buddhist courtesan is explicitly

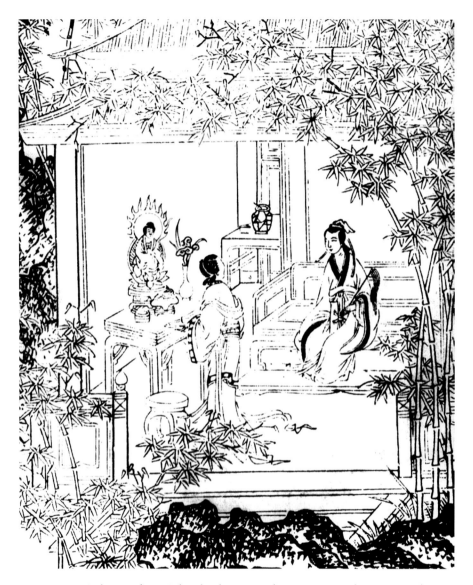

FIGURE 1.4 Xu Jinghong meditates in her chamber. *Source:* Zhang Xu, comp, *Caibi qingci*, 1624 edition (Harvard Yen-ching Library Collection), microfilm, juan 5, 6b.

revealed by the couch-bed and the young maid at her side. In a late-Qing illustration (figure 1.5.), a courtesan disguises herself as Guanyin as a form of meditation in her inner chamber. This further confirms the visual codes embedded in the representation of a courtesan's ritual space.

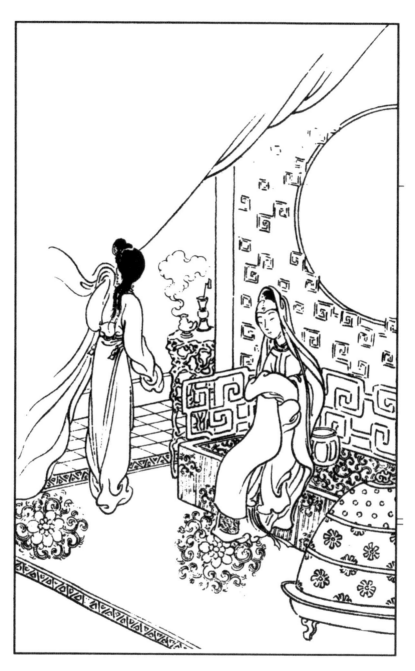

FIGURE 1.5 Fei Xiaolou (1802–1850), Huazhuang dashi 化裝大士 (*Masquerading as the Great Being* [Guanyin]), 1890s. Woodblock print *Source:* After Fei Xiaolou *Fei Xiaolou baimei tu* (Shanghai: Shanghai guji chubanshe, 2005), 6.

The only recognizable references to Guanyin in this image are shown through the courtesan's pose and the Guanyin hood. Wearing a late-Qing Han Chinese-style woman's coat, she sits on a carved wooden couchbed in a pose known as the "Royal Ease". Her right leg is bent semivertically in front of her body while her other leg is bent horizontally on the ground, though both legs are hidden beneath her long coat and skirt. Both hands are placed on her right knee and covered by her long sleeves. On top of her head, the so-called Guanyin Hood, covers her hair and drapes over her shoulders. Her eyes are contemplatively downcast. A wisp of smoke coming out of the incense burner in the corner further enhances the religious atmosphere while a moon-shaped window alludes to the *Water and Moon Guanyin*.

The courtesans' interior space was the place where they received clients and worshipped Buddhist saints, Daoist deities, local spirits, and their professional god simultaneously.[94] The most popular protective spirit in the late imperial prostitution circles was the Spirit of White Eyebrows (Baimeishen 白眉神).[95] Courtesans conducted different daily, monthly, and periodic rituals in front of a statue of this spirit, and they appealed to him to deal with unexpected situations when they serviced clients.[96] Ming prostitutes also prayed to the Spirit of White Eyebrows to gain wealth. Nonetheless, this deity is mostly invisible in writings about ideal courtesans.

Courtesans sought to connect with Guanyin using media in various ways. Many used painting and embroidery to make icons of the bodhisattva. When they did so, their purpose was not related to a Confucian familial system but was either for themselves or to suggest a relationship with male scholars. Lin Jinlan's 林金蘭, for instance, created a hair embroidery intended to thank Guanyin for healing her eye disease, not to for filial piety purposes like that of Ming gentrywoman Chen Shuzhen 陳淑真, who made a hair embroidery to ask Guanyin to cure her mother's eye disease.[97]

Laywomen often tried to maximize an item's meritorious effect by stating in the inscription that it was made by their hands. On a Guanyin painting attributed to Lin Xue, a courtesan from the late Ming and early Qing and became a nun in her hometown in Fujian, inscription noted that she had made at the request of scholar on Buddha's birthday (figure 1.6).[98] Whether this painting was actually created by Lin Xue, this inscription tries to validate her social network with male scholars; however, by frankly noting that her painting was created as a present to other people her own genuineness toward Guanyin diminished to a certain degree because her role as a worshipper included her role as a gift giver.[99] The scholar Li Rihua 李日華 (1565–1635) explains that Xue Susu, a courtesan who was in the business of entertaining men, had witnessed all types of unfulfilled love relationships. Thus, Xue created a Guanyin icon as a prayer for all couples to have a smooth bond.[100] Because the painting no longer exists, it is unclear whether this was Xue Susu's original intention or whether it was merely attributed to her by Li Rihua. Although the wish to secure a romantic relationship is not expressed on other women's Guanyin icons, we cannot assume that no gentrywoman ever prayed on this account.[101] Still, codes of moral correctness pertaining to the intention of making an icon specified what could be inscribed on its surface.[102] This moral correctness corresponded to the devotee's own social status.

In general, the religious practices of lower-ranked courtesans or prostitutes were questioned and ridiculed in popular literature. In a song titled "Mocking the Prostitute Zhu Guanyin-nu" (*Chao ji Zhu Guanyin-nu* 嘲妓朱觀音奴) included

FIGURE 1.6 Lin Xue (fl.17th c.), *Water and Moon Guanyin*, 1609. Ink on silk (146 by 50 centimeters). The collection of Nantong Museum.

in *Yuefu qunzhu* 樂府群書, a collection of popular songs published in the Wanli period, Zhu Guanyin-nu, a singer and a dancer, is ridiculed for wandering freely between the entertainment quarters and monastic space.[103]

歌徹海潮音	Her singing reverberates among the sound of crashing waves,
舞動天花旋	Her dance moves like swirling heavenly flowers.
纔離洛浦又下梨園	She has just left the banks of Luo River and comes down again to the theatrical world.
四十八般呪誓別	She made a vow of forty-eight wishes to depart,
五十三度容顏變	Her appearance has altered fifty-three times.
羅漢同遊韓王殿	Touring together with a monk in a Buddhist temple,
散香風歘步金蓮	Her golden lotus feet wander, stirring up an aromatic breeze.
旨慈悲救苦把群生	The compassionate one intends to save all sentient beings from suffering,
普濟結歡喜良緣	[But] the being of universal mercy has just happily found a good match and tied the knot.

The phrases such as forty-eight vows, fifty-three appearances, and compassion to save all suffering sentient beings are often associated with Guanyin. The images of the sea and Luo River, a shortened version of *luopu shuiyue* 洛浦水月 (Water and Moon on Luo River), suggest two feminine Guanyin forms, Guanyin of the South Sea and the Water and Moon Guanyin. Before the Ming era, the name of Guanyin-nu did not necessarily refer to either a woman or an entertainer.[104] In this poem, however, Guanyin (in the name of Guanyin-nu) as well as other Buddhist references create an overlap between the image of the bodhisattva and a prostitute. The idea of Guanyin is satirized when, by attaining a romantic relationship, she falls short on her divine intentions. Although the words "living Guanyin" do not appear in this poem, the imagery of this figure is explicitly evoked.[105]

Unlike the cynical tones used to describe lower-ranked courtesans' visits to temples, the spirituality of famous courtesan was highly promoted. As several scholars have pointed out, literati invented the late-Ming courtesan as a cultural ideal and, at the same time, male literati constructed self-representations through courtesans.[106] In other words, writing about their favorite courtesans' religious lives is not a simple matter of fact; rather, it was entangled with their ideals.[107] In Buddhist doctrinal texts as well as in popular novels, dramas, poems, songs, and jottings (*biji*) 筆記, courtesans functioned as instruments that enabled men to overcome their desires and demonstrate the transcendent nature of the Buddhist doctrine

of nonduality—that is, getting beyond purity and impurity or reality and illusion. Male scholars used courtesans to justify their religious belief. Meditating on *chan* (*canchan* 參禪), a practice that fused different Mahayana teachings and was cherished by a significant number of late-Ming literati, also typified the meritorious daily activity in a courtesan's life. Courtesans would gain social prestige by being recognized as devotional figures, and this changed their roles from being socially debased to being morally acceptable by male literati standards.[108]

Some scholars not only endorsed the spirituality of courtesans through explanations of their former lives but also glorified the courtesan's moment of death as a way for her to secure utmost transcendence. Unlike gentrywomen and imperial women who were usually buried in their husband's family cemetery, courtesans were excluded from familial systems after death. Sometimes their tombs were publicly commemorated in both literature and reality, as in the case of Su Xiaoxiao's tomb in Hangzhou. Similar rhetorical devices were repeated to venerate historical courtesans' moment of death. These courtesans are often described as having died in the manner of an eminent monk, thereby wiping away both their sexual and professional identities. For instance, in the *Banqiao zaji* 板橋雜記 (*Diverse Records of Wooden Bridge*), author Yu Huai 余懷 (1616–1696) describes Gu Mei 顧媚 (1619–?) at her death as "manifesting the appearance of an old monk when she was encoffined."[109] This sign revealed Gu Mei's true Buddhist nature.

Ma Shouzhen's daily Buddhist ritual is described even more vividly in her biography written by Wang Zhideng, her lifelong lover.[110] According to Wang, before Ma's death, she had practiced Buddhism for seven years and erected a shrine with gold statues in her chamber. When she sensed that her life was coming to an end, several days before her death, she invited monks to her place to perform the Liangwu Repentance (*liangwu chan* 梁武懺), a ritual to send souls to the Pure Land. She burned two types of incense, sandalwood and borneol (*longnao* 龍腦), and offered vegetarian food. Ma then asked her serving girl Xiaojuan 小娟 to support her as she walked around the Guanyin statue and to help lower her right leg to a kneeling position in which to pray for several days and nights without stop.[111] After this, she ordered people to prepare her coffin. Next, she took a bath and changed into clothes made of cotton. She then sat for a long time, closed her eyes, and passed away (*mingran erhua* 暝然而化).

The manner in which Ma died, in Wang's words, "could only have characterized an eminent monk who had practiced and accumulated merit for years."[112] Wang further eulogized Ma:

> As soon as she achieved a transcendental understanding, she regarded the four elements [water, earth, fire, and wind] as disguised corpses and the

body as filled with filth. She abandoned them as if they were worn-out shoes. Is this not derived from the power of the golden rope and precious boat?[113] Who caused the lotus flower to be born in a filthy world? The Nymph of the Luo River riding on the fog and the Goddess of Wu Mountain transforming into clouds have not yet left the realm of desire constituted of the four elements. How can they be on par with her (Ma)![114]

In other words, although Ma was from an unclean world, she had a strong motivation to comprehend Buddhism, and she eventually regained merit through her mode of death and freedom from desire. Wang Zhideng did not witness Ma's death in person, but the important issue is not to decide whether this is a true reflection of Ma's death but rather to understand that Wang's literary creation framed Ma's death in terms of transcending to the Buddhist world.[115]

MALE IDENTIFICATION WITH GUANYIN

An even stronger male literary hand is involved in the case of Xu Jinghong, the startled swan of Guanyin dance fame. Xu's case is dissimilar to those of the courtesans Gu Mei and Ma Shouzhen who were said to have manifested as eminent monks at their deaths. Male scholars elevated Gu and Ma's spirituality by writing about their departure to the other world. By describing their monk-like appearance, their female gender (or at least their gendered appearance) was changed, and on that basis, they could secure a smooth good rebirth in the Pure Land. In Wang Daokun's writings dedicated to Xu Jinghong, however, he expressed a different fantasy about her becoming a Buddhist deity in a worldly ritual space—that is, a liminal space between heaven and earth, or in a Buddhist celestial world. Xu Jinghong, in Wang Daokun's account, transformed rapidly from a courtesan into a heavenly being and then was reincarnated as a secular courtesan. So she went from courtesan to heavenly being back to reincarnated courtesan. Through these transformations, she remained in essence a heavenly being.

On the fifteenth day of the seventh month in the fourteenth year of Wanli (1586), Wang Daokun invited several monks from different monasteries to conduct a *shuilu* (水陸 Water-Land) rite in Jiaoshan, Zhejiang Province.[116] After Xu Jinghong realized a final breakup with a lover, she accompanied an unidentified scholar to Jiaoshan to worship the Buddha. Once she heard that Wang was also in Jiaoshan and paid him a visit.[117] Wang, who was about sixty-one at the time, apparently felt affection for Xu who was roughly forty years old. Right after they met, Wang composed "A Chapter on the Heavenly Being Huiyue" in the format of a Buddhist sutra.[118] By adapting a Buddhist literary genre (*pin* 品, chapter), Wang created a

text in the form of a pseudo-scripture. Wang probably presented this to Xu at the wall of the Crystal Lodge (Shuijing an 水晶庵) facing Xiangshan 象山 in Jiaoshan.[119] Given the influence of Wang and Xu in literati circles and in the pleasure district in Qinhuai, this event was soon celebrated. Crystal Lodge was turned into a popular tourist site by contemporaries in the Wanli period (1572–1620).[120]

Although the title of this piece only credits Huiyue [Bright Moon] or Xu Jinghong, the text reveals Wang Daokun as Han Dashi 函大士 (the Great Being Han). To do this, Wang combined his name with that of Guanyin, as the first character *han* is taken from his literary name Taihan 太函.[121] In this long piece of more than twelve hundred words, Wang Daokun adopts the rhetorical style of a Buddhist sutra to which he first adds the setting of Crystal Lodge and includes a record of how he met Huiyue Tianren (Heavenly Being of Bright Moon) there. Xu is described differently from her appearance in the Guanyin dance.[122] She "arrived with her hair unadorned and wore a plain white robe,"[123] a dress code often found in portrayals of devout laywomen in late-Ming illustrations, including the aforementioned woodblock prints of Xu.[124] Then, Wang directly states that Xu is indeed a heavenly being who possesses musical and other artistic talents:

> My disciple Jiaoling (Xu Jinghong) was born in the realm of Anabhraka (Shaoguang tian 少廣天). Like any other heavenly being, she possesses all the auspicious marks. She relishes all kinds of music and studies all lavish arts. However, Jiaoling is not equal to men. If (we) allow her to contemplate the most sublime music and unrestrained lavish arts with utmost sincerity, she can then leap into the waves and reach the other shore [achieve nirvana or deliverance].[125]

Tianren or heavenly being also refers to a dancer.[126] Wang Daokun compares Xu Jinghong with a heavenly being who has acquired skill in the arts in the realm of Anabhraka. But Wang also indicates that if Xu could cultivate herself further, she could achieve enlightenment. Indeed, it is through art and music that she might be able to transcend her specific circumstances—her life as a courtesan—under his tutelage. Later in the text, Xu is given a voice and expresses her admiration for Wang: "I secretly heard that the Great Being is fond of the unsurpassed Way and practicing the most supreme Vehicle (the Mahāyāna)."[127] Xu wants to become his disciple. Wang points out that Xu has good roots in her, but by mistake "fell into an intermediate state."[128] Once she is transformed and attains the way, then she can achieve excellence. After this statement, Wang accepts Xu as his acolyte and conducts a set of rituals by which a master takes on a disciple. Xu offers gifts such as incense, garments, and a vase with blue lotus flowers. Wang

uses every offering as a metaphor to teach Xu about suffering, happiness, life, death, and nothingness.

Toward the end of the teaching, Wang Daokun as the Great Being holds a flower with a smile and says to the Heavenly Being:

> Good indeed and rare! You offered me a *youboluo* bowl, you belong in the highest pool of the ninth grade, which has thousands of magnificent leaves, and there is a Buddha sitting on each one. (Your) dharma-laksana is everlasting like the Buddha (on each leaf). Your body is resplendent; it is a perfect reward body. Your splendor may have come out of the mud, (but) you are pure and unpolluted. You should be raised up and placed in a high and wide-open space.[129]

In this section, Wang Daokun as a Great Being ensures that Xu Jinghong (or Huiyue) will be reincarnated as the being of the highest class in the Pure Land. Xu is so touched by the Great Being's words, she bursts into tears. She then chants a *gāthā*, to express her dedication to the Buddhist faith before the Great Being. The first couplet of the *gāthā* reveals that Guanyin appears as "a lay Buddhist to teach" Xu.[130] This implies that Wang as the Great Being Han is a manifestation of Guanyin—that is, Wang Daokun has imagined himself as the layperson form of Guanyin.

This dramatic moment captures a male scholar's anticipation of deity embodiment. On one hand, we have observed how male scholars objectified Guanyin as a desired object, a beauty, and a sexually available female deity. On the other hand, we see resistance to Guanyin's feminization. Among the thirty-three Guanyin manifestations in the "Universal Gateway Chapter" and the thirty-two manifestations in the *Śūtaṅgama Sūtra*, scholar-officials frequently adopted Guanyin's two male forms—the body of a chief minister (*zaiguan shen* 宰官身) and that of a layman (*jushi shen* 居士身)—to eulogize each other.[131] A significant number of painters insisted on creating male forms of Guanyin. Artist Ding Yunpeng, for instance, included male, female, and androgynous forms of Guanyin in his album *Guanyin*, which he painted in 1618 (figure 1.7).[132] Ding was noted for creating remarkable feminized Guanyin images, and he is credited as the author of the most influential Guanyin painting manual: the *Thirty-Two Manifestations of Guanyin*, from which female painters and embroiderers made copies. Simultaneously, a lay Buddhist and also a member of Wang Daokun's circle, Ding aligned with Wang and other male painters and writers, who pointedly revived the male-gendered Guanyin.[133]

Moreover, various discourses and practices alluding to gender ambiguity were in play, such as the story of Guanyin's gender transformation; Wang Daokun and other male scholars who envisioned themselves as male forms of Guanyin; pious

FIGURE 1.7 Ding Yunpeng, *Guanyin*, 1618. Album leaves, leaf no.16, ink on paper (31.9 by 28.3 centimeters). The collection of National Palace Museum, Taipei.

women's miraculous transformations into monks at the last stage of their lives; and even male actors performing the female Guanyin form on stage. All of these actions raise questions about whether, before the rise of modern biomedicine, there *was* a firm belief in the direct correlation between the anatomical body and sex-gender in China.[134] The eulogy on one illustration of Guanyin popular during the seventeenth century states that "[Guanyin] enters meditation in the body of a man, and awakens from meditation in the body of a woman."[135] In other words, Guanyin can be both

male and female depending on the circumstance. Guanyin provides gender fluidity to both women and men, but the power to invoke Guanyin might not be socially equal, especially because Guanyin was so identified with prostitute. Guanyin's gender fluidity does not imply that gender was considered generally fluid for all people. In Wu Zhensheng's play *The Glory of Switching Bodies*, Guanyin serves as surgeon effecting a sex-change on the male protagonist, after which his nanny touches his body to verify the physical changes and laments that now he has to be a passive receiver during intercourse.[136]

Wang Daokun's deification of a woman was not an isolated case in late-Ming and early Qing literati circles. Many scholars have demonstrated how the political situation and economic growth stimulated various Buddhist, Daoist, Confucian, and local folk religious and mystical practices. Several of Wang Daokun's acquaintances, such as Wang Shizhen 王世貞 (1526–1590) and Tu Long, were core disciples of the female prophet Tanyangzi,[137] whose cult was highly influential. Her icon was enshrined and worshiped by many followers during the late-Ming period.[138] In contrast to Xu Jinghong, both Tanyangzi and Ye Xiaoluan 葉小鸞 (1616–1632) (another talented and ill-fated young woman who was also cast as an immortal), were from gentry families, retained their virginity, and were associated with hybrid religious practices.[139]

Wang Daokun's effort to elevate Xu Jinghong's and his own religious status is intimately linked to his romantic emotions. He wrote two extremely long verses "Composed for Jiaoling on the Trip to Baiyue" (*Baiyuexing wei Jiaoling zuo* 白岳行為皎靈作) and "Song of Sending Huiyue back West" (*Song Huiyue xihuan ge* 送慧月西還歌), eleven shorter poems, and a set of *sanqu* for Xu Jinghong. A letter to her also survives.[140] In the two short pieces, Wang explicitly expressed his longing for her. But in all the other poems, he continued to envision Xu's transcendence to the Pure Land, and sometimes he provided a vivid description of her progress as she journeyed to the Pure Land, describing how she straightens her back, prepares to ascend to heaven, and leaps over the heavenly gate (*tianmen* 天门), with her white-robed body unencumbered by gravity. When she reaches the realm of Western Paradise and faces the Buddha, looked upon by thousands of monks, Xu finally completes her transcendence.[141] Romantic love is a broad category that often encompasses contradictory dimensions. It implies sexual love, but at the same time, it can involve yearning to be one with the deity. Both cases, assume a longing for transcendence. In the case of Wang Daokun and Xu Jinghong, we see precisely this dual aspect of romance. Moreover, Wang's romantic love for Xu is preserved, because he wrote about it in various places.[142] He transformed her into something resembling a Buddhist deity or at least an extremely pious Buddhist. In this second romantic mode, he sublimated his desire into something higher, a religious experience. By changing the object of his desire, he changed his own status.

MATERIALIZING THE DANCING DEITY

To enhance the religiosity of Wang's "A Chapter on the Heavenly Being Huiyue," one of his students had the text carved on a woodblock to approximate the idea of reproducing a scripture for printing. There is no evidence that this pseudo-scripture actually circulated, but the woodblock was presented to Xu Jinghong as a gift. News of Wang Daokun and his students' peculiar conduct set off alarms at the Ministry of Punishments in Nanjing. The minister, Jiang Bao 姜寶 (1513?–1593), ordered the expropriation of the block from Xu's residence and had it destroyed. He then wrote a letter to Wang Daokun urging him to make a greater effort to serve the state rather than write such worthless pieces.[143] Despite Jiang Bao's disapproval, "A Chapter on the Heavenly Being Huiyue" continued to elicit comment and was even transcribed like scripture by other notable scholars such as Qian Gongfu 錢功甫 (1541–1624), Tu Long, Wang Zhideng, and Hu Yinglin in the following years.[144] For instance, three years later, in 1589, Wang Zhideng commented on Qian's copy. His inscription also celebrates the religious intent around the piece: "The Great Being Han composed this sutra to illustrate illusion with exquisite words; the Heavenly Being Bright Moon kept this sutra to illustrate illusion with rouge and kohl; the Layman Qian [Qian Gongfu] transcribed this sutra to illustrate illusion with brush and paper."[145] Each of the practitioners mentioned in Wang's comment points to an *illusion* created by using his or her own skills. His observation leads us back to an issue discussed at the beginning of this chapter: how a woman with the power to tempt sexually, exemplified by Matangi's daughter in *Śūtaṅgama Sūtra* and by well-known courtesans in real life, was constructed as both teachable and a teaching device in male discourse. Tu Long confirms this attitude toward Xu Jinghong: "The Bright Moon's filthy body possesses a pure nature: neither filthy nor pure, both filthy and pure. This intermingling explains why Matangi's Daughter was the Buddha's disciple."[146]

Xu Jinghong's voice is mute during her "deification." Her participation in Wang Daokun's other religious activities are subtly indicated but could be deliberately erased from his collected works.[147] After Xu encountered Wang, she might well have participated in the *chan* group, the Zhaolin Society (Zhaolin she 肇林社), organized by Wang and his brother Wang Daohui 汪道會(1544–1633). The seal of Xu Pianpian 徐翩翩 is included in *Yinjun* 印雋 edited by Wang Daohui, which collects the seals of members of the Wang brothers' poetry and *chan* societies.[148] Wang Daokun stresses that he explained the *Śūtaṅgama Sūtra* to the Zhaolin Society members every day during their gathering.[149] If Xu appeared in such an assembly, she would serve in some sense as a learning aid by which participants could comprehend that sutra.

Furthermore, compared with laywomen of other social status, some of the religious items she received from literati are considered unconventional. Besides the block carved with "A Chapter on the Heavenly Being Huiyue," Wang Daokun once presented her with a Tibetan Guanyin statue (*wusizang dashi* 烏斯藏大士) and a *rudraksha* rosary (*jingangzi nianzhu* 金剛子念珠).[150] In the letter that accompanied these two items, Wang wished that Xu Jinghong could free herself from her uneasiness through chanting.

Xu Jinghong's skill at the Guanyin dance took on enhanced religious meaning after she had received Wang Daokun's endorsement. In a poem titled "Presented to Xu Feiqing" (*Zeng Xu Feiqing* 贈徐飛卿), Pan Zhiheng eulogizes Xu:[151]

花筵翻作散花場	She converts a flowery banquet into a place of scattered flowers,
繡佛長依刺繡旁	With an embroidered Buddha, she has been doing embroidery.
應是法名稱慧月	Her dharma name should be Huiyue,
美人元自出西方	This beautiful woman comes from the West.

In the *Vimalakirti Sutra*, to see whether Buddhist disciples are truly free from desire, the Heavenly Maid scatters flowers on their bodies in Vimalakirti's home. The flowers will stick to the body of a disciple who is not completely detached from desire. Flowers and the Heavenly Maid become a visual cue to test whether someone is truly free from desire.[152] Pan Zhiheng implies that when Xu Jinghong dances the Guanyin dance at a banquet, she acts as the Heavenly Maid, scattering flowers (*Tiannü sanhua* 天女散花). Xu's subjectivity is reconstructed into that of an enlightened being. But in the second half of the couplet, Pan aligns her with the many other laywomen who devoted themselves to embroidering Buddhist icons. Dancing Guanyin and embroidering Guanyin are conflated, just as Xu Jinghong is also Huiyue.

Xu Jinghong kept at least one of Wang Daokun's poems, "Song of Sending Huiyue back West," until 1605 when she shaved her head and became a nun.[153] In this long verse, stretching to almost four hundred characters, Wang Daokun again reviewed Xu's life. He described her youth, entering a brothel and achieving fame in the pleasure district. He even mentioned her success as a dancer and her commitment to Buddhism. At the poem closing, he wrote, "[I hope] you can return soon and build a Lotus Pavilion, so you can transcribe the seven volumes of the Lotus Sutra."[154] This last couplet is perhaps not just coincidental, given the last stage of Xu's life. She may have followed Wang's spiritual guidance in her decision to enter monastic life. Xu Jinghong was endlessly constituted through the gaze of others, the male gaze. Wang placed her in the space and time of Guanyin, which presented

her as a kind of transcendent being. She read this image of herself, which she then emulated, although perhaps always incompletely.

CONCLUSION

This discussion enables us to theorize how dance became religious expression among courtesans. Whereas other Buddhist laywomen produced images of Guanyin by painting and embroidering them, Xu Jinghong choreographed her own Guanyin dance and performed it before her clients. Throughout this chapter, I have wrestled with the problem of lived presence and representation. We have seen that courtesans were called "living Guanyin." But the act of dancing is different from the other modes of representation, because the dancer is active. Dance has at its base the fundamental dimension of temporality. One movement must follow another and it must harmonize with rhythm and music. In this context, Guanyin could be approached through the dancer's bodily movement and music.

We have also seen, however, that Guanyin could not emerge just in the dancer. The viewing subjects are as important as the dancing subject. The male literati are partially responsible for constructing the connection between courtesans and Guanyin. This construction then mediates the way the dance is perceived. In short, courtesans were able to mimic or embody Guanyin through the celebratory texts of their clients and in performance, through the gaze of a male audience. This dependence on male literati for the promotion and records of the dancing Guanyin courtesans should not lead us to conclude that the courtesans had no religious subjectivity. After all, Xu Jinghong became a nun. But her own perception of dance and Guanyin differed from that of men who watched her. Xu's perception of herself as a Guanyin dancer in her younger days will perhaps always be something of a mystery, a presence forever deferred because it already has been mediated by the male text. This highlights the difficulty of uncovering courtesans' gendered subjectivities in Ming times. Xu's gendered experience, which can never be fully grasped through texts, could well have been responsible for decisions she made later in her life.

Painting Guanyin with Brush and Ink

Negotiating Confucianism and Buddhism

Xu Can 徐燦 (1617–1698),[1] a well-known woman writer of *ci* poetry and painter from Suzhou, began to draw portraits of Guanyin in ink-and-wash style in the second half of her life after suffering many tragedies. She accompanied her husband Chen Zhilin 陳之遴 (1605–1666), head of the Ministry of Rights during the Shunzhi reign (1644–1661), into exile in the remote northeastern border city of Shengjing (today's Shenyang). Her husband and three sons sadly passed away within a decade or so of their exile.[2] Her fame as a Guanyin painter grew after she committed to complete two large painting projects: She vowed to do 5,048 Guanyin paintings to pray for her mother-in-law's longevity and promised to create 1,000 Guanyin paintings for the Qing court. In 1671, when the Kangxi Emperor, (1654–1722, r.1661–1722) visited the Manchu ancestral tombs, Xu knelt by the roadside to plead with him to allow her to take her husband's body back to his native place. Having gained the emperor's permission, she transported her husband's coffin south and had it properly buried.[3] The number of extant Xu Can Guanyin paintings is far fewer than those indicated in various textual sources, although several of her paintings listed in the Qing imperial painting catalog have survived (figure 2.1). In both of her devotional projects, painting images of Guanyin was a means to fulfill her role as a filial daughter-in-law and a loyal widow. Being a member of the gentry class or gentlewoman (*guixiu* 閨秀), Xu Can received training to master brush, ink, and paper and thus could meet her filial obligations in this way. In the Ming and Qing periods, few examples of imperial women and courtesans painting portraits of Guanyin were recorded,[4] but most women who drew Buddhist icons, particularly Guanyin, were members of the gentry class.[5] Xu Can's life story may be seen as a narrative template for other women who painted Guanyin, even if their precise motivations varied.

In this chapter, I explore two facets of gentrywomen's projection onto Guanyin images: first, how their identification with Guanyin was complicated, and

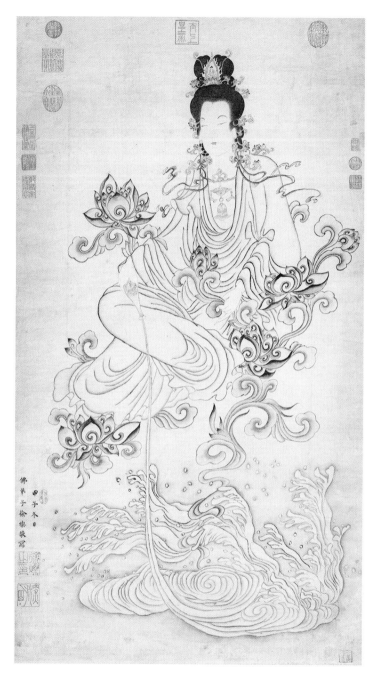

FIGURE 2.1 Xu Can, *Guanyin*, 1684. Ink on paper, hanging scroll (102.2 by 56.7 centimeters), The collection of National Palace Museum, Taipei. *Source:* Photo courtesy of National Palace Museum, Taipei.

Situated in the middle of an empty space, Guanyin leans on a lotus-branch. She holds a standard attribute-water dropper in her right hand and a booming lotus in her left hand. The liquid from the dropper transforms into waves. Contrasting to Guanyin's white robe rendered in straightforward outlines, Guanyin's adornment and her surrounding lotus flowers are executed in different shades of monochromic ink color. The ornate quality alludes to floral pattern that could be observed on textile and ceramic from early Qing period.

second, how they expressed that identification by drawing the bodhisattva. I consider their identification as complicated because, in Xu Can's case, the act of devotion is fraught with ambiguities, if not contradictions. Women long to become Guanyin, but this appears to them as an impossible possibility. In other words, they seek in numerous ways to overcome the gap between themselves and Guanyin, but this gap can never be completely effaced and is constantly recreated. Identification was not a simple correspondence between women's lives and the traits and narratives commonly associated with Guanyin. Although her reincarnation as Princess Miaoshan is often considered an exemplar of filial piety, Guanyin was never married and thus could not have been a model widow for her devotees. This suggests that the identification explored in this chapter occurs at a more abstract level. Guanyin's form transcends the material to become a symbol of exemplary womanhood and therefore can be embodied in various roles by women of different social standings. Because her religious powers are not circumscribed by the particulars of her story, all women could identify with her equally. Gentrywomen's identification often focused on the bodhisattva's virtuous qualities, such as purity. This example could be extended to virtuosity in actions, such as drawing Guanyin and in a particular style, namely *baimiao* (plain drawing). In this way, the image of Guanyin is mediated by society: the image and its production mutually reinforce a socially constructed ideal, and, as we will see, this ideal involves the sublimation of desire.

By repetitively creating portraits of Guanyin with brush and ink, I would like to suggest that gentrywomen projected themselves onto an image of Guanyin to transcend their bodies and, in the abstract, to become Guanyin. The practice of portraying her bodily form in an aestheticized style represented the taming of sensuality. More precisely, the gentry conceived the act of drawing as an expression of exemplary purity, and the austere style of *baimiao* Guanyin images reinforced the mirroring of women and the bodhisattva. These images suggest purity and a certain amorphous physical form as well, which invites identification.[6] In other words, the identification between painter and the painted through the act of brushwork is not based on mere physical likeness, but rather involves a more abstract and complex symbolism of equivalence. In contrast to practitioners who connected with Guanyin viscerally through direct embodiment (performing the Guanyin dance, see chapter 1, or imitating Guanyin through jewelry, see chapter 4), those who used ink and brush connected with her by externalizing her. The image is made through two material elements (ink and paper) external to both Guanyin's body and the practitioner's body. In this way, both bodies are transcended. More precisely, the practitioner transcends Guanyin's physical form to become an exemplary woman, one who might resonate with Princess Miaoshan and White-robed

Guanyin in the abstract. Unlike courtesans and other classes of women whom we will encounter in other chapters, gentrywomen's identification develops another dimension through the more complex mechanism of mimesis between women—painting as object, painting as action—and Guanyin. A Guanyin stitched in hair is even more multilayered because a woman invests her material body in the product rather than just in her body's labor.

The historical background of gentrywomen who made Guanyin icons began with the generally improved quality of art education for women and the increased availability of models to paint icons. How and why *baimiao*-style painting would become the preferred mode for women of the scholar-official class to identify with Guanyin continues this thread. The paintings of Xing Cijing 邢慈靜 (1568?–after 1640)[7] and Fang Weiyi (1585–1668), two artists who painted Guanyin in quite different contexts, shed light on the intersections between the social and individual construction of identity and artistic activity in the seventeenth century. They give us an entry point into the larger relationship between gender roles and the painting of Guanyin by women in late imperial China.

GENTRYWOMEN AS PAINTERS OF GUANYIN

There is a long tradition of women's patronage of Buddhist art in China, and scattered records refer to women creating icons by embroidery or painting from the Tang to Yuan dynasties.[8] But as painters of Buddhist images, women became prominent only during the Ming and Qing periods. The popularity of Guanyin as a subject grew because of a number of historical developments. Following the marked increase in female literacy from the late Ming onward, gentrywomen were encouraged to cultivate other art forms, such as painting, calligraphy, and music. According to the first catalog of Chinese women painters, *The Jade Terrace History of Painting* (*Yutai huashi* 玉台畫史), which was published in 1831, the number of artists who were women from all social classes from the Ming to the Qing Jiaqing period (1796–1820) was four times greater than the number that appeared in the entire four-thousand-year history preceding the Ming.[9] Mastery of writing and painting with a brush marked the educated amateur, which was common in the gentry class of this period. Guanyin was the most popular subject for *mingyuan* (renowned gentrywomen) painters from the Ming and Qing periods.

Gentrywomen's religious activity, including painting Guanyin, was primarily confined to domestic space during the late-Ming and early Qing periods. The home was where women practiced both Buddhism and Confucian rituals associated with female chastity. In addition to chanting sūtras, practicing meditation, and observing a vegetarian diet, some women also took up the challenge of

making religious icons. Drawing and embroidery were the two primary means by which women could reproduce the image of Guanyin at home.[10] How these practitioners used these two media, however, differed. Drawing (i.e., painting in monochrome) was limited to women who had acquired the skill of using brush and ink; embroidery, traditionally defined as a female skill, was more widely practiced by women from various social classes.

Drawing, as visual literacy, was part of gentrywomen's education (active in the seventeenth century), a well-educated woman and an official wife from Fujian, was a close friend of Fang Mengshi 方孟式 (1582–1640), a celebrated poet and the sister of Fang Weiyi. In a preface dedicated to Fang Mengshi's poetry collection *Renlan ge shiji* 紉蘭閣詩集 (The Poetry Collection from the Boudoir for Wearing Orchid Flowers), she wrote, "I maintain that literary works are the worldly expression of the Buddhist dharma. Those skilled at writing are worldly expressions of the human Buddha. A heart-mind that can write literature well is the worldly expression of the Buddha-heart-mind. Diamonds are detached from all forms. So why cling to the forms of 'male' and 'female' as if they were established in the Formless Realms of heaven?"[11] This remarkably bold statement from the seventeenth century unites the ideology of culture and writing or *wen* and Buddhist notions of equality.[12] Writing is compared to the Buddha heart-mind. In a preface to celebrate a woman's literary achievement, Wu Huijing suggests that a woman's intellectual training enables her to seek enlightenment in this world. Fang Mengshi, like her sister, created Guanyin paintings along with her literary writings. Her painting of Guanyin was even collected by Wu Huijing and another good friend from the same official-wife circle.[13] *Wen* cultivation in general also includes visual literacy, such as painting and calligraphy, which provides a path ostensibly open to all women.

Guanyin was, of course, a popular subject for painters of both genders. Indeed, more Guanyin paintings were executed by male painters than their female counterparts, and women learned to draw her figure from studying old models and painting manuals created by male artists. Only a few textual sources reference women copying work by female artists, such as Guan Daosheng's Guanyin painting.[14] Nonetheless, the practice of rendering Guanyin entailed a gendered dimension that merits examination. The significance of painting generally stems from its place in a larger socially constructed field of meaning, where it had particular gendered connotations. Women who painted did so for reasons related to their roles in the family and in larger networks of interpersonal relations (as daughters, wives, and mothers, friends, and so on); those roles were inextricably connected to their gender.[15] Women performed those roles as part of a historical and social legacy they could not ignore and that shaped the meaning of both gender and painting. Because gender constructions are "social," they take on a force that

is quasi-independent of the choices made by individual men and women and that play a large role in shaping identities. The act of painting Guanyin must be understood in the context of such a legacy: women drew in response to experiences and events encountered in their prescribed social roles.

Jin Liying 金禮嬴 (1772–1807), for instance, one of the most accomplished woman painters at the end of High Qing era (1683–1839) exemplifies the relationship between Guanyin and the gentrywoman painter of Guanyin on multiple levels.[16] Jin Liying grew up in a gentry family in Kuaiji 會稽 (today's Shaoxing) and studied both Confucian and Buddhist classical texts from her grandmother in her early years.[17] She married at the age of twenty-two as the second wife to Wang Tan 王曇 (1760–1817), a prodigy poet yet unsuccessful scholar.[18] As a filial daughter, Jin Liying performed *gegu* while her father was sick and she had to suffer bleeding and infection of the wound for years.[19] As a newlywed, she was thoughtful to her husband's deceased principal wife, Zhu Xixiang 朱樨香 (?–1794). Zhu was a sincere follower of Guanyin and died in a miraculous manner.[20] In order to ease Wang Tan's grief for losing his first wife, Jin Liying created two portraits of Zhu Xixiang as a sūtra chanter and an embroiderer of Buddhist icon, yet she saw herself in the latter.[21] As fellow spouses, Jin helped Wang's concubine Qian Wan 錢畹 (late eighteenth century to early nineteenth century) to raise her son. When her husband failed in the official exams and faced financial crisis, she took on the responsibility to support the family by selling her paintings.[22]

Jin Liying mastered a wide range of subjects including different types of religious paintings; however, her spiritual life was very much materialized through making Guanyin paintings. She copied the same set of thirty-two Guanyin images in *baimiao*-style as the late Ming women painters did, but she did not simply repeat herself. Instead, she combined *baimiao* plain drawing and *gongbi* (工筆 or meticulous brush work) technique.[23] Specifically, as her *Guanyin* painting demonstrates (figure 2.2), she used ink outline to form Guanyin's white robe on plain rice paper, and then applied ink water to create a light gray hue along with the outline of Guanyin and extended this ink wash to the rest of the background. Jin depicts Guanyin's face, hair, and jewelry with pigments in three dimensional fashion. Such a contrast increases artistic sophistication of the Guanyin image and maintains the *baimiao* painting style on the body of Guanyin.

In 1803, when she was thirty-two years old, on lunar June 19, the Day of Guanyin's Enlightenment (*guanyin chengdaori* 觀音成道日), she created this *Guanyin* painting to commemorate her completion of the rite of the Bodhisattva Vows (*pusa jie* 菩薩戒). The vows are a set of moral codes that help Mahayana Buddhist practitioners to discipline themselves along their path to becoming a bodhisattva.[24] Such a deliberate choice of the date of making the Guanyin icon draws a parallel to

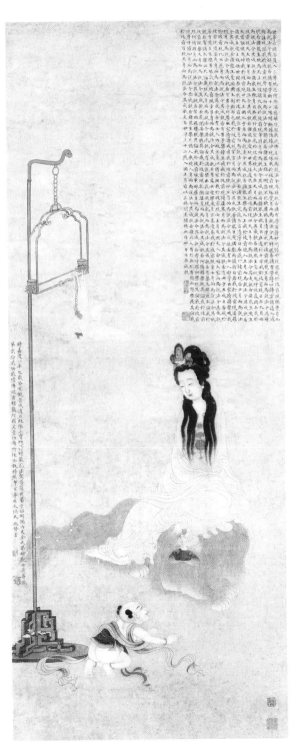

FIGURE 2.2 Jin Liying, *Guanyin* (detail), dated 1803, on the Day of Guanyin's Enlightenment (Lunar June 19), No. 22 icon. Hanging scroll, color and ink on paper (116.6 by 44.2 centimeters). The collection of Zhejiang Provincial Museum.

In the inscription on the left margin of the painting, Jin Liying stresses that she became a follower of *Śūtaṅgama Sūtra* and she venerates the *Śūtaṅgama Sūtra* with rituals for one hundred times and hopes that the faith in *Śūtaṅgama Sūtra* will last for a hundred years. Unlike other women artists from late Ming who often invite a male scholar to copy a scripture and pair it with Guanyin painting, Jin Liying transcribes the section on thirty-two manifestations of Guanyin in *Śūtaṅgama Sūtra* on top of the painting by herself.

Guanyin's enlightenment and her own path to becoming a bodhisattva. Moreover, this painting draws a striking contrast between a White-robed Guanyin riding on a lion and a domestic setting subtly implied by a carefully crafted wooden hanger for the parrot and a baby boy in his mundane hairstyle and outfit. The realistic representation of the furniture alludes to an actual object that Jin Liying might have used. The worldly boy reminds us of Jin Liying's stepson, whose nickname is Shancai 善才, a homophone for Shancai 善財 or Sudhana, Guanyin's disciple. Such a deliberate arrangement enables us to envision dual images of Guanyin and her disciple Shancai with Jin Liying and her stepson Shancai.

Just few years later, in 1807, she died at the age thirty-six of vomiting blood. As a professional artist and a devotee to Guanyin, toward the end of her life while she lay on her sick bed, she expressed extreme anxiety about unfinished commissioned works. In one of her poems, she even wished that she could have ten thousand hands, just like the Ten-thousand Handed Guanyin, so she could hold ten thousand brushes.[25] I have mentioned elsewhere how Guanyin served as a model for women during the different stages of their life cycle. Jin Liying's wish (or perhaps fantasy) brings up another dimension of how a professional artist seeks encouragement from Guanyin. Her anxiousness is further verified by her husband's memorial note of an incomplete Guanyin painting sketched in only one ink stroke with a trace of an unexpected splash caused by a dropping brush.[26] This suggests that she tried to create Guanyin paintings even during the last moments of her life. Wang Tan reinforces his wife's posthumous legacy by describing how Jin Liying was buried close to a temple hosting an ancient Guanyin statue. In the last line of her epitaph, he writes: "There is a shrine of the Great Being and Wuyun [Jin Liying's courtesy name]'s burial site."[27] The juxtaposing of the shrine of the Great Being/ Guanyin and Jin Liying's tomb suggests a relationship beyond mere physical proximity. By mentioning these two in the same line, it implies that the burial site of Jin Liying is analogous to the shrine of Guanyin, which I read as Jin Liying becoming Guanyin.[28] We must understand this process of becoming in relation to the Pure Land practice. Toward the end of her life, Jin's participation in the rite of Bodhisattva Vows reveals her aim to transcend to the Pure Land. Such a mimetic relation is the culmination of Jin Liying's years of practice of painting Guanyin.

BAIMIAO GUANYIN AND GENTRYWOMEN WHO WERE EXEMPLARY PAINTERS

The short biographies of the women who painted Guanyin always juxtapose their literary achievement and virtuosity with their drawings of the deity. For instance, Fang Mengshi is described in the following manner: "She had great passion for

books and poetry, she had womanly virtue, she drew icons of Guanyin, and she achieved compassionate *samadhi* (or mental concentration)."[29] Many other biographic records specify women's drawing style as *baimiao* or plain drawing.[30] Such a coded set of phrases raises an important question: what is the symbolic meaning embedded in the style of *baimiao*?

When used to describe the output of a woman who painted during late imperial China, the term *baimiao* referred loosely to disparate practices of monochromic ink painting. It could indicate plain drawing in ink or gold-ink on regular rice paper and indigo paper. Or, possibly, it could reference "Chan" painting with its more expressive brushwork and ink wash painting. For instance, Xu Can's Guanyin paintings were recorded as both *shuimo* 水墨 (watery ink) and *baimiao* Guanyin.[31] Although no clear textual reference explains the explicit connotation of *baimiao* Guanyin painted by women, morality has been always embedded in this brush technique.

Ink drawing was not associated with scholarly painters in the early period. Named artists such as Wu Daozi 吳道子 (ca. 710–760)—whose painting technique inspired Fang Weiyi (to be discussed later)—usually drew outlines of a mural painting while artisans filled in colors. Sometimes, the linear drawings on murals were not covered with pigments. In these cases, they were called *baihua* 白畫 (plain painting). Later, the aesthetic taste of ink brushwork was highly promoted by a long list of scholar painters from the tenth century to late imperial China.[32] These scholarly painters found color distracting and projected a set of meanings onto the inner essence of inked brushes.[33] The minimal color of ink was linked to elegance (*ya* 雅), reclusion, austerity, and simplicity, all of which might be adopted by gentrywomen as an effective gender-appropriate expression.[34] The rhetorical trope of women who painted Guanyin suggests that during the late Ming and early Qing, the straightforward linear painting style provided a visual vocabulary that produced an icon aligned with expectations about women's purity. Plain drawing was not just an aesthetic choice but also contained moral judgment and symbolic meaning associated with the identity of a gentrywoman. The feminized Guanyin configuration in *baimiao* painting, with its absence of added color, was seen to mirror female chastity, a virtue that was strongly promoted in late imperial China.

The phenomenon of female gentry using similar material forms, styles, and subject matter in their icons raises another important issue of the relationship between objects and class. Pierre Bourdieu's concept of "distinction" suggests why a certain social group might select a certain model. This term implies that people distinguish between and align with various classes based on the things they buy and consume.[35] Late-Ming gentrywomen distinguished themselves from the lower classes by making certain things and thus exhibiting their skill. In this case, skill

becomes a tangible manifestation of class, but this is only perceptible through the products of that skill, namely the artistic works created.

The popularity of *baimiao* Guanyin among gentrywomen was also due to the revival of *baimiao* painting among male artists at that time and the late-Ming revitalization of Chan Buddhism.[36] A booming publishing culture produced a number of specialized painting manuals, which gave women greater access to Guanyin iconography.[37] Typical use of these manuals can be seen in the work of gentrywomen Qiu Zhu 仇珠 (active from the mid- to late-sixteenth century) and Xing Cijing (figures 0.3 and 2.3), both of whom copied from a work commonly called *The Heart Repentance of the Great Compassion with the Thirty-two Manifestations of Bodhisattva Guanshiyin* (*Guanshiyin pusa sanshier xiang dabei xinchan* 觀世音菩薩三十二相大悲心懺, hereafter the *Thirty-two Manifestations*) which circulated in both woodblock print and ink-rubbing formats.[38] Gentrywomen's work was further validated by male scholars' inscriptions. In many cases, renowned scholars transcribed sūtras or inscribed poems onto Guanyin paintings (and also embroideries) to eulogize the deity; these inscriptions might be copied directly onto the painting or on a separate sheet and mounted to the top of a painting or at the beginning of an album. The most common scriptures used were the *Heart Sūtra* and the "Universal Gateway Chapter." For instance, at the beginning of Qiu Zhu's copy of *Thirty-Two Guanyin Manifestations*, the literatus Tu Long transcribed the *Heart Sūtra*. This pairing strategy was even adopted on forgeries, such as a copy created after the well-known woman painter Huang Yuanjie 黃媛介 (seventeenth century). The alleged Huang painting is paired with an inscription by one Da Chongguang 笪重光 (1623–1692).[39] This suggests a conventional dichotomy between image and text in which the woman produces the physical image while the man makes doctrinal use of language by imposing scripture onto it.[40]

Baimiao style may have been dominant among gentrywomen who were painters, but the latter also produced Guanyin images in color. Indeed, some painters such as Qiu Zhu, Zhou Shuxi 周淑禧 (1624–1705?), and Zhou Shuhu 周淑祜 (active late-seventeenth century) produced Guanyin icons both with pigments and in monochrome ink. Qiu Zhu, daughter of the famous painter Qiu Ying 仇英 (1494–1552), had been trained to paint professionally from a young age. She was not remembered for her proficiency in poetry, although this was another important skill among gentrywomen. Thus, her reputation fluctuated between that of a painter with strong artistic skills and a gentrywoman with weak literary ones. Her elegant *White-robed Guanyin* clearly demonstrates that she copied from her father's painting *Spring Morning in the Han Palace*, flipping the figure and altering the clothing and settings (figures 2.4 and 2.5). The pictorial transformation of a palace beauty into a goddess suggests that a mundane woman could be transformed

FIGURE 2.3 Xing Cijing, *Thirty-two Manifestation of Guanyin*, Ming dynasty, sixteenth and seventeenth centuries. Album leaves (twenty-four leaves,) gold ink on paper (each image 28.5 by 29.5 centimeters). *Source*: Photo courtesy of National Palace Museum, Taipei.

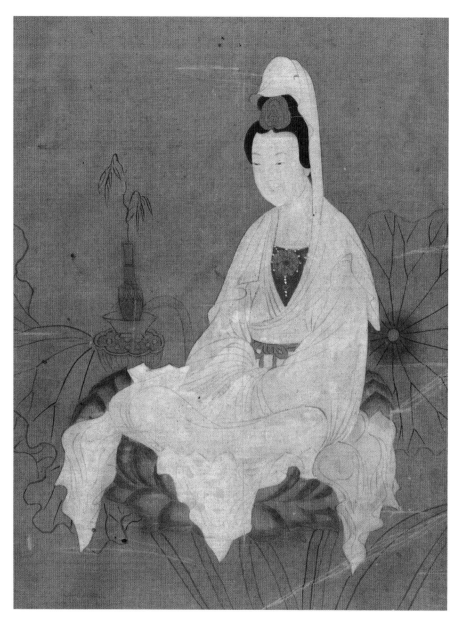

FIGURE 2.4 Qiu Zhu, *White-robed Guanyin* (detail), second half of sixteenth century. Hanging scroll, color on silk (54 by 28.6 centimeters). The collection of National Palace Museum, Taipei.

Qiu Zhu's elegant White-robed Guanyin is perhaps one of the most outstanding examples that can bring Guanyin's purity, otherworldliness and femininity together. Seated on top of a booming louts flower rising from the water pond below, Guanyin is contemplating the water in front of her. The striking feature of this panting is the contrast of the color palette used to depict Guanyin's outfit: the pure white robe and hood contrast with sensuous red trouser, a combination that is indicated as a theatrical outfit of Guanyin by Wu Zhensheng in the Glory of Switching Bodies from early Qing period (see chapter 1).

Qiu Zhu depicted Guanyin's necklace pendant and hair decoration in a realistic style. In particular, the gold like hair deco with an image of a Buddha that is tied to her hair bun through flosses echoes several excavated hair accessories in Changzhou area. This is an interesting example to show that a woman painter depicted Guanyin's icon with the knowledge of women's things inspired by Guanyin (see chapter 4).

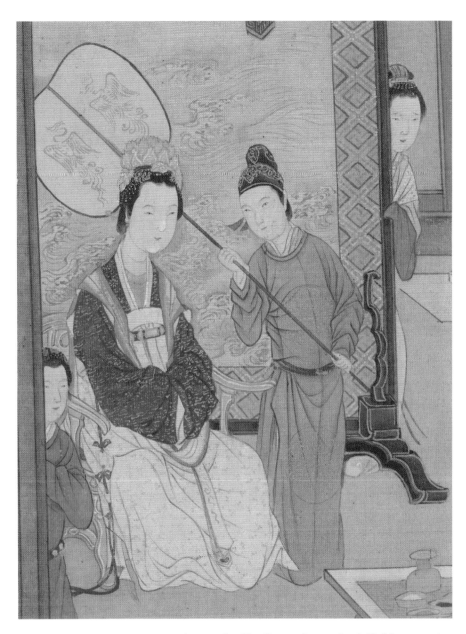

FIGURE 2.5 Qiu Ying, *Spring Morning in the Han Palace* (detail), Ming dynasty, first half of the sixteenth century. Handscroll, ink and colors on silk (30.6 by 574.1 centimeters). The collection of National Palace Museum, Taipei.

into an image of Guanyin.[41] Qiu Zhu's devotional intent did not preclude using lay subjects as models for her representation of Guanyin. The women painters of the eighteenth and nineteenth centuries would develop new tastes and iconographies in their Guanyin paintings. Chen Shu 陳書 (1660–1736) (see figure C.1 in the conclusion), Wu Gen 吳艮 (active in the eighteenth century),[42] Jin Liying (see figure 2.2), Ding Henggong 丁恆恭 (nineteenth century), and Ding Hengchi 丁恆持 (nineteenth century) followed more diverse models than late-Ming women and even created their own compositions. In particular, we see a tendency in the eighteenth and nineteenth centuries when women painters became more professionalized in their skills and mastered a wide range of subjects, the *baimiao* Guanyin was less associated with the construction of gentrywomen's chastity, and a new visual form defining a lay gentrywoman painter is gradually formed.

CASE ONE: XING CIJING—GUANYIN AND THE IDEAL OF PROCREATION

In 1614, the forty-second year of the Wanli era, Xing Cijing, then around forty years old, painted a long handscroll of five White-robed, Child-giving Guanyin figures (*baiyi songzi guanyin* 白衣送子觀音) in the *baimiao* style (figure 2.6).[43] This painting is now in the collection of the Qingdao Museum in Shandong Province and is commonly known as the *Picture of White-robed Bodhisattva* (hereafter *White-robed Bodhisattva*).[44] The long handscroll (30.3 cm high and 371.5 cm long) is divided into five sections. Each contains a Guanyin figure with a little boy and a colophon of poetic verses.[45] Unlike Xing's other *baimiao* Guanyin paintings, which exhibit clarity of delineation (see figure 2.3), this work is drawn in extremely fine lines. The bodies of Guanyin and the child are nearly invisible unless the viewer moves very close to the painting. Only the figures' hair and the inscriptions rendered in dark ink are noticeable at first glance. The evident effort exerted to produce such thin lines raises several questions: Why would Xing render Guanyin in such a manner? How is this handscroll different from her other *baimiao* paintings? What is the relationship between these meticulously depicted Guanyin images and the artist Xing Cijing?

At the end of the scroll, Xing Cijing inscribed her reason for creating this work: "It has been passed down for generations that the White-robed Bodhisattva can bestow a child. As soon as someone prays for children [to the White-robed Bodhisattva], its miraculous efficacy is clear for all to see and hear. It is not easy to fully describe [this efficacy], so I now draw five images to memorialize my faith [in the White-robed Bodhisattva]."[46]

This painting serves as testimony to her devotion to the White-robed Bodhisattva or White-robed Guanyin as a fertility goddess. When seen alongside the

FIGURE 2.6 Xing Cijing, *White-robed Bodhisattva*, Ming dynasty, 1614. Handscroll, ink on paper (30.3 by 371.5 centimeters). The collection of Qingdao Museum.

countless other visual representations of the Child-giving Guanyin—from two-dimensional art such as painting, woodblock prints, frescoes, and embroideries, to three-dimensional sculptures made with a wide range of materials—Xing Cijing's *White-robed Bodhisattva* is one more example from the late Ming and early Qing reflecting the common belief in the White-robed Guanyin's power to bestow a child and, in particular, a boy.[47] The painting reflects the larger framework of Confucian tradition in which continuation of the family is the major duty of both husband and wife.[48] Although the idea of women as well-educated wifely companions was promoted in the late Ming, thus allowing a certain degree of gender parity, women still bore most of the responsibility for carrying on the family line. Xing's case provides a good example of how gentrywomen combined Buddhist and Confucian practices: She prays to the Bodhisattva White-robed Guanyin for a son so she can fulfill her Confucian role as wife and enhance her position in her husband's family.

The Iconographic Features of the *White-robed Bodhisattva*

To better understand how Xing Cijing painted to express her joy about successfully bearing a son, we must first analyze her painting. Because the image and text in this painting are two relatively independent semiotic systems, I first analyze them separately and then examine them together for a fuller discussion of how Xing uses them to express her emotion toward her son.

The usual composition of Guanyin paintings consists of either a single manifestation or a number of different manifestations grouped together to demonstrate her transformations. Xing Cijing, however, broke with convention and creatively presented only one transformation in five different popular postures. In each section, a colophon is placed to the top left of the child figure. Both Guanyin and the boy are depicted in three-quarter view, and in each section, they assume different postures. The visual focus in all cases is the intimate interaction between Guanyin and the child (figure 2.6a).[49]

The composition of the five sections (figures 2.6b–2.6e) is roughly identical. Each is arranged asymmetrically with Guanyin, a larger and taller figure, on the right and the boy, smaller and lower, positioned on the left. Guanyin is portrayed with characteristic emblems: she is clothed in a simple white robe, her head covered with a white hood. The likeness of every Guanyin in this painting is delineated in meticulous detail. Their necks and chests are gracefully bejeweled with similar pearl necklaces linked to a floral-shaped plaque, the classic decoration for the Bodhisattva (figure 2.6a, detail). Guanyin's signature mark, a small Amitābha Buddha image above her forehead, is not represented, however; instead, the hair

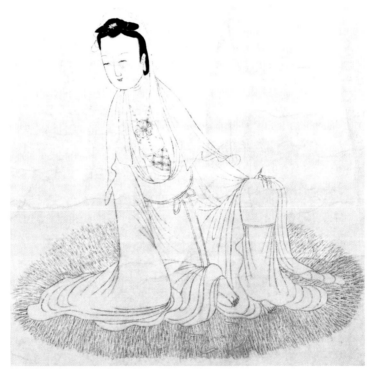

FIGURE 2.6a (*Top*) Xing Cijing, Section 1 of *White-robed Bodhisattva*, Ming dynasty, 1614. Handscroll, ink on paper (30.3 by 371.5 centimeters). The collection of Qingdao Museum. The first Guanyin takes the pose known as "Royal Ease". She sits on a straw mat with her left leg folded vertically in front of her body and the other leg folded horizontally on the ground. Her left hand is placed on her left knee and her body tilts toward the right with the support of her right arm. Smiling gently, her eyes look at the little boy to her right, who wears pants and a jacket. His two legs partially bent, the boy presents Guanyin's most magical instrument, a water bottle with a willow branch.

(*BOTTOM*, DETAIL) Xing Cijing, Section 1 of *White-robed Bodhisattva*, Ming dynasty, 1614. Handscroll, ink on paper (30.3 by 371.5 centimeters). The collection of Qingdao Museum.

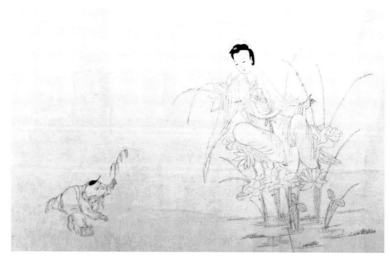

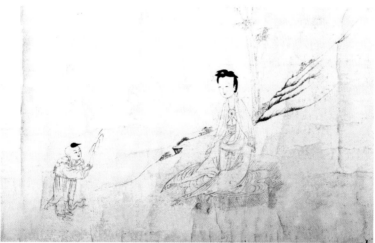

FIGURE 2.6b (DETAIL) Xing Cijing, Section 2 of *White-robed Bodhisattva*, Ming dynasty, 1614.

In the second section, Guanyin sits on a lotus leaf in the gesture of quasi Royal Ease: her right leg is not folded horizontally as in the first depiction, instead her legs are naturally placed on the lotus leaves. Growing from the water and mud below, the lotus leaves and flowers are all above the ground and lean to the right; Guanyin's body mimics the leaves and also veers to the right. She looks down at the little boy on her lower right side, and her left hand is ambiguously portrayed as if she were pointing something out to him. Looking up towards Guanyin, the boy's pose is caught in motion with one foot on the ground and the other one stretching in the air. He seems to be running to Guanyin and to be eager to present her with the willow branch in his left hand.

FIGURE 2.6c (DETAIL) Xing Cijing, Section 3 of *White-robed Bodhisattva*, Ming dynasty, 1614.

The third Guanyin, however, is back on the ground and sits on a mat on a hillside with several bamboo trees in the background to indicate her residence in Zizhulin 紫竹林 (purple bamboo forest) in Guanyin's mythological Chinese home Putuo Mountain. Guanyin's hands are clasped on her thighs but hidden in the sleeves of her robe. With the same compassionate expression as in the previous images, she is again looking at the boy who is standing in front of her and offering a water bottle containing willow branches. The boy is now dressed in a long gown decorated with a cape. The streamers of his waistband are flying in the air.

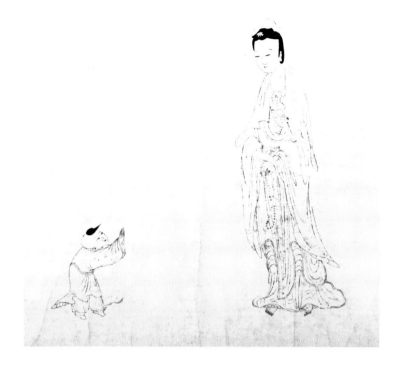

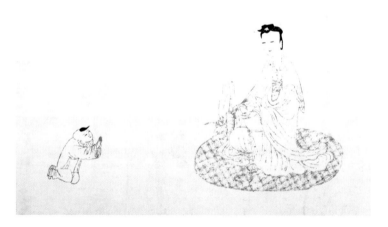

FIGURE 2.6d (DETAIL) Xing Cijing, Section 4 of *White-robed Bodhisattva*, Ming dynasty, 1614.

The fourth Guanyin, the only standing Guanyin among the five, holds a rosary in her hands. The boy, now empty-handed, bends over with folded hands to show his respect to Guanyin.

FIGURE 2.6e (DETAIL) Xing Cijing, Section 5 of *White-robed Bodhisattva*, Ming dynasty, 1614.

The fifth and final Guanyin sits on a silk or cloth mat. She holds her left knee with two hands and her right leg rests on the mat. A bookcase representing scripture is placed next to Guanyin. The water bottle and willow branch, which were presented by the child in the first and third sections, have now returned to Guanyin's side and are placed behind the bookcase along with a lotus flower. The little boy then fully kneels down with two palms together in the gesture of worship. His clothing has now switched back to the set he wore in the first sector.

of all five Guanyins is simply adorned by a lotus flower hairpin. In contrast to Guanyin's consistent appearance, the little boy, save his conventional patch of hair above the forehead, is pointedly presented in different types of clothing.

The specific religious connotations of the five Guanyins in Xing Cijing's painting are still unclear. The only true precedent is a handscroll by Ding Yunpeng (1547–1628), *Five Forms of Guanyin* (1579 or 1580, 28 cm by 134 cm), now in the collection of the Nelson-Atkins Museum of Art (figure 2.7). Ding depicted popular late-Ming forms of Guanyin: three of them can be easily identified as the Fish-basket Guanyin, White-robed Guanyin, and Guanyin from the South Sea. The other two do not have distinguishing features but are simply wearing Guanyin jewelry and sitting on mats, one in the half-lotus, the other in the royal ease posture. The poses and settings of the Guanyin figures in Xing's painting remind us of the archetypical iconography of those in Ding Yunpeng's scroll and in Guanyin painting manuals, such as the *Thirty-two Manifestations* and the *Fifty-three Manifestations in Praise of the Compassionate Appearance of the Great Being Guanyin* (*Guanyin dashi cirong wushisan xian xiangzan* 觀音大士慈容五十三現象贊 hereafter the *Fifty-three Manifestations*).[50] The posture and gestures of Xing's fourth Guanyin and her interaction with the little boy recalls the overall layout of the first image of Guanyin and the boy pilgrim Shancai or Sudhana in the *Thirty-two Manifestations* (figures 2.6e and 2.8).[51] Although one is a holy figure and the other is a mundane boy, Shancai and the male child Guanyin gives to the supplicant are sometimes deliberately conflated because both are boys.

If we compare the *White-robed Bodhisattva* with various images of Guanyin and the child or Guanyin and Shancai (figures 2.6a and 2.9), we find that Xing Cijing's painting is unique in its deployment of the two figures: Guanyin and the boy face each other in a state of mutual attentiveness. In all five sections, Guanyin is presented as a compassionate mother-like figure watching the little boy. This makes one wonder: Does the painting reveal something of Xing's own life? Why did she make this painting in middle age? How do we understand Xing's religious engagement with the White-robed Guanyin deity through the painting? And finally, what can we deduce from the work with regard to Xing's negotiation of a middle-way between Confucianism and Buddhism?

Xing Cijing's Confucian Family and Buddhist Practice

Xing Cijing grew up in a typical Confucian family. She was a native of Wanliu 萬柳 village (today's Xingliuxing 邢柳行 village) in Linyi 臨邑 County, Shandong Province, and was born into a family of imperial physicians in the Ming Wanli era.[52] In both official and unofficial histories, including random jottings, she was often

FIGURE 2.7 Ding Yunpeng (1547–ca. 1621). *Five Forms of Guanyin*, ca. 1579–1580, Ming Dynasty (1368–1644). Handscroll, watercolor on paper; silk mount, (28.6 by 134.6 centimeters). The Nelson-Atkins Museum of Art, Kansas City, Missouri. Purchase: William Rockhill Nelson Trust, 50–22. Photo courtesy Nelson-Atkins Media Services / John Lamberton

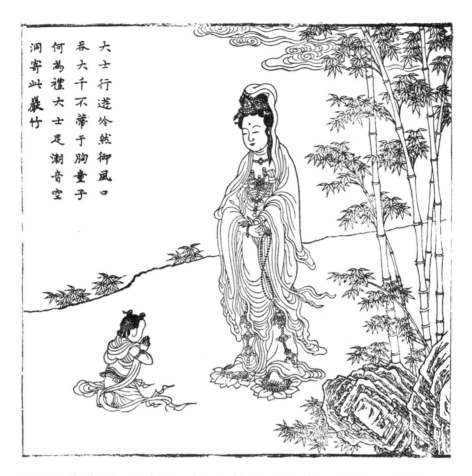

FIGURE 2.8 *The Thirty-two Manifestations of Guanyin*, late Ming. Woodblock prints. *Source:* After Ding Yunpeng et al., *Mingdai muke Guanyin huapu huapu* (Shanghai: Shanghai guji chubanshe, 1997), 111.

introduced as the younger sister of Xing Tong 邢侗 (1551–1612), the most accomplished man of her generation, who achieved an official position and was a much admired writer and calligrapher.[53]

By any standard, Xing Cijing was a talented woman. She was an acclaimed poet, calligrapher, and painter specializing in depicting Guanyin.[54] In her later years, she followed in the footsteps of her brother and sponsored a project concerned with carving the Collected Model of Calligraphy from Zhishi (*Zhishi jitie* 之室集帖) on wooden slabs. The second component of this calligraphic model contains one of Xing's poetry collections, The Illusory Running Script from the Studio of Orchid (*Zhilan shi Feifei cao* 芝兰室非非草 hereafter *Feifei cao*). She transcribed forty-one of her own poems in the style of *xingshu* 行書

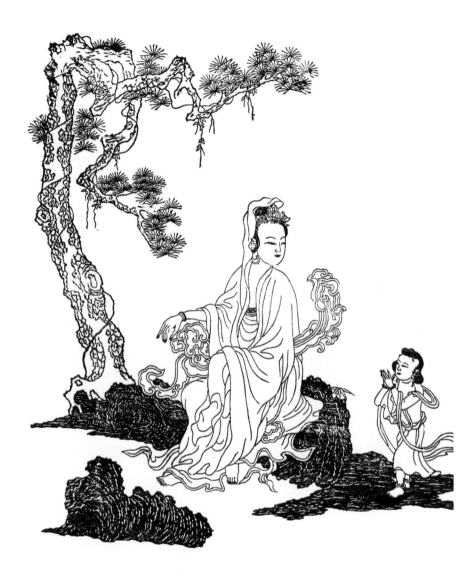

FIGURE 2.9 *Fifty-three Manifestations of Guanyin. Source:* After Ding Yunpeng et al., *Mingdai muke Guanyin huapu* (Shanghai: Shanghai guji chubanshe, 1997), 63.

(running script).[55] Unlike other female writers, who circulated their poetry collections primarily in printed or manuscript formats, Xing published her collection in the *tie* 帖 (model calligraphic book) format to spread both her poetry and calligraphy through the medium of ink rubbing.[56]

Different from most young ladies who married before their twentieth birthday, Xing Cijing waited until the age of twenty-eight before marrying a Chinese Muslim, a native of Wuding 武定 County in Shandong. His name was Ma Zheng 馬拯 (?–1617) and he was magistrate of Datong 大同 Prefecture in Shanxi Province at the time of their marriage.[57] Xing would accompany her husband to his official posts in Shanxi, Liaoning, and Guizhou until his death in Guizhou in 1617. Xing then spent the remainder of her life in her natal home in Linyi where she is still listed as an exemplary woman in the local history because of her perseverance and achievements during widowhood.[58]

In addition to her proclaimed faith in the White-robed Guanyin, the precise details of Xing Cijing's religious life remain unclear. We can reconstruct part of her life story, however, from texts left by people who lived around her at the time. She was apparently an exceptionally well-educated teenage girl according to records in the biography of her equally talented sister-in-law, Madam Yang (Yang shi 楊氏), the wife of her cousin Xing Guan 邢信.[59] Among the women in the Xing family, only Xing Cijing and Madam Yang are recognized for their cultural achievements.[60] Other women, including Xing's mother, sister, and sisters-in-law, were celebrated for their filial piety, austere lifestyles, and generosity to others.[61] They all had a basic education but did not demonstrate any particular enthusiasm for reading and writing. This was quite different from some of Xing's other contemporaries, such as the women of the Ye family from Wujiang 吳江 and the Fang family from Tongcheng 桐城, who had a strong female community bond created by their shared intellectual and artistic interests.[62]

Unlike the Ye family women, who were emotionally and actively engaged in Buddhist and Taoist learning from an early age,[63] Xing Cijing grew up in an environment in which women practiced Buddhism primarily through ritual rather than reading and writing. In the local gazetteers of Linyi and the (Xing Family Genealogy) *Xingshi jiacheng* 邢氏家承, women's religious activities tend to be omitted from the narratives of their life stories. Among these women, only the wife of Xing Cijing's brother, Madam Chen (Chen shi 陳氏 1552–1587) was revealed to follow the cult of Guanyin. In the epitaph for his wife, Xing Tong describes with deep grief the details of his beloved wife's death in childbirth and how, as a sincere follower of Guanyin, she had pleaded with a diviner to interpret her bad dreams.[64] Madam Chen's practice as a strict vegetarian is combined with her other virtues derived from Confucian discourse.[65]

Despite the silence of the literary sources, there is reason to believe that Xing Cijing could have had an early exposure to the Guanyin cult. Documents reveal that during the Ming period, a Guanyin Nunnery, Baiyi an 白衣庵 (White-robed Nunnery), sat to the east of Xing Tong's studio, Laiqin guan 來禽館 (Hall of Coming

Birds), only ten houses away from the Xing family residence. A jade Guanyin statue was found in the ruins after the nunnery had been overrun in the riots of 1631. That statue was then moved into the late Xing Tong's studio, which was converted by worshipers into a new White-robed Nunnery.[66] This nunnery likely played an important role in the Xing women's Buddhist practice.

Xing Cijing included several poems with Buddhist connotations in the aforementioned poetry collection *Feifei cao*, so we at least have some understanding of her religious life during her later years. Indeed, four poems with the title "*Jingzuo*" 靜坐 ("Quiet Sitting") appear at the very beginning of *Feifei cao*. These poems express her understanding of the emptiness of the phenomenal world and her determination as a follower of the Buddhist path.[67] Other poems such as "*Nianfo*" 念佛 ("Chanting Buddha"), "*Chenqi fenxiang*" 晨起焚香 ("Burning Incense After Getting up in the Morning"),[68] and "*Yougan*" 有感 ("Casual Thoughts") are written in the same vein but also illustrate her daily Buddhist ritual practice and her perception of Buddhism more concretely. For instance, in "Casual Thoughts" she wrote,

懺悔身心澹幻情	Repenting body and mind, avoiding illusory emotions,
名香一柱讀心經	Lighting fine incense and intoning the *Heart Sūtra*.
從今細悟無生理	I vow to awaken to the subtleties of non-rebirth,
要上蓮花頂上行	And ascend to the pinnacle of the lotus blossom.[69]

This poem was probably written during Xing Cijing's widowhood and perhaps after she lost her son or even her grandson, because she used the soubriquet of her later years *Putuan zhuren* 蒲團主人 (*Master of the Prayer Mat*), and then signed her name Xing Cijing as calligrapher below. Her attitude differs markedly from when she created the *White-robed Bodhisattva* in which her compassion as a new mother was expressed in her portrayal of figures and the delicacy of the ink drawing. Later in life, her vow is to devote herself to practices and attitudes that would allow her to "ascend to the top of the lotus flower" or to be reborn in the land of the Buddha.

Strikingly, this poem describes a Buddhist transformation, which involves a process of self-negation. Body, heart, and emotions constituted her own identity and kept her from overcoming herself and identifying with Guanyin. The reference to the *Heart Sūtra* suggests the sūtra's famous statement, "form is nothing other than emptiness; emptiness is nothing other than form."[70] Such lines point beyond one's physical form and toward identifying beyond the self. After reading the *Heart Sūtra*, she realizes the principle or dharma of no birth or the emptiness of living things. At this point, she has overcome herself, but the overcoming is of a specific type. The particularity of her transcendence is reflected in the final line of the

poem, which mimics the painting of Guanyin, although a Guanyin manifestation is quite different from the Child-giving Guanyin. Seated on the lotus flower, she not only goes beyond the principle of birth and death but also becomes Guanyin and embodies her compassion.

Prayer and Gendered Materializations of the *White-robed Sūtra*

Xing Cijing probably married Ma Zheng in the twenty-eighth year of the Wanli period (1600).[71] Thus, at least fourteen years passed between her entrance into married life and her painting of the *White-robed Bodhisattva* in 1614. As the only surviving Guanyin painting with a description of the rationale behind the image-making, the *White-robed Bodhisattva* clearly marks her proclaimed faith in the White-robed Guanyin. In particular, she stressed that this White-robed Guanyin was also the Child-giving Guanyin. Xing did not explain how she had benefited from worshiping this Guanyin; instead, she left only the general statement that anyone who followed this deity would discover its efficacy.

The question then arises: did Xing Cijing and her husband have difficulty producing an heir? The various testimonials attached to scriptures of the White-robed Child-giving Guanyin share one common point, namely that the benefactors were mostly middle-age people who could not have sons.[72] After they had chanted related scriptures a thousand times, they all miraculously brought a child into the world, usually a son. They would then donate money to have those scriptures printed in several thousand copies.[73] Interestingly, Xing did give birth to a boy Ma Shixing 馬時行 probably between 1612 and 1614.[74] This means that after she had been married for more than ten years, she and her husband finally produced a son, the couple's only child. Therefore, we can safely infer that *White-robed Bodhisattva* was created at the beginning of Xing's long-awaited motherhood.

Xing Cijing must have been determined to have her own child, and the intensity of her feelings seems clear from the fact that she did not pursue the common option of finding a concubine for her husband, although she had reached middle age and had been infertile for nearly a decade. As Francesca Bray points out, to continue the patrilineal line, elite women would help their husbands find concubines of lower social status.[75] This was considered the duty of a wife and was recognized as a form of virtuous behavior. For instance, Fang Mengshi gave birth to a son and a daughter in her twenties, but both children died in infancy. She then bought concubines for her husband, and they were blessed with three sons. Thereafter, her husband's family line was considered prosperous.[76] Indeed, Xing Cijing's own elder sister, Xing Dazi 邢大姊 (1543–1591), was also praised for selling all the jewelry from her dowry to buy a concubine once she lost hope of producing a child of her own.[77]

Xing Cijing's situation seems to have presented a dilemma for her. Although she longed to embody the Confucian ideal by bearing a male heir for her husband's family, she did not encourage her husband to find a concubine. Thus, she needed to find some other way to procreate.

It is no surprise that Xing Cijing turned to the Buddhist fertility goddess, the White-robed Guanyin, after desperately wanting a child for such a long time. As discussed earlier, compared with other Xing women, Xing Cijing was exceptional for her intellectual achievement. In this respect, she took after her father and brother more than any of the women in the family. Similarly, her religious life cannot be compared to that of her female relatives. Her brother Xing Tong, twenty-two years her senior, had a fundamental influence on her literary and artistic training.[78] He also may have shaped her religious practice. Xing Tong and his eldest son Xing Wangrui 邢王瑞 (1577–1611) were both Buddhists. The inventory of Xing Tong's collection of ink-rubbings and books shows that he hand-copied a sūtra dedicated to the White-robed, Child-giving Guanyin, the *Baiyi dabei wuyinxin tuoluoni jing* 白衣大悲五印心陀羅尼經 (*Dharani Sūtra of the Five Mudra of the Great Compassionate White-robed One*, hereafter *White-robed Sūtra*) in the running script style, had it carved on woodblocks, and printed it. This sūtra was probably dedicated to Guanyin in gratitude for bringing Xing Tong another son at the age of forty-two.[79] More dramatically, between the first son and his youngest son was a lengthy interim of sixteen years, during which time Xing Tong had suffered the loss of three infant sons from his first wife, Madam Chen.[80]

Xing Tong's first son, Xing Wangrui, also faced the pressure of continuing the family line. He followed his father's example and prayed for a son by copying out the *White-robed Sūtra*. In 1607, at the age of thirty-one, he not only transcribed the *White-robed Sūtra* and had it carved on wooden printing blocks but also copied a Guanyin image, had it transmitted onto a wooden block, and then printed it on the front page of what was possibly the same *White-robed Sūtra*.[81] Even so, when he died at age thirty-four, he had not left an heir.

Both Xing Tong and Xing Wangrui's endeavors to reproduce sūtra and image to express either gratitude to Guanyin for granting a son or longing for an heir were typical forms of behavior among believers.[82] The only difference was that members of the Xing family could use their calligraphic skill to copy sūtras or draw images of Guanyin by hand and could have this work carved onto wooden printing blocks and have them reproduced, instead of purchasing sūtras and drawings.[83]

Living in the same household, Xing Cijing must have been familiar with both her brother and her nephew's activities of copying and printing the *White-robed Sūtra*, and she must have understood the function of this sūtra. In the face of both successful and unsuccessful effects in these two men's lives, however, Xing's long

journey of committing to the White-robed Guanyin suggests an interesting problem. She might have distinguished between praying and conversion. For Xing, the empirical sign of giving birth to a child transformed the liminal stage between believing and not believing to full commitment to the White-robed Guanyin.

Unlike her brother or many other benefactors described in the various testimonials, Xing Cijing chose drawing over printing to reproduce the scripture and Guanyin images. We can deduce that the reasons for her choice of a different medium were complex. The choice might simply have been due to economic considerations. When Xing created this painting, she was probably with her husband at his post in remote Liaoyang where they lacked the craftsmen and facilities for reproducing scriptures and images through woodblock plates. Xing's preference, however, for this alternative device to repay the efficaciousness of the deity might also suggest the gender differences among the patrons who reproduced such scriptures. Both her brother and nephew's printed scriptures echo male literati involvement in promoting the cult.[84] In particular, they recorded and spread the miraculous tales in which Guanyin successfully brought sons to the family.[85] Xing was likely influenced by this convention but chose to practice it by painting, a skill that gentrywomen, too, could cultivate and achieve. In particular, she chose to create *baimiao* Guanyin images to express her gratitude as well as to claim her exemplarity as a dutiful wife and compassionate mother. Xing unites Guanyin's compassion and her own motherly compassion toward her child through the painstakingly delicate ink lines, soft contours, and intimate arrangement of Guanyin and the child. Her hair-thin brush strokes also possess the refined lineation associated with devotional imagery, including embroidery. Indeed, Xing is also recorded to have been an expert at embroidering Guanyin icons using human hair (see chapter 3). The *mogao* 墨稿 or ink reference copy for hair embroidery must be extremely fine; otherwise, the ink underdrawing would show through the hair stiches. Xing's *baimiao* painting strokes are described by male scholar Chen Weisong as "jade terrace [women's] clinging hair" (*yutai nifa* 玉台膩髮) and "spider silk in the spring" (*chunri yousi* 春日游絲).[86] The effort of making ink lines as thin as a human hair and the visual effect of such line strokes calls our attention to the artist's necessarily calibrated control of her eyes, wrists, and breath.[87] In the process of making such hair-thin strokes, Xing could not use the conventional method of tracing a model to make a draft or make even the slightest mistake. Such an intense practice fosters an intimate relationship between the artist and the icon.

Reorganizing Scriptural Text in Painting

Religious art typically shows the image of a deity, above which a eulogy or scripture is inscribed; this is equally true for both hanging scroll paintings and stelae from the Ming period. Xing Cijing adapted this format from the usual vertical

organization to a horizontal handscroll arrangement. She borrowed various visual models of Guanyin and texts on the fertility goddess from different sources and recontextualized them in her handscroll.

The colophons have two primary sources: the *White-robed Sūtra* and a hymn entitled "Guanyin shixian," which was attached to *King Gao's Guanshiyin Sūtra* (*Gaowang guanshiyin jing* 高王觀世音經).⁸⁸ Passages from these sources are arranged in alternation, with the sūtra in the first and third sections, and the hymn in the second and fourth sections. Xing Cijing composed the fifth colophon. Xing's treatment of these colophons has a strong narrative quality appropriate to the handscroll format. In the following discussion, I demonstrate how she repositioned texts to create her own expression of gratitude to Guanyin.

We know that Xing Cijing was familiar with the *White-robed Sūtra* through her male family members. Although she did not reproduce this scripture in a printed form, she nonetheless did homage to it by inscribing part of the scripture on her painting. A short scripture of only 245 words, the *White-robed Sūtra* consists of three Buddhist genres: *dharani* (a type of ritual speech similar to mantra), *gāthā*, and Buddha names. Because no other painting containing the *White-robed Sūtra* has been found, we can only compare Xing Cijing's work with surviving Ming-period ink-rubbings that combine both the sūtra text and an image of Guanyin (figures 2.6 and 2.10). This comparison reveals that although the scripture usually was transcribed in full on stelae,⁸⁹ Xing incorporated only two of its *gāthās*, which in the original scripture have a descriptive title: "*Kaijing jie*" 開經偈 (sūtra-opening *gāthā*) and "*Qingqi*" 請啟 (invocation). These *gāthās* are arrayed on the first and third sections of *White-robed Bodhisattva*. Xing did not include the *dharani*, Buddhist names, or descriptive titles of the two *gāthās*. These omissions suggest some modification of the ritual aspect of recitation in Xing's painting.⁹⁰

The first colophon, which is also the opening *gāthā* of the sūtra, reads,

The subtle and wondrous *dharma* of utmost profundity
is difficult to encounter over millions, nay, billions of *kalpas*.
Now that I have heard it [with my own ears], I will take it securely to heart
And hope I can understand the true meaning of the Tathagata.⁹¹

A common opening verse that also appears in other sūtras, this *gāthā* should be read before chanting the main part of the sūtra. Positioned to accompany the first White-robed Guanyin on Xing Cijing's painting, it has a dual function: As a convention in ritual recitation, it expresses the worshiper's—in this case Xing's—willingness to understand the *dharma*; it also represents the opening of the handscroll and the journey to be undertaken there.

FIGURE 2.10 *White-robed, Child-giving Guanyin with Dharani Sutra of Five Mudra of the Great Compassionate White-robed One*, late-Ming or early Qing period. Ink-rubbing. *Source:* After *Lidai minghua Guanyin baoxiang*, pl. 114.

The texts of the second and the fourth sections are originally from the same hymn, "Guanyin Demonstrates Manifestation" Xing Cijing divided the hymn into two parts and also deleted five lines from the original text. The translation of the second colophon reads,

The Holy Master Perceiver (Kuan-zi-zai, another name of Guanyin) who is the Bright Ruler of the True Law of Putuo Island, situated by the isolated seashore. Her hair is as purplish black as distant hills, her lips are a gorgeous vermilion red, her cheeks are like a morning cloud, and her eyebrows are curved like the new crescent moon. She is usually referred to as great benefit and is sometimes called propitious. The pupils in her eyes glow and she wears a white garment. She sits on a green lotus and her body is majestic with abundant blessings.[92]

This hymn, associated with *King Gao's Sūtra of Guanshiyin*, a popular sūtra in the Ming period, was believed to be efficacious for bringing forth a son.[93] Guanyin's magical powers are presented through different imagery in the text compared with Xing Cijing's painting. The close description of Guanyin's face helps the viewer-reader to visualize a more fleshy, colorful, and life-like image, such as was visualized by female painter Jin Liying in 1803 (figure 2.5). The *baimiao* style Guanyin, in contrast, does not convey a sensuous appearance. Instead, the delicate, fragile ink lines individualize the attachments between Xing and Guanyin and Guanyin and the child as well as between Xing and her own son.

In the original script of the *White-robed Sūtra*, the invocation follows immediately upon the opening *gāthā*; however, they are separated on the *White-robed Bodhisattva*. The invocation is the third colophon and reads as follows,

> Bowing my head to the Great Compassionate One,
> Po-lu-chieh-ti.
> Practicing meditation focused on the sense of hearing,
> [The bodhisattva] entered Samadhi.
> Raising the sound of the ocean tide,
> Responding to the needs of the world.
> No matter what one wishes to obtain,
> [She] will unfailingly grant its fulfillment.[94]

This verse performs a ritual procedure, which involves calling the names of the buddhas and bodhisattvas. In the case of *White-robed Sūtra*, five names are mentioned.[95] After expressing her sincerity in the sūtra-opening *gāthā*, it is likely that Xing Cijing used this invocation to demonstrate her confidence in divine power.

The fourth colophon reads,

> She is like a moon appearing in the ninth empyrean or a star reflected in myriad bodies of water. She can eliminate three disasters when encountering one, then the disasters turn into non-disasters. She can avert eight calamities in the places with such calamities, then calamities turn into non-calamities.[96]

This colophon comes from the same hymn as the second one, but it is not about visualizing the deity. Instead, it describes what Guanyin can accomplish or what kind of divine power she possesses.

On their face, the first four colophons seem merely to alternate between different sources; however, when we single out the main function of each one, we can read them as a serial representation of temporal progression. The first

states a willingness to understand the dharma, the second concerns the discipline of visualizing Guanyin, the third expresses faith in Guanyin, and the fourth explains Guanyin's divine power. Then in the fifth and final colophon, by inserting herself into the text, Xing Cijing testifies to the efficacy of Guanyin's magical powers. This arrangement is an ingenious innovation. We cannot identify a precedent for her arrangement at this point, but the texts in this disposition speak for themselves.

Art historians remind us that handscrolls are usually rolled up in storage. The act of viewing or unrolling is such that the viewer can only examine one arm's-length section at a time.[97] Xing Cijing's *White-robed Bodhisattva* scroll is 371 centimeters long, so when we imagine unrolling the scroll, with each arm's-length section about 70 to 80 centimeters long, we can only see one Guanyin and one colophon at a time. If we consider the consecutive colophons discussed previously alongside Xing's visual scheme of presenting one form of Guanyin throughout, we would recognize the very same White-robed Guanyin moving around or appearing five times in a different environment and posture. Even though the variety of Guanyin's poses are based on individual models and do not necessarily follow each other, the repeated appearance of the same Guanyin form in different poses lends visual, temporal, and conceptual continuity to the series. Second, with the help of the colophons, we deepen our understanding of the goddess's divine power step by step until we read Xing's testimony of the efficaciousness of the White-robed Guanyin in her own life.

Celebrating Motherhood

At the end of this painting, Xing Cijing included a hymn she composed to praise the White-robed Guanyin for bringing life to the world. It reads as follows:

惟其好生 是為慈悲	Cherishing life, she is compassionate.
若無慈悲 生亦悉為	Without compassion, what is life for?
既已有生 何能無情	How can any living being lack feeling?
人之鍾情 乃在所生	Human beings feel deepest affection for what she produces.
佛於一切 皆作子視	The Buddha considers all beings his children.
去忍去嗔 以畜吾子	Guanyin banishes suffering and anger to nourish our children;
莊嚴者像 匪像惟心	The image of the ornamented one—that image is one's heart.
吾心不昧 是謂觀音	My unobstructed heart is called Guanyin.[98]

As mentioned earlier, after waiting more than ten years, Xing Cijing finally bore a son in her middle age. This painting was created after she became a mother. This passage celebrates this important moment in her life. In it, she establishes a connection between Buddhist principles of compassion toward life and the love that a mother feels for her child. This love and the importance of having a son are mediated by a Confucian framework, but Xing links the actual appearance of a child to Buddhist compassion. That compassion allows Xing to express an aspect of the parental and indeed maternal relationship that is obscured by Confucianism.[99] She defines compassion as cherishing life, which she claims is almost synonymous with life. Without compassion, life becomes incomprehensible. Then from the opposite perspective, she notes the "givenness"[100] of life and realizes that it always already entails passion or feeling (*qing*). But Xing further associates this emotional sense toward living things with the idea of motherhood, stating that "the Buddha considers all beings as his children." This implies a relationship of reproduction. Things emanate from Guanyin and then she cultivates them by eliminating suffering and anger. She cultivates all living things as her children by relieving suffering, and this act is signified by her dignified or majestic heart, which is clear and not obscure. By having a child, Xing also participated in this process and, in her love toward her child, she understood and experienced some of the compassion Guanyin has toward all living things. One could say that Guanyin enabled Xing to have a child to alleviate her suffering and to allow her to glimpse the workings of compassion in the world. Thus, we can observe a parallel between the microcosm, Xing and her child, and the macrocosm, Guanyin's relation to all living things.

By depicting the image of Guanyin and carefully selecting the various eulogies, Xing Cijing sought to express her gratitude to Guanyin for bringing her a son. Moreover, the previous point about the relationship between microcosm and macrocosm is further strengthened if we consider the complicated relationship between Guanyin, the symbolic boy in the painting, Xing, and her son. In the painting's first three sections, the boy presents Guanyin with her magical tools, the water bottle and the willow branch, in prayer so that Guanyin would show her miraculous power. When Guanyin gives a child to Xing, who physically gives birth to her son, we can say that Xing physically embodied Guanyin to receive a gift and that that gift was the giving of life. Thus, the painting depicts a symbolic mother and a child, who in turn mirror the existence of Xing and her child. At the same time, when we look at the painting and text, we note that the particular child can stand for all living things and Guanyin can stand for a type of universal mother with infinite compassion.

CASE TWO: FANG WEIYI—PAINTING GUANYIN IN THE MIDST OF WIDOWHOOD

Wang Shizhen 王士禎 (1634–1711), the well-known scholar-poet and advocate of women's literature, once commented that Fang Weiyi's Guanyin painting was not inferior to that of his fellow provincial Xing Cijing.[101] Fang was born more than a decade after Xing Cijing, and both women are considered accomplished poets and painters; they were also the pride of their localities.[102] Under the influence of different cultural milieus and the dissimilar hardships in their lives, however, their approaches to the practice of creating the image of Guanyin differed.

Around 1656, at age seventy-one, Fang Weiyi painted a White-robed Guanyin in monochrome ink (figure 2.11).[103] In this painting, a Guanyin seated against a blank background is depicted in only a few brush strokes. Fang's ink line drawing and the way her subject is situated convey the bodhisattva's elegance, purity, compassion, and serenity. Unlike other gentrywomen, Fang did not follow any of the popular Guanyin painting manuals. Instead, she was fascinated with painting Guanyin as a form of meditation. Fang lived as a widow for more than six decades, and in what follows, I investigate how, during that period, she combined practices related to the Confucian ideal of female chastity with the Chan Buddhist concept of emptiness.

A Confucian Virtuous Woman

Fang Weiyi, style name Zhongxian 仲賢 and studio name Tower of Clear Fragrance (Qingfenge 清芬閣) was born to a renowned gentry family in Tongcheng, Anhui.[104] She was well educated and exhibited precocious talent in poetry and painting. Fang was married to her fellow townsman Yao Sunqi 姚孫啟 (?–1602) who had been sick for six years before their marriage and continued to be weak during their wedded life. Fang served him wholeheartedly, but to no avail. She became a widow at the age of eighteen, and her only daughter died when she was nine months old. Because her parents-in-law at the time were in Fujian, Fang answered to the orders of her own mother and returned to her natal house.[105] She remained chaste for sixty-six years until she died at age eighty-four.[106]

Fang Weiyi's identity as a virtuous woman is clearly noted in the local gazetteers.[107] In the *Continually Revised Tongcheng Gazetteer*, women in the Fang family appear in the sections on virtuous women and women who were martyrs. They include Fang Weiyi; her sister Fang Mengshi, who committed suicide after her husband died resisting the Manchu army in Shandong; her sister-in-law Wu Lingyi 吳令儀 (1593–1622); and her nephew Fang Yizhi's (方以智 1611–1671) two wives, Madam Yao and Madam Pan.[108] The short accounts of these women differ in their

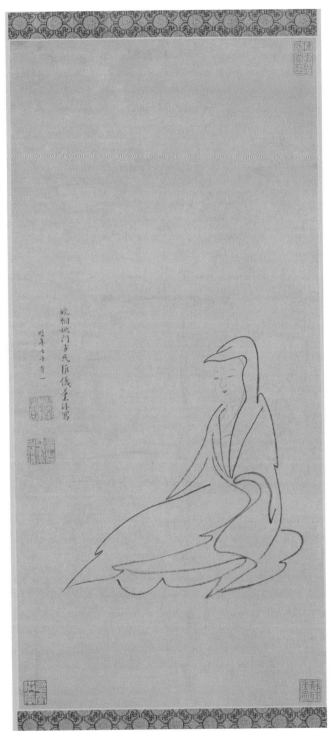

FIGURE 2.11 Fang Weiyi, *Guanyin*, Qing dynasty, dated 1656. Hanging scroll, ink on paper (26.6 by 56.5 centimeters). The collection of Beijing Palace Museum.

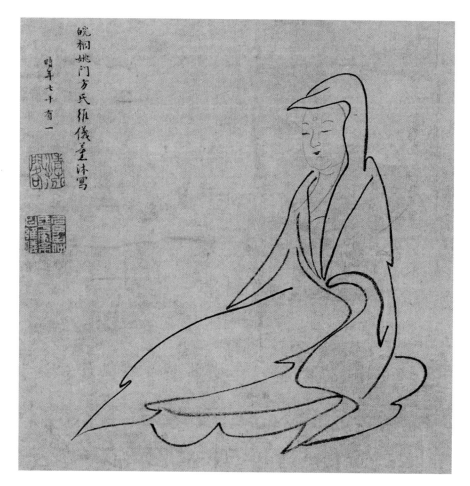

FIGURE 2.11A (DETAIL) Fang Weiyi, *Guanyin* (detail), Qing dynasty, dated 1656. Hanging scroll, ink on paper (26.6 by 56.5 centimeters). The collection of Beijing Palace Museum.

details, but taken together, the stories reveal common patterns in the lives of exemplary women: They wholeheartedly devoted their lives to their husbands' families, remained chaste in widowhood, and lent their considerable talents to educating their children. As Katherine Carlitz points out, Confucians in Ming and Qing times saw women as the symbol of faithfulness.[109] Women dedicated their lives and bodies to their husbands and, by extension, to their husbands' families and the state. One exceptional feature of the Fang family women is their notable success in literary circles, which enhanced their natal and married family's social status.[110] Fang Weiyi and other female family members practiced a Confucian ritualism based in

a social network structured by an economy of honor: by preserving their female purity, they increased the prestige and honor of their families.

Even among these renowned women, Fang Weiyi stands out as extraordinary. She lived chaste for decades and educated five of her brother's children after her sister-in-law died young. She earned the soubriquets "Yao jiefu" 姚節婦 (virtuous wife from the Yao family) and "Yao zhenfu" 姚貞婦 (chaste wife from the Yao family).[111] To a young widowed gentrywoman like Fang, there seem to have been only two choices: suicide or widowhood. She was barred from suicide immediately following her husband's death because she was pregnant, so she could only choose to live as a widow.[112] Because she was from a well-respected and wealthy family, she would receive both moral and economic support in her widowhood. Fang had been deeply inculcated in the culture of chaste women and was fully aware of how to present a righteous image. She was actively engaged in moral education and wrote a book called *Guifan* 閨範 (*Models for the Women's Quarters*) that instructs women how to follow Confucian norms.[113]

An accomplished writer and painter, Fang Weiyi took part in the florescence of Ming–Qing women's literature that many modern scholars have explored.[114] In the preface by her sister Fang Mengshi to the poetry collection *Qingfenge ji* 清芬閣集 (*Collection from the Tower of Clear Fragrance*), Fang Weiyi's merit lies in concealing her intelligence. Indeed, she often detested her writing and hesitated to publish her poetry.[115] Even after her collection was printed, she wrote to her nephew Fang Yizhi that he should not promote her work because she did not want other people, especially men, to know about it.[116] Such a request suggests that her artistic work turned inward rather than being produced for others to admire. Her creative practice had a therapeutic dimension. This dimension was closed off from society and led to a split in her subjectivity. Fang Weiyi was internally a talented woman and externally a virtuous woman, roles that carried no small contradiction.

When a woman lives through a long widowhood, she undergoes tremendous pain. Exemplary women like Fang Weiyi were rewarded for their suffering. She often wrote verses that expressed her sorrow, but perhaps because they did not fit the image of the chaste woman who should above all be determined and brave, she destroyed most of them.[117] In her surviving poems like "*Sibie li*" 死別離 ("Bidding Farewell after Death"), Fang Weiyi voiced her feelings in the following manner:

昔聞生別離	I have heard of bidding farewell alive,
不言死別離	Not of bidding farewell after death.
無論生與死	Yet life and death,
我獨身當之	I must face alone.

北風吹枯桑	The north wind batters my withered frame,
日夜為我悲	Day and night, I sorrow.
上視滄浪天	Gazing into the azure sky above,
下無黃口兒	I have no living child on earth.
人生不如死	I wish I were dead,
父母涕相持	Weeping, my parents hold me.
黃鳥各東西	A pair of yellow birds flies separate ways—east and west,
秋草亦參差	Autumn grasses, too, grow tall and short.
余生何所為	For what have I lived?
余死何所為	For what will I die?
白日有如此	It is clearly this way,
我心自當知	Deep in my heart, I know.[118]

This poem was probably written at the beginning of her widowhood.[119] Although her family supported her, her fear of living or dying in solitude is evident. None of the moral or economic support from her family could rescue her from such sadness. However, perhaps Buddhism could.

A Devout Buddhist

Although Fang Weiyi and Fang Mengshi were considered virtuous women on all accounts by Confucian reckoning, they were also devout Buddhists, a fact downplayed by the local gazetteers. Zhou Yiqun's study of the epitaphs, biographies, and guidebooks written for married women by male literati during the Ming and Qing periods reveals that these accounts stress their careful observance of Confucian ancestral rites and showing filial piety toward their in-laws. Women were portrayed as keeping a healthy distance from Buddhism. Even in biographies of Buddhist laywomen, filial piety was always listed as the first virtue, above their devotion to Buddha.[120] When Buddhism reached new heights of popularity in the Ming–Qing period, Confucian patriarchs and officials viewed it as a threat to the foundations of the Confucian family order. Accounts of local history and, in particular, narratives of exemplary women, were squarely framed in Confucian terms. Timothy Brook has noted that although Confucianism was an absolute patriarchal system, Buddhism was a welcoming space for female religiosity. As long as Buddhism was considered inferior to Confucianism, men accepted the fact that women held Buddhist beliefs and observed Buddhist practices.[121]

No document indicates when Fang Weiyi first became engaged in Buddhism and particularly Chan Buddhism. She once published a book called "*Nishuo qihuo*" 尼說七惑 (*A Nun Explains Seven Puzzles*), which might have contained evidence of

her inquiries into Buddhism, but unfortunately, this book is no longer extant.[122] The *huo* 惑 (or doubt; also termed *yi* 疑) in her book title may indicate her participation in a practice of cultivating in *kanhua chan* 看話禪 (Chan of investigating the topic of inquiry), which was popular in the Ming.[123] Unlike other lay Buddhist women who expressed their understanding of Buddhism in poetry and painting,[124] Fang never used poetry to explore or explain her attitudes toward religion. The main subject matter of her poetry is history, the state, her social life, and lamentations about her own circumstances. But Fang's devotional practice as a Buddhist was intimately associated with her ink Guanyin painting. She seems to have conceived of writing poetry and painting religious figures as two distinct practices. Here we can draw a parallel with Brook's description of the relationship between Confucianism and Buddhism in late imperial China.[125] In her poetry, Fang engaged the Confucian literatus ideal, while painting was related to her daily religious practice.

From Fang Weiyi's painting and accounts of her left by her nephew, Fang Yizhi, we know at least one additional fact about her religious practice: She worshipped the White-robed Guanyin in the context of Chan Buddhism. Xing Cijing and Fang Weiyi prayed for different types of protection from the same deity. The former embraced her life when she created *White-robed Bodhisattva*, whereas the latter needed to distance herself from the hardships she endured.

Despite the integration of the White-robed Guanyin and Child-giving Guanyin cults in Ming–Qing times, evident in the case of Xing Cijing, the White-robed Guanyin's earlier association with Chan Buddhism had not disappeared. Initially, the White-robed Guanyin and the teaching of emptiness in the *Heart Sūtra* both pointed to the serenity of Chan meditative states; therefore, the White-robed Guanyin remained a suitable icon for meditation within the walls of monasteries and outside them.[126] In Fang Weiyi's case, as this becomes mingled with Confucian ideals of purity and chastity in widowhood, it forms a complex set of aspirations. By her ongoing practice of rendering the image of the bodhisattva, Fang placed her heart under the protection of the dharma; by maintaining her chastity, she adhered to Confucian doctrine.[127]

All extant Fang Weiyi paintings and calligraphy are works she created after she was seventy years old.[128] This was when Fang had probably been through most of the turmoil in her life and attained spiritual maturity. Indeed, the only surviving text by Fang herself that speaks to her Buddhist practice is a work of calligraphy entitled "Ciyun chanshi yuanwen" 慈雲禪師願文 ("Prayer Text of the Chan Master Ciyun [Benevolent Cloud]"), now in the collection of the Shanghai Museum. This prayer text was probably composed by Ciyun, a Chan master, and spread among his or her followers.[129] Although there is no evidence that Fang actually cultivated the

chan in a monastery, she could certainly have followed the monastic leader Ciyun by transcribing a text, and she could develop a lifestyle similar to that of a nun within her own domestic space.[130]

Drawing Guanyin as a Meditation Exercise

Fang Weiyi's rather small-scale *Guanyin* is about 26.6 centimeters wide and 56.5 centimeters high. Guanyin is positioned in the lower section of the paper with the upper space left empty. She is turned so the viewer can see her at three-quarters height, with her eyes lowered in front of her. Guanyin is seated, her body covered by a robe except for her face (figure 2.11, detail). In pale ink and fine lines, Fang depicts Guanyin's face as compassionate with womanly humanity. Without drawing any other of her usual attributes, Fang has applied a brush heavy with ink to depict the outline of Guanyin's robe and hood.

Following the alternation of the ink from dark to light, which indicates a brushstroke's start and end points, we can clearly count the nine strokes that form Guanyin's robe. This is an uncommon style of line drawing and the calligraphic manner is different from Xing Cijing's. Xing uses light ink and thin lines that diffuse the images in the background, and she employs fragmentary and meticulous lines to formulate an object. Fang Weiyi, however, makes succinct and economical use of her brush. She forms the shape of parts of Guanyin's body in one continuous brushstroke. For instance, she depicts the hood, shoulder, back, waist, and hips in one stroke, with several turns. Although Fang's Guanyin painting is often classified as *baimiao* in various textual sources, her calligraphic manner is closer to the expressive mode in art works created by Chan masters.

Fang Weiyi's delineation of Guanyin is strikingly similar to the painting *White-robed Guanyin* (figure 2.12) by Jueji Yongzhong (active around 1300), which is now held in the Cleveland Museum of Art. Jueji was a student of the Yuan dynasty Chan master Zhongfeng Mingben (1263–1323). In Fang's execution, Guanyin's meditative body is flipped horizontally and her halo is removed. Another painted scroll from later period in the Cleveland Museum bears great resemblance to the Jueji painting. A stone carving features similar imagery dated to 1132, which is held at the Liuhe Pagoda in Hangzhou. These works confirm that the Chan iconography that Fang imitated circulated widely in prints as well as ink-rubbing versions.[131] Among all Buddhist sects, only in Chan Buddhist practice are paintings an effective medium for representing lineage and, in Yukio Lippit's words, "a particularly potent means of Chan/Zen self-definition."[132] Unlike her fellow painters who were gentrywomen, Fang reveals her religious association through the pictorial surface of her Guanyin portrait.

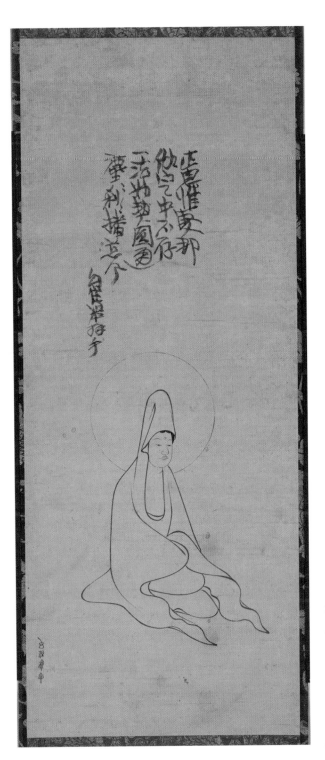

FIGURE 2.12 Jueji Yongzhong (fl.1300), *White-robed Guanyin*, with a poem inscribed by Zhongfeng Mingben (1263–1323). Hanging scroll, ink on paper (Image: 78.7 by 31.7 centimeters; overall 163.9 by 33.7 centimeters). The Cleveland Museum of Art, Purchase from the J. H. Wade Fund 1978.47.1

Fang Weiyi attributed this aesthetic to Wu Daozi, the Chinese "painting sage," the best-known Buddhist and Daoist figure painter, whom Fang most admired. Fang once observed that with line drawing, "it is most difficult to [draw] the halo in a single stroke as Wu Daozi did."[133] The compound expression she used, "*yibi yuanguang*" 一筆圓光 (with one stroke, complete the halo), is likely the concept at work in Jueji Yongzhong's single-stroke halo on his *White-robed Guanyin*. *Yibi* and *yuanguang* as two separate phrases had been associated with Wu Daozi since the twelfth century. A legend in the *Xuanhe huapu* 宣和畫譜 (*Painting Catalogue of the Xuanhe Era*) describes how Wu Daozi painted large figures on a temple wall as several thousands of people watched him. He would leave the halo to the last, and with a spin of his arm finish the halo in one stroke. People would cheer and praise his uncanny painting skill, suggesting that he must be possessed by a divine power.[134] The setting in which Wu Daozi painted was more like a stage and painting the halo was the spectacular finale to his performance. When we try to understand Wu Daozi's performance from a more technical perspective, ninth- and twelfth-century canonical texts on Chinese painting provide accounts of the "single stroke," which suggested that Wu Daozi "painted the halo without the aid of a compass."[135] According to the ninth-century scholar Zhang Yanyuan 張彥遠 (815–907), Wu Daozi did not rely on ruler and compass because he "kept his spirit and was single minded."[136] In other words, by concentrating and envisioning an image in the mind as well as focusing one's *qi* or energy, a painter could finish a work in a swift and accurate manner. Obviously, the artist's considerable practice and the skill embedded in his muscle memory were deliberately eliminated for effect in such legendary accounts.

Fang Weiyi's "single stroke" is better understood as a continuous line by which a running brush can depict several parts of Guanyin's figure and the minimal lines that form the figure.[137] The purpose of this technique is to create an image in a visceral manner—brush following from hand and hand following from heart, forming the essential parts of a figure in plainest lines. Furthermore, Fang developed her way of creating in accordance with Wu Daozi's legacy of concentration, combining meditation with painting. After his description of how Fang Weiyi was possessed by Wu Daozi's *yibi yuanguang*, Fang Yizhi discloses that every time she painted, she would first "meditate and contemplate [Guanyin's representation] for a long time and only then start to draw."[138] We see here that out of solitude and stillness an image comes into being. It is as if both Fang Weiyi's imagination and her body emerge from a type of spiritual emptiness. This process illustrates the manner in which emptiness relates to Fang's practice. Subject-object dualism is "emptied" of content and the spontaneous response of Guanyin's image arises from Fang's brush.[139]

Zhongfeng Mingben's inscription on Jueyi Yongzhong's painting further explains Guanyin meditation:

> The right thinking [Samkalpa] is embodied within
> His deep meditation on the Buddha [naga-samadhi]
> Retaining not even one single object of thought,
> A perfect harmony was wonderfully achieved.
> In the endless time and space,
> His all-embracing compassion prevails.[140]

The pure line drawing has been considered as a perfect form of a meditator emptying the mind. The delineation of the figure represents Guanyin's meditative body and the interior void of the figure signifies the state of mind.[141]

Mingben's prose insightfully explains what Guanyin does on this painting, but Fang Weiyi's ideal of "a single stroke" may help us to understand how a painter creates such a Guanyin painting and calls up the Chan belief in sudden enlightenment: executing an exact figure without the mediation on tools means there is no distance between the artist's mind and her brushstroke. Imagination is immediately expressed on paper, and immediacy is crucial to Chan Buddhist practice. Although we cannot document precisely what kind of Chan Buddhism Fang Weiyi subscribed to, her painting method reflects a common feature of Chan Buddhism in seventeenth-century China: immediate enlightenment is systematically reconstructed on various rhetorical levels and artistic mediums.[142] We can see an example of this in Beata Grant's study of laywoman poet Jiang Zhu from the Qing dynasty:

> One of the recurring motifs in Chiang [Jiang]'s early poetry in particular is the repeated assertion of the centrality of the individual quest, whether for Ch'an Buddhist enlightenment, rebirth in the Pure Land, or spontaneous and untrammeled self-expression—a hallmark, as we have seen, of late Ming thought in general. Often these goals were combined into one, as exemplified by the ideal of writing poetry with immediacy and spontaneity that it was said could only emerge from an enlightened mind. This equation of the religious and aesthetic was by no means a new idea.[143]

Grant's account of Jiang Zhu's combining religious and aesthetic value in poetry may help us understand Fang Weiyi's fascination with creating Guanyin's image in "a single stroke."[144]

To understand Fang Weiyi's persistence in "a single stroke," it might be useful to glimpse the painting technique that she denounced. In Fang Mengshi's words,

"[Fang Weiyi] occasionally drew golden [Buddha or Guanyin] images, but then she would unexpectedly burn the glorified [image]. She kept [her painting of the golden image secret] in her tower and omitted it from the record of her works. She held it as a frivolous skill."[145] It is unclear what exactly the "golden manifestation" (*jinxiang* 金相) means in this context.[146] One possibility is that *jinxiang* might refer to a kind of linear-drawing in gold ink on black or deep indigo paper. As we can see in both Qiu Zhu's and Xing Cijing's albums of the *Thirty-two Manifestations*, their icons were directly copied from the painting manual with exacting care (figures 0.3 and 2.3). To transmit an image from a painting manual to paper, the artist generally places a regular sheet of white paper on top of the manual page like a piece of tracing paper. Because rice paper is translucent, the painting manual image will show through on the top sheet. The artists can then sketch the outline. When the paper is black or indigo, the original manual is laid on the paper onto which it will be copied. A fine needle is used to poke holes along the outline of the painting manual image.[147] Because the needle penetrates the top sheet of paper and also pokes through the lower sheet and leaves holes on the black and indigo paper, the artist can then use silver or gold to draw the outline by following the holes. While making a copy in this fashion, the artist's attention is fully concentrated on accurately duplicating the image.

This suggests why Fang Weiyi counted painting the golden colored Buddha or Guanyin's image as a "frivolous skill" (*moji* 末技). But in this process, Guanyin is rendered in different phase or layers. The step-by-step method and the method of direct copying equally muddy the Chan ideal of representing Guanyin directly from the artist's mind; by overworking the image, they distort the Buddhist notion that "everything exists according to its own nature, our individual perceptions of worth, correctness, beauty, size, and value exist inside our head not outside of them."[148] The expression *"frivolous skill"* does not just point to different processes of making, it is also a term of judgment against any meticulously wrought image. That Fang burned such images suggests she believed those paintings did not demonstrate the sense of Chan she valued most highly. Perhaps the control and determined judgment for which she was so famous is why the acclaimed poet Chen Weisong 陳維崧 (1626–1682) praised her as having reached the uppermost realm of Chan Buddhism.[149]

Still, the idea that Fang Weiyi pursued the aesthetic ideal of Wu Daozi's style is misleading, because Wu's paintings had only survived as legend by Fang's time. All she had was his name and the stories about him, but her ambition to fashion herself after a male master of Buddhist and Daoist paintings in pursuit of transcendence would distinguish her from other painters who were gentrywomen. Wu as a model was a simulacrum of Fang's artistic imagination. This Wu legend allowed

Fang to create a regulative ideal and treat this religious authority as something she held externally.

Fang Weiyi's precise inked brush strokes in steady tempo suggest that she might have practiced the same contour many times until the sequence of the strokes and the form of Guanyin became part of her muscle memory. Spontaneity emerges through tonal variations in the ink and brushwork. Indeed, we can observe a counter example of less trained hands in the copy of Yongzhong's *White-robed Guanyin* at the Cleveland Museum of Art (figure 2.13). The lack of fluidity of the ink lines shows that the painter was anxious about following the model accurately. The denigrated "craftswoman" skills and the prized "spontaneous" style cannot be easily separated. The repetitive exercise of the same pure line drawing is part of devotional practice and merit-making. The time and labor consumed in making devotional objects, which will be discussed in the next chapter, are manifested through different painted forms. For example, Xu Can drew several thousand Guanyin paintings to accumulate merit. Fang would draw the same model repetitively until she could internalize the figure. Many other women painstakingly traced the outline of Guanyin from Guanyin painting manuals.

This case allows us to return to the issue of the gendered transformation of Guanyin, the gendered identity of the painters, and the relationship established between the two parties. Although Fang Weiyi's copy bears surprising similarities to the White-robed Guanyin painted by the two male painters noted earlier, it remains uncertain whether they copied the exact same model. Such gaps in research, however, should not halt our inquiry. By the Song period, the White-robed Guanyin was already considered a female deity. Modern scholars have suggested that this configuration in a white robe was modeled on a laywoman's outfit.[150] Yongzhong's *White-robed Guanyin* does not explicitly convey a feminine ideal. Guanyin's chubby cheeks, bold nose, thick lips, and uncurving eyelids together constitute a face that shows a meditative state that is detached from the material world. Mingben's poem enhances a sense of seeing Guanyin as a meditator and elucidates Guanyin's thought. Hence, he created a distance between Yongzhong, himself, and Guanyin.

On the contrary, by removing Guanyin's halo, lowering the hair bun or cap covered by the hood, and further feminizing Guanyin's body and facial features, Fang Weiyi created a "laywoman-like" figure and shortened the distance between herself and Guanyin. The two skeins of Guanyin's hair softly drape down either side of her face and neck. The shape of her face and facial features are meticulously outlined with soft fine brushwork. Guanyin has a feminine look of compassion and lowers her gaze as if she were meditating. Her eyelids and eyebrows are defined in slightly curved lines. The corners of Guanyin's mouth slightly curve up. Such pictorial elements express a gentle and caring sensation. To cover Guanyin's chest,

FIGURE 2.13 Tingtian Jiucheng, *White-robed Guanyin*, copy of Jueji Yongzhong's *White-robed Guanyin*.
Hanging scroll, ink on paper (image: 78.7 by 31.7 centimeters; overall: 163.9 by 33.7 centimeters). The
Cleveland Museum of Art, Purchase from the J. H. Wade Fund 1978.47.2

a thin pale gray line is explicitly drawn. Unlike Yongzhoug who depicts the essential parts of Guanyin's body through a minimal number of inked brush strokes, Fang likely considered such minute detail as essential parts to construct Guanyin's female body. Fang's depiction of Guanyin is an expression of her intimacy with the deity. Moreover, by drawing Guanyin, Fang conveyed to her nephew her skill in concentration that can produce a true icon. Fang Yizhi wrote about her in the first person: "I made my deity live in here" (*wu yi xi wushen* 吾以栖吾神).[151] The phrase *yixi wushen* (以栖/棲吾神) or "to have my idol reside" is a common expression referring to someone's wish to construct a shrine for the spirit.[152] By adding "I" (or *wu* 吾) in front of this phrase, Fang endorses both her brush and her meditation technique that can bring a lived Guanyin onto her paper. But more importantly, this process of meditation and painting allows Fang to encounter Guanyin in a personal space and helps her to realize her desire to be with the deity. The practices associated with painting and, in particular, painting Guanyin, put Fang in direct relation to the bodhisattva.[153]

CONCLUSION

Through the case studies of Xing Cijing and Fang Weiyi and the brief discussion of Qiu Zhu, Xu Can and Jin Liying, we have seen that although painting Guanyin was not in itself a gender-specific practice, painting in the late-Ming dynasty and Qing dynasty was not practiced "in itself." In other words, once we realize that painting had gendered significance, it becomes clear that women created Guanyin icons for quite different reasons than men. In particular, the feminized Guanyin was a reflective device by which painters who were laywoman expressed affinity with the deity. Such devotion entailed giving form to Guanyin's virtuous qualities, such as compassion and purity, through the skilled physical act of painting her, and doing so in the *baimiao* style.

This practice also brings to the fore the complex intersection of Buddhism and Confucianism in late imperial times. Neither of these cultural systems was monolithic, but in the context of this chapter, Confucianism delimited the social roles and desires of women, especially gentrywomen, whereas Buddhism provided a space outside such hierarchical relations and the hardships they imposed. This religious refuge became especially important when individuals had trouble fully identifying with their roles, as in the cases of Xing and Fang. For different reasons, each of these two women perceived a gap between the role that she was supposed to play and her existential situation.

We have seen that it was in this space between the woman and her projected role that Buddhism and Guanyin entered. Whether portraying Guanyin's compassion as

a motherly figure or purity in meditation, Xing and Fang projected their prescribed roles onto the images they made of Guanyin. This chapter has focused on how they tried to become Guanyin through painting, a practice specific to gentrywomen and something that set them apart from other women. Thus, one can speculate that as gentrywomen tried to be close to Guanyin, they also attempted to distance themselves from nongentrywomen.[154] Devotion had a doubled dynamic. On the one hand, it was most directly connected to seeking solace in difficult emotional situations. On the other, the form and artistic style that such devotion took implied status or class distinctions. In chapter 3, we explore examples of women's expression of their intimacy with Guanyin through silk and hair embroidery, a form of devotion practiced by both non-gentrywomen and gentrywomen. This will provide a wider window into the complex intersection between religious consciousness and artistic creativity in women's lives in the late Ming and beyond. These laywomen not only used their bodies and skills to create images but also stitched their hair into these Guanyin icons to raise their devotion to a kind of material fusion with the bodhisattva.

Embroidering Guanyin with Hair

Efficacious Pain and Skill

I n 1877, a little-known writer, Xuan Ding 宣鼎 (1832–1880), published a collection of short tales titled *The Record of an Autumn Lantern on Rainy Nights* (*Yeyu qiudeng lu* 夜雨秋燈錄). One of the stories, "Buddha Embroidered with Hair" (*Faxiu fo* 髮繡佛),[1] begins by describing a Ming dynasty wall-hanging displayed in Luewang Temple 掠网寺 in Donghai 東海 (today's Dafeng 大丰, Jiangsu). This piece is said to be two *zhang* and four *chi* long (about 8 meters) and eight *chi* wide (about 2.66 meters), which is enormous compared with other surviving Ming Buddhist embroideries. The detailed description indicates the ambiguous iconography of a standing Buddhist icon, an atypical hybrid form of a Buddha and a bodhisattva. The inscription is transcribed as follows, "I, Upasika female disciple Ye Pingxiang, created this hair-embroidery after washing [my] face and hands in a certain year during the Jiajing era (1522–1566)."[2] The author then moved on to the colophon on the left margin of the embroidery in which Yi Qiding 伊戚丁 (the chief state secretary) explains Ye's motivation for creating this piece:

> When Ye Pingxiang was fourteen years old, her father, a state official, was wrongly convicted and sentenced to death. Ye Pingxiang was desperate to rescue her father. She prayed to the Buddha for help, crying day and night. Then she experienced *gan-ying* 感應, meaning that the spirit responded to her prayers by urging her to make an image of the deity using her skill, namely, embroidery. She purchased a large piece of satin in the market and plucked out strands of her own hair, then, using an extremely sharp knife, she further split each strand into four. She used these split hairs to embroider the image of Buddha and a scripture on the satin. After two years, she finally finished the piece, but she had lost her eyesight. In return for her effort and sacrifice, her father was miraculously released.[3]

This account is highly suggestive of the ways that hair embroideries of Buddhist icons—the highest form of devotional embroidery in the late imperial period—was seen as a practice with miraculous spiritual power. The tale achieves its dramatic effect by detailing the sensory dimensions of making devotional hair embroidery. Ye Pingxiang not only endured the pain of plucking strands from her own head over two years to acquire the corporeal material to make this religious icon, she also sacrificed one of her senses, her eyesight, to transform her pious sincerity into a material object. This story epitomizes the devotional significance of such Buddhist images. It allows us to speculate about the purposes and functions of hair embroidery and describes the practice's techniques; it also makes us ponder why hair embroidery was chosen to express women's profound emotional and religious longings.

To explore how this arduous practice gained its devotional significance, this chapter first addresses how embroidery was different from other devotional practices by examining its functionality, performativity, and ritual process as well as the symbolic meanings of needle pricking and its subject matter.[4] Mentions of embroidery in both Buddhist canonical texts and in nonreligious writings may illuminate its religious connotations and the particular meaning of hair embroidery. What lay behind this form of materialization? From the perspective of praxis, I then shift to the actual making of hair embroidery and ask precisely how and in what circumstances human hair was used in embroidery. What was the significance of using one's own hair to embroider an icon? How did combining women's bodies (their hair) with a womanly skill (embroidery) make a uniquely gendered devotional form in late imperial China? What kind of relationship between worshiper and worshipped (often Guanyin) emerged through the process of bodily practices? Sensory behaviors and objects constitute a type of residue that has tangible effects that cannot be reduced to ritual practice; rather, they make rituals and performance possible and inflect them in a particular manner. Sensory practices and material objects create experiences that go beyond symbolic meanings. At the same time, they are constantly inscribed and reinscribed in a web of meanings, which are reproduced through performance.

EMBROIDERY AS BUDDHIST DEVOTION

Before any in-depth discussion of hair embroidery can begin, we need to situate this practice within its larger cultural and religious scenario. The following two questions are central: What are the special features of embroidered religious icons and how are embroidered icons different from those done in other mediums? These questions lead us to a discussion of specific issues surrounding the ritual process

of embroidering Buddhist images, Guanyin in particular. How, for example, did the act of producing Guanyin images via needle and thread or hair give expression to women's religious lives?

In his study of early Chinese ritual art, Wu Hung employs the term "costly art" to describe the material nature of objects produced for ritual purposes. This type of object is mostly "made of precious material and/or requires specialized craftsman-ship and an unusual amount of human labor."[5] It is important to consider these defining factors—material, craftsmanship, and labor—in approaching embroidered Buddhist icons as devotional objects because the three cannot be easily separated. When male scholars from the Tang (618–907) and Song (960–1276) periods wrote about Buddhist embroidery, however, they stressed only the third factor, "an unusual amount of human labor." In my discussion of a few miraculous testimonies with embroideries, the term "material" must refer to the fact that an embroiderer makes a piece from scratch. In other words, the preciousness of the materials does not lie in their monetary value, but rather in the difficulty of preparing them by one's physical effort.

For instance, scholar official Lü Wen 呂溫 (772–811) wrote that around the twentieth year of the Zhenyuan era (804), he went to Tubo (present-day Tibet) on an official mission. His wife, Madam Xiao, was extremely worried about his safety. When she heard that the Medicine Buddha or Bhaisajyaguru Buddha could rescue people from turmoil, she embroidered a Medicine Buddha to pray for her husband's safe return. Using her hands, she wove the ground fabric, twisted the silk threads, dyed the threads different colors, and then stitched the icon. After she finished the embroidery, she selected an auspicious time to display it and burned incense in offering to this deity day and night until her husband had returned home.[6] In this and other male writers' eulogies around Buddhist embroidery, the "labor" involved in various phases of making is conspicuously mentioned, but the issue of technical knowledge and skill goes unremarked.[7]

Embroidery, a labor-intensive activity, amounts to the accumulation of stitches produced one after another, and it is this repeated labor that is cherished in the act of creating Buddhist imagery. The making of any object, regardless of its mate-rial medium, requires time and skill. With such crafts as jade carving or metal chasing, traces of the handiwork are usually concealed beneath a polished sur-face. Embroidery, however, vividly displays the human labor expended in its pro-duction. In particular with respect to early embroideries that feature a profusion of chain stitches, every stitch is visible on the surface of the piece and each indi-cates the action of the needle. This explains why the earliest Chinese Buddhist embroideries are completely covered—image and background—by stitches, a for-mat called *manxiu* 滿繡. In his introduction to recitation as a devotional use of

sutras in early medieval China, Robert Campany points out that the number of recitations, both in terms of the time spent and "the number of words or the frequency and speed of recital," were often recorded as a measure of a sutra's efficacy in various miraculous stories.[8] These different ways of calculating point to a core feature of devotional practice: the intensive investment of time and bodily movement needed to successfully complete any religious ritual or ceremonial activity. This configuration of value in devotional practice is fully manifest in the making of embroidery.

A comparison of embroidery and painting helps us recognize the unique feature of the embroidery's materiality. The embroidered *Miraculous Image of Fanhe Buddha*, commonly referred to as *Sakyamuni Preaching on Vulture Peak*, was found in cave 17 at Dunhuang and has been dated to the late-seventh to eighth centuries.[9] The image is completely rendered in *pizhen* 劈針, the split stitch that was a popular technique from the Wei-Jin to the Tang periods.[10] Just the bridge of Buddha's nose consists of two to three hundred stitches (figure 3.1). We can compare this embroidery with the painted mural image of a similar size, subject, and period on the south wall of the central pillar in cave 332, where the Buddha's nose is completed with just one or two brushstrokes.[11]

Writings about Buddhist embroidery from the Tang and Song periods indicate three important considerations: first, each stitch represents a Buddha. In devotional Buddhism, reproductions of the Buddha—whether as a stitch, an image, a chanted passage of a sutra, or a book—are, at their root, all the same matter (i.e., the body of the Buddha). Second, because repetition is central to Buddhist devotional practice, the act of embroidering more stitches not only reproduces more images of Buddha but also accumulates more merit.[12] Third, the practitioner or embroiderer's physical body is extended to her or his needle when making a divine image.

The kind of labor needed to embroider a Buddhist image was thus highly valued. Especially in Song period records, accounts of embroidered Buddhist images are more numerous and often appear in writings influenced by Chan discourse. Su Shi 蘇軾 (1037–1101), a paragon of male artistic genius, describes the meaning of the needle-drawn stitch in the making of Buddhist embroidery and highlights the connection between the practitioner and embroiderer's mind and her needle when producing a divine image. His account of how embroidery as a womanly practice was connected to women's inner religious practice launched an influential discourse on how to interpret women's embroidery. In "A Eulogy for Embroidered Guanyin Done by Madam Xu from Jing'an County," he explains how Madam Xu spent three years contemplating Guanyin and searching for the *Dao*. As a result of her mental cultivation practice, "she managed to 'see' [Guanyin], but she could not

FIGURE 3.1 *Miraculous Image of Fanhe Buddha* (*Sakyamuni Preaching on Vulture Peak*) (detail). The collection of British Museum.

describe [Guanyin]'s visage verbally."[13] Su Shi praises Madam Xu's effort to realize her vision of the Goddess of Mercy:

發于六用 以所能傳	From the six sense organs, she uses any means she can to convey [Guanyin].
自手達鍼 自鍼達線	From her hand, it reaches the needle, from the needle it reaches the thread.
為鍼幾何 巧歷莫算	How many times does she ply the needle? Even an adept at calendric cannot calculate.
鍼若是佛 佛當千萬	If each stitch were a Buddha, there should be ten million Buddhas.
若其非佛 此相曷緣	If each stitch were not a Buddha, how then could this likeness [be achieved]?
孰融此二 為不二門	Who can combine these two and reach the dharma gate of non-duality?[14]

The couplet "if each were a Buddha, there should be ten million Buddhas" points to the meaningfulness of needlework in a ritual context, in which each stitch is an act of devotion.[15] Therefore, the more labor expended, the greater the efficacy.

Moreover, the couplet "she uses any means she can to convey [Guanyin]. From her hand, it reaches the needle, from the needle it reaches the thread," directly demonstrates how the woman's contemplation of the Buddhist saint is materialized—from her mind to her hands, then to needle and thread, and finally it takes form on silk or cloth as an image of Guanyin. This process suggests a profound connection between a woman's mind, hands, needle, and thread. Su Shi states his view of how a practitioner should perform Buddhist rituals in another poem called "A Eulogy to Embroidered Buddhas": "One should offer all one has in serving the Buddha; the rich with wealth and the sturdy with strength; a skillful person with his skills and debater with words."[16] The implied message is that a woman skilled in needlework should use it to make Buddhist images. Su Shi's approach to women's Buddhist embroidery informed later scholars' views on women's embroidered icons in the late imperial period. For instance, his eulogy on Madam Xu's embroidery was transcribed by late-Ming calligrapher Sheng Keji 盛可繼 (1573–1620) on an embroidery of Guanyin made by Jin Shufang 金淑芳 in 1619 (seventeenth century). By removing Madam Xu's name from the original poem, this eulogy was appropriated for a different women's devotional effort.[17]

Because this discourse on Buddhist embroidery was established by male Confucian scholars, we must consider other accounts of the practice. The craftsmanship or technique of making embroidery goes unmentioned in treatises honoring women's works.[18] These texts simplify and romanticize embroidery as merely the

laborious repetition of stitching.[19] Although these men's writings perfectly replicate Buddhism's meritorious practice theory, they only abstractly grasp the complex processes of making. The complicated skills and techniques required to produce embroidery, also important elements in women's devotion, are trivialized in male scholars' writings. In the early nineteenth century, Ding Pei 丁佩 (fl. first half of the nineteenth century), a gentrywoman from Songjiang 松江, composed *The Embroidery Manual* (*Xiupu* 繡譜).[20] In it, she provided a detailed guide to the proper work setting and tools for embroidery, discussing such matters as space, light, needle, scissors, thread, ground material, embroidery frames, patterns, the colors of silk flosses, and subject matter; she also explained how to fix the ground fabric on an embroidery frame and transfer patterns. In contrast to Su Shi and other male scholars who described embroidery in terms of the number of stiches, Ding focused on techniques for producing various visual effects unique to embroidery, such as how to keep stitches even and how to balance shimmer, straightness, height, smoothness, and the density of stitches. This was the first systematic instruction manual in Chinese history on the art and craft of embroidery in which Ding attempted to make tacit knowledge explicit.[21] Thanks to Ding's effort, we can conceive more clearly that when women produced an embroidered Buddhist icon, the material, craftsmanship, and labor all were important expressions of their sincerity.

MAKING WOMANLY MERIT THROUGH EMBROIDERY

In the study of Chinese women's history, many scholars have pointed out that works related to making cloth were traditionally defined as womanly work—*nühong* 女紅, *nügong* 女功, and *nügong* 女工 were interchangeable phrases for this domain in imperial China.[22] Although "woman's work" referred to any work done by women, which might include feeding the family pigs, "womanly work" had gravitas as a "moral activity linked to a gendered identity."[23] These two concepts became fused when women performed their crucial role as textile producers. Embroidery was considered one of four womanly arts, along with spinning, weaving, and sewing.[24]

Embroidering Buddhist imagery was not limited to women during the Tang and Song dynasties. Accounts of laymen and monks embroidering Guanyin and other Buddhist images can be found in literature.[25] Men and women alike used needle, thread, hand, and mind to make Buddhist images, but the rhetorical tropes used to describe the two sexes were different. Needlework, for example, is constructed as women's natural skill. For men, needlework was either downplayed or substituted for brushwork.[26] The examples we do find of men embroidering Buddhist devotional images suggest that the prevailing ideology of needlework as a womanly practice was subverted in practice. On a symbolic level, needlework had a different

meaning if it was performed by a man or by a woman. When done by women, it declared their womanhood. When done by men, it was seen as an alternative to using brush and ink to cultivate manhood. For instance, He Changxi 何昌系, a county magistrate from Anyang during the eighth century, stitched a full-length Guanyin image when he turned sixty years old. He groaned about the bitterness of the living world and then made the embroidery of Guanyin in the hopes that Guanyin might liberate him from his sufferings. In particular, Dugu Ji 獨孤及 (725–777), a literary critic, praises He Changxi for "using embroidery to construct a literary writing and to draw the true form of the Bodhisattva."[27] Dugu Ji presupposes that men write and that He Changxi employed the form of embroidery as a substitute for the form of writing. For Dugu Ji, even though He used a needle and thread, the result was still to construct a *wen* or prose. Embroidery thus inscribed sexual differences even when men might be performing the same type of actions as women.[28]

Embroidering Guanyin became firmly established as a feminine practice only in the late imperial period. It is unclear just when laymen and monks stopped embroidering as a devotional act. We find only a few records of amateur male embroiderers stitching secular motifs from the Yuan to the Qing dynasties.[29] When the demand for embroidery greatly grew in domestic and foreign markets in the nineteenth century, male professional embroiderers appeared in Shanghai and Guangdong.[30] As men ceased to embroider Buddhist images, we see from numerous records that increasing numbers of women, including both gentrywomen and women from the lower classes, committed themselves to this practice.[31] The earliest treatise on embroidery *Cixiu tu* 刺繡圖 (*Illustration of Embroidery*), which was included in the late-Ming collectanea *Lüchuang nüshi* 綠窗女史 (*Women Scholars by the Window of Green Gauze*),[32] asserts that the *xiufo* 繡佛 (embroidered Buddhist figures) was the most common subject for embroidery.[33] *Xiufo* in fact might include the Buddha, Guanyin, and *luohans*, but the most popular was Guanyin.[34] Women even used the term *xiufo* to refer to their boudoirs, their poetry collections, or Buddhist shrines converted from their secular residencies.[35]

As mentioned earlier, chaste womanhood was promoted much more vigorously during the late imperial period.[36] Making embroidery not only spoke to the image of a diligent and pious woman but also came to epitomize a moral ideal: virtuous womanhood. Laywomen's quotidian practices were codified in phrases that describe certain principles: *changzhai xiufo* 長齋繡佛 (keeping a vegetarian diet for a long time and embroidering the Buddha)[37] and *sushi gaoyi xiu dashixiang* 素食縞衣繡大士像 (keeping a vegetarian diet, wearing a plain white robe, and embroidering an image of Great Being/Guanyin). In the late-nineteenth century, this archetypal image of a devoted laywoman was assimilated into the canon of the one hundred beauties (figure 3.2). The illustration represents Mao Xiang's 冒襄 (1611–1693)

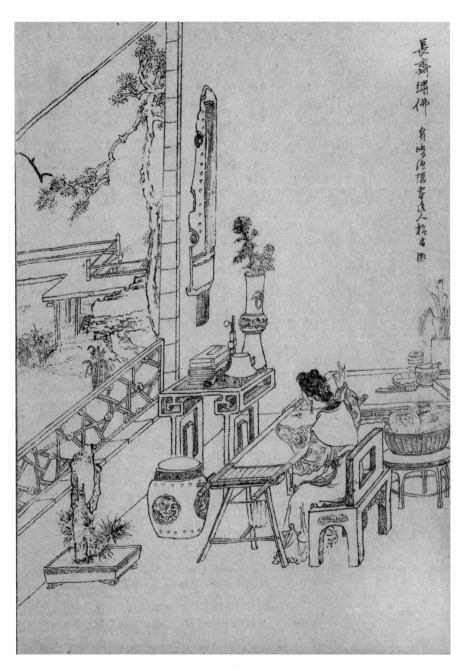

長齋繡佛

鳥窈池隱畫遠人橅古

FIGURE 3.2 *Keeping Vegetarian and Embroidering a Buddhist Figure*, a representation of Cai han. Courtesy name Nüluo 女羅, *Xinzeng baimei tushuo* (Shanghai: Shanghai shuju, Qing Guangxu 13 [1887]). Photo courtesy of the University of Chicago Library.

concubine Cai Han 蔡含 (1647–1686), a well-known female painter of the early Qing dynasty, sitting in front of an embroidery frame stitching a Guanyin in her boudoir. Cai's face is barely represented. Her right thumb and index finger hold a threaded needle. Her left hand is under the frame, ready to pull as the needle comes through the tightly stretched fabric. The face of the White-robed Guanyin on the fabric looks like Cai's reflection, evocative of Ming woodblock prints that feature a mirror reflecting the image of a sitter's face.[38] Although this illustration is from a later period, it reveals the intimate relation between a personal icon and the devotee.[39] The relation of worshipper and icon is based on a long period of dedication and trust (in both directions). The worshipped icon is actually created by the woman, not merely carried as a talisman hidden somewhere on her body. In the case of hair embroidery, the personal icon is created by transferring conspicuous parts of the worshipper's body.

In a wide range of examples—including the chaste wife or widow, the filial daughter-in-law, and the righteous mother—the attainment of purity is facilitated and indeed enabled by the act of stitching an image of Guanyin. For instance, during the Tianqi period (1621–1627), Zhu Dezhen 朱德貞, a young girl from Yujiang, Jiangxi Province, was already familiar with various stories of exemplary women compiled by the Empress Renxiao 仁孝 (1362–1407).[40] After her betrothed passed away when she was ten, she became determined to remain chaste for her deceased husband-to-be. She kept a vegetarian diet, wore a simple white robe, embroidered the image of Guanyin, and chanted sutras day and night.[41] Zhu's parents disapproved of her extreme behavior and tried to persuade her to get engaged to someone else, but she refused to take food, a protest that defied filial piety to her own parents. Her parents eventually gave up, but Zhu passed away not long after, in 1626.[42] In this story, the fulfillment of Confucian wifely virtues is brought seamlessly together with the accumulation of Buddhist merit.

In another example, Hanshan Deqing 憨山德清 (1546–1623), a prominent Buddhist monk, wrote a eulogy on an embroidered Great Being/Guanyin.[43] In its prologue, he mentions that Madam Fan, the matriarch of the Xia family of Jiahe, was fifty-two years old. She had remained vegetarian for thirty-five years and chanted the *Diamond Sutra* day and night. At one point, she developed an anal fistula and suffered terribly. Her daughter-in-law, Madam Feng, was so filial that she wanted to suffer the pain in place of her mother-in-law. Embroidering the Guanyin was a means of doing that. From the mother-in-law's perspective, this was a reward for her more than three decades of devotion. In the span of three years, the daughter-in-law never slackened in her efforts and created more than twenty embroidered Guanyins. Her mother-in-law finally recovered from her illness and could walk better than she had been able to before her illness. But Madam Feng

became ill and passed away. In both cases, the embroiderers sacrificed their lives to meet their goals.

In some texts, writers use the term *zixiu guanyin* 自繡觀音 (embroidering Guanyin by oneself) to describe these devout practices. The term, a product of the popularity of domestic religiosity, bespeaks the devotee's control over her salvation and merit, without the aid of monastic specialists. The ideological linking self-making and making an icon is clear; however, the question of why a personally stitched icon was considered more efficacious deserves scrutiny. To understand that logic, we have to grasp the concept of *ganying*, the sympathetic response recounted in the story of Ye Pingxiang. *Ganying* reflects the belief that everything in the world is interrelated and interdependent. Buddhism absorbed this belief from indigenous Chinese cosmology. As Robert Sharf explains, "*Kan-ying* [*ganying*] is the principle underlying the interaction between practitioner and Buddha—the supplicant is said to ['stimulate' or 'affect' (*kan*) [*gan*] the Buddha, an action that elicits the Buddha's compassionate response (*ying*)." How to "affect the Buddha" or *ganfo* 感佛 becomes crucial in Buddhist practice. Its most basic forms include calling aloud the name of Buddha or Guanyin and chanting sutras. The primary aim is to demonstrate enough sincerity to stimulate the divine power. When women used their hands to create Guanyin icons, it required intense concentration, painstaking skill, and time-consuming labor. These exertions demonstrated their earnestness, which would then stimulate Guanyin's response. More than simply stimulating Guanyin's response, however, the practice of embroidery also closed the distance between worshipper and deity.

WHY HAIR?

The practice of hair embroidery (*faxiu* 髮繡) uses natural human hair to produce images on textiles.[44] No documents clearly indicate when and how hair embroidery began.[45] Unlike the modern conception of a technique that can be used to represent any subject, Ming and Qing period hair embroideries were primarily an extreme form of Buddhist devotional practice undertaken by pious women of some means.[46] This kind of image-making was usually related to the practice of *fayuan* 发愿 (vow-making) and *huanyuan* 还愿 (vow-fulfilling). In other words, hair embroidery often was done to appeal for intervention or express gratitude to Guanyin's for her miraculous power. Most extant hair embroideries and textual sources alike suggest that the subjects of such works were largely images of Bodhisattva Guanyin, Buddha, and Bodhidharma, in descending order of popularity. In addition, we also find hair embroideries of auspicious motifs related to rank promotion and material prosperity. The reasons for the appearance of non-Buddhist subjects

in later examples are unclear. Such works may have been produced by commercial embroidery shops as well as by individuals.[47]

One hair-embroidered portrait of Guanyin, attributed to Guan Daosheng 管道昇 (1262–1319), the most well-known female painter from the Yuan dynasty, is an early extant example of the practice (figure 3.3). On this embroidery, only Guanyin's hair, eyebrows, and eyelashes are stitched in with hair while the tracing of the robe, face, and other parts of her body are done with silk thread (figure 3.3a, detail). This kind of hair embroidery is similar to a type found in the Kamakura period in Japan (1185–1333). Japanese hair embroidery was often a part of funerary practices associated with Pure Land Buddhism; some of the deceased's hair was offered by relatives and stitched into the image of Amitābha Buddha and two of his assistant Bodhisattvas—Avalokiteśvara (also known as Kannon in Japanese) and Mahāsthāmaprāpta—in the hope that the deceased would be reborn in the Pure Land.[48] On both Guan Daosheng's Guanyin and the Japanese hair-embroidered Amitābha Triad, the use of hair in locations on the body where it naturally occurs might at first glance suggest a kind of hyperrealism. Beneath the visual representation, however, directly transplanting a person's hair to an icon's head indicates a recognition of hair as a site of vital regeneration. "Regeneration," in this context, perhaps can be understood as "rebirth" as well.[49]

Different Chinese religious and cultural traditions impose different connotations upon the root meaning of hair.[50] One common understanding of hair symbolism in the Buddhist context comes from the head-shaving ceremony that takes place when a person enters monastic life. The shaving off of the hair indicates renunciation of attachments to the mundane world. This flew in the face of a Confucian prescription for filial piety that called for not harming one's hair or body because they were given by one's parents. The regenerating nature of hair, however, may have been more important to lay people. In Chinese medical discourse, for instance, hair is linked to blood, another part of the human body associated with regeneration. In *Bencao gangmu* 本草綱目 (*Compendium of Materia Medica*), hair is prescribed as medicine for problems related to loss of blood, such as nosebleeds, coughing up blood from the lungs, urinary bleeding, rectal bleeding, and several other ailments. As a general rule in these prescriptions, hair is to be burned into ash and combined with other ingredients. It is used either externally or internally depending on the symptom. One treatment for nosebleeds is to blow unadulterated ashes of hair into the nose when bleeding occurs.[51] This is perhaps the most direct contact of hair and blood prescribed in the medical corpus: hair functions as a means to stop bleeding. Hair and blood are linked not only in medical practice but also in more general contexts to Buddhist devotional practices, such as hair embroidery and, as will be discussed next, the writing of scriptures with blood.

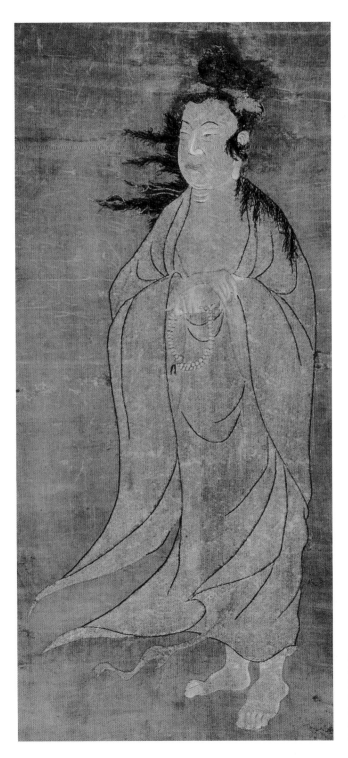

FIGURE 3.3 Guan
Daosheng, *Guanyin*,
1309. Hair and silk
embroidery (105 by
50 centimeters). The
collection of Nanjing
Museum.

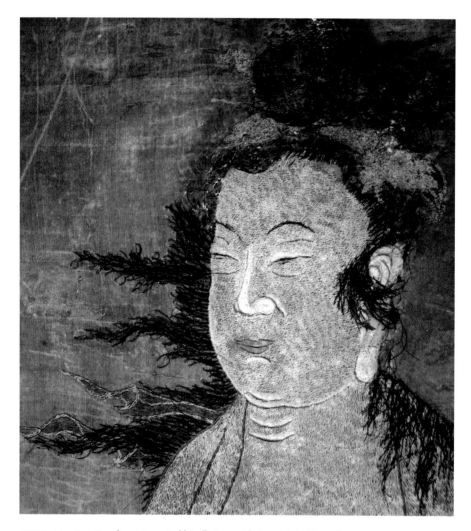

FIGURE 3.3a Guan Daosheng, *Guanyin* (detail). *Source:* Photograph by the author.

When hair was used as medicine, practitioners did not focus on gender except for problems related to menstruation, in which case equal amounts of women's and men's hair were required.[52] Although the idea that women's menstrual blood is impure and dangerous was promoted through Chinese indigenous Buddhist sutras, such as *Xuepenjing* 血盆經 (*Blood Bowl Sutra*), women's hair does not have the connotation of being polluted. Indeed, in the Buddhist discourse about hair offerings to the Buddha or to monks, the hair is supposed to come from women devotees. Buddhist canonical texts contain accounts of both male and female devotees spreading their hair on the ground for the Buddha or monks to walk on,

but in Buddhist miracle stories, the cutting of hair as a gift seems restricted to female devotees.[53]

A story about an impoverished woman selling her long hair to obtain offerings to Buddha appears in the sixth-century Buddhist encyclopedia *Jinglü yixiang* 經律異相 (*Different Forms of Sutra and Vinaya*).[54] Similar plots are included in Ming Buddhist story collections such as *Fahua lingyan zhuan* 法華靈驗傳 (*Record of Responsive Manifestations of the Lotus Sutra*).[55] The protagonists of these stories share two distinctive features. First, these women are extremely poor and have nothing to offer but their hair. Second, after they cut off their hair, it miraculously grows back to the same length it had been before, so they could continue to sell their hair and buy offerings. When these stories circulated, women were not the only people with long hair, but they seem to have been the ones to use their long hair as a resource to procure offerings. This adds another gendered dimension to the meaning of hair, giving it a particular type of religious exchange value.

When hair was used as thread and transformed into the embroidered bodies of divine figures, as an integral part of the devotee's body, it becomes a gift (*bushi* 布施). In Buddhist canonical texts, such as *Dazhidu lun* 大智度論 (*Commentary on the Great Prajñā-pāramitā Sūtra*), gifts are divided into internal ones, such as body parts, and external ones, which refer to other kinds of objects.[56] Reiko Ohnuma categorizes them both as material gifts (*wu bushi* 物布施) in contrast to the gift of dharma (*fa bushi* 法布施).[57] The hair used for icon embroidery is a "material gift" in both senses—it is a part of the body that is externalized as an object offering.

The stories of Bodhisattvas relinquishing their bodies to the dharma are cherished in the Buddhist tradition.[58] A passage from the *Flower Ornament Scripture* contains a particularly important scriptural account of sacrificing part of the body and transforming it into a material object.

> Since the inception of his career as a bodhisattva, Vairocana Buddha has been extremely diligent in practice and has offered his own bodies [lifetime after lifetime] in inconceivable ways. He peeled off his skin and used it as paper, broke his bones and used them as pens, and pricked himself to draw blood for ink. The scriptures he copied in this manner accumulated as high as Mount Sumeru. He did so out of great reverence for the Dharma.[59]

Vairocana Buddha serves as a model for copying scriptures using the material body. As Jimmy Yu has observed, "Not only are his body parts used to produce the scriptures, but the scriptures are also his bodies."[60] Although only Vairocana Buddha could manage such terrible sacrifices, practitioners tried to follow in his steps by copying out scriptures in blood. The blood writing of scriptures has been a common

practice throughout the history of Buddhism in China; it continues unabated today in both monastic and lay communities. In most cases, men and women collect blood by pricking their fingers and tongues and use it to copy out scripture.

In the previous example of Vairocana Buddha recreating the material form of dharma in scripture, the idea of using parts of his body in place of secular tools, such as pens, paper, and ink, is dramatic and clear. This story also raises intriguing questions about gender. Vairocana is male, but he set an example for both laymen and laywomen. In other words, the bodhisattva offered a model by which men and women both could express their religious feelings. This kind of bodily sacrifice was closely associated with a person's acquired skill and that skill itself—whether writing or embroidery—was deeply bound up in the social construction of gender.

A significant historical change in the late-Ming period informed these practices. In early Buddhist texts, the prescribed ways for women to express devotion were limited to the straightforward use of tangible body parts: for instance, a woman's long hair could be sold for money and then used to buy other offerings. But from the fifteenth century onward, women increasingly combined intangible skills and talents with the tangible resources they found in their bodies. The use of hair instead of thread to stitch images of Buddhist deities is an example of this value-added approach. It became a common way to emulate other bodily offerings, such as blood-ink scripture writing.

Blood writing and hair embroidery have not been found together on surviving objects.[61] There are, however, examples of collaboration between monks transcribing scripture in ink and laywomen embroidering each written character and illustration in silk thread.[62] Therefore, in actual practice, the use of blood and hair follows a clear gendered divide. Blood scriptures have been mainly produced by Buddhist priests and hair embroidery has been mainly done by Buddhist laywomen (figure 3.4).[63] These parallel traditions reflect the conventional gender division in society: paper and brushes are masculine tools; needle and thread are feminine. This ideal division was transmitted to the religious realm in which men wrote in blood on paper and women used their hair to stitch on silk.

While recognizing this gendered division, note that the two practices have much in common: first, as explained previously, both hair and blood were considered vital parts of the body that regenerate. Second, practitioners must suffer pain when collecting the raw materials from their bodies before they can create the devotional objects.[64] Third, both blood scripture writing and hair embroidery require a certain level of skill. Fourth, in their respective practices, blood and hair are transplanted from the body to paper or silk in the creation of calligraphy or images and transformed into devotional objects. Both practices initiate a subjective transformation of the devotee: By externalizing intimate parts of their bodies

FIGURE 3.4 Buddhist Priest Zongxian, *Huayan jing (Avatamsaka Sutra)*, Qing dynasty, 1644–1911. Blood on paper, album (34 by 13 centimeters). The collection of Wenshu Monastery, Chengdu. *Source:* After Zongxing et al., eds., *Zhongguo Chengdu fojiao wenhua zhencang shiji dazhan, zhanpin xuanji* ([Publisher unknown], 2005), pl. 44.

and transforming them into religious objects, the devotees transform themselves through devotion. This transformation imparts a mediated quality to blood-ink or hair-thread that is different from the materiality of relics or bodily remains in the Buddhist tradition. Blood and hair are not the objects of veneration; instead, they serve as a medium. In other words, the life force of blood or hair continues to be present in the icon or scripture. In contrast, a relic is not representation of the Buddha or his disciples, but rather it is their actual presence.[65] The hair, with its root meaning of regeneration, is a device that re-enlivens the image of the deity to ensure Guanyin's efficacy.

PLUCKING OUT THE HAIR (*BAFA* 拔髮): A BUDDHIST PRACTICE OF SELF-INFLICTED PAIN

Making a hair embroidery is a highly ritualized practice: from obtaining the hair to stitching the image, each step is infused with religious meanings. In cases in which hair embroideries were produced as offerings, they were usually made with hair

taken from the embroiderer. The inscription on an image of Guanyin produced in 1480 describes in no uncertain terms that Lin Jinlan, a well-known courtesan, used "hair from her own body" (*jishen fa* 己身髮) to make an embroidery on the day of Guanyin's birthday to heal her eye disease.[66] Inscriptions on hair embroideries from later periods further explain the act of extracting hair from the embroiderer's head. Ni Renji 倪仁吉 (1607–1685), a renowned poet and artist, stitched an image of Buddha when she was around forty-three years old (figure 3.5).[67] She described her motivation in these embroidered lines: "In the fourth month of the year of *jichou* (1649), this pious woman, née Wu, in honor of my parents plucked my own hairs and made this image of the Buddha to be worshipped and handed down from generation to generation in my family."[68] The word *bafa*, or *choufa* 抽髮 (pulling hair), is also notable on two other extant embroideries of Guanyin from later periods. Miss Yang, the daughter of Yang Yuchun 楊遇春 (1761–1837), the governor of Shaanxi and Gansu during the Daoguang period, made a hair-embroidered Guanyin sitting on rocks under bamboo branches (figure 3.6). A colophon mounted on the margin of the scroll relates how Miss Yang, of Sichuan, extracted her own hairs (*choufa*).[69] This ritual practice continued into the Republican period. A Miss Diao, (Diao shi刁氏, fl.1947) who grew up in Chengdu, plucked her hair to stitch a Guanyin image before she started her monastic life in 1947.

These surviving objects confirm the ritual nature of plucking hair described in Ye Pingxiang's story. The hair must be plucked or pulled from its root instead of being cut with scissors, which certainly caused physical pain to the practitioner. The precise process of extracting hairs from the embroiderer's head is unclear. Whether the hairs were gradually accumulated during the making of the embroidery or pulled out all at once before the first stitch was made is not known. Either way, plucking hair means that female devotees endure substantial pain to accumulate sufficient strands to embroider an image.

Bafa is one of many forms of extreme ascetic practice in Buddhism. For instance in *Bailun* 百論 (*One Hundred Treaties*), a Madhyamika Buddhist text attributed to Aryadeva, a scholar of the Mādhyamika school in southern India during the third century, the Chinese translation states that along with burning the body, plucking out hair is a good method of inflicting physical suffering on oneself.[70] But compared with other forms of sacrificial suffering in the Buddhist context, such as self-immolation, hair plucking is not life-threatening.[71]

However, the pain of plucking hair is the only verbalized devoted pain. When an embroiderer sits for long periods doing needlework, she would encounter a full range of physical discomfort over her whole body. Repetitive hand and finger movements can cause aches in the hands, shoulders, necks, eyes, and back. Gripping the needle with thumb and index finger and passing it through the

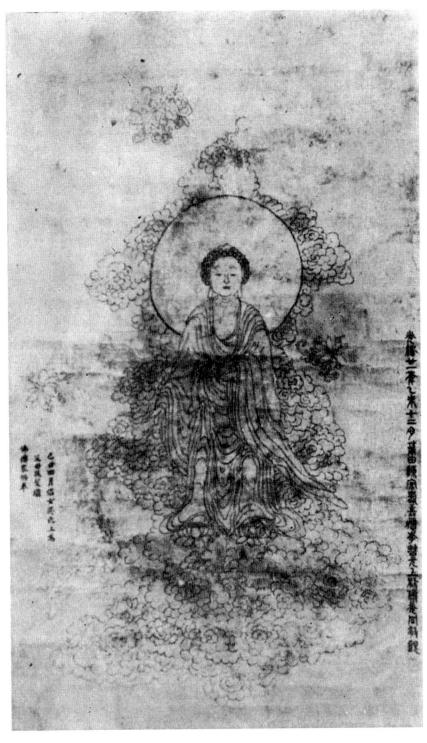

FIGURE 3.5 Ni Renji, *Buddha*, 1649. Hair embroidery. *Source:* From Hong Liang, "Ming nüshiren Ni Renji de cixiu he faxiu," *Wenwu cankao ziliao* 9 (1958): 21.

南無大慈大悲救苦
救難廣大靈感觀世
音菩薩
南無佛南無法南無
僧怛只他唵伽囉哦
哆伽囉哦哆伽訶哦
哆囉伽哦哆囉伽哦
哆娑訶

FIGURE 3.6 Miss Yang, *Guanyin*, Qing dynasty, nineteenth century. Hanging scroll, hair on silk (104 by 41 centimeters). The collection of Wenshu Monastery, Chengdu. *Source:* After Zongxing et al., eds., *Zhongguo Chengdu fojiao wenhua zhencang shiji dazhan, zhanpin xuanji* ([Publisher unknown], 2005), pl. 155.

fabric, fingers would get pricked. Such intensive actions would mark the hands with callouses and cracks.[72]

The ritualized experience of pain can be found across time and cultures. In an examination of the role that pain has played in religions around the world, Ariel Glucklich provides an explanation of the devotee's psychological reaction in the face of such pain: "Religious pain produces states of consciousness and cognitive-emotional changes that affect the identity of the individual subject and her sense of belonging to a larger community or to a more fundamental state of being. More succinctly, pain strengthens the religious person's bond with God and with other persons."[73] In other words, pain increases one's proximity to the deity. I suggest that in the Chinese context, we must understand this reduction of distance from the divine in relation to the idea of *guanying*, which implies a compassion for the pain of others. When a given subject inflicts pain on herself in a religious context, she tends to transcend her finitude and to approach the Buddha or Guanyin, feeling herself a recipient of divine sympathy. Divine sympathy is considered to be universal by believers, but self-inflicted pain can individuate the practitioner who constructs a personal relationship with the divine. In this case, the voluntary suffering of pain by plucking out one's hair is integral to creating images of Guanyin.

Even when experienced alone, religious pain is not endured in isolation. Through suffering, the devotee can identify with a larger community. In a similar way, we can focus on the social and historical contexts of hair embroidery to connect this practice to larger themes. Practices such as blood writing, body slicing, and burning parts of one's body are linked to the larger phenomenon of people deploying the "instrumentality of their bodies" to accomplish the religious goals of filial piety, chastity, loyalty, benevolence, self-cultivation of the way (*dao*), and many others.[74] Such practices are related to social, political, doctrinal, and personal crises in the late-Ming and early Qing periods. People used self-violence to exercise power and affect the environment. In so doing, they could demonstrate moral values, restore order, establish new social relations, and resolve moral ambiguity.[75]

In the practice of devotional hair embroidery, however, using the body as a means of contestation is more complicated, because it involves making the image of another body, namely the divine body. Self-inflicted suffering may be understood to restore social order and moral value, but the practice of hair embroidery reveals that women tended to prioritize their parents over their in-laws in matters of filial piety. In the cases of Zhou Zhenguan and Ye Pingxiang, the women remained unmarried and endured pain to express their filial piety. This fits into the pattern of legendary Miaoshan, a form of Guanyin who relinquished her eyes and hands to her father.[76] Unlike the story of Madam Feng, who sacrificed herself by embroidering numerous images of Guanyin in silk to free her mother-in-law from illness, hair embroideries

made to fulfill the duties of filial piety were always dedicated to the embroiderers' birth parents, *not* to their parents-in-law. This is clear from both surviving objects and textual accounts. It is easy to understand this phenomenon in the cases of embroiderers who were unmarried because they followed Miaoshan's path. Ni Renji, however, had already been widowed for more than twenty years by the time she made her hair embroidery of the Buddha's image and had fulfilled all her duties as a daughter-in-law. She returned to her natal home to avoid troubles of war and created the piece in the name of her own parents. The same is true of Wang Yuan 王瑗, who promised to make a hair embroidered Guanyin to relieve her parents' sickness.

The practice of hair embroidery thus seems at odds with the expectations of Confucian ethics, which states that a woman once married should always prioritize her husband's family. At marriage, a woman is supposed to shift her filial devotion from her own parents to her in-laws. This ideology was incorporated into certain aspects of the cult of Guanyin, as the latter took root in Chinese soil. Stories of wives practicing *gegu* (cutting flesh) in the hope of rescuing their in-laws' lives are recorded in such books as *Guanshiyin pusa linggan lu* 觀世音菩薩靈感录 (Record of Bodhisattva Guanshiyin's Efficacious Responses).[77] Nonetheless, hair embroidery seems to take on a particular significance that is connected to a woman's natal family and *not* to her marital family, at least suggested from these extended cases. The deep association of hair with regeneration probably played a role in this practice. Regeneration is linked to birthing and calls to mind one's intimate link with one's birth parents rather than in-laws. Moreover, although embroidery as womanly work is associated with Confucian discourse, using hair as a material for image-making is modeled on Buddhist doctrinal text. Buddhism thus provides an alternative legitimate venue for women to express their personal wishes, and in their Buddhist practices, women indeed alter the order of the hierarchical Confucian relationships to some extent. I argue that such indirect challenges to the social order are realized through transforming integral parts of their bodies in creating Guanyin icons. When a woman's body, through the vehicle of her hair merges with Guanyin's body, it is as if Guanyin authorizes and protects that woman's personal interests.

SPLITTING HAIRS: EXEMPLIFYING A DIFFICULT SKILL THROUGH THE MAKING OF DEVOTIONAL OBJECTS

After obtaining the hair, preparing it for stitching is the next crucial step in this ritual process. From surviving examples, we observe at least three different methods of using hair as thread: (1) multiple strands of hair were grouped together as one, (2) a single hair was used as a single thread, and (3) one single hair was split into multiple finer strands (figure 3.7). These different techniques likely reflect the development of hair embroidery over time and also represent a spectrum of individual skills.

a

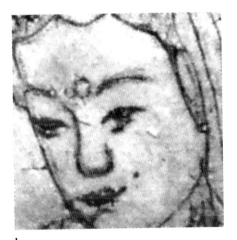

b

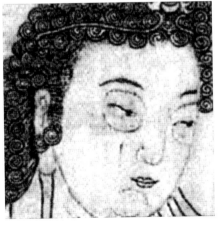

c

FIGURE 3.7 Three different ways of using hair as thread. (a) Multiple strands grouped together as one thread. Guan Daosheng, *Guanyin* (detail). (b) A single hair as a single thread. Miss Diao, *Guanyin* (detail). (c) A single hair split into multiple strands. Li Feng, *Guanyin* (detail).

The method of hair embroidery that uses multiple strands can be seen in the Guan Daosheng example and in Japanese hair-embroidered Taima mandalas made by the monk Kun'en in the seventeenth century.[78] The embroidered inscription on the Guan image indicates that it was likely based on one of Guan Daosheng's paintings.[79] Wearing a white robe, this Guanyin holds prayer beads in her left hand and stands in the middle of an ambiguous open space (figure 3.3). Sections of Guanyin's hair are piled on top of her head. The loose hair on the right side of her face is blowing in the wind, and the loose hair on her left side rests on her shoulder. Compared with the fine stitches in silk thread on Guanyin's face and robe, those used to render her hair are primarily *changduan zhen* 長短針, long and short stitches (figure 3.3a). For these, three or four hairs are grouped together in one strand. The length of each stitch is much longer than those made using a single silk thread. To create the effect of hair dancing in the wind, the hair stitches point in all directions. This vividly conveys the materiality of her hair.

With respect to the second method, in which a single hair functions as a single thread, only one example survives. In 1947, much later than any other objects considered in this book, a certain Miss Diao from Sichuan embroidered a *baimiao*-style White-robed Guanyin (figure 3.8). An ink outline was first laid down, and brownish hairs were applied on top of the ink line with meager stitches. Because the stitches do not follow each other closely and are inconsistent in terms of direction and size, the outline of Guanyin is not smoothly rendered. Traces of hairs can be easily observed.

The Guan Daosheng example of multiple-strand embroidery comes from the Yuan period. The Miss Diao example comes from after the Qing dynasty. These two examples represent the range in *baimiao* style, from the partial to extensive use of hair in their execution. Another example from the Qing dynasty represents the third category, which features the splitting of the hair, which seems to be unique to. One of its practitioners is Wang Yuan 王瑗 (active during the Kangxi period), a native of Gaoyou 高郵. The daughter of Wang Xinzhan 王心湛 (active during the Kangxi period), she was the wife of Li Bingdan 李炳旦 (fl.1715), a prestigious literatus in Gaoyou. She is the only Qing woman listed in the section of "talented women" in the Gaoyou gazetteer, which stresses Wang's skill at hair embroidery in her biography. When her parents fell ill, she promised to make an image of Guanyin. Her biography reads, "She split one hair into four strands. Its refinement was magical, and it was just like a brush painting without any trace of the needle. Viewers celebrated this as a unique skill."[80] What stands out in Wang's work is her seemingly improbable splitting of one hair into four strands and then using these extremely fine strands to imitate the continuous flow of a literati painter's brushwork. This chimes with broader standards of the time, because for nonreligious decorative embroidery, the highest goal was to reproduce the visual effects of painting by managing to hide the prick holes made by the needle in tightly stretched fabric.[81]

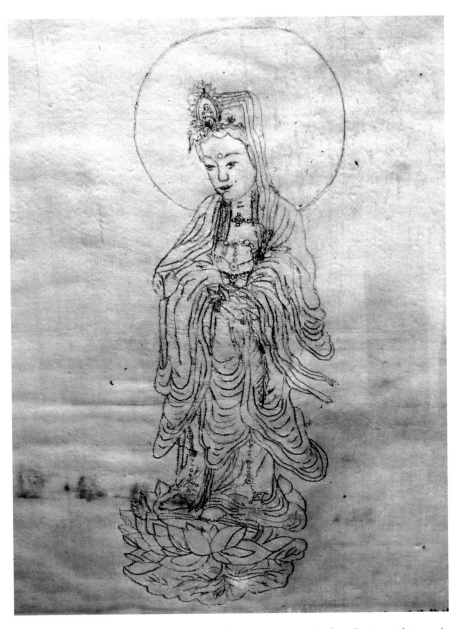

FIGURE 3.8 Miss Diao, *Guanyin*, 1947. Hair embroidery. Baoguang Temple, Chengdu. *Source:* Photograph by the author

Although hair is a more intimate material than thread, in both cases, embroidery tries to efface its own materiality and mimic painting. The idea of splitting a hair might not have been driven by religious concerns, but rather it may have been adapted from the embroidery-related practice of splitting a silk thread into several strands.[82] In discussing the sensuous experience of surface in craft art, Jonathan Hay has insightfully revealed the dual double-sidedness of an object: the first double-sidedness is the viewers' experience of seeing an object's visible decoration alongside their mesoperceptual awareness of its functionality; the second double-sidedness is the trace of its making and the questions about how such effects are produced. This second double-sidedness often distinguishes a luxury object from an ordinary one that shares the same decorative motifs.[83] Hair-embroidered Guanyin icons were not commercial decorative art, but even as a ritual object, the comment on Wang Yuan's skill at using split hair echoes Hay's observation about high-craft objects, making it a costly ritual object. The proofs of this are the absence of any trace of needle, the refinement of stitched imagery with split hair as well as the effect that the hair thread is indistinguishable from ink. The merit expressed by needle pricking and its conspicuous visual presence in early Buddhist silk embroidery shift to the skill of hiding all traces of the needle while provoking the viewer's interest in how such a surface came to being. The labor and time consumed in the repetition of stitching is elevated by the embroiderer's more intimate and sensuous bodily engagement, by her extreme attentiveness to refining the surface of the object.

Although none of Wang Yuan's hair embroideries survive, a Guanyin created by one of Wang Yuan's contemporaries, Li Feng 李蘫 (seventeenth century) provides an excellent example of this kind of work. Calligraphy of a poem by Wang Yuan's father, Wang Xinzhan, is stitched in silk threads on this embroidery. The seated Guanyin appears as a manifestation of a Buddha in the usual half-*ruyi* posture on a grass mat arranged in the center of the scroll (figure 3.9). Unlike the feminized Guanyin with long hair often seen in Ming and Qing images, here, Guanyin's hair is rendered shoulder length with "snail-shell" curls typical of the Buddha but sometimes borrowed to represent an arhat. The iconography cannot be identified with any particular form from the Guanyin painting manual *Thirty-two Guanyin Manifestations*, but the eulogy embroidered at the top is borrowed from the poem on the last leaf of that manual. This eulogy was first transcribed by Wang Xinzhan in a standard script and then was embroidered by Li Feng. We do not have sufficient material to speculate on whether this image is based on Li Feng's creation or someone else's painting, and at this point, it is not clear just how Li Feng is related to Wang Xinzhan. What we can observe is that the artist has mastered hair embroidery with a skill that echoes the work of the well-known embroiderer Wang Yuan.

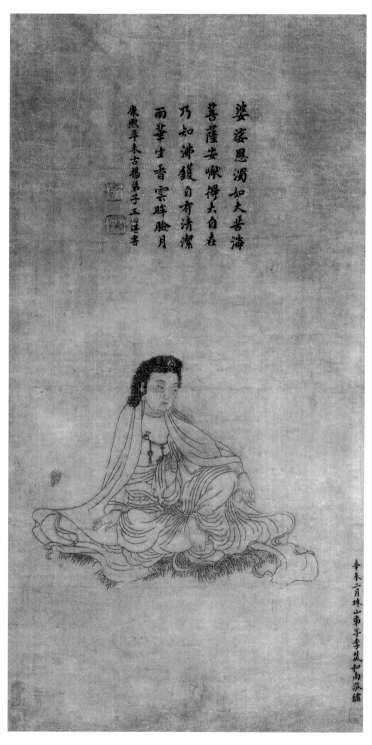

婆婆恩濁如大菩薩

菩薩安歟得夫自在

乃如沸鑊自有清潔

雨華生香雲眸臉月

康熙辛未古揚弟子王澤書

辛未一月珠山男弟子李蕆智南敬繡

FIGURE 3.9 Li Feng, *Guanyin*, 1691. Hair embroidery, hair on silk (68 by 35 centimeters). The collection of Beijing Palace Museum.

This embroidery follows *baimiao* painting closely and reproduces the ink outline in *gunzhen* 滾針 (outline stitches). The different parts of Guanyin's body are stitched in three different tones of black, from lightest to darkest. Because of the closely stitched snail-shell curls, the hair on Guanyin's head becomes the darkest part of the embroidery. The outline of Guanyin's exposed body is rendered in brownish hair and so appears lighter than her hair, eyebrows, robes, and jewels. When we observe the outline of a body part, such as the face, nose, arms, and hands, we see that the hair strands are much thinner and appear lighter in color (figure 3.9a).

FIGURE 3.9a Li Feng, *Guanyin* (detail), 1691. Hair embroidery, hair on silk (68 by 35 centimeters). The collection of Beijing Palace Museum.

How was this visual effect created? Was it accomplished using the legendary split hairs? Because of the lack of scientific analysis, we can only speculate that such fine lines are likely made of split hair.

Shoubofa 手擘髮, using one's hands to split hair, is the phrase used in various short accounts of hair embroidery from the early Qing period onward.[84] For instance, in the Pingyuan (in Shandong) gazetteer, one Madam Zhao is reported to have been able to draw a *baimiao* Guanyin and then split hairs to embroider the image.[85] Other than the ambiguous phrase *shoubofa*, the only reference to the technique of splitting a hair comes from the story *Hair-Embroidery Buddha*. That story asserts that Ye Pingxiang, the woman who made the hair embroidery, "used a metal blade as sharp as the tip of an awn to split the hair into four strands."[86] It is difficult to determine whether this description was the product of its author's literary imagination or actually reflects the true method for this exacting operation. This technique certainly required special knowledge and skills, which unfortunately have since been lost. We have no reason to doubt, however, that this technique was once practiced. Textile scholars have pointed out that in extant samples of hair embroideries, the traces of hairs being split have been discovered under a microscope.[87]

TECHNIQUE, ARTISTIC REFINEMENT, AND DEVOTION

Clearly, making hair embroidery involved a complicated skill-set combined with the making of a devotional object. The achievement of mastery at a difficult skill became part of the devotional practice during the Ming and Qing periods. An embroidered Buddha by Mrs. Chen 陳 from Dinghai 定海 (today's Zhoushan) mentioned in the gazetteer of Qixia Temple, for example, has received high praise: "By examining the meticulousness of her knife and ruler, we know the extremity of her sincerity."[88] Here "knife and ruler" (*daochi* 刀尺) is a metonym for needlework. The logic behind this appraisal ranks the technical refinement of the embroidery as commensurate with the level of devoutness we can ascribe to its creator, the embroiderer.

This returns us to the concept of "costly art" introduced earlier. The three factors—precious materials, specialized craftsmanship, and an unusual amount of human labor—demonstrate the relationship between artistic technique and the value of devotion. Although making a sacred icon from hair embroidery is completely different from producing "ritual art" in the sense of Wu Hung's early Chinese ritual vessels, these elements are still operative, with the added factor of a woman using her body as a material resource.

The preciousness of the material in hair embroidery lies in the status of hair taken from a woman's body and the way devotees obtain that material through suffering pain. As for the specialized craftsmanship, making hair embroidery is

considered to be a special skill and one that not every embroiderer acquires. The word *neng* 能 (expert ability) is underlined in accounts of women who possess the know-how to create Buddhist images using hair and needles. For instance, Xu Can, the well-known Guanyin painter discussed in chapter 2, also was noted for being "able to use hairs to embroider icons of the Great Being."[89]

This expert skill features a set of procedures, including preparing hair, cleaning and softening it, splitting the strands, and then stitching them onto silk. In contemporary China, in preparation, the oils and dirt need to be soaked away with alkaline water first and rinsed with clean water later, and then a special treatment is required to soften the hair with egg yolk and water.[90] Although we do not know whether embroiderers applied similar methods to hair hundreds of years ago, by observing the surfaces of surviving objects, we can at least infer several facts. We know from written accounts that during the Ming and Qing periods, women often applied oil to their hair.[91] Because the background silk of the embroidered pieces do not have oil stains, the hair must have been cleaned. Second, as we can see from the hair embroidery Guanyin done by Li Feng, her stitches are meticulous and tidy; the hair thread needed to be pliable enough to be manipulated as easily as a silk thread. Hence, some kind of softening treatment was probably applied. Third, as I just discussed, the outline of the skin is likely stitched with split hair. We can at least conclude that this difficult innovation represents the intention of making religious objects with a finer artistic effect. From Guan Daosheng's multiple strands of hair to form one stitch, to the technique of splitting one hair into several strands, these techniques represent another measure of the time devoted by the practitioner, because it took significant time to learn a skill and to perform it. These types of labor are more intense than that of silk embroidery and produce objects of a different aesthetic quality.

Subsequently, there is the question of whether artistic quality proportionally reflects a practitioner's faith in the making of religious objects. A good visual example from the modern period might help us think through this issue. According to the inscriptions on the *Guanyin* found in the Baoguang Temple near Chengdu, Miss Diao from Sanhechang 三河場 studied Buddhism for many years and promised to pluck her hairs and use a needle to create a Guanyin embroidery (figure 3.8). In 1947, before she entered the monastery and changed her secular name to a monastic one, Chengguo 澄果, she embroidered a Guanyin with her own hair and offered it to the temple Guchuan zhumiao 古川主廟, in Shihuixiang 失迴鄉.[92] In this image, Guanyin holds a willow branch in one hand and is standing on lotus flowers. Her haloed head looks down slightly, and she wears a compassionate expression. Comparing this image with the Ming- and Qing-era hair-embroidered Guanyin images, we can see from the humble quality of Miss Diao's embroidery that she clearly did

not have sophisticated training in needlework.[93] Can we conclude, however, that she was any less sincere than her predecessors in making this image? Indeed, the roughness of her stitches does not erase the materiality of her hair; on the contrary, it brings out the physicality of the hair more vividly. Because Miss Diao made this embroidery before becoming a nun, we can imagine how by using her hair, a symbol of her secular attachments, she proved her determination to leave the secular world. Her skill might be less than expert, but her sincerity is not in doubt.

MERGING WITH GUANYIN

The making of a hair-embroidered Guanyin should be viewed in light of women drawing Guanyin in the *baimiao* style. Hair embroideries from the Ming and Qing periods adopted the aesthetic of *baimiao* painting, as I have argued in chapter 2, a metaphorical meaning of female purity implanted in the *baimiao* style when pious women created *baimiao* Guanyin images. Some eminent women painters, such as Xing Cijing, Ni Renji, Xu Can, and Qian Hui 錢蕙 (active in the mid-nineteenth century) produced both *baimiao* paintings and hair embroidery.[94]

One Guanyin scroll from the Kangxi period reveals an ink outline drawing in which the hair floss has deteriorated (figure 3.10). Although it is hard to make out the drawing on this work, if the viewer moves close to the scroll, one can see a standing Guanyin delineated in extremely fine lines. Modeling her image after the *Thirty-fourth Manifestation of Benevolent Visage* from the manual the *Fifty-three Guanyin* (figure 3.11), the embroiderer omitted Sudhana, which appears on the manual's prints, and instead transferred Guanyin onto a satin background.[95] The refined brushwork echoes Xing Cijing's *White-robed Bodhisattva*. All the minutiae of the Amitābha Buddha-style hairpins and jewels and the attributes of vase and willow branches are faithfully rendered from the original illustration.

Such careful treatment in the underdrawing is different from the usual primary sketching on embroidered work, which is less detailed and sometimes is even sketchy. This surviving example enables us to problematize the discursive formation of the medium specificity of embroidery: A *mogao* or ink reference copy provides only the structure of an image; it is usually thought of as an outline that an embroiderer builds on using different colored silk threads and various stitches to fill in the volumes of a figure.[96] This medium specificity, however, is only true to the embroidery that imitates regular painting and the pictorial surface is covered with stitches. The two phases of making hair embroidery, ink drawing and stitching, are equally important with respect to creating the visual effect. Because hair embroidery emulates *baimiao* painting, the outline drawing of a figure should be a precise description. The excellence of hair floss stitch depends on the excellence of

FIGURE 3.10 Anonymous *Guanyin*, 1689. Hair embroidery, ink and hair on silk (100.6 by 26 centimeters). The collection of Beijing Palace Museum

FIGURE 3.11 *The Thirty-fourth Manifestation of Benevolent Visage* from the *Fifty-three Manifestations of Guanyin*. Woodblock prints. *Source:* After Ding Yunpeng et al., *Mingdai muke guanyin huapu* (Shanghai: Shanghai guji chubanshe, 1997), 67.

the underdrawing. Hence, the "underdrawing" in the making of hair embroidery is not simply to provide an outline of an image, but rather it is a complete image in its own right.

Every so often, in Buddhist devotional image-making, the two processes (outline and silk stitch) and their two mediums (ink drawing or sometimes chalk drawing and silk threads) are executed on the same silk surface by two different devotees. For instance, on an embroidered *Lotus Sutra* from the fourteenth century, which is now in the Shanghai Museum, a student monk named Daoan 道安 first transcribed

the text with ink and brush in the first phase of the work. The laywoman Li Delian 李德廉 then covered Daoan's calligraphy with black silk floss.[97]

Another textual source indicates that some women made skilled use of both hair and blood. A girl named Zhou Zhenguan 周貞觀, supposedly from Song dynasty, lost her father when she was only six years old. Because she did not have brothers, she vowed to remain unmarried to take care of her mother. Zhou then received Buddhist precepts and changed her secular name. When her mother passed away, Zhou was devastated by the realization that she would no longer be able to repay her mother directly. Therefore, she vowed in front of the Buddha that she would prick her tongue and copy out the seventy-thousand characters of the *Lotus Sutra* in her blood and then she would split the hairs from her head and use them to stitch every character. She started this work at age thirteen and finished by the time she was just twenty-three years old. After she finally completed the piece, she passed away sitting cross-legged in the manner of a Buddhist saint. According to Zhu Qiqian, Zhou's *Lotus Sutra* scroll was handed down from the Song to the early Qing period. The first section of the scroll was lost sometime in the Ming dynasty, but it was restored by a woman from Qiantang in Zhejiang Province. By the time of Shunzhi period, a nun asked a widow named Yu Ying to continue to restore Zhou's embroidered scroll.[98]

These examples primarily deal with the duel practices of calligraphy and embroidery: scripture was written in ink and blood and each character was adorned with silk and hair. The hair embroidered Guanyin images follow this same logic. The "double making" of a Buddhist scripture suggests that through the two processes of monochromatic line drawing and hair embroidery, the devotee's piety is amplified through the double Guanyin imagery. The second medium, hair, stands for the embroiderer and signifies a material gift that decorates and venerates the painted icon.

If hair is a pictorial gift of ornamentation, and a personal gift of veneration to the *mogao* image, we might push our understanding to see the intimate process of making a hair embroidery as a form of becoming Guanyin. By using her own hair, the embroiderer in effect has merged with Guanyin both symbolically and physically. This returns us to an overarching theme in this book, namely, the female devotee's efforts to become one with Guanyin. This entails a two-step process: first the embroiderer created a Guanyin in ink through the *baimiao* drawing. This *baimiao* signifies Guanyin as separate from the devotee's self. The embroiderer then projects herself into this Guanyin by embroidering the image with her own hair. Normally, the two images are unified to such an extent that one cannot even see the dual nature of the execution. This distinction cannot be detected with a casual glance, but by focusing on the icon, we can read the process of the

embroiderer going beyond the self to approach Guanyin. I suggest further that the regeneration of hair originally was ascribed to Guanyin's hair, but now this meaning encompasses the whole body—the mindful incorporation of hair thus expands the regeneration to the life and force of the whole icon. The gifting of labor, a gifting of self, and the subsequent forming of the image from the means and materials of one's own body, makes merging and becoming Guanyin possible.

CONCLUSION

By investigating the technical aspects and religious connotations of making hair embroidery in late imperial China, we can better understand how women creatively connected themselves with deities, and with Guanyin, in particular. Female devotees express wishes through this highly personal devotional practice. We have seen how this form of devotion can bridge the gap between devotee and the exalted being. But the symbolic function of hair embroidery also made these objects a type of spiritual exchange. By connecting hair and embroidery, women fused labor and pain. Embroidery was valuable partly because of the amount of labor and time that went into completing a work, and Guanyin recognized this devotion. Hair embroidery intensifies the meaning of the object, because of the pain experienced in the process of making it. This intensity then could be used to channel Guanyin into the mundane realm of the devotee and account for the efficacy of Guanyin imagery.

As we have seen, Ni Renji, Wang Yuan, and Lin Jinlan each used hair embroidery to merge with Guanyin, but they did this either to demonstrate filial piety or to cure an ailment (in Lin's case, eye disease). Lin's actions and aims show that the practice of hair embroidery was believed to have worldly effects and could be a medium through which Guanyin intervened in the mundane world. The detachable parts of the body can become magical. Hair embroideries of Guanyin had a number of different significations and functions all linked to the particular situations of women in late imperial China. The practice of creating these hair embroideries was connected to women's obligations and to the bitter nature of their conditions in the secular realm. This type of merit-making brought women closer to transcendence. In the next chapter, we see how, in posthumous settings, women used their bodies to imitate Guanyin and secure direct transcendence.

Mimicking Guanyin with Hairpins

Jewelry as a Means of Transcendence

An anecdote in the *Record from Langhuan* (*Langhuan ji* 琅環記), a collection of strange tales, tells of a woman who gave up her headdress and dedicated herself to wholeheartedly worshipping the Bodhisattva Guanyin. A nun had persuaded her to practice Pure Land Buddhism and told her that she should contemplate Guanyin and visualize Guanyin's dharma body: the bigger the better. From that time, she began to dream of Guanyin every night. In these dreams, however, Guanyin appeared very small—so small that she was no bigger than the Buddha on a woman's jade hairpin. One day, her husband gave her a jade Guanyin similar in size to the one she saw in her dream. Thereafter, she venerated the statue even more earnestly.[1] This vignette evokes multiple presences of Guanyin: the visualization of Guanyin in meditative practice, the miraculous manifestation of Guanyin in a dream, and the tiny jade statue of Guanyin for worship. Unusual in this short account is that all of the archetypal presences of Guanyin are associated with a woman's hairpin. The story suggests a curious intertwining between fashion and religion, particularly in the late Ming when this story was written.[2] To understand the ritual and religious context of these hair accessories, however, we must go beyond the textual sources. In fact, a rich repository of objects reveals the place of hairpins in changing practices of veneration and how women's gender identity was implicated in those changes.

A number of lavish silver, gold, and white jade hair accessories bearing the images of Buddha or Guanyin have been excavated from tombs dating from the early to late-Ming dynasty.[3] These hairpins usually adorned the female tomb occupants' hair or were attached to a cap worn by the deceased. They have been found in three kinds of tombs: those of common officials mainly in the Yangtze River delta, the imperial tombs of empresses in Beijing, and kingly tombs (*fan-wang mu* 藩王墓) throughout the empire.[4] The very existence of these objects attests to the intersection of fashion and religion as indicated in the story from

the *Record from Langhuan.* Their function as burial objects provides a significant context for understanding the complex development of hair ornaments and their overlapping significations.

Context and location become all the more important when we realize that in all kinds of tombs, the hair ornaments have been found arranged in the middle of the front of the deceased's hair or head. This careful positioning makes clear reference to the iconography of Guanyin's headdress; it also demonstrates that women used hairpins to imitate the bodhisattva's appearance. In this chapter, I argue that when women wore hair ornaments similar to Guanyin's ornaments, this use went beyond the conventional practice of invoking the deity's presence for meditation and worship purposes. The hairpins did not simply function as talismans; their use in imitation of a Buddhist deity's hairstyle instead points to a new aspect of mimetic devotion for women at that time.

The act of wearing a Guanyin hairpin changes the nature and relationship of worshipped and the worshipper. Whether the object was commissioned or the decorative article put in place by the women or by their relatives, women's own bodies by this merger became the agent by which to secure their rebirth. I suggest that hairpins thus manifested women's desire to overcome the distinction between the worshipped as an object and the worshipper as a subject. Their shared female identity, in the case of Guanyin, was a necessary condition for this mimetic behavior. As I have argued through various cases in this book, once Guanyin became widely feminized, women began pursuing different modes of becoming Guanyin. This mimetic relation was not unmediated, but rather realized through material paraphernalia, and among these, hair accessories had the particular power to transform the devotee's physical body.

Although hairpins have been discussed in relation to a history of jewelry, their status as religious objects challenges how we categorize and discuss "women's things." On a discursive level, we find the notion of women's religious adornment largely dismissed. In Buddhist doctrinal texts, jewelry that laywomen wear is considered antithetical to the ultimate goal of religious salvation, and in popular literature, jewelry with Buddhist motifs or other religious symbols is treated as mere luxury items, no different from secular pieces.

A close look at two hairpins excavated from Ming tombs, however, alert us to the possible entanglements of ornamentation and religious practice. One of the earliest hairpins bearing an Amitābha Buddha icon and carefully emulating Guanyin's hair ornament (as depicted in paintings) was excavated from the tomb of Xu Yingxu 徐膺緒 (1372–1416), an assistant commissioner-in-chief, in 1982. This tomb was located outside the Taiping city gate in Nanjing and dated to the fourteenth year of Yongle (1416) (figure 4.1).[5] Madam Zhu, Xu's principle wife, was

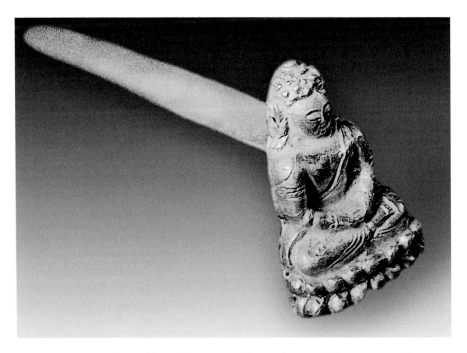

FIGURE 4.1 Hairpin with Amitābha Buddha, Ming Yongle period, 1416. Gold (5.8 centimeters long; head of hairpin: 2.2 by 1.4 centimeters). Xu Yingxu tomb, Nanjing, excavated in 1982. The collection of Nanjing City Museum.

likely the owner of the piece.[6] The head of the hairpin is cast in gold with a three-dimensional Buddha at a very small scale (2.2 centimeters high and 1.4 centimeters wide). The Buddha sits on a lotus platform with hands folded into each other in what can be identified as both a meditation pose and a hand gesture (*mudra*) of the Amitābha Buddha from the highest grade in Pure Land. A single flat peg is welded to the back of the Buddha at a right angle. This structure suggests that the hairpin was to be directly inserted at the front of the deceased's hair.

The second example hairpin is a triangular golden plaque inlaid with sapphires and rubies (figure 4.2). This elaborate piece of jewelry, along with a number of other gold accessories, was found in a tomb that belonged to the wife of a *tusi* 土司 or aboriginal commissioner in Maoerpu 貓兒堡, Enshi 恩施 prefecture, in modern-day Hubei.[7] On this hair adornment, the usual Amitābha Buddha represented as on Madam Zhu's hairpin, is replaced with the popular iconography of Guanyin of the South Sea, accompanied by her attendants Dragon Girl and Sudhana. Guanyin typically wears a crown with a Buddha in the middle. The Buddha on this Guanyin's crown, however, is replaced with a Guanyin wearing a crown of Buddha. These doubled references are intriguing. They clearly retain the identity of the hairpin as a

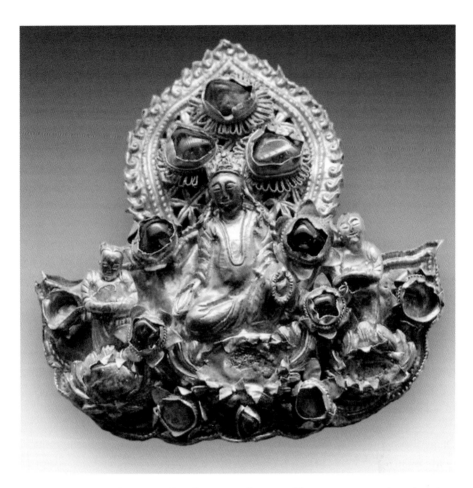

FIGURE 4.2 Hairpin with Guanyin of South Sea, Ming dynasty. Gold. Maoerpu, Tusi, Enshi, Hubei, The collection of Tujiazu zizhizhou Museum.

Guanyin's hairpin, but simultaneously, they create an independent Guanyin icon on the woman's head.

During the Ming period, most hairpins related to the cult of Guanyin fall between the two poles suggested by these two appropriations: faithful representations and modifications of Guanyin's divine mark. In these cases, the design varies with respect to their subjects, material, and decorative style, according to different time period, region, and the social status of the owner. The symbolism of Guanyin's Heavenly Crown (*tianguan* 天冠) and its transformation into hair accessories illustrate the creative process whereby a Buddhist doctrinal reference could become a tangible material object. This seems to have happened in response to the conventional discourse that jewelry was an obstacle to religious practice. In contrast to

doctrinal restrictions, wearing jewelry as a devotional medium transmuted it into merit-making, and in emulation of Guanyin, it became an effective way for women to gain religious authority.

In the last part of the chapter, I examine two case studies of women buried with such hairpins to help them achieve salvation. These cases not only help us comprehend the ritual and religious contexts of the use of these hair accessories but also enable us to more generally understand the social control of women's bodies through material objects in the Ming period.

DEVOTIONAL MIMESIS AND MERIT-MAKING WITH HAIRPINS

The Ming practice of wearing jewelry on the same location of the body as a deity was not completely novel.[8] In Chinese burial practices of the late medieval period (600–1000), mimicking the attributes of the bodhisattva was already part of amuletic practice. For instance, a skeleton bearing a silver armlet on its upper right arm was excavated from a Tang tomb in Chengdu. Inside was a folded sheet of paper printed with the *Great Dhāranī of Wish Fulfillment*. The location of the armlet was similar to the location of an armlet on a bodhisattva icon.[9] The practice of copying Guanyin hairpins reflects a logic similar to that of this early *dhāranī* piece, but Guanyin hairpins found to date bear no written spell, save her six-syllable mantra, which is sometimes arranged on the surface of a hairpin.[10] The magic power of these hairpins cannot be fully comprehended as a function of incantation practice. Given Guanyin's feminization, they allow us to think through another aspect of the mimetic relationship between worshipper and the worshipped that was established through women's things.

Devotion implies the separation of the devotee and the object of devotion. Devotional mimesis creates new constellations of meaning because the logic of devotion overlaps with the logic of mimesis. A commentary on the power of belief (*xinli* 信力) in the "Universal Gateway Chapter" from the Tiantai School's doctrinal text *Guanyin yishu ji* (*Recorded Annotations on the Guanyin Sutra*) points to a connection between devotional mimesis and merit-making.[11] "When one prays to be like Guanyin, one refers to the transformation body; when one speaks of Guanyin's merit and acquires it, this refers to the reward body."[12] This statement implies that devotional mimesis works on three levels. First, it serves as imitation. Second, that imitation serves as a form of devotion—through mimesis, practitioners wish the merit carried by Guanyin to be transferred to themselves. Third, this combination of mimesis and devotion closes the gap separating the subject from the object of devotion. The unity of subject and object helps bridge another

gap, namely the distance separating the earthly realm from the Pure Land, where good rebirths occur.

The imitation of Guanyin can be comprehended in terms of metonymy, as one attribute of Guanyin—the hair ornament—comes to signify the whole. Devotional mimesis makes use of this to effect a transformation. As we will see, signs of a transformation buddha or Amitābha Buddha was the most important mark of Guanyin's divinity. When Guanyin manifests as anyone on earth, the Buddha emblem on the manifestation's head is the single sure sign revealing his or her identity as a bodhisattva.[13] No textual source clearly instructs laywomen to wear hairpins like Guanyin's to mimic the deity, but the material objects found on women's bodies suggest the logic of metonymic mimesis.

Furthermore, the visual semantics of the hairpin are key to this logic. Roman Jakobson describes the nature of metonymy by focusing on positionality. "The capacity of two words to replace one another is an instance of positional similarity, and, in addition, all these responses are linked to the stimulus by semantic similarity (or contrast)."[14] Guanyin hairpins are a visual sign, but their positional similarity is important.[15] The hairpin is placed in the same place on Guanyin's and the practitioner's body, a structural similarity that becomes a catalyst for the larger transformation mentioned above.

Last, mimesis is usually understood as a practice of imitating some original entity, whether it is nature, truth mannerisms, or actions.[16] In the case of Guanyin hairpins in late imperial China, however, there is recurrent disjuncture between the copy and the original. In devotional mimesis, the copy is fundamentally creative and not merely secondary. When I discuss how jewelry was treated as a devotional medium, we will see that it did not involve strict replication. Instead, creativity in interpretation was encouraged. As with acting, creativity at the heart of mimesis aims to destabilize the ontological difference between copy and original.

The commentary from *Guanyin yishu ji* implies that mimetic devotion is a good deed that earns merit. As Wendi Adamek's research on Chinese medieval discourse on merit- making and merit transfer reminds us, in Mahayana contexts, generosity is understood to be one of the excellences performed by bodhisattvas on their path to Buddhahood, and both lay and monastic devotees can achieve this path.[17] Generosity in the practice of wearing hairpins is manifested in luxury jewelry. From the pieces excavated in tombs and dedicated pagodas, we can observe two levels of merit-making: Most of the hairpins were found in tombs and adorned female devotees' bodies to achieve mimesis to Guanyin. A few cases, such as Lady Xiong's two hairpins from the White-robed Pagoda, which was part of a White-robed Nunnery (*baiyian* 白衣庵) in Lanzhou, possess double functions: The forms of the hairpins retain their potential to assist women in imitation of Guanyin, and

at the same time, they were offered as votive objects to the bodhisattva.[18] Indeed, *all* hairpins could have these two functions.

When we compare a medieval banner of Guanyin leading the deceased soul to the Western Paradise with the hairpin worn by deceased women from the Ming period, we see a new relationship emerge between the worshipper and worshipped (figures 4.3 and 4.4). Instead of Guanyin leading someone to the Pure Land, the hairpin is a device by which Guanyin can "ferry" the deceased to the Pure Land directly through her own body. I suggest that the hairpin icon thus functions both metonymically and as way to help transform and transport the deceased. The hairpin's double function arises from the part and the whole: Guanyin and her hairpin are structurally similar to the deceased and her hairpin, which sets up a transformative relationship. In the mode of "becoming Guanyin" by mimicking her hairstyle, we saw a process of imitating, merging with, and then becoming the deity. The condition for this new type of relationship to the bodhisattva was a shared gender identity. That shared gender identity stimulated material practices in which women used their bodies and their ornaments to forge a connection with Guanyin. Their ultimate goal was to gain merit and secure a good rebirth in the Pure Land.

GUANYIN'S HEAVENLY CROWN

To comprehend a laywomen's practice of wearing accessories in imitation of Guanyin's hair decoration, it is helpful to first ask several questions: Why does Guanyin wear a crown with a sign of Amitābha Buddha? What is the precise symbolism imbued in this emblem? In Buddhist doctrinal instruction on contemplating Guanyin, what role does her heavenly crown play?

Guanyin's hair decoration was first specified in the context of visualizing the Pure Land. The earliest record we have of its use comes from the fifth-century Buddhist text *Foshuo guan wuliangshoufo jing* 佛說觀無量壽佛經 (*Amitāyurdhyāna sūtra*,)[19] in which the Buddha Shakyamuni taught Queen Vaidehi sixteen steps to contemplate the Pure Land for future rebirth. The first thirteen steps involve visualizing the fantastic paradise of Amitābha Buddha, the lord of the Pure Land, and his two assistants the bodhisattvas Guanyin and Dashizhi (Skt. Mahāsthāmaprāpta, Arrival of the Great Strength). The last three steps enable practitioners to imagine their ranked spot in the Pure Land. This text provides a graphic description of the color, light, medium, form, and size of various phenomena from the sun, water, and trees to the architectural spaces, decorations, and appearance of Buddha and the bodhisattvas.[20] After explaining every step of the visualization, Buddha ensures that the devotee will see certain consequences of accumulating

FIGURE 4.3 *Guanyin as Guide of Souls, Five Dynasties*. Ink and colors on silk (84.8 by 54.7 centimeters). The collection of British Museum.

FIGURE 4.4 Née Sheng wears a *jiuji* wig with Guanyin decoration. Wang Luo family cemetery. The line drawing of Née Sheng's corpse reveals how a Guanyin hairpin is reappropriated on her head when she was entombed. She is fully dressed and her body is covered with a damask blanket. Outside of her wig, she wears an e-pa 額帕 (headband). *Source:* The line drawing is based on a photograph of Née Sheng's corpse from the exhibition at the Wujin Museum. Illustration by Su Tong.

merit if his instructions are followed exactly. For instance, after the tenth contemplation of Guanyin, the practitioner "will not encounter any calamity, will utterly remove the obstacles [caused by Karma], and will eliminate sins that [otherwise would have led to] numberless kalpas of rebirth."[21] Such promises are loosely related to Guanyin's magical power, explained in the "Universal Gateway Chapter" as helping people deal with worldly disasters and assisting people in overcoming obstacles. One obstacle women faced was their biological sex, and I explore the ramifications of this in more detail in later sections of this chapter.

The figure of Amitābha Buddha on Guanyin's crown signifies his power as an agent connecting sentient beings with Buddha land. In the *Amitāyurdhyāna sūtra*, Amitābha along with Guanyin and Dashizhi are described as the triadic receivers who welcome all beings from the cycle of birth and death to the Buddha land. But only Guanyin is described as the representative whose body carries the signs of living beings and their imminent form—a transformation buddha. In the tenth contemplation on Guanyin's dharma body, the meditator should envision the size and color of Guanyin's body from top to bottom in sequential order, from his topknot, head halo, body halo, crown, face, *urna* (the white twisted hair circular between his two eyebrows), arms, garland, hands, fingers, and feet. His connection to all living beings is indicated through the sign of the living beings in the five paths of existence in his bodily halo. Three other areas on Guanyin's body include the signs of a transformation buddha (*huafo* 化佛): the head halo, crown, and *urna*. The *huashen* or transformation body of a buddha usually indicates that Buddha's response to the suffering of living beings. On Guanyin's head halo and *urna*, the transformation buddha is multiplied to five hundred and countlessness, respectively. [22] The only single transformation buddha, a standing buddha (*li huafo* 立化佛), is located at the center of Guanyin's heavenly crown ornamented with precious gems.[23]

Not until the eighth-century esoteric Buddhist texts is the buddha on Guanyin's crown clearly designated as Amitābha Buddha.[24] When Guanyin underwent his gender transformation, Amitābha Buddha, as a mark of the bodhisattva's divinity, remained the same. Its representation varies, however, according to time period and regional, cultural, and ethnic preferences. It is not specifically a sign of Guanyin's feminization. Although the symbolic meaning of a transformation buddha or Amitābha Buddha on Guanyin's crown is not made explicit in Buddhist canonical text, it was likely used to mark Guanyin's status as assistant to Amitābha Buddha. In the thirteenth step in the contemplation of the Pure Land, the Buddha Sakyamuni explains to Queen Vaidehi that because both Guanyin and Dashizhi will appear in mundane form, looking like anyone else on earth, the marks on their heads become the most important sign of their identity as bodhisattvas.[25] Among triadic receivers of Pure Land, only Guanyin make *motions*—lifting and putting his feet on the

ground and reaching out his jeweled hands to receive all living beings. The single standing buddha on Guanyin's crown signifies his credentials as an agent who can reach out to people and transport them to the realm of bliss. Hence, Guanyin's crown bearing a transformation buddha becomes the most important sign on his body, and thus, it is the most concrete emblem the meditator can envision.

TRANSFORMING GUANYIN'S HEAVENLY CROWN INTO WOMEN'S HAIR ACCESSORIES

When a transformation buddha or Amitābha Buddha is placed on a Guanyin icon, it is either seated in the middle of the crown or is represented in a high relief plaque tied onto Guanyin's topknot. Amitābha Buddha either stands or sits on a lotus seat and is surrounded by body and head halos. In sculptural form, such as a gilt bronze statue from the Ming period (figure 4.5), the material of Guanyin's hair decoration is usually in the same medium as the rest of the sculpture. Unlike a statue, in paintings, artists drew Amitābha Buddha's robe, halo, and lotus seat in a wide range of colors.

When the representation of a hair accessory on a religious icon is made into a real ornament used by laywomen, this object falls into a gendered category. Although representations of divine ornaments were originally un-sexed, when detached from a divine form into a tangible artifact, these ornaments became "woman's things." Those things, especially types of hair accessories, were used at the final stage of a woman's life to adorn her dead body for transformation to the Pure Land.

Religious practice and fashion share a paradoxical relationship. The emblems on religious icons, such as the Amitābha Buddha on Guanyin's hairpin, explicitly mark the divinity of the figure and its sacredness. That sacred power is usually embedded in the consistent form of the emblem. The variety of styles of actual hairpins with Buddhist images, however, reflect an alternative logic, that of fashion as novelty and change. Although the Chinese concept of fashion and what counts as change may be different from a modern concept of fashion and fashion cycles, terms such as *shiyang* 时样 (contemporary styles) and artifacts produced to follow some trend or style still indicate that change was an important factor in jewelry-making in premodern China.[26]

When Guanyin's crown was transformed into a laywoman's hairpin, it went from an emblem to an object. This materialization involved choices: of medium, value, practicality, design, and craftsmanship.[27] The emblem on a sacred image was transmitted to secular items that possessed both sacred and profane qualities. Textual sources and excavated accessories reveal a wide range of subjects, from

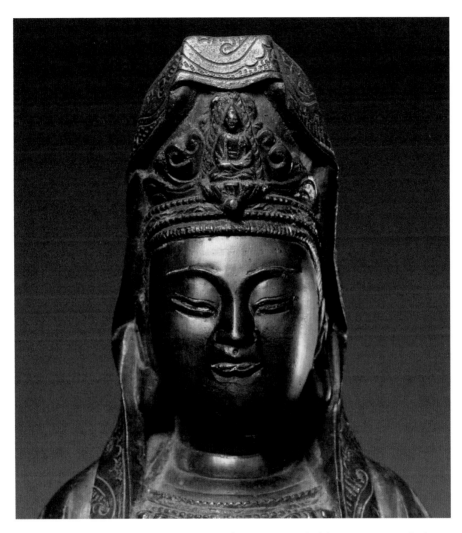

FIGURE 4.5 *Guanyin* (detail), Ming dynasty. Bronze (33.1 centimeters high by 23.4 centimeters). The collection of Beijing Palace Museum.

Amitābha Buddha on Guanyin's crown to depictions of different manifestations of Guanyin.

These depictions can be seen, for instance, in the inventory of confiscated property belonging to the corrupt Grand Secretary Yan Song (1480–1567), in the category of "miscellaneous jewelry." At least six sets of hair accessories feature six different designs of Buddha and Guanyin.[28] The types of hair accessories with Buddha and Guanyin range from a single peg hairpin to be inserted centrally in the front hairline to a set of hairpins and trendy ornamented caps that were popular in

the mid- to late-Ming period. These were expensive possessions. They reflect multiple factors, such as sumptuary laws, different religious traditions, and personal choices. They also announce their class by their materials and craftsmanship.[29] We can recognize general differences between hairpins excavated from official tombs in the Jiangnan area and the imperial tombs belonging to royal families around the country. In the lower Yangzi regions, the design of Guanyin hairpins closely emulated a Guanyin hairstyle and showed less interpretive creativity. Even when the Amitābha Buddha icon is replaced with Guanyin, the overall structure still emulates Guanyin's crown. In contrast, hairpins found in imperial tombs, especially in the kingly tombs, not only display delicate technique and expensive luxury materials, such as pure gold, pearls, and gemstones, but also have inventive designs. Influenced by both esoteric Buddhism and Daoism, the Amitābha Buddha on Guanyin's heavenly crown is sometimes replaced with esoteric deities, such as Marici.[30]

The materials used for such hair decorations were usually gold, silver, and jade, which were expensive. The malleability of gold and silver allowed women to reconfigure their hairpins to follow the current style. Ming textual sources reveal that women often had shops melt down their gold or silver hairpins and recast them in a new design.[31] It remains unclear how many times a woman might reuse the same gold and silver on new designs during her lifetime.[32] It is apparent, however, that the hairpins found in women's tombs were the final designs aimed at adorning their dead bodies for the afterlife.

WOMEN'S HAIR ORNAMENTS: OBSTACLE OR AID?

To understand women's practice of wearing hair ornaments similar to Guanyin's, we should first review the discourse on women's bodies and jewelry in the Pure Land Buddhist tradition. Distinct approaches were taken to pious women's successful transcendence to the Pure Land, including those recorded in doctrinal texts and those documented in women's epitaphs and burial practices of the period. Male patriarchs and scholars in the Ming and Qing periods compiled most of the doctrinal texts. When pious women begin to practice Pure Land Buddhism, they often are portrayed as denouncing interest in adorning themselves. Like the woman discussed at the beginning of this chapter who saw a tiny Buddha in her dreams, the first action a woman typically performed on her devotional path was to remove her hair ornaments.[33]

This conflict between self-ornamentation and religious devotion was resolved ingeniously in the account of Madam Zhang, a woman from Zhejiang Province in the late Ming who had practiced Buddhism since childhood. Soon after getting married, she no longer wore makeup or jewelry. Instead, she kept a golden Buddhist

statue in her cosmetics box.[34] By transforming her cosmetics box into a tiny shrine, Madam Zhang demonstrated the depth of her sincerity. She not only constructed a shrine but also did so by forsaking the box's original purpose. This act had the merit of demonstrating detachment from the material world in Buddhist terms, but it could also be applauded as virtuous according to Confucian ideology. She would be a diligent wife who, by being thrifty in running her household, became virtuous in both traditions.

More important, disassociating oneself from adornment was also a sign of defeminization. This is important in Mahayana Buddhist discourse, which throws up obstacles to women achieving Buddhahood because of their female bodies. In the central Mahayana scripture, the *Lotus Sutra*, the eight-year-old princess of the Naga king Sagara was determined to become an enlightened being, but she was questioned due to her female nature. Without hesitation, she removed a priceless jewel from her head, the sign of a female *naga*, and offered the jewel to Buddha as a commitment to his teaching.[35] She then quickly turned into a man; her female sex disappeared and a male organ became visible on her body; thus transformed, the Naga Princess became a bodhisattva.[36] As Bernard Faure observes, Kumārajīva (334–413) did not translate into Chinese the detail of the Naga Princess's transsexual moment from the Sanskrit.[37] Therefore, to Chinese practitioners, the act of proffering her jewel became the only signal of her radical transformation from female to male. Indeed, the nineteenth-century woman painter Jin Liying, discussed in chapter 2, discovered the Naga Princess's story about jewels through reading the *Lotus Sutra* and she felt ecstasy in her mind (*Sixin kugangxi* 私心狂喜). Interestingly, after doing research on the *gongan* 公案 (public case) stories related to various Buddhist women, including Buddha's aunt Mahāpajāpatī Gotamī, Jin Liying detested the Naga Princess's changing to male form. She thought the precious jewel should be kept by women, and she believed that a woman without a male body can also transcend.[38]

In the section regarding women's transformation in the Pure Land in *Wangsheng ji* (The Collection of Rebirth), Yunqi Zhuhong (1535–1615), the most influential leader of Pure Land Buddhism in the late Ming, states, "In the land of extreme happiness, there is no woman. If women can be reborn, they all manifest the form of a great gentleman."[39] Some male scholars who promoted female religiosity also accepted this orthodox view on the gender of inhabitants of the Pure Land. Tu Long, for instance, confirms, "There are only men and no women in the Western Paradise."[40] Zhuhong criticized laywomen who practiced Pure Land Buddhism for having one common problem: "They admired the male body only, but they did not leave off their womanly habits."[41] Although Zhuhong does not explain "womanly habits" in detail, he likely is referring to women's habit of beautifying their

appearance. He describes thirty-two pious women who achieved rebirth in the Pure Land, who, like their male counterparts, pursued perfection as a self-conscious and self-controlled process. Pious women could predict their departure from this world, and in preparation, before passing away or transcending, they often performed rituals such as purifying and cleaning themselves, donning clean clothes, facing west toward Amitābha Buddha, sitting cross-legged, burning incense, chanting sutras, and calling Amitābha Buddha's name. These rituals emphasize no gender specificity.[42]

A quite different image emerges from representations of Buddhist laywomen as donors, as visualizations in paintings of female souls on their journey to the Pure Land, and from female bodies in actual burial practice. Their elaborate headdresses, clothing, accessories, and makeup declare their gender identity. Does this phenomenon simply indicate that laywomen did not follow doctrine and used material objects as resistance? Should we simply denounce such practices as non-devotional behavior because they do not match Buddhist doctrine? Or does this burial tradition, part of merit-making and merit-transfer, merely demonstrate filial piety on the part of the deceased's children?[43]

JEWELRY AS A DEVOTIONAL MEDIUM

In 1631, Lady Xiong or Xiong shi 熊氏 (active in the mid of seventeenth century) and her husband Zhu Shihong 朱識鋐 (?–1643), the ninth generation of the Princes of Su (present-day Lanzhou in Gansu Province), had a pagoda constructed inside the White-robed Nunnery.[44] A year later, in the aboveground crypt on the top of the pagoda, they deposited a group of artifacts that included Buddhist statues, scriptures, a ceramic Daoist figurine, two hairpins, and other items. The hairpins, one representing the Child-giving Guanyin (figure 4.6) and the other a Fish-basket Guanyin (figure 4.7), are carved in white jade and framed with a lotus base and flower garlands made of coiled gold wires, pearls, and gemstones. These two items bear identical inscriptions that indicate Lady Xiong was their donor. The functions of the two seem to be different: the first was donated either to pray for a son or to express gratitude for being granted a son, a merit-making practice we saw in the case of Xing Cijing.[45] The second item seems to express the hope that Guanyin will use her divine power to secure the donor's successors.[46] Because most Guanyin hairpins have been found in tombs, and a woman would not be troubled with the duty of producing heirs in her afterlife, this is perhaps the only such burial piece that carries an image of the White-robed, Child-giving Guanyin. Fish-basket Guanyin hairpins have been found in other burial contexts, such as in Empress Dowager Xiaojing's coffin and in the crypt of another Ming dynasty pagoda Juxing Pagoda

FIGURE 4.6 *Child-giving Guanyin*, King of Su's consort, Née Xiong offered, to the Duozi ta (Pagoda of Plenty Children, Yao Jin assembled, dated 1632. Coiling gold wires, pearls, and gemstones (6.5 centimeters high; 0.0575 kilograms). Lanzhou Museum. *Source:* Photograph provided by Professor Wei Wenbin

FIGURE 4.7 Fish-basket Guanyin hairpin, King of Su's consort Née Xiong offered, to the Duozi ta (Pagoda of Plenty Children, Yao Jin assembled, dated 1632. Coiling gold wires, pearls, and gemstones (6.5 centimeters high). Excavated from the White-robed, White-robed Nunnery Pagoda. Lanzhou Museum. *Source:* Photograph provided by Professor Wei Wenbin

(Juxing ta 聚星塔) in Wuxing 吳興 at Zhejiang Province.[47] Most of the hairpins I discuss were used by laywomen to emulate the bodhisattva, but Lady Xiong's offerings at the abbey pagoda were used in exchange for favors from Guanyin.[48] The intriguing issue with these pieces is why Lady Xiong selected this form of icon. Why did she not offer a statue of the Child-giving Guanyin, as was more common in imperial China? What is the sacred power embedded in these hairpins?

The inscriptions on these artifacts suggest the conventions of a merit-making economy. Something used by women or something made by women's own hands added value to the object given. It is as if the sincerity embodied in the hairpin

translated into spiritual value, which then could be exchanged for favors. More important, as I have pointed out, the form of the hairpin suggests the function of assisting in women's imitation of Guanyin, which is a different type of merit-making, because they were offered as votive objects. The characters inscribed on the front and back of the hairpins' pegs read as follows: "Consort of the King of Su *Née* Xiong offered, and reading partner Yao Jin additionally assembled"[49] and "Tenth day of August during the fifth year of Chongzhen (1632)."[50] These inscriptions do not explicitly say whether these two hairpins were actually worn by *Née* Xiong or whether they were simply made as votive offerings. But whenever the character *shi* 施 (to offer) is incised onto objects, the status of the object is elevated to a gift to the deity. Yet, the inscription also indicates that the hairpins were attached to Lady Xiong, either literally or metaphorically. It is not clear how exactly Madam Yao "assembled" or venerated the pieces. One possibility is through the technique itself: both hairpins' frames are made in delicate filigree wires. The gold frame that embraces the jade icon was likely made as a flat sheet. In general, a gold filigree sheet is gentle enough to be bent and reshaped into a frame.[51] We have already discussed how extracted hair from a woman's body stitched into Guanyin imagery was a means to get attention from a deity. I suggest that offering a woman's hairpin expresses the same logic. Jewelry is considered a woman's private possession, and by being worn, it also has an intimate connection with her body—or at least a connection can be implied. In Chinese literary discourse, jewelry is treated as an extension of women's bodies.[52] Jewelry worn by women for a longer time was considered a particularly precious offering. When a donor, most likely a woman, converted a beloved item into a religious offering, the change was commemorated by inscribing the donor's name and date either in ink or by incising the characters on the artifact, as Lady Xiong had had done.[53]

Women's devotion is measured in terms of material value and the physical labor invested, and in particular, the amount of effort taken to transform these treasured personal belongings into religious items. This idea is worked into a fascinating story called *The Pearl Pagoda*, one of the most popular *tanci* (plucking lyrics) performed in the lower Yangzi delta in Qing times and still widely enjoyed in South China today. The plot is believed to be based on a real story from Suzhou in the Wanli period.[54] Madam Fang transformed her pearl wedding phoenix crown into a pagoda with her own hands. This artifact, originally received as a gift from her sister-in-law, then becomes a prop that leads the narrative in which Madam Fang's nephew eventually builds a real pagoda, based on the style of the pearl pagoda, in an abbey home to a large White-robed Guanyin statue.

A couplet from the late Ming describes the relationship between a woman, her hairpin, and a Buddhist female deity. "I specially present a gold hairpin to venerate

the Buddha-mother, and pray that her efficacious power will fulfill my wish of giving birth to a son."[55] Here, the Buddha-mother might refer to Guanyin. These lines suggest that she offers the gold hairpin to decorate the hair of a female deity's icon. In other words, a laywoman's body and a female deity's body (a statue) can be linked through the hairpin, whose offering is hoped to stimulate the deity's divine power. The similar logic can be observed on early hair embroidery, such as Guan Daosheng's *Guanyin*, on which only Guanyin's hair, eyebrows, and eyelashes are decorated with human hair. When the Bodhisattva Guanyin was widely accepted as a female deity, shared gender identity allowed women to establish a closer relationship with Guanyin's body. Women made a direct connection with Guanyin through their bodies and specifically through female jewelry, which created a convenient and intimate way to present their various requests. The intimate nature of jewelry was assimilated into Buddhist material practices full scale in the late imperial period. When hair accessories associated with decorating a religious body became part of women's fashion system, the relationship among laywomen, Guanyin, and jewelry was mutually established and a mundane accessory could thus be transformed into a sacred symbol.

THE BURIAL BODY WITH HAIRPINS

That Guanyin hairpins were deposited in temple pagodas reveals only one aspect of their ritual context as they were used by living women. Several sources like the catalog of Yan Song's confiscated property, the travel journal of Korean scholar official Choe Bu (1454–1504), and vernacular stories, such as *Jinpingmei* (*The Plum in the Golden Vase*) and *Xingshi yinyuan zhuan* (*Marriage Destinies to Awaken the World*), confirm that women wore hair ornaments bearing the image of Guanyin during their lifetimes.[56] But the rituals associated with Guanyin hairpins in the living world require further research. A story in *Xingshi yinyuan zhuan* illustrates one of the ritual contexts in which such ornaments were worn in Ming Beijing. When a young aristocratic woman, Madam Xu, visits Huanggu si (Temple of the Emperor's Sister) to offer a banner, she carefully dresses in ceremonial robe and wears a filigree Guanyin hairpin made of pure gold (*chijin basi Guanyin* 赤金拔絲觀音).[57] This dress code echoes the imagery of aristocratic female donors represented in murals from earlier periods. When a woman performs the role of a worshipper, she adorns herself with jewelry to venerate the deity. In other words, she presents herself as a gift.[58] Madam Xu carries a Guanyin icon on her body in imitation of Guanyin wearing an icon of her "teacher," the Buddha. This suggests that laywomen like Madam Xu considered Guanyin to be a spiritual leader and tried to be close to her by imitating her hairstyle.[59]

A woman could have worn a Guanyin hairpin in her lifetime and continued to be thus adorned when she was buried, but Guanyin hairpins also were made exclusively for the afterlife. In his study of Chinese tomb furnishings, Wu Hung has elucidated the importance of considering the nature of an artifact according to its status as a lived object (*shengqi* 生器) and as a spirit object (*mingqi* 明器 or *mingqi* 冥器). The former refers to a piece originally used by a deceased person when she was alive, and that then was buried with her. An object made solely for the afterlife is called a spirit object. Both of these secure the tomb occupant's afterlife, but the lived object bridges life and the afterlife.[60] Spirit objects are often made with no practical function but to enhance the status of the deceased as an ancestor or transcendent being. There are no equivalent terms for the subcategories of lived jewelry (*shengshi* 生飾) and spirit jewelry (*mingshi* 明飾 or *mingqi* 冥飾) in textual sources, but on a conceptual level and in actual practice, the concepts did exist.[61] Attending their decline in tombs of the late imperial period, mural painting and relief carvings were no longer considered major allegorical mediums to represent the afterlife.[62] But this does not mean that the concern for the afterlife and the transcendence of the dead body disappeared. Instead, because most tombs found in the Ming period were single-pit structures, and even the magnificent multi-chambered Wanli Emperor's mausoleum was constructed with only bare walls, ideas of the afterlife were reflected mostly in burial objects.[63]

Jewelry, especially women's hair accessories, gradually became a new luxury burial item that bore symbols, religious figures, and narrative scenes that represented the afterlife. Although both men and women kept long hair in premodern China, a woman's head became the place where she could express her view of cosmology by adopting different hairstyles and using special accessories.[64] By wearing a crown, hairpins, a cap-type wig, or jewelry that featured religious figure or symbols, women could deliver a message.[65] Earlier sources reveal that images of deities had been used as emblems on men's and women's headgear for different purposes, but none of them was modeled on the hair décor associated with any religious icon.[66] A more direct reference to women wearing a crown with Buddhist imagery and drawing a connection with a bodhisattva can be found in a description of the *Sixteen Tianmo* dance that was performed in the Yuan court. The lead dancer would wear an ivory Buddha Crown (*foguan* 佛冠) with elaborate necklaces and dress to approximate a heavenly being.[67] It is still uncertain whether this performance tradition might have suggested the mimetic practice of embodying Guanyin through hair decorations.

The imitation of Guanyin's hair ornaments can be divided into two different types: (1) those strictly modeled on Guanyin's iconography—an Amitābha Buddha either standing or seated is placed at the middle of the deceased's forehead or in

the middle of a cap; or (2) the Amitābha Buddha is replaced by Guanyin in her various forms, such as the White-robed Guanyin, the Guanyin of the South Sea, Fish-basket Guanyin, or Child-giving Guanyin.[68] Notably, the religious and ritual functions associated with these hair decorations are often diminished in the literature of the Ming period. Iconographies of Amitābha Buddha and various Guanyin manifestations on these hairpins are simplified to "*guanyin*" in various Ming textual sources. The naming convention usually focuses on the monetary value of a piece. Along with a simple mention of the subject, material, technique, and function, as well as sometimes the weight and number of items in one set, are mentioned.[69] By simplifying the subject of women's jewelry, the women's role in choosing and wearing these artifacts is diminished. The decoration on these pieces is not mere ornamentation, but rather it was designed for a particular individual. We should simultaneously read the jewelry alongside its wearer or tomb occupant. Hence, in the following two cases, I unpack the design of these Guanyin hairpins and explore how a specific hairpin could transport an individual woman to the other shore of happiness and transcendence.

CASE ONE: NÉE SHENG AND NÉE XU

The two hair coverings excavated from the Wang Luo 王洛 family cemetery in Wujin 武進 in Jiangsu Province provide a more comprehensive picture of how women from the same family could reach different choices with respect to the iconography of Buddhist adornment.[70] Née Sheng 盛 (1459–1540) was the principal wife of Wang Luo (1464–1512), and her daughter-in-law Née Xu 徐 (dates of birth and death unknown) was the second principal wife of Wang Chang 王昶 (1495–1538), Née Sheng's second son. Both women were found wearing caps adorned with ornaments bearing Buddhist subjects when their bodies were excavated in 1997.[71] The Wang family is one of the acclaimed clans in Wujin. Wang Luo's father, Wang Yu 王傃 (1424–1495), served the Ming court for more than four decades and led the Ministry of Revenue and the Ministry of Civil Service Affairs during the Hongzhi reign (1488–1505).[72] Unlike his father and his elder brother Wang Yi 王沂 (active in fifteenth century), Wang Luo achieved only a third-rank degree and was promoted to the status of military general in Zhenjiang.[73] Among the women who married into the Wang family, Wang Luo's principle wife, Née Sheng, came from a most prestigious family. Her father Sheng Yong 盛顒 (1418–1492) received his *jinshi* degree in the second year of Jingtai (1451), the same year as her father-in-law and became the provincial governor of Shandong at the end of his career.[74] Née Sheng contributed significantly to the lineage of the Wangs, giving birth to three sons and three daughters. She passed away at age eighty-one and received a *ruren* (scholar's wife) title.[75]

On the cover of her coffin, her posthumous name is inscribed as "Wang tai ruren Sheng shi 亡太孺人盛氏" or deceased tai ruren *Née* Sheng.[76] In contrast, Née Xu, the daughter-in-law, is rarely mentioned in the family genealogy. She was recorded as Wang Chang's second principle wife after the first wife Madam Hua passed away, and she was awarded with a *ruren* title as well.[77] It seems that Née Xu did not produce any heirs. Unfortunately, the tomb tablets of both women are damaged and the text of their epitaphs is not included in the family genealogy. Only the fact that they were buried in the family cemetery, Fangmaoshan 芳茂山, is specified.[78]

The religious practice of family members goes unmentioned in the *Piling wangshi zongpu* (*Wang Family Genealogy from Piling*). Various sources, such as the biographies, epitaphs, birthday-celebratory prose, and dress-code regulations, for mourning all follow the Confucian norms of "wise officials, exemplary women, and rituals of ancestor worship." It was common in some regions during the late imperial period to exclude religious practices from written family history.[79] The contemporary local gazetteer of Wujin, however, reveals the vital power of Buddhism in this area.[80] The abbeys dedicated to Guanyin such as the White-robed Nunnery (Baiyi an 白衣庵) and the Northern Guanyin Abby (Bei Guanyin yuan 北觀音院) were located in the town of Wujin, not far from where the Wang family resided.[81] Because of a lack of textual sources, the religious practices of the Wang family women may never be fully known. The material objects found in their tombs, however, convey a visual message intimately tied to the cult of Guanyin.

Both Née Sheng and Née Xu wore a *jiuji* 鬏髻, which literally means a bun hairstyle, but usually refers to a kind of cap fashionable among married women during the Ming period (see figure 4.4).[82] Both of their caps, although different in shape and height, are made of silver wire covered with black gauze, a type of *jiuji* worn by women from wealthy families.[83] The hairpins or accessories on these caps, bearing images of Buddha and Guanyin, are each part of a set of jewelry. Each accessory adorns a different part of the cap and is named according to its function and position. An article of any of these types could be altered according to the fashion of the period. The set of adornments, from the front, sides, back, and top to lower edge of the cap, are as follows: the *tiaoxin* 挑心 (charging the center), *yanbin* 掩鬢 (concealing the sideburns), *manguan* 滿冠 (cover fully [the back of] a cap), *dingzan* (the top hairpin), and *tougu* 頭箍 (small-headed hairpins) (figure 4.8).[84] The hair décor featuring Amitābha Buddha and Guanyin belongs to the category of *tiaoxin*. Ni Renji, one of the hair-embroidery artists introduced in chapter 3, once copied a design from an album of her husband's family ancestors who had lived in today's Yiwu 義烏 in Zhejiang Province. She painted two female ancestors wearing this kind of cap decorated elaborately with gold hairpins. One has an image of the Amitābha Buddha and the other has what resembles the White-robed Guanyin (figure 4.9).

FIGURE 4.8A Née Sheng's *jiuji cap*. Left image: front side of the cap and right image: back side of the cap, Wang Luo tomb (10.3 centimeters deep, 5.6 centimeters high). Cap: silver wires covered with black gauze, gold, and turquoise. The collection of Wujin Museum. *Source:* Photograph by the author.

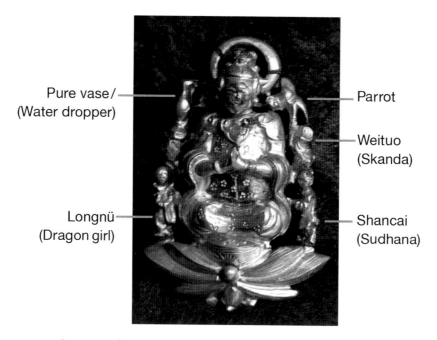

FIGURE 4.8B The Guanyin of South Sea hair decoration, Née Sheng's *jiuji* cap (detail). The collection of Wujin Museum. *Source:* Photograph by the author.

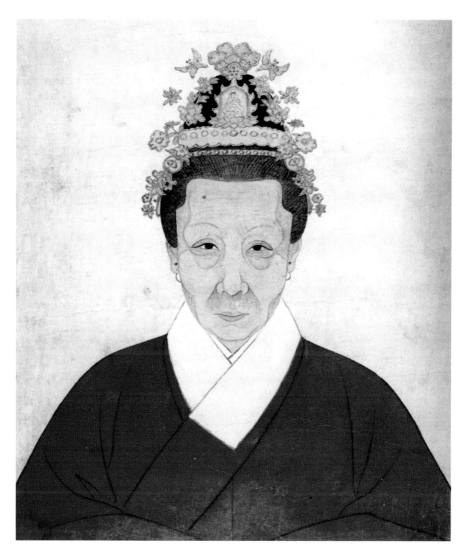

FIGURE 4.9 Ni Renji (1607–1685), *Wushi xianzu tuce* (*An Album of the Ancestors from Wu Family*). Ink and color on paper, album (27.3 by 24 centimeters). The collection of Yiwu Museum.

Ni depicted the jewelry in detail and provides an idealized view, with all the hair accessories equally visible from the front. This high cap adorned with filigree hair ornaments echoes the hairstyle of Guanyin and other bodhisattvas.

Front and center on Née Sheng's cap is a gold appliqué of Guanyin of the South Sea (figure 4.8b). Guanyin sits upright on a lotus blossom with crossed legs. Instead of wearing a long robe, Guanyin wears a jacket. Her attendants Weituo, Shancai,

and Longnü, and symbols such as the pure vase and parrot, are arranged along either side of her body. Unlike the same Guanyin manifestation on Madam Zhu's hairpin from the Maoerpu tomb (see figure 4.2), Guanyin's attendants and attributes on Née Sheng's cap are reduced and compressed such that they cannot be distinguished easily from the central icon. In other words, the presentation of this small Guanyin is more like that of the Buddha on Guanyin's original crown. This deliberate fusion of Buddha and Guanyin might arise from the intent to closely emulate Guanyin's hair decoration.

Exactly why this Guanyin manifestation was selected for Née Sheng's hair décor is unclear. One of the most popular manifestations of Guanyin in the late imperial period, Guanyin of the South Sea was intimately identified with Mount Putuo, a sacred mountain on an island on China's southeast coast. From the late sixteenth to the eighteenth century, Mount Putuo was an important pilgrimage site.[85] During the Jiajing period (1521–1567) when Née Sheng lived, however, the Ming government closed Mount Putuo in response to raids by Japanese pirates and relocated the monks to temples in Ningbo. Pilgrims were not allowed to visit the mountain.[86] Moreover, during this period, the Jiajing emperor (1507–1567, r. 1521–1567) turned to favor Daoism and implemented an anti-Buddhism policy, which also adversely affected pilgrimage activity.[87] Therefore, it is unlikely that Née Sheng would have visited Mount Putuo during her lifetime. Still, a rectangular-shaped incense bag with a triangular flap and a single shoulder strap, an item of pilgrimage, was found in Née Sheng's coffin (figure 4.10). Unfortunately, the archeological report does not provide details of the bag's location. It is made of damask in *assorted treasure pattern* (*zabao wen* 雜寶紋.). The same damask was also used for other items, such as Née Sheng's coffin bed sheet, pillow, and socks.[88] This sort of fabric was likely typical of mid-Ming spirit objects. [89] On the bed sheet, the third register is filled with a soul banner pattern (*fanzhuang wen* 幡狀紋) and a pattern of clouds and thunder (*yunlei wen* 雲雷紋) that are related to the symbols of rebirth in the Pure Land. Given that an incense bag is unusual in Ming burial practice, even among the tombs where jewelry with Buddhist motifs has been found, Née Sheng's incense bag was likely customized for her as a personal spirit object. The tiny Guanyin icon and the incense bag both point to Née Sheng's imagined role as a pilgrim. Whether she actually participated in pilgrimages in her lifetime, the fact that she was buried with the markers of a pilgrim speaks to a particular relationship with merit. Pilgrimage implies a devotional relationship between a worshipper and the object of worship. When the worshipped icon, Guanyin, is also positioned on the body of the worshipper (Née Sheng's) in Guanyin's own fashion, however, I like to suggest that the deceased meant to secure a good rebirth through merit earned from dual channels—that is, devotional mimesis and symbolic pilgrimage.

FIGURE 4.10 Line drawing of Née Sheng's incense bag. Damask with pattern of assorted treasures (22 centimeters long, 14.5 centimeters wide). *Source:* The line drawing is based on a photograph in the excavation report. Wujin bowuguan, "Wujin Mingdai Wang Luo jiazu mu," *Dongnan wenhua* 124, no. 2 (1999): 31, Figure 11. Illustration by Su Tong.

Anticipation of a good rebirth is further suggested by a lotus seedpod placed in between lotus flower petals just below Guanyin (figure 4.8a). Because a seedpod usually grows in the middle of a lotus flower, it is often obscured by the petals or is covered by the sitter, unless the artist represents the deity from a bird's-eye view.[90] Here, however, the seedpod is explicitly indicated between lotus petals on these hairpins bearing both Amitābha Buddha and Guanyin imagery, which have been found on other items excavated from the lower Yangzi River regions. The seedpod is another commonly used symbol for rebirth in the Pure Land and is often held by a reborn baby. As we can observe on Née Sheng's cap, each individual

seed is carefully cast to indicate that they are fertilized lotus seeds, which can be reborn in the Pure Land. The body of an anonymous woman excavated from a Ming tomb was found with her feet resting on a round clay vessel with holes resembling those on a lotus pod (figure 4.11).[91] That tomb occupant was buried with two other Buddhist items, a strand of sandalwood prayer beads and a piece of square cotton fabric covering part of her body. Most of the writing on the fabric is in Sanskrit, but a line of Chinese in the middle indicates the scripture on the fabric as "*Fanshu dabo guangbo louge shanzhu tuoluoni*" 梵書大寶廣博樓閣善住陀羅尼 (Written in Sanskrit, Great Treasure Fathomless Celestial Mansion, Virtuous Resident Dharani.)[92] The vessel with holes likely mimics a lotus seedpod to help the woman's body transcend to the Pure Land.

No textual sources tell us that Née Sheng wished to be buried this way. Nonetheless, we cannot exclude the possibility of her agency. It was a common practice in premodern China to prepare spirit garments (*mingyi* 明衣/冥衣) while someone

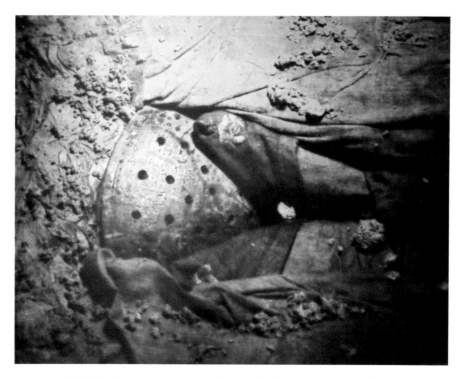

FIGURE 4.11 The body of an anonymous woman from a Ming dynasty resting on a *taobi*. Excavated in Jingzhou 荊州, Shishou shi 石首市, Dongsheng zhen 東昇鎮, Fengshan 鳳山村 cun in 2002. *Source:* Jingzhou bowuguan, "Mingdai nüshi zhan" (An exhibition of a Ming dynasty female corpse) (2015). Photograph by the author

was alive. Née Sheng died at the age of eighty-one. Having lived that long, she—or her family members—would have already prepared her spirit garments, jewelry, and even coffin. Indeed, her father-in-law Wang Yu once wrote an epitaph for his friend's mother Madam Jiang. When Madam Jiang foresaw her own death, she handed the funeral outfit she had made herself to her daughters-in-law and instructed them in how to dress her after her death. She then gave her own clothes to the female members of the family as a virtuous gesture.[93] The *Collection of Going to Rebirth* gives an account of a laywoman with the family name of Xue predicting her upcoming rebirth into the Pure Land. She put on a special hat called a Zhigong *mao* (誌公帽) and then immediately passed away or transcended.[94] Zhigong is believed to be the reincarnation of an Eleven-headed Guanyin from the fifth century. The hat he is often described as wearing has a flat crown and a long hood at back. In this short account, not only is the Zhigong hat a magical tool by which Lady Xue secures a miraculous transformation, but also it does so by her choice and action.

The cap of Née Xu, the daughter-in-law, follows the iconography of Guanyin more strictly and the front is adorned with a seated Buddha (figure 4.12). The Buddha's two palms are pressed together and he sits atop a lotus base. It is unclear whether her mother-in-law's cap inspired her own. Two other examples of Buddha appliques, one silver and one gold, were excavated from Ming tombs in Qingtan 清潭 and Zhengluzhen 鄭陸鎮, respectively, in Changzhou, not far from the Wang family cemetery.[95] They were probably similarly attached to caps like those found on the Wang wives. Although the original context of these other tombs has been

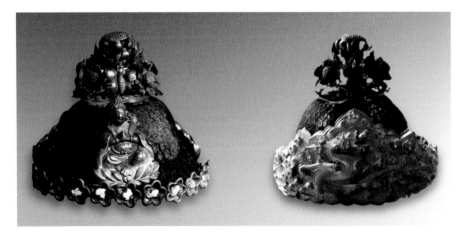

FIGURE 4.12 Née Xu 's *jiuji*, front (left) and back (right) (10.3 centimeters deep, 5.6 centimeters high). Cap: silver wires covered with black gauze, gold, between Jiajing to Wanli period, Wang Luo family tomb. Wujin Museum. *Source:* Photograph by the author.

lost, the Buddha ornaments demonstrate a diversity of materials, sizes, and styles within the same region.

Note that all of these Buddhas are depicted with their palms pressed together. In general, the Amitābha Buddha on Guanyin's crown is depicted in meditation or making a receiving *mudra*. Each of the *mudra*s is associated with Amitābha Buddha's role in the Pure Land. On the earliest hairpins from Xu Yingxu's tomb, the Amitābha is rendered in the standard meditation *mudra* (figure 4.1). This *mudra* represents the highest-ranked spot in the Pure Land to which the practitioner could be reborn. When Buddha's hand gesture shows palms pressed together, this indicates a prayer position (figures 4.8a and 4.12). Prayer images can be found in both the worldly and heavenly realms. This gesture complicates exactly what this connotation of the Buddha means, because it was not common iconography in the Ming period. As Michael Taussig points out, one characteristic of mimetic practice is that it is never simply a duplication of the original, but rather it often involves a degree of slippage.[96] Although we do not know who first created the new design for this jewelry, the agency of the woman practitioner is not only evident in her mimicking Guanyin by wearing a similar hairpin but also through the altered detail of showing Buddha in prayer, which seems more likely to mirror the role of the devotee. These two women of the Wang family provide a case that may allow us to speculate about women's own wishes regarding how their bodies should be dressed to be reborn in the Pure Land. The meticulous details on Guanyin hairpins show us that women were able to insert multiple meanings and express their multifaceted relationship with Guanyin. Additionally, the various hairpins excavated from Ming tombs in the Jiangnan area reveal that women's religious authority might be textually silent but was effectively expressed and shared through womanly adornments.

CASE TWO: LADY WANG/EMPRESS DOWAGER XIAOJING 孝靖 (1565–1611)

The Empress Dowager Xiaojing, with the natal name of Wang, was commonly referred to as Lady Wang (Wang shi 王氏). She was the consort of Emperor Wanli whose eye she caught while she was initially serving as chambermaid for Wanli's mother, Empress Dowager Li (?–1614). She was sixteen years old when she was promoted to become Consort Gong 恭 (consort of courtesy) one month before she gave birth to Wanli's first son Zhu Changluo 朱常洛 (1582–1620), who later became Emperor Taichang.[97] Wanli favored the Imperial Noble Consort Zheng (Zheng guifei 鄭貴妃) (1565–1630) and her son Zhu Changxun 朱常洵 (1586–1641); hence, Changluo did not become crown prince until 1601. Because of a dispute with his powerful ministers over endorsing Changxun as successor to his throne, Emperor Wanli refused to perform his duties as a

sovereign for nearly three decades. Only after Lady Wang's son produced a grandson, was she honored with the title of imperial noble consort. Still, she was quarantined until she died in 1611, almost ten years before her husband. Lady Wang was initially buried at the rank of an imperial consort who did not produce an heir. Once Wanli had passed away, Zhu Changluo, then became Emperor. Taichang 泰昌 (r.1620–1620) and planned to promote his birth mother to empress dowager, but he died within a month after ascending the throne. His own son Emperor Tianqi (1605–1627, r.1620–1627) then fulfilled his father's wish and conferred the title of empress dowager on his grandmother. Thus, Lady Wang was reinterred from an imperial concubine's tomb in Dongjing 東井 to Wanli's tomb in Dingling 定陵.[98] The Wanli emperor was the only Ming emperor buried with two wives. With the second entombment, Wanli's grandson promoted Lady Wang to the status of Empress Dowager Xiaojing.

In this second case, by unpacking the layers of meaning conveyed in the hairpins found on the empress dowager's head, I argue that her posthumous promotion also included reveneration. That is, her body was transformed into a divine body and her transformation buddha form in the Pure Land was secured by the symbolic power of her hair adornments.

The Deification of Imperial Women in the Late Ming

Throughout this book, we have discussed different methods by which Buddhist laywomen try to identify with or become Guanyin. The practitioners' socioeconomic class determined their choices of media. In the Ming court, we see a tendency to deify an empress or empress dowager either before or after death as an expedient means to stabilize or promote their political status. Indeed, reincarnation as a Buddha or a bodhisattva in the living world or in the afterlife was a key goal for female rulers.[99] The paths taken by Empress Wu (Wuzetian 武則天, 624–705, r. 690–705) and Empress Dowager Cixi, two of the most well-known imperial women from before and after the Ming period, were dramatically different, with one embodying the Maitreya Buddha indirectly in the early Tang period and the other directly assuming a Guanyin identity through costume, settings, props, and modern techniques of photography in the late Qing.[100] One fundamental change over this thousand-plus years was the disappearance of gendered struggle as Guanyin became feminized in later dynasties. The female form of the bodhisattva provided a visual frame to create a direct bodily connection with the divine for women at all social levels. But imperial women, like their counterparts the emperors, combined rulership with divinity. In the case of imperial women, such as Empress Dowager Xiaojing, who did not have the power to mobilize any resources, a son or grandson could deify them posthumously to demonstrate filial piety and also to bolster their supremacy. This form of filial piety also served the purposes of merit-making to ensure their good rebirth.

Lady Wang was chambermaid to Empress Dowager Li, her future mother-in-law. It is possible that the empress dowager influenced the spiritual life of Lady Wang and other imperial women serving at court. A generous patron of many pious projects, the empress dowager devoted herself to Buddhism, Taoism, and other popular cults and thus was deified.[101] She and her son, the Wanli emperor, promoted a new cult centering on the belief that she was a reincarnation of a heterodox deity, the Nine-lotus Bodhisattva (*jiulian pusa* 九蓮菩薩), an unorthodox form of Guanyin (figure 4.13).[102] Her deification followed the typical avenues of endorsing a person's sanctity, through image-making and creating miraculous stories and scriptures, both before and after her death in 1614.[103] In 1618, Empress Dowager Li was enshrined in a Buddhist temple, the Changchun Monastery (Changchun si 長春寺) in Beijing and also was worshiped in other sectarian temples. Emperor Chongzhen 崇禎 (1611–1644, r. 1627–1644), Emperor Wanli's grandson and Emperor Taichang's fifth son, followed the same path to elevate his birth mother who had been sentenced to death when he was five years old. Emperor Chongzhen had a court artist create a posthumous portrait of his mother Lady Liu (Liu shi 劉氏, ?–1615), who was later promoted to Empress Dowager Xiaochun 孝純. The painting was enshrined in the hall opposite that of the Nine-Lotus Bodhisattva/Empress Dowager Li in Changchun Monastery. In a photographic reproduction of this painting dated to the 1930s, Empress Dowager Xiaochun, dressed in a robe with wide sleeves and a *jiasha* cloak, sits on a lotus base and holds a *ruyi* with two hands at midchest level; she wears a five-Buddha crown on her head (figure 4.14). She was honored as Bodhisattva with Superior Wisdom (Shangzhi pusa 上智菩薩) on the tablet placed in front of the portrait.[104] Hence, this painting is more like a *fozhuang xiang* 佛裝像, that is, a portrait done in Buddha's clothing in which the Buddha's attributes are auspiciously displayed. The different levels of deification and diverse venues in which Empress Dowager Li, Empress Dowager Xiaojing, and Empress Dowager Xiaochun (three consecutive generations of mother-in-law and daughter-in-law) were glorified provide us much interesting information regarding the relationship between imperial women and female deities in the late Ming.[105]

Empress Xiaoduan and Empress Dowager Xiaojing's Posthumous Hair Accessories

Before looking at Empress Dowager Xiaojing's accessories in detail, a glimpse at those belonging to Emperor Wanli's principle wife, Empress Xiaoduan 孝端 (1565–1620) will help us understand the preciseness of religious messages presented in Xiaojing's items. On the forefront and sides of Xiaoduan's wig are five almost identical white jade hairpins with the character *fo* 佛 (Buddha) arranged atop a lotus base. The hairpins

FIGURE 4.13 Anonymous, *Nine-lotus Bodhisattva*, 1593. Hanging scroll, ink and colors on silk. The collection of Metropolitan Museum of Art.

FIGURE 4.14 Empress Dowager Xiaochun was honored as Bodhisattva with Superior Wisdom (Shangzhi pusa 上智菩薩), Changchun temple, Beijing. Photograph of an old painting. *Source:* After Beiping shizhengfu mishuchu, ed., *Jiudu wenwu lue* (1935), 16, pl. 34.

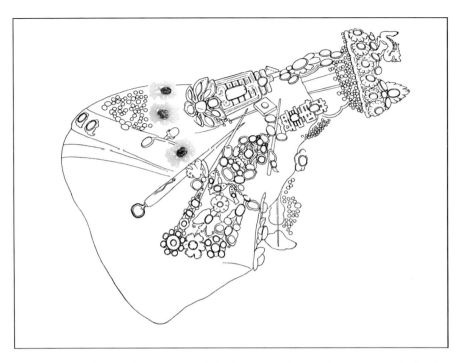

FIGURE 4.15 Line drawing of the hairpins with the characters of *fo* or Buddha on Empress Xiaoduan's cap Excavated in Dingling. *Source:* The line drawing is based on the line drawing in *Dingling* (Beijing: Wenwu chubanshe, 1990), 1:25. Illustration by Su Tong.

were inserted along the crown of the head (figure 4.15). The position of these five hairpins and the five *fo* 佛 characters echo loosely to the five-Buddha crown that is associated with tantric Buddhist practices and esoteric Buddhist death rituals. The central hairpin is a large *shou* 壽 character (longevity) carved in white jade. The only hairpin with a Buddha image on Xiaoduan's head shows a half-length Buddha set in a piece with large rubies (figure 4.16). The configuration of the Buddha's ruby body is not clearly defined, which indicates that the accuracy of the iconography was not the main concern. Like the other hairpins, this piece is impressive for its pricey materials rather than its subject. The ambiguity around iconography is echoed by the plurality of subjects on Xiaoduan's hairpins, which feature symbols of eternity from different religious traditions. The assemblage was intended to secure Xiaoduan's longevity from various perspectives.

Two sets of hair decorations containing ninety-four hairpins and other accessories were found on Empress Dowager Xiaojing's head and nearby. The archeological report suggests that the set on Xiaojing's head, which includes all of the hairpins with Buddhist symbols, is from her first burial and the set near her head comes

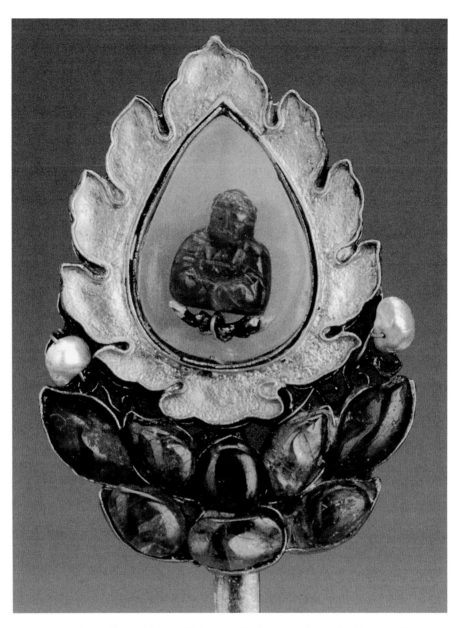

FIGURE 4.16 Hairpin with a Buddha (detail), Empress Xiaoduan, Dingling, gold, rubies, sapphire, and pearls (10.6 centimeters). Ornamented top (4.3 centimeters long, 3 centimeters wide; 15.3 grams). The collection of the Ming Tombs Museum. *Source*: Dingling bowuguan, *Dingling* (Beijing: Wenwu chubanshe, 1990), D112–41.

from the second burial.[106] This requires further proof, however, as the Buddhist symbols and the impeccable craftsmanship of the hairpins found on Xiaojing's head are more complicated and much more superior to those on the other cap next to her head. Given her status as an unfavored imperial consort at her first burial, the set on her head were likely venerated during her second burial, in keeping with her posthumous promotion in status.

The arrangement on Empress Dowager Xiaojing's head ostentatiously contrasts with Empress Xiaoduan's hair accessories. The archaeologists first noticed a hairpin with a standing Buddha inserted in the middle of Xiaojing's pointed cap, similar to Madam Sheng's from Wujin (figures 4.17 and figure 4.18). When excavators continued to detach other hair decorations from different sides of Xiaojing's head, they found one other hairpin with Buddha imagery, two more hairpins with Guanyin images, and more than forty hairpins with a wide range of auspicious symbols. Xiaojing's head was not only fully pinned with an array of signs, but those signs were divided into two parts: on the front of her cap and on its other sides. The latter suggests that those sectors held a symbolic meaning different from the front of her cap. Some of the hairpins inserted on the sides of her cap seem to have been intended to operate more like talismans, having the magical power to reduce the suffering from her lifetime. The front hairpin, as we'd expect, mimics Guanyin's hair decoration. To fully unpack the layers of meaning these hairpins carry, we first consider those meant to dispel suffering, and then we turn to the front hairpin, which was used to secure her a good rebirth. This case allows us to explore spirit adornments made solely for posthumous purposes. These two imperial women's burial items again call our attention to how jewelry and particular parts of women's bodies, namely head and hair, could become a site of agency, even in the face of the regulations on dress and jewelry corresponding to the women's rank at the Ming court.[107]

Eliminating Peril with Hairpins

Empress Dowager Xiaojing is perhaps the only person whose corpse carries multiple hairpins with Buddhist icons. In addition to the Amitābha Buddha hairpin on the front of her cap, she also wore one hairpin with the Medicine Buddha (Bhaiṣajyaguru, Yaoshi fo 藥師佛) on one side of her head, a hairpin with the Fish-basket Guanyin (another similar Fish-basket Guanyin hairpin was found on the cap placed nearby), and a hairpin with a stupa containing a tiny Buddha-like figure inside. The meaning behind the organization of the various hairpins on Xiaojing's head remains unclear. We can only speculate about the grouping based on craftsmanship, media, subjects, and location.

FIGURE 4.17 Line drawing of the Amitābha Buddha hairpin inserted in the middle of Empress Dowager Xiaojing's cap. *Source:* Line drawing is based on a photograph in *Dingling duoying*, pl. 166. Illustration by Su Tong.

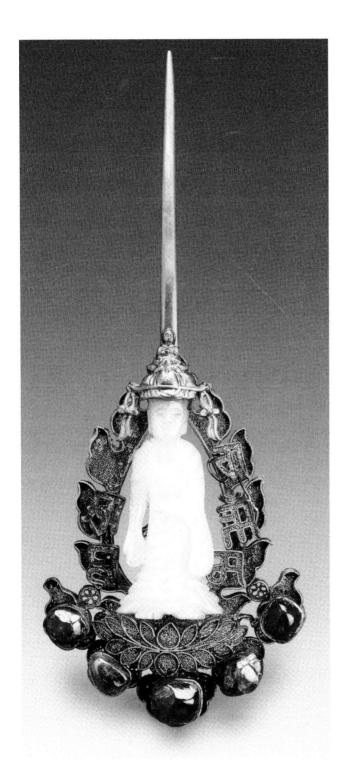

FIGURE 4.18 Amitābha Buddha tiaoxin hairpin (J124.18). Coiling silver wires, gold gilt, and gemstones (15 centimeters high, 5.7 centimeters wide; 0.0405 kilograms). The collection of the Ming Tombs Museum. *Source:* After Beijing shi changpingqu shisanling tuqu banshichu ed., *Dingling wenwu tudian* (Beijing: Beijing meishu sheying chubanshe, 2006), pl. 153.

The Medicine Buddha hairpin is filigree gold work inlaid with a pearl, rubies, and sapphires (figure 4.19). Standing on two separate lotus flowers, his left hand is positioned in front of his belly and holds a bowl, the signature attribute of Medicine Buddha. His right arm hangs down with the right palm facing outward.

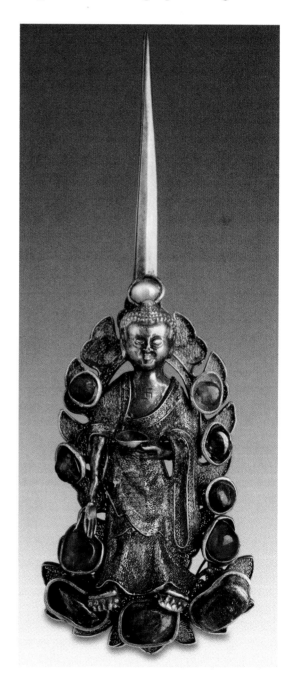

FIGURE 4.19 The Medicine Buddha hairpin (J124.2). Filigree gold inlaid with a pearl, rubies, and sapphires (11.8 centimeters high; 0.0276 kilograms). *Source:* After Beijing shi changpingqu shisanling tuqu banshichu, ed., *Dingling wenwu tudian* (Beijing: Beijing meishu sheying chubanshe, 2006), pl. 14.

The Buddha's exposed body parts are carefully formed. His robe and body halo are done in coiled gold wires, a technique often found on objects produced by imperial workshops. In contrast to Xiaoduan's large but sketchy ruby Buddha hairpin, the visual detail of this icon's gestures, signs, and even the folds of his monastic robe are meticulously achieved. I suggest that such accuracy enhances the efficacy of the hairpin. Unlike the Amitābha Buddha who manages the Western Pure Land and assists people with rebirth in the Western Paradise, the Medicine Buddha is believed to control the Eastern Pure Land of Lapis Lazuli and primarily eliminates sentient beings' suffering. The pairing of Amitābha Buddha for the afterlife and Medicine Buddha for eliminating earthly perils was common in late imperial China.[108] In a parallel fashion, the hairpins on Empress Dowager Xiaojing's cap joined her two lives and two bodies together: her physical body that had suffered during her lifetime and her transformation body that resided in the Western Pure Land. More on the latter in the following section.

The two white jade Fish-basket Guanyin hairpins inserted on Xiaojing's two different caps represent the popular late-Ming iconography of this Guanyin as a way to ensure efficacy. Apart from minor differences in size and weight, the iconographic forms of these two hairpins are nearly perfectly mirrored: the Guanyin on Xiaojing's head holds a basket in her right hand, the conventional arrangement (figure 4.20); the one found next to Xiaojing's head, holds a basket in her left hand (figure 4.21). Both figures are portrayed in robes with the front open and long skirts. Their bodies are adorned with floating streamers.

In chapter 1 about the Guanyin dance and Buddhist courtesans, we examined literature that noted the Fish-basket Guanyin uses her sexual appearance as an expedient means to spread the dharma. The discourse of sexual allure as illusion is woven into late-Ming courtesan culture. In contemporary *chuanqi* dramas, novels, and the *baojuan* literature on the Fish-basket Guanyin, however, storylines are developed in a different direction. Guanyin's power to capture evil spirits embodied by a fish, usually a carp, becomes the focus. The core belief about the Fish-basket Guanyin is that she can manifest her divine efficacy and help commoners.[109] Emperor Wanli's mother, Empress Dowager Li, showed great interest in transmitting the Fish-basket Guanyin image. She commissioned a pictorial stele of the deity in 1601, which was widely reproduced in various media and extended to the popular level (figure 4.22).[110] This is also the year when Xiaojing's son Changluo was elevated to crown prince. Whether or not she believed in Fish-basket Guanyin, this must have seemed a miracle to Xiaojing. On the stele, Guanyin, disguised as a laywoman, walks forward carrying a fish basket, but she walks along an embankment lined with huge lotus flowers. Dressed in layers of finely patterned silk, she lifts her skirt to reveal her bodhisattva jewelry underneath. The key visual message is Guanyin manifesting as a layperson on her way

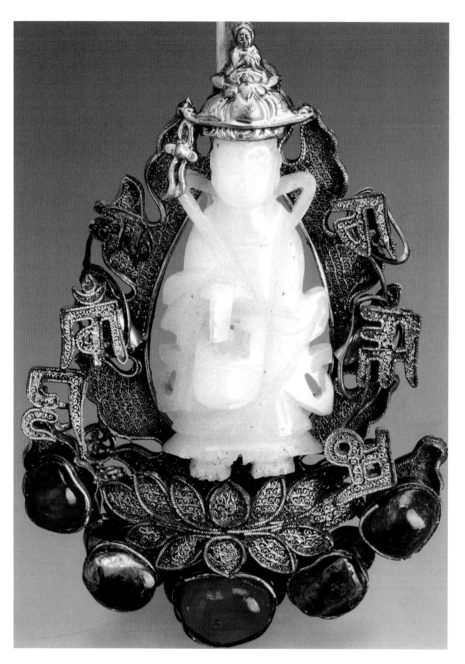

FIGURE 4.20 Guanyin hairpin (J124.17 detail). Coiling silver wires, gold gilt, and gemstones (17 centimeters long; 0.0373 kilograms). The collection of the Ming Tombs Museum. *Source:* After Beijing shi changpingqu shisanling tuqu banshichu, ed., *Dingling wenwu tudian* (Beijing: Beijing meishu sheying chubanshe, 2006), pl. 150.

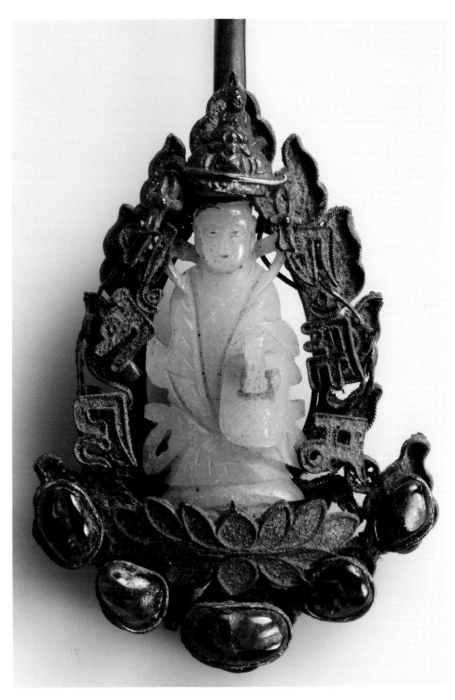

FIGURE 4.21 Guanyin hairpin (detail Jing 125–14). Coiling silver wires, gold gilt, and gemstones (11.1 centimeters long; 0.0358 kilograms). The collection of National Museum of China.

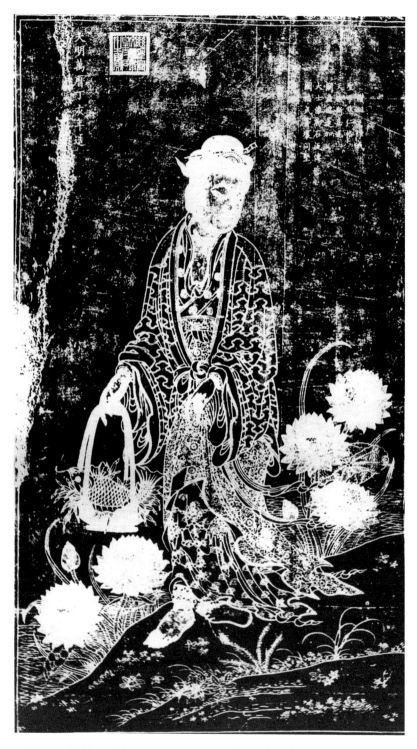

FIGURE 4.22 Fish-basket Guanyin, dated 1587. Ink rubbing of a stele at Cishou Monastery, Beijing. The collection of National Library of China. *Source:* After Beijing tushuguan jinshizu ed. *Beijing tushuguan cang zhongguo lidai shike taben huibian.* (Zhengzhou: Zhongzhou guji chubanshe, 1989–1991), 7:22.

to help people in the mundane world. Sexual allure is diminished. The Empress Dowager Li's promotion of the Fish-basket Guanyin was followed by aristocratic women who wore a hairpin cast in the same design. (figure 4.23) A representative piece, done in gold and belonging to the wife of one of the princes of Jing from Wanli period, was found in Qichun in Hubei Province.[111] But soon after, Fish-basket Guanyin became popular through literary texts, such as the late-Ming *Journey to the West*, and the idea of disguise fell from the iconography. Instead, the moment when Guanyin reveals her true identity as a divine figure becomes the representative icon.[112] In these images, she is rendered in a frontal iconic view, holding a basket with a fish in her right hand and wearing a goddess outfit with flowing streamers, as shown on Xiaojing's hairpins. The same design can be seen on the Fish-basket Guanyin hairpins offered by Lady Xiong in the White-robed Guanyin Pagoda and the Juxing Pagoda. Hence, the selection of the Fish-basket Guanyin as hairpins in Xiaojing's case, with their goddess-like iconography, suggests a talismanic function aimed to eliminate lived suffering and smooth her transcendence to the Western Paradise.

Empress Dowager Xiaojing as a Transformation Buddha

Turning to Empress Dowager Xiaojing's frontal view, the central hairpin attached to the middle of Xiaojing's cap is made of filigree gilt silver inlaid with jade and precious stones (figure 4.18). At the center, a standing Amitābha Buddha is carved in pure white jade. Like the Medicine Buddha hairpin except for his attributes, his right arm hangs naturally along the side of his body with right palm facing outward and his left hand is lifted to the level of his belly. He stands on a lotus platform made of coiled silver wires that are gilded. This posture and *mudra* are the standard iconography of the Amitābha Buddha who welcomes souls to the Pure Land. The body halo and lotus base are like those of the two Fish-basket Guanyin hairpins. The flame-shaped body halo made of coiled silver wires coated in gold is linked with a lotus base. The six-syllabic mantra "*oṃ maṇi padme hūṃ*" is arranged symmetrically along the right and left of the body halo. The bottom of the lotus base is decorated with rubies and sapphires.

The most intriguing feature of this Amitābha Buddha and the two Fish-basket Guanyin is a small figure that sits atop their heads (figure 4.24). This figurine wears a robe with wide sleeves, and her bun hairstyle indicates that she is an aged woman. She sits on a lotus base with two hands folded together in front of her chest. The archaeological report identifies this as a seated Buddha or another small Buddha image.[113] But the logic of the combined Amitābha Buddha (or Fish-basket Guanyin) and another small Buddha seems obscure.

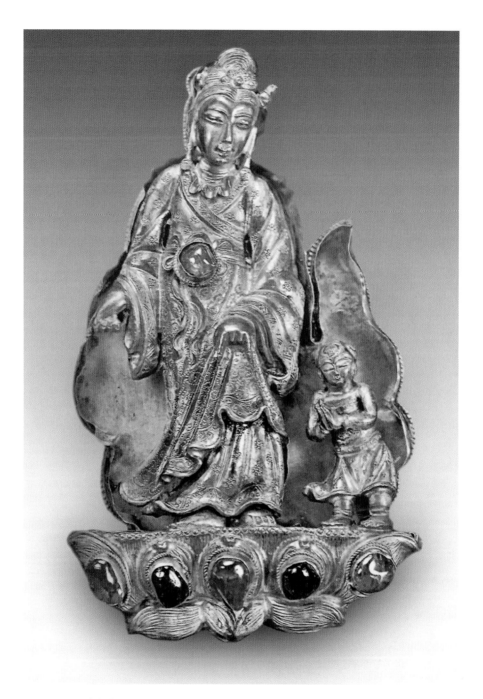

FIGURE 4.23 Fish-basket Guanyin hairpin, Wanli period. Gold with semiprecious stones (8.6 centimeters high, 5.4 centimeters wide; 39 grams). Excavated from Zhu Zaiyong 朱载塎 (sixteenth century) and his consort's tomb. Zhu is one of the Princes of Jing (Jingwang 荆王). The collection of Hubei Provincial Museum. *Source:* After Craig Clunas, Jessica Harrison-Hall, and Luk Yu-ping eds., *Ming China: Courts and Contacts 1400–1450* (London: British Museum, 2016), pl. 18.9.

FIGURE 4.24 Empress Dowager Xiaojing's three transformation body.

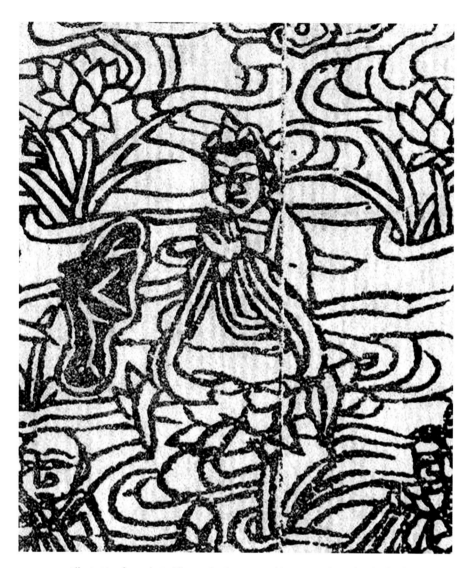

FIGURE 4.25 Illustration from *The Buddha Speaks of Great Amitābha Sutra*, Lady Lu (Lu shi 盧氏), conferred with titled of Consort Jing (Jing fei 靖妃) patronized, 1522–1566. Woodblock prints. *Source:* After Zhou Xinhui, ed., *Zhongguo fojiao banhua* (Hangzhou: Zhejiang *Wenyi chubanshe*, 1996), vol. 4, pl. 233.

When the three tiny figures are compared, they are surprisingly alike and apparently signify the same person. The iconography of this small portrait reminds us of the imagery of the female soul depicted in the Pure Land on the opening piece of *Foshuo da a mi tuo jing* 佛說大阿彌陀經 (*The Buddha Speaks of Great Amitābha Sutra*) (figure 4.25).[114] Even given the strict anti-Buddhist policies of the Jiajing court, Lady Lu, conferred the title of Consort Jing, was the patron

of these prints. The woman is adorned with a lotus flower crown, wears a long robe, and sits on a lotus. The stem of the lotus emerges from the surface of the pond. Her two hands are folded together in utmost reverence. Both print and figurine are presented in similar fashion, and both of them have hairstyles and clothing characteristic of women. It is possible that the minute figurine on hairpins represents the empress dowager's soul or her transformation buddha form. Although a Buddhist master like Zhuhong has argued that women could not be reborn in the Pure Land, in material practice, the imagery of Consort Jing's print and Empress Dowager Xiaojing's portrait suggests that women are directly positioned in the Pure Land.

Among funerary objects containing Buddhist elements, we often find miniatures that signify the reborn form in the Pure Land, loosely reflecting the soul's doctrinal "transformation birth" (*huasheng* 化生) as a newborn baby. In most cases, the miniature size also contrasts with the immenseness of the Amitābha Triad. Such a person's good rebirth can be positioned directly in the Pure Land or as on his or her way to the Pure Land. A clear example is the printed scripture blanket excavated from Zhang Mao's tomb, which was constructed during the Zhengde 正德 period (1505–1521) in Hubei Province. This scripture blanket (called a *fabei* 法被, dharma blanket) covered the body of Zhang Mao 張懋 (1437–1519), a teacher who devoted himself to Buddhism.[115] At top center, Amitābha Buddha places his right hand on the head of a small figure that sits with crossed legs and wears an outfit echoing the Buddha's robe (figure 4.26). This small figure likely represents the transformation buddha form of Zhang Mao. Guanyin and Dashizhi bodhisattvas hold the lotus base below the small figure. Zhang's reborn body is not rendered directly on the lotus base, but rather it sits on a cloud-like circle with a squiggly line coming behind him as if it has penetrated the sheet of paper. When the scripture blanket was found over the body, this section of the Amitābha Triad covered Zhang Mao's heart region. The squiggly line signifies that the dead body beneath the scripture blanket is changing into a transformation buddha.

On Xiaojing's hairpin, in between the portrait of her transformation body and the Amitābha Buddha, a canopy functions much like the squiggly line in that it signifies the transportation of Xiaojing's rebirth to the land of ultimate happiness. This canopy is in a reverse lotus-leaf shape adorned with tassels on two sides (figure 4.24). It not only signifies the divinity of Amitābha Buddha but also serves as an omen that can carry the soul to the Pure Land just before someone's death.[116]

The placement of Xiaojing's transformation form echoes the logic of channeling the soul from inside the human body.[117] A mural painting from the Northern Song period provides a visual cue as to how someone's soul was believed to emerge from

FIGURE 4.26 Dharma blanket (detail), Ming dynasty, dated 1519. Print on hemp paper (162 centimeters long, 77 centimeters wide). Excavated from the tomb of Zhang Mao (1434–1519) in Guangji 廣濟 County, 1983. The collection of Hubei Provincial Museum. *Source:* After Fan Jeremy Zhang, ed., *Royal Taste: The Art of Princely Courts in Fifteenth-Century China* (New York: Scala Arts Publishers, 2015), 72.

the body and travel to the other world (figure 4.27). The subject of the scene is verified by the title in the cartouche: "The Great Saint of Sizhou Delivers an Old Man and Woman" (*Sizhou dasheng du weng po* 泗洲大聖度翁婆).[118] Sengqie or the Great Saint Sizhou is often believed to be a reincarnation of Guanyin. On this mural, Sengqie is accompanied by his attendants and enveloped by clouds. He wears a hood and a *kasaya*, holds a scripture in his hand, and descends to receive an old couple in plain clothes. Both man and woman kneel with their palms pressed together prayerfully. The woman's hair is piled up in a bun and is fixed with hairpins front and back. A line rises from the top of her piled hair, and another rises from her husband's hat.

FIGURE 4.27 "The Great Saint of Sizhou Delivers an Old Man and Woman," mural, dated 1108. North wall, excavated from a tomb in Pingmo 平陌, Xinmi 新密, Henan Province. *Source:* Photograph provided by Professor Li Qingquan

These lines culminate in the shape of a *lingzhi* cloud that indicates their departure. A wavy line beneath rising clouds was used to frame heavenly scenes of buildings, musical instruments, and fairies in early Buddhist art. In the Ming period, this convention is carried forward by the peg of a hairpin. The cloud head becomes the head of the hairpin.[119] Therefore, when the Amitābha Buddha hairpin was inserted into Xiaojing's cap, that single peg served as a metaphor for delivery. The peg of the hairpin, Amitābha Buddha, the canopy, and Xiaojing's transformation form together suggest a vertical, ferrying movement in her corpse.

In addition to the hairpins with obvious Buddhist icons, many others are placed on Xiaojing's cap or nearby, including a pair of baby-holding lotus flowers, treasure flowers and birds, and immortals. The various auspicious symbols and treasured hairpins create a symbolic Pure Land, the destiny of the transformation body of Empress Dowager Xiaojing.

Unlike the bodies of the Wanli Emperor and Empress Xiaoduan, which were covered with layers of objects, robes, and blankets, Xiaojing's corpse was protected with a plain satin blanket called a *jingbei* 經被 "scripture blanket" or "dhāraṇī blanket," originally inscribed with scripture in a red color.[120] Most of the characters have faded. Several large characters arranged vertically in the middle can be recognized

as *nan wu a mi* 南無阿彌. The complete phrase should be *nan wu a mi tuo fo* 南無阿彌陀佛 or Amitābha Buddha. The other two identifiable characters are *hua yan* 華嚴 (*Avataṃsaka* or flower garland).[121] It remains unclear whether these two characters are directly related to the Avataṃsaka Sutra. Because the Avataṃsaka Sutra was one of the scriptures on the *dhāraṇī* blanket, it is important to mention one of the merit-transfers (*huixiang* 迴向) described in this sutra. The merit accumulated by the living can be transferred to the dead and can free the dead from the cycle of rebirth to achieve nirvana.[122]

Funerary objects like the scripture blanket and Xiaojing's hairpins were media by which to bridge the corpse and its reborn form in the Pure Land. They solve the classic issue in Chinese funerary art, namely, how people signified a dead body transcending to the other world in a tomb context. In these two cases from the Ming period, that transformation is materialized through objects intimately connected to the bodies: a blanket covering and jewelry attached to headwear. When Empress Dowager Xiaojing's soul or transformation buddha form is positioned atop Amitābha Buddha and Guanyin hairpins, it signifies the internal transformation that took place inside her body as realized at the top of her head. It starts with mimicking Guanyin's appearance by wearing a hairpin similar to Guanyin's. Yet Xiaojing's hairpins also explicitly visualize the purpose of mimesis, which is to enable her rapid transformation to the Pure Land.

CONCLUSION

By discussing women's devotional mimesis of Guanyin through hairpins in the Ming period, we learn how wealthy women participated in devotional practices. Thanks to a shared gender identity, women could metonymically mimic Guanyin and thus seek enlightenment. Simultaneously, the shared gender identity stimulated material practices that allowed women to use jewelry worn on their bodies to create an intimate connection with the deity. The rich evidence in the design of women's hairpins and the context of each piece and its wearer show that jewelry is not simply an adornment but rather is an efficient and powerful device by which women could declare their religious authority. In premodern China, with limited access to spiritual and secular authority, women creatively manipulated these objects as well as elements of their bodies. Devotional hair adornments became a vehicle by which they could insert their interests between the cracks of state regulations around dress and ornaments. Even when these hairpins were arranged on their dead bodies by relatives, those bodies can still be considered sites of agency, because the items they bore afected their success in the afterlife.

By unpacking the semantic and contextual meanings of these objects, we can uncover religious practices that went unrecorded or were even intentionally omitted from the historical record. If some of the discussion in this chapter and in this book sounds speculative, it remains a first step toward recovering women's roles in the cult of Guanyin. Where written history is silent, we should turn to material objects as evidence and explore the logic of those objects in relation to their owners.

Women's elaborate devotional practices took place only in the Ming dynasty. On one hand, a feminized Guanyin provided a convenient form by which women could transcend to the Pure Land; on the other hand, women's material practices were still conditioned by historical transformations. After the fall of Ming, although devotional dance (unlikely by courtesans), painting, and embroidery continued to be created by laywomen, the practice of wearing devotional hairpins vanished. This was due to several factors, such as changes in hairstyle and dress code, as well as the regulation of gold, silver, and jade under a new regime. Even so, women continued to seek other ways to empower themselves through the worship of Guanyin.

Conclusion

From Home to Temple and Court: Restaging Women's Devotional Objects

Throughout this book, I have tried to answer two central questions: How did a gendered transformation of a deity affect believers in terms of their own gender identities? What did Buddhist laywomen in late imperial China actually *do* to forge a connection with the subject of their devotion, the bodhisattva Guanyin? These questions arise at the intersection of several historical trajectories: First, Guanyin was primarily worshipped as a female deity after a thousand-year period of feminization and domestication, although in late imperial China, gender politics were still in play regarding the feminine and masculine manifestations of Guanyin. Second, the Ming-Qing period is understood to be a time during which many women attained advanced levels of literary and artistic accomplishment. Women's training in writing, painting, embroidery, sewing, dance, and many other skills enabled them to express devotion by creating Guanyin icons. Third, under the influence of neo-Confucianist discourse, women's chastity and purity was widely promoted throughout China. Domestic space was the central site for woman to practice filial piety, participate in the cult of purity, and pursue religious practices, such as Guanyin worship. Fourth, over the course of the Ming dynasty, major transformations occurred in the political economy, including the rise of burgeoning markets. The wealth these markets generated supported an increase in literacy, which in turn fueled a major booming in publishing and book culture.[1] The growth of the economy also gave rise to an expansion of material practices, which came to include circulation of printed painting and embroidery manuals, elaborate hairpins, and dance crazes. These numerous factors and processes came together in what one could call the structure of conjuncture, and together, they created the conditions for the possibility of the practices studied in this book.

This book explores the relationship between worshipper and worshipped in practice. For women in late imperial China, that relationship was established

through material objects that facilitated various forms of mimetic connection between their bodies and their object of worship: Guanyin, or more precisely, a feminized form of Guanyin. With a feminine bodhisattva, women could project physical likeness in various ways to achieve transcendence of the finite world. The process of making and using things was gendered because the materials, skills, and subject matter, as well as the motivation for making and the function of the object, could all be directly linked to creator's body. Women used the power and efficacy of their bodies to echo that of Guanyin and manipulated material objects to create their religious authority.

The practices and beliefs around dance, painting, hair embroidery, and jewelry explored in the proceeding chapters together present a picture of how laywomen of different social status linked themselves to Guanyin. Each practice and its discourse were a choice of medium for merit-making, and each involved gender politics with respect to Guanyin's feminization, Guanyin's embodiment, and the practice of writing about or omitting Guanyin from the historical record. This highlights one of the key arguments of the book: Buddhism provided a space for female agency, and this space could either challenge or reproduce existing power structures. We see the emergence of a new idea of merit-making that physical likeness to the deity enabled a transcendence of the finite world. A new, mimetic means of forging the relationship between worshipped and worshipper created the conditions for the worshipper's merging with the worshipped.

I conclude by considering a vernacular story written by Ling Mengchu (1580–1644) that illustrates how women's devotional objects (including many of the objects discussed in the chapters here) functioned as "living objects," which leads to a closing discussion of their continued presence and effects in temple rituals and at court through the early twentieth century.

In the story, "Wine Within Wine, Nun Zhao Intoxicates the Beauty; A Trick Within a Trick, Scholar Jia Avenges a Grievance," we meet Lady Wu, an exceptionally beautiful and virtuous woman.[2] Her merits include skill at needlework, pious womanhood, and her self-restriction to the boundaries of her domestic space. She embroiders an image of Guanyin in prayer for a child, a practice the story claims to be the most efficacious way to ask for the bodhisattva's aid. Her Guanyin embroidery is glorious. When her husband takes the piece to a shop to have it mounted as a scroll, everyone applauds its skill. Lady Wu then hangs the scroll on a wall in a special room at home and prays in front of the image every day.[3]

Sometimes, when her husband is away, she invites a nun surnamed Zhao to her home. The nun, from a nearby Guanyin abbey, asks Lady Wu to go to the shrine with her. But Lady Wu maintains her womanly virtue and goes to the shrine only once or twice a year for important festivals, such as Guanyin's birthday. Once, as

she is escorting the nun to her door, a local hooligan named Pu Liang catches a glimpse of her face and lusts after her for her beauty. Pu Liang begs the nun to create a situation in which he can seduce Lady Wu. As in many other vernacular stories from the late Ming, monastic women are defamed as troublemakers who lead chaste women to "the outside," the contaminated world.[4] This is true in this story as well. Nun Zhao is, in fact, a female procurer who collects money by having her acolyte, a young nun, provide sexual services to different clients. Zhao finally entraps Lady Wu by telling her that the most efficacious way to get pregnant is to chant the White-robed Guanyin Sutra, just as we read in "Case One: Xing Cijing— Guanyin and the Ideal of Procreation" in chapter 2. The nun further persuades Lady Wu that she must go to the abbey to get the sutra herself, and when she does go to the Guanyin shrine, Zhao drugs her. As Lady Wu lays asleep on a bed in one of the shrine's rooms, Nun Zhao leads in Pu Liang, who rapes her. When Lady Wu wakes up, she tragically discovers that her chastity has been violated. She rushes home and, weeping in front of her embroidered Guanyin, prays for help.

That very night, her husband has a dream of a white-robed woman entering his place in Pozhou, and when he follows her into a room, the woman suddenly walks into the embroidered Guanyin scroll hanging on the wall. There he reads a line of characters that tell him to take revenge. Upon waking up, he realizes his wife must be in trouble and so he returns home. When he hears what happened to his wife, he decides to make the nun and the hooligan pay for what they have done. He persuades Lady Wu not to commit suicide, because more people would find out about her impurity if she did so. Finally, they entrap Nun Zhao and Pu Liang, and all the nuns of the Guanyin Nunnery, both old and young, are killed; Pu Liang also is put to death. At the end of the story, the narrator-author instructs every chaste woman to avoid befriending nuns and to remain in the inner chambers.

This story clearly juxtaposes two trajectories in the cult of Guanyin, which are represented by two distinct sociomoral spaces: home versus the temple. At home, women pursued virtue, embroidering images of Guanyin and worshipping in their domestic religious space, which, like their painting and embroidery, is self-supplied (chapter 3). The laywomen introduced in this book conducted their various religious practices mostly in the domestic domain. At a shrine or temple, women worshipped statues and donated money to print scriptures, which meant visiting a public place and interacting with clergy. This narrative verifies a fact that many scholars have articulated—although Buddhism's popular appeal reached new heights in the Ming and Qing periods, the Confucian strand in society viewed its religiosity as a threat to the foundations of the Confucian family order and gender segregation. In strict families, women were prohibited from contacting clerics, participating in religious associations, and going to temples.[5] These prohibitions may

have reflected the actual situation in some communities. This vernacular story, and many others like it, clearly warn about the consequences of women not heeding these restrictions. The distinction it presents between Guanyin and her shrine is telling—the real Guanyin with sacred power was created by a woman's hands at home, whereas the Guanyin shrine was a place where scandalous nuns resided. This surprising contrast seems to resonate with the fact that Guanyin was also associated with prostitutes and courtesans in the late Ming (chapter 1). Although some literati connected their courtesans' inner purity with the bodhisattva, this story frames the Guanyin shrine as a brothel.

Contrary to the literary imagination, in actual practice, the Buddhist temple in late imperial China was considered a sacred place where people could be granted their wishes if they achieved sufficient merit. Unlike the story's claim that Lady Wu's embroidered Guanyin was seen only by outsiders in the mounting shop and was primarily worshipped in a shrine in her home, women's paintings as well as embroidered, woven, and sewn Guanyin images have been discovered in many monastic collections. That women considered their homes to be the place to worship Guanyin does not exclude the circulation of icons they created or mean that objects such as hairpins were used exclusively in domestic spaces. Indeed, there were various channels through which women's Guanyin works and objects entered the world beyond the boudoir.

Throughout this book, I have cited women's visits to temples and offerings of Guanyin objects at temples or shrines. Remember how Madam Xu donned a Guanyin hairpin and visited Huanggu Temple in Beijing to present a banner. Xu Can, Lin Jinlan, The daughter of Yang Yuchun, and Miss Diao all dedicated their Guanyin paintings and embroideries to local Buddhist institutions. Lady Xiong offered hairpins to the White-robed Pagoda in Lanzhou to secure an heir, while Madam Sheng's burial alluded to pilgrimage to Putuoshan.

In the case of Ni Renji's hair-embroidered Buddha (or Guanyin according to a Qing textual source), the inscription clearly states that she anticipated that the icon would be kept by the family forever. After she passed away and was buried in Longping Temple (Longping si 隆平寺) with her husband, her hair embroidery was offered to the temple.[6] This icon, made from part of her physical body, was originally intended as merit-making on behalf of her parents. Now, it also protected her body and safeguarded her transformation as an item sanctified by being part of a temple collection.

From both surviving Guanyin objects and textual materials, we know that Guanyin images made by women in their inner chambers were created as offerings for Buddhist temples and shrines, either to make or fulfill a vow as merit-making, as in the story of "Hair-Embroidered Buddha" and the case of Lin Jinlan's Guanyin

(chapter 3). Vow fulfillment often took place in a public religious space where others could witness it. One Qing-era anecdote introduces a young girl from Sheng County in Zhejiang Province, named Jin Xingyue 金星月. When she was seventeen years old, her fiancé died before she could marry him. She decided to enter the household of her fiancé and vowed to make an embroidered wall hanging of the five hundred Arhats to accumulate merit for the "husband" she never married (and perhaps never met). She remained in her chamber for more than ten years completing the embroidery. When it was finished, her father accompanied her to the Zhaoqing Temple in Hangzhou to display the piece. When this became a publicly known, her work attracted a vast audience.[7] Her more than ten years of dedication was manifested in the countless stitches across five hundred figures on the huge embroidery. Her determination to remain a chaste virgin widow and her vow were both fulfilled under the public eye. She was widely applauded for her dedication, and the author of the anecdote composed thirty poems to eulogize her.

Religious icons and other ritual objects made by women also survive as living objects that continue to affect monastic rituals. The gender specificity embedded in the material and skill is sometimes explicitly referenced during the rituals. For instance, Defeng, a late-nineteenth- and early twentieth-century abbot from the Wenshu Temple in Chengdu, inscribed a comment on the margin of Miss Yang Yuchun's hair embroidery hanging scroll in 1915. His colophon discloses that he had no knowledge of the practice of hair embroidery until seeing Yang's work. He was amazed at how someone could use hair to create a Guanyin icon. It is precisely for this reason that Yang's Guanyin was selected as the only one used in the Śūtaṅgama assembly (Lengyan hui 楞嚴會), a ceremony in which monks get together to chant the *Śūtaṅgama sutra*, especially the long *dharani* or magical spells (chapter 1). This ceremony takes place only twice a year. The "Magical Spells of White-robed Guanyin with Great Compassion" (*Baiyi dabei Guanyin shenzhou* 白衣大悲觀音神咒) is stitched above Guanyin on Yang's scroll. Although these spells are not directly related to the chanted *Śūtaṅgama sutra dharani*, they loosely echo the nature of the Śūtaṅgama assembly. The sacred power concentrated in Yang's work is revealed in the ceremony that Guanyin magically illuminates.[8] Here, women's hair and skill in needlework are recognized and celebrated as animating the presence of Guanyin.

Certain temples deliberately collected women's artworks. We can look to the surviving pictures in a group of collected Guanyin images from the small Buddhist temple Bianlijiang Yuan 辯利講院 (commonly known as Jingting an 井亭庵) in an eastern suburb of Hangzhou. The Guanyin images in the possession of this temple are made in a wide range of media and include paintings, embroideries, paper cutouts, and ink rubbings. Most were produced during the Qing dynasty. They include works by well-known female painters and embroiderers, such as Xu Can, Han

Ximeng, and Zhou Shuxi (1624–1705), from the gentry class as well as by courtesan painters like Lin Xue.

The Bianlijiang Yuan Collection was built up in two ways: first, through personal offerings from both male and female devotees mainly during the Qing period. For instance, at least two embroidered Guanyin scrolls, one by a Mrs. Zhu (née Xu) in 1794 and one by a Mrs. Li (née Ding) in the year of *renshen* in the Qing period, were dedicated to this temple.[9] Second, family or people other than the artists donated items. Several collectors from the Hangzhou area contributed their Guanyin objects to the temple as a form of merit-making in the mid- and late-Qing period. Ding Bing 丁丙 (1832–1899), a book collector from Hangzhou and frequent visitor to Bianlijiang Yuan during the second half of the nineteenth century, asked his two daughters Ding Henggong and Ding Hengchi to create at least five Guanyin paintings so that he could commemorate his late teacher (even though this teacher was not a Buddhist), his mother (also the girls' grandmother) on her posthumous birthday, and his pilgrimage to Potalaka Mountain. Both daughters were exceptionally skilled painters, but the motivation behind their image-making was to support their father's project to expand the collection of Guanyin images for the temple.[10]

Zhang Jian 張謇 (1853–1926), entrepreneur, politician, and educator, purchased the entire collection from Bianlijiang Yuan in the early twentieth century and offered it to the Guanyin temple in Langshan, Nantong. He even had a new building constructed to house the collection and named it Zhaohui shenxiu zhilou 趙繪沈繡之樓 (The Tower of Zhao's Painting and Shen's Embroidery) after the eminent male painter Zhao Mengfu (1254–1322) and the most successful female embroiderer Shen Shou (1874–1921) in the twentieth century.[11] Up until 1938, these works were reproduced as collotype prints and circulated to the public.[12]

Long before Zhang Jian's efforts to purchase, curate, and exhibit this collection, Bianlijiang Yuan had already conducted rituals surrounding the display of the icons and chanting Buddha's name (*zhangxiang chanson* 張像禪誦). These rituals were held twice a year, in February and August. The public viewing attracted countless people from the Hangzhou area.[13] Before museums were introduced to China, temples were perhaps the only public place where people could see an organized thematic exhibition. This type of exhibit, however, was curated specifically for a *daochang* 道場 or a ritual space.[14] Shen Chengxi 訛承禧, a native of Hangzhou from the Daoguang period (1820–1850), was so impressed by the spectacle of so many Guanyin images and felt such tremendous joy in the viewing that he voluntarily distributed the catalog of artists' names and donated a Ding Yunpeng painting of Guanyin from his own collection.[15] In this context, images of Guanyin go beyond gender, class, and social status. They show how religious venues in certain circumstances transcend the mundane distinctions embedded in

social and political structures. This type of transcendence resembles what Amino Yoshihiko describes in his discussion of Sengoku Japan (1467–1568), and specifically what he calls *muen no ba* 無縁の場 (spaces free from karma).[16] These were places where various relations, including those of lordship, bondage, and gender were suspended. Amino's temples overlap with my narrative about late imperial China, but they do so with some important differences. In the Japanese case, people go to these places and are freed from hierarchical relations. In China, however, objects or works were brought into religious spaces where they functioned as vehicles that enabled transcendence, irrespective of the gender or status of the person who made them.

Outside the temple collections, women's paintings and embroidery were a form of cultural capital. They represented local pride and were sometimes even presented to the court. The specifics about the artist and medium were usually confirmed in the gift transaction. During the early and mid-Qing period, in particular, women's representations of Guanyin were considered precious presents. Additional uses besides the original function of these icons accrued to them, and this redounded to their maker's social status in both this life and the afterlife. For instance, Chen Shu, one of the most prolific women painters of the early Qing, in 1713, at the age of fifty-four, created a painting of Guanyin in ink and color titled *Universal Gate of Great Being by the Sea* (*Pumen dashi chuhai xiang* 普門大士出海像 (figure C.1). Six decades after she created the painting, her eldest son Qian Chenqun 錢陳群 (1686–1774), a secretary in the Ministry of Rites, presented his deceased mother's painting to the Qianlong emperor who then inscribed a poem on the painting as a sign of favor.[17] Qian Chenqun eulogized his mother's painting and wrote a memo thereon noting that he was eighty-six years old when he presented this object to the court as a gift. His gesture honored his mother posthumously, while also demonstrating his filial piety. What is hidden beneath the textual surface of Qian Chenqun and Qianlong's inscriptions, however, is a female gift-giving practice between locality and court. As Marsha Weidner has correctly suggested, Chen Shu's painting was likely presented to Emperor Qianlong's mother Empress Dowager Chongqing 崇慶 (1693–1777) for her eightieth birthday when Qian Chenqun went to Beijing to participate in the celebration.[18] Many more examples of women's Guanyin paintings and embroideries were given as birthday gifts to empresses or empress dowagers to build connections between local gentrywomen and the Qing court.[19] Such gift-giving practices seem to be a self-evident practice: female artists created icons of a female deity that was also favorably seen by imperial women. In such cases, however, these artworks did not merely use Guanyin as a symbol for longevity; rather, they transformed Guanyin into a catalyst that enabled both Han Chinese women and Manchu women to cross ethnic boundaries.

FIGURE C.1 Chen Shu, *Universal Gate of Great Bing by the Sea*, Qing dynasty, 1713. Hanging scroll, ink, color on paper (70.7 by 27.2 centimeters). The collection of National Palace Museum, Taipei.

Marsha Weidner has provided precise observation of this painting, in her words: "depicted at home on Mount Potalaka, the deity sits on a rocky outcropping over the water and holds a willow branch in one hand. The rocks are described with dark, modulated outlines, based on academic landscape painting of the Southern Sung [Song], the period in which this type of Kuan-yin [Guan-yin] image was definitely formulated. Elements such as the fluid drawing of the wavy contours of the bodhisattva's robe and the hint of archaism in the narrow, rippling fabric folds can be connected to the styles popular with late-Ming and early-Ch'ing[Qing] painters of religious figures." (Weidner, "The Conventional Success of Ch'en Shu," 130)

Just where a woman's religious art landed in the vast properties of the court also could shape its meaning. Such objects were not only kept inside the Forbidden City in Beijing but also were brought to different imperial resorts across the north. Even inside the Forbidden City, the function of each palace was different; therefore, the location of a piece would have defined its significance.

During the Qianlong period, embroidery and *kesi* silk-woven tapestry were highly promoted and used as media to reproduce a vast number of paintings and calligraphies.[20] Prosperity and durability are both embedded in the making of these luxury goods and in the media used. Inside his court, Qianlong knew very well how to use a decorative object to project his benevolence and the cultural prosperity of his empire. Women's religious art made with a clear attribution, although a small holding, were part of his cultural enterprise.[21] Women's Buddhist art, used as a *type* of object, along with other decorative arts, could be displayed or stored in different palaces to map out his ideal of cultural affluence. For instance, Madam Wang, the mother of Qiu Yuexiu 裘曰修 (1712–1773), minister of rites, along with her grand daughters-in-law, embroidered three types of Buddhist subjects—Guanyin with the Heart Sutra, Wenshu, and Bodhidharma—and dedicated these embroidered icons to the Qianlong emperor.[22] The objects were displayed in both the Qianqing Palace (Palace of Heavenly Purity) in the Forbidden City and at the Mountain Resort in Chengde.[23] A large embroidered Wenshu or *Mañjuśrī on a Lion* is a copy of but one of Ding Guanpeng's 丁觀鵬 (active 1708–1771) paintings of the same title and was associated with Emperor Qianlong's project of transforming Mount Wutai into his own imperial site.[24]

The imperial Manchu women of the Qing court also created religious images with needle and thread just like Han women, but they followed the Tibetan Buddhist visual tradition in terms of techniques and subject. Emperor Qianlong's mother, Empress Dowager Chongqing, and her palace girls were believed to sew a large silk applique (*duiling* 堆綾) *thangka* of Green Tara dedicated to her deceased husband Emperor Yongzheng 雍正 (1678–1735), for the Hall of Eternal Protection (Yanyou dian) in the lama temple Yonghegong 雍和宮 in Beijing. [25]Seven thousand silk pieces are stitched to mimic *thangka* painting.[26] As we have seen, the Empress Dowager Cixi went further, theatrically identifying herself with Guanyin by means of costume, staging, painting, and photography. Cixi's own transcription of the *Heart Sūtra* with a date of 1904 and her portrait as Guanyin on the frontispiece took her embodiment of Guanyin to a new level by inserting herself into the format of Guanyin's scripture (figure C.2). We can observe the dual religious behaviors behind the simultaneous embodiment of Guanyin and transcribing Guanyin's text. This doubleness of image and text changes the visual code embedded in the dynamic relationship between Guanyin's icon and Guanyin's words in the *Heart Sūtra*. In other

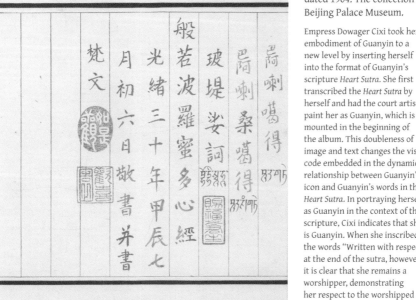

FIGURE C.2 Anonymous court artist, *From the Brush of Her Majesty Cixi Heart Sutra of Prajna Paramita*, Album, color on paper. Qing dynasty, dated 1904. The collection of Beijing Palace Museum.

Empress Dowager Cixi took her embodiment of Guanyin to a new level by inserting herself into the format of Guanyin's scripture *Heart Sutra*. She first transcribed the *Heart Sutra* by herself and had the court artist paint her as Guanyin, which is mounted in the beginning of the album. This doubleness of image and text changes the visual code embedded in the dynamic relationship between Guanyin's icon and Guanyin's words in the *Heart Sutra*. In portraying herself as Guanyin in the context of the scripture, Cixi indicates that she is Guanyin. When she inscribed the words "Written with respect" at the end of the sutra, however, it is clear that she remains a worshipper, demonstrating her respect to the worshipped deity—Guanyin.

words, Guanyin is presented through the pictorial image of Cixi and the text of Guanyin's scripture is manifested though the hand of Cixi. This would mesh with the import of the *Heart Sūtra*, which repeats that form is none other than emptiness. However, Cixi is never able to completely empty out into Guanyin and turn her form into nothingness. For this reason, becoming Guanyin is not the same as "being" Guanyin. She circulated a similar portrait at court, and commoners outside court could purchase photographs of her as Guanyin. In this way she both exercised her power as monarch and aimed for religious salvation.[27]

The material practices of women's religious lives constitute a vast topic, and this book represents a preliminary attempt to address them. Although I focused mainly on domestic practices, I hope this study will be a springboard for broader future research. When women practiced religion at home, they incorporated practices originating outside the domestic domain, which they learned of through literary and artistic works. Women may have performed their devotions at home, but the products of those devotions reached beyond the boudoir to circulate their names and virtue. By producing religious icons or using spiritual objects, individual women collectively created a religious realm. We must contextualize the wide range of their religious expressions to help us understand the relationship between things and the people who created and used them. This book presents but one historical consideration of how people's religious beliefs and practices are mutually constituted.

Notes

INTRODUCTION

1. I refer to Guanyin as *popular* in three senses. First, in the straightforward sense that many people believed in Guanyin; Guanyin worshippers are from all geographical regions in late imperial China. Second, Guanyin goes beyond the distinction between elite and popular religion; Guanyin believers cover the full spectrum of social strata. Third, although Guanyin is a Buddhist deity, s/he was assimilated into a practice that combined different religions such as Confucianism, Daoism, and many local beliefs.

2. The key pioneering studies on this topic are Chün-fang Yü, *Kuan-yin: The Chinese Transformation of Avalokiteśvara* (New York: Columbia University Press, 2001).

3. For a critical analysis of Confucian discourse as a male-dominated discourse, see Alan Cole, *Mothers And Sons in Chinese Buddhism*. (Stanford, Calif.: Stanford University Press, 1998), 14–15.

4. In recent years, more scholars have explored the material culture of Buddhist practice. John Kieschnick has mapped out a wide range of objects that evolved in Buddhist rituals, mostly in monastic settings, to show how objects initially associated with Indian Buddhism had a profound influence on Chinese material culture. John Kieschnick, *The Impact of Buddhism on Chinese Material Culture* (Princeton, NJ: Princeton University Press, 2003).

5. For a proper term to categorize Guanyin's gendered transformation, see the discussion in the latter section of this introduction.

6. To date, literary historians are the most productive and provocative. They have concentrated on Chinese women's roles as literary producers and have discussed them in terms of women's writing communities, individual writers, women's role as teachers, and compilers and have examined the relationship between male and female authors. For a critical review of the field of literature written by women in China, see Emma Jinhua Teng, "The Construction of the 'Traditional Chinese Women' in the Western Academy: A Critical Review," *Signs* 22 (1996): 115–151; and Guotong Li, "A Research Review on the Studies of Women's History in Late Imperial China," in *Excursions in Sinology*, ed. Lee Cheuk Yin (Hong Kong: Business Press, 2002), 279–299. Robin Yates's extensive bibliographical information on the study of women in Chinese history in the Western language testifies to the development of this field. Robin Yates, *Women in China from Earliest Times to the Present: A Bibliography of Studies in Western Languages* (Boston: Brill, 2009).

7. Kang-i Sun Chang, "Ming-Qing Women Poets and the Notions of 'Talent' and 'Morality,'" in *Culture and State in Chinese History. Conventions, Accommodations and Critiques*, ed. Theodore Huters, R. Bin Wong, and Pauline Yu (Stanford: Stanford University Press, 1997), 236–258.

8. Dorothy Ko, *Teachers of the Inner Chambers: Women and Culture in Seventeenth Century* (Stanford: Stanford University Press, 1994), 160. Wang Cheng-hua also insightfully points out another set of paradox. When women's talent was highly promoted by scholars in the late Ming and early Qing, women also became objectified by male desire. Wang Cheng-hua, "Nüren, wupin, yu ganguan yuwang: Chen Hongshou wanqi renwuhua zhong Jiangnan wenhua de chengxian," *Jindai Zhongguo funüshi yanjiu*, no. 10 (December 2002): 11.

9. Beata Grant, *Eminent Nuns: Women Chan Masters of Seventeenth-Century China* (Honolulu: University of Hawai'i Press, 2009), 130–145.

10. Scholars in Chinese religious studies have pointed out that no Chinese religious system can be considered monolithic; different approaches to similar issues and practices co-existed in each. Nonetheless, one can still discern the practices that dominate in each religious system. Anthony C. Yu, *State and Religion in China: Historical and Textual Perspectives* (Chicago: Open Court, 2005), 5–25. For a discussion of various interpretation of Confucianism, see Viren Murthy, "The Politics of Time in China and Japan," in chapter 9 of *Oxford Encyclopedia of Comparative Political* Theory, ed. Leigh Jenko, Murad Idris, and Megan Thomas. Oxford: Oxford University Press, forthcoming, 2020.

11. Ko explains how the distinction between inner and outer spheres in late imperial China does not map onto the simple distinction between domestic and public spaces. Rather, these inner and outer spheres represented points on a continuum; consequently, women's practices would begin in the inner chambers and extend to "the neighborhood and to the heart of the so-called public sphere." Ko, *Teachers of the Inner Chambers*, 13.

12. Barend J. Ter Haar, "Buddhist-Inspired Options: Aspects of Lay Religious Life in the Lower Yangzi from 1100 until 1340." *T'oung Pao*, Second Series, 87, no. 1/3 (2001): 92–152. Yi Ruolan, *Sangu liupo: mingdai funü yu shehui de tantao*. Taipei xian banqiaoshi: Daoxiang chubanshe, 2002.

13. See chapter 7 in *Miaofa lianhua jing*, translated by Kumārajīva, T9, no.262.

14. For an introduction to the illustrations of this chapter, see Miyeko Murase, "Kuan-yin as Savior of Men: Illustration of the Twenty-Fifth Chapter of the Lotus Sūtra in Chinese Painting," *Artibus Asiae* 33 (1971): 39–74. Sha Wutian further discusses the development of the visual representation of the different sections of the "Universal Gateway Chapter" on Dunhuang murals and silk paintings with respect to subject, composition, and location of each mural painting in a cave-temple. Sha Wutian, "Guanshiyin pusa pumenpin yu guanyin jingbian tuxiang," *Fayin* 3, no. 319 (2011): 48–54.

15. In the study of monks' hagiographies, John Kieschnick reveals that Guanyin was considered as having particular power in curing illness. John Kieschnick, *The Eminent Monk: Buddhist Ideals in Medieval Chinese Hagiography*, Kuroda Institute Studies in East Asian Buddhism 10 (Honolulu: University of Hawai'i Press, 1997), 103–106.

16. Unlike the later imagery of Guanyin who directly appears as a woman, a Northern Qi vignette indicates that a beautiful woman and Guanyin were manifested as two consecutive representations to imply that the beautiful woman is the transgressive form of Guanyin. See "Xu Zhicai zhuan" 徐之才傳 (Biography of Xu Zhicai), in Li Baiyao, *Beiqishu* 北齐书, (Beijing: Zhonghua shuju, 1973), 446.

17. Yü, *Kuan-yin*, 223.

18. Yü, *Kuan-yin*, 176–194, 223–262. For an example of the Child-giving Guanyin before the late imperial period, see a green-glazed statue made in the Yaozhou kiln (Yaozhou yao 耀州窯) during the Jin dynasty (1115–1234). Gugong bowuyuan comp. *Gugong guanyin tudian*. (Beijing: Gugong chubanshe, 2012), 222.

19. An example of how Guanyin helped a girl change her body to male can be seen in the story of Sigu 嗣姑 from Jingzhou 荆州. Sigu grew up with her older widowed father who was a village tutor. She was exceptionally bright and had studied with her father since she was a child. At the age of fourteen, she embroidered a White-robed Guanyin and worshiped the icon with utmost sincerity. One day she dreamed that Guanyin told her: "Your father is a good person and he deserves to have a son. But he is too old, what can he do? I have decided to give you to him as a son." Guanyin then touched Sigu's whole body with her hands and gave her a red medicinal bolus. After Sigu swallowed it, she felt very hot like there was a fire from her chest to her two thighs. She was in a coma for seven days. When she woke up, she discovered that she had been transformed into a boy. Zhang Chao, comp., *Yu Chu xinzhi*, Vol. 1783 of *Xuxiu siku quanshu*, (Shanghai: Shanghai guji chubanshe, 1995), juan 17, 382–383. For other examples, see Glen Dudbridge, *The Legend of Miao-shan* (Oxford: Oxford University Press, 1978), 103. For an in depth discussion of Guanyin and medical treatment, see Xiaosu Sun, "Performing the Bodhisattva Guanyin: Drama, Ritual and Narrative" (PhD diss., Harvard University, 2017), 144–155. For a general discussion of the role of Buddhism as a venue for medical treatment, see Chen Yunü, "Buddhism and the Medical Treatment of Women in the Ming Dynasty: A Research Note." *Nannü: Men, Women, Gender in Early and Imperial China* 10, no. 2 (2008):279-303.

20. Ding Yunpeng et al., *Mingdai muke Guanyin huapu* (Shanghai: Shanghai guji chubanshe, 1997). The first couplet and last line of this poem are borrowed from Song dynasty Zen monk Shi Huiqin 釋慧勤. In this quatrain, Guanyin is also compared with well-known historical beauties, such as Xi Shi and Yang Guifei.

21. See "Jishengcao" 寄生草, *Bei xixiang* 北西廂 act 1, "Fodian qifeng" 佛殿奇逢, Wang Shifu. *Xixiang ji* in Mao Jin (1599–1659), *Liushi zhong qu*. Vol. 1770 of *Xuxiu siku quanshu*, 146–203. Shanghai: Shanghai guji chubanshe, 1995. 6. Similar examples can be found in the *chuanqi* drama the *Guanyin Yulan Ji* 觀音魚籃記. In act 14, when the male protagonist first sees his prenatal fiancée Jin Mudan, her beauty appeals to him. As Zhang sings: "I only saw her ten tiptoes and exposed embroidered shoes and she is so adorable when she takes a step; I only saw her soft and attentive like the Guanyin of the South Sea." *Guanyin Yulan Ji*, in *Guben Xiqu Congkan Erji* (facsimile of the Ming Wenlinge ed.; Shanghai: Shangwu yinshuguan, 1955), juan 2, 17.

22. Binbin Yang, *Heroines of the Qing: Exemplary Women Tell Their Stories* (Seattle: University of Washington Press, 2016), 45–46.

23. James Cahill, *Pictures for Use and Pleasure: Vernacular Painting in High Qing China* (Berkeley: University of California Press, 2010), 129–131. Various portraits of Liu Xiang 劉香 on the cover of Liu Xiang *baojuan* directly emulate Guanyin iconography from a Guanyin painting manual. Also see the illustration of Xiuying in *Xiuying baojuan* published in 1889.

24. Anthony C. Yu, *The Journey to the West* (Chicago: University of Chicago Press, 1977–1983), 2:396–397. Such a semidressed Guanyin image would not have been so peculiar to worshippers because Guanyin's womanly manner was not reinforced. During the Ming and Qing periods, a semidressed and androgynous Guanyin representation can be found as statues and painted images in temples, paintings, and popular prints. An androgynous Guanyin exists throughout Chinese history during the process of Guanyin's feminization, but this process, rather than an intentionally neutral gender form is instead

a gradual feminizing process. However, when Guanyin's female forms became more widespread in late imperial China, whether androgynous Guanyin was considered to have specific efficacy is unclear. Further research needs to be conducted. For a general discussion of the androgynous body, see Charlotte Furth, "Androgynous Males and Deficient Female: Biology and Gender Boundaries in Sixteenth- and Seventeenth-Century China," *Late Imperial China* 9, no. 2 (1988): 1–31. It is inspiring to see how Japanese artists try to make an androgynous Guanyin in late nineteenth century. See Chelsea Foxwell, "Merciful Mother Kannon and its Audiences," Art Bulletin (2010): 326–347.

25. Zhou Qingyuan, *Xihu erji* (Shanghai: Beiye shanfang, 1936), juan 3, 54.
26. Zhou Muqiao 周慕橋 (1868–1922), "toujia Guanyin" 偷嫁觀音, Wu Youru et al. ill., Zheng Qiming, ed. *Dianshizhai huabao: Daketang ban.* (Shanghai: Shanghai huabao chubanshe, 2001) 40:54. For a discussion of paralleling Guanyin and sexual conduct in late Qing, see Katherine Laura Bos Alexander, "Virtues of the Vernacular: Moral Reconstruction in Late Qing Jiangnan and the Revitalization of Baojuan" (PhD diss., University of Chicago, 2016), 82.
27. Ding Yunpeng for instance, created an album that contains both feminine and masculine images of Guanyin. The moustache became the primary sign of Guanyin's maleness. Lee Yu-min, *Guanyin tezhan* (Taipei: Guoli gugong bowuyuan, 2000), 90–93. For other examples, see the Guanyin painting by Shao Min dated to 1626. Lee, *Guanyin tezhan,* 88–89. A small bronze statue of Guanyin as Pratyekabuddha from the Ming period is in the collection in the USC-Pacific Asia Museum. The gender politics of Guanyin is also mocked when Louis XIII's portrait was brought to China in early Qing, as it was reappropriated as a manifestation of Guanyin in *The Fifty-Three Manifestations.* Ding et al., *Mingdai muke Guanyin huapu,* 101. The image is based on a portrait of Louis XIII by Philippe de Champaigne (1655) in the Prado Museum, Madrid, Spain.
28. Yü, *Kuan-yin,* 413–419.
29. José Ignacio Cabezón, "Mother Wisdom, Father Love: Gender-based Imagery in Mahāyāna Buddhist Thought," in *Buddhism, Sexuality, and Gender*, ed. José Ignacio Cabezón (Albany: State University of New York Press, 1992), 181–214.
30. Susan Mann, *Precious Records: Women in China's Long Eighteenth Century* (Stanford: Stanford University Press, 1997), 178–83.
31. Barbara E. Reed, "The Gender Symbolism of Kuan-yin Bodhisattva," in *Buddhism, Sexuality, and Gender*, ed. Ignacio Jose Cabezón (Albany: State University of New York Press, 1992), 159–80.
32. Yü, *Kuan-yin,* 418.
33. For an example of the sacred power of a Guanyin painting in relation to fertility during the Song period, see the miraculous account of Zhai Ji 翟楫 in *Yijianzhi.* A man named Zhai Ji, who is in his fifties, paints a Guanyin icon. His wife then dreams that a white-robed woman holds a plate with a son and walks toward her. Hong Mai, *Yijianzhi, Yingyin wenyuange siku quanshu* (Taipei: Taiwan shangwu yinshuguan, 1983), yi, 17:877.
34. Charlotte Furth, *The Flourishing Yin: Gender in China's Medical History, 960-1665* (Berkeley: University of California Press, 1999), 187–223.
35. Megan Bryson, *Goddess on the Frontier: Religion, Ethnicity, and Gender in Southwest China* (Stanford, Calif.: Stanford University Press, 2017), 5.
36. For further discussion on this point, see the case study of Xing Cijing in chapter 2.
37. Although the nunnery is conceived as a space outside the family system and there are interesting commonalities between the lives of courtesans and nuns, I confine my discussion of nuns to the courtesans who enter the monastery.
38. James Robson, "Brushes with Some 'Dirty Truths': Handwritten Manuscripts and Religion in China," *History of Religions* 51, no. 4 (2012): 330–333.

39. Grant points out that popular literature, such as *baojuan*, created religious heroines with an "unnatural" enthusiasm for spirituality. Beata Grant, "Patterns of Female Religious Experience in Qing Dynasty Popular Literature," *Journal of Chinese Religions* 23 (1995): 29–58.

40. Ko, *Teachers of the Inner Chambers*, 6–7.

41. Zhou Yiqun, "The Hearth and the Temple: Mapping Female Religiosity in Late Imperial China, 1550–1900," *Late Imperial China* 24, no. 2 (December 2003): 109–155.

42. In a discussion of early Buddhist women's struggles between filial piety and their religious practice, Bret Hinsch reveals four different ways these women tried to solve their dilemma. Bret Hinsch, "Confucian Filial Piety and the Construction of the Ideal Buddhist Women." *Journal of Chinese Religions* 30, no. 1 (2002): 49–75, 56. With respect to examples of laywomen from a later period, see the case of Ji Xian 季嫻 (1614–1683) discussed by Grace Fong, " 'Record of Past Karma' by Ji Xian (fl. 1650s)," in *Under Confucian Eyes: Writings on Gender in Chinese History*, ed. Susan Mann and Yü-yin Cheng (Berkeley: University of California Press, 1997), 134–146.

43. Bans on women's going to temple were visible through different sources such as law codes issued by the court and morality books composed by Confucian scholars. The description of punishments for female temple-goers in both the Ming Code and Qing Codes entails that the male members should take the responsibility and be penalized. This might explain why, in this vernacular story, the husband has to take revenge. Vincent Goossaert's research on the late Qing bans on women visiting temple reveals that a strict ban was never strictly followed but involved complicated negotiation among the court, the temple, and lay people. Such negotiation would regulate female presence in the temple. In some cases, class and individual official play a crucial role in determining the regulation. Vincent Goossaert, "Irrepressible Female Piety: Late Imperial Bans on Women Visiting Temples," *Nan Nü: Men, Women, and Gender in Early and Imperial China* 10 (2008): 212–241. However, as many scholars have pointed out, in actual practice women still visited temples and participated in religious festivals. See Zhao Shiyu, *Kuanghuan yu richang: Ming Qing yilai de miaohui yu minjian shehui.* (Beijing: Shenghuo-Dushu-Xinzhe sanlian shudian, 2002), 259–296. For a discussion of this issue in the early Qing period, see He Suhua, "Qingchu shidafu yu funü: yi jinzhi funü huodong wei zhongxin."*Qingshi yanjiu* 3 (2003): 62–72.

44. Mann, *Precious Records*, 178–183. Suzanne Cahill discusses how Daoist women from the Tang period systematically controlled their own bodies through food, fasting, and elixir ingestion for various purposes, such as productivity, sexuality, and transcendence. Suzanne E. Cahill, "Discipline and Transformation: Body and Practice in the Lives of Daoist Holy Women of Tang China," in *Women and Confucian Cultures in Premodern China, Korea, and Japan*, ed. Dorothy Ko, JaHyun Kim Haboush, and Joan R. Piggott (Berkeley: University of California Press, 2003), 251–278.

45. Beata Grant, "Who Is This I? Who Is That Other? The Poetry of an Eighteenth-Century Buddhist Laywoman," *Late Imperial China* 15 (1994): 47–86.

46. Grant, "Who Is This I? Who Is That Other?" 63. Grant also discusses the relationship between writing and religious practice. In her early years, Tao Shan was concerned with "literary adornment," and in her later years, writing poetry became a way to express the truth of the True Mind. This shows a difference between two views of poetry and language. The first is a more aesthetic mode, whereas the latter concerns religious truth.

47. In a different article on the Chan Buddhist discourse of *da zhangfu* 大丈夫 (the great gentleman), Grant reveals how monks and laymen used "great gentleman" to evaluate

religious women's competence in pursuing the Chan path in the seventeenth century. Beata Grant, "Women, Gender and Religion in Premodern China: A Brief Introduction," *Nan Nü* 10 (2008): 177–211.

48. "Mother of Luo Maoming" 罗懋明母, illustrations attributed to Qiu Ying, *Huitu lienü zhuan* (illustrated biographies of exemplary women). Liu Xiang; Qiu Ying; painted; and Wang Geng, comp., *Huitu lienü zhuan* (Taipei: Zhengzhong shuju, 1971), juan 16, 1b–3b.

49. Grant, "Women, Gender and Religion in Premodern China," 21. Starting from medieval China, as Christine Mollier demonstrates, Guanyin was already assimilated by Daoism. Christine Mollier, *Buddhism and Taoism Face to Face: Scripture, Ritual, and Iconographic Exchange in Medieval China* (Honolulu: University of Hawai'i Press, 2008), 174–208. This phenomenon continued to be developed during late imperial China. Mark Mculenbeld, "Death and Demonization of a Bodhisattva: Guanyin's Reformulation within Chinese Religion," *Journal of the American Academy of Religion* 84, no. 3 (September 2016): 690–726. Nonetheless, in the material practices that I have studied, most of them are still tied clearly to Buddhist practice.

50. Tanyangzi made a paper-cut of Guanyin and started to worship her at the age of five. She also spelled the name of Amitābha Buddha; see Wang Shizhen, "Tanyang dashi zhuan," in Wang Shizhen, *Yanzhou sibu gao, xugao* (Taipei: Taiwan shangwu yinshuguan, 1983), juan 78, 2a. Another example is Liu Xianggu 劉香姑 from the Jiajing period (1522–1566). Liu's mother dreamt that a *baiyi mu* 白衣母 (White-robed Goddess) presented a baby to her before her pregnancy. In Liu's hagiography, Guanyin not only continued to protect her from various illnesses but also safeguarded her transcendence as an immortal when she was a teenage girl. Yang Erzeng, ed., *Xinjuan xianyuan jishi*, *Qiantang Yangshi caoxuan ju*, Ming Wanli 30 [1602] (Harvard Yen-ching Library Collection), juan 9, 1a–3b.

51. Tu Long, "Shang shoumu taifuren jiushi xu" 上壽母太夫人九十叙, Tu Long, *Xizhenguan ji*, juan 11, *Tu Long ji*, vol. 5 (Hangzhou: Zhejiang guji chubanshe, 2012), 214–215. The cult of Tanyangzi was actually quite influential and her icon was enshrined in temples and worshiped by many followers of both genders during the late-Ming period. For a representation of Tanyangzi's statue and worshipers in the Tanyangguan, see the illustration in Yang, *Xinjuan xianyuan jishi*, juan 8, frontispieces. For a discussion of the cult of Tanyangzi, see Ann Waltner, "T'an-yang-tzu and Wang Shih-chen: Visionary and Bureaucrat in the Late Ming," *Late Imperial China* 8, no. 1 (1987): 105–127. Multi religious practices are practiced by late Ming people on different levels. Rivi Handler-Spitz's research on Li Zhi's hair and clothing provides an eccentric case about how a person's body is used as a site to have experiments to combine different systems. Rivi Handler-Spitz, *Symptoms of an Unruly Age: Li Zhi and Cultures of Early Modernity*. (Seattle: University of Washington Press, 2017), 69–87.

52. Zhuhong also advocated other practices such as nonviolence and releasing living things. Chün-fang Yü, *The Renewal of Buddhism in China: Chu-hung and the Late Ming Synthesis* (New York: Columbia University Press, 1981), 64–100.

53. The words Lady Zhang chanted were "(then those people) in not only one, two, three, four, or five Buddha's lands have rooted themselves in kindness, but indeed in innumerable lands of the Buddha, have already rooted themselves in kindness." Wang Qilong [Ming], comp., *Jinggangjing xinyi lu*, juan 1, X87, no. 1633.

54. One can also argue that this coupling of sutra and cloth happened at a time of commercial development. Perhaps religion was being recruited to encourage productivity.

55. Ko, *Teachers of the Inner Chambers*, 198.

56. Yü, *Kuan-yin*, 337–378. Grant's fruitful discussion on the established women chan master reveals that some laywomen entered a convent after they fulfilled their worldly duties. Grant, *Eminent Nuns*, 130–145.

57. Kai-wing Chow, *The Rise of Confucian Ritualism in Late Imperial China: Ethics, Classics, and Lineage Discourse* (Stanford: Stanford University Press, 1994), 207–214.

58. David Morgan, "Introduction: the Matter of Belief," in *Religion and Material Culture: The Matter of Belief*, ed. David Morgan (London and New York: Routledge, 2010), 7–12.

59. Dorothy Ko, *Cinderella's Sisters: A Revisionist History of Footbinding* (Berkeley: University of California Press, 2005), 189.

60. Grant, "Women, Gender and Religion in Premodern China," 134.

61. Chris Tilley et al., *Handbook of Material Culture* (London: Sage, 2006), 4.

62. John Kieschnick, "Material Culture," in *The Oxford Handbook of Religion and Emotion*, ed. John Coorigan (Oxford: Oxford University Press, 2007), 223–224.

63. Fabio Rambelli, *Buddhist Materiality: A Cultural History of Objects in Japanese Buddhism* (Stanford: Stanford University Press, 2005), 7.

64. Wang has suggested that both women and things together materialized as men's things during the economic growth in seventeenth century. In this process, women became things as objects of male desire. Wang, "Nüren, wupin yu ganguan yuwang."

65. Anne M. Birrel, "The Dusty Mirror: Courtly Portraits of Woman in Southern Dynasties Love Poetry," in *Expressions of Self in Chinese Literature*, ed. Robert E. Hegel and Richard C. Hessney (New York: Columbia University Press, 1985), 39–69; Sarah Dauncey, "Bounding, Benevolence, Barter and Bribery: Images of Female Gift Exchange in the *Jin Ping Mei*," *Nan Nü: Men, Women Gender in Early and Imperial China* 5, no. 2 (October 2003): 170–202; and Mao Wenfang, *Wu, xingbie, guankan: mingmo qingchu wenhua shuxie xintan* (Taipei: Taiwan xuesheng shuju, 2001), 281–374.

66. Joan Scott, "Gender: A Useful Category of Historical Analysis," *American Historical Review* 91 (1986): 1053–1075.

67. Scott, "Gender: Still a Useful Category of Analysis?" *Diogenes* 225 (2010): 10–11.

68. Mann, *Precious Records*, 45–75. Post-parenthood refers to time after which parents have finished the responsibility of raising their children.

69. Dorothy Ko, *Every Step a Lotus: Shoes for Bound Feet* (Berkeley: University of California Press, 2001), 66.

70. Bray introduces an important concept of gynotechnics, which includes materials and techniques for childbirth and motherhood. Francesca Bray, *Technology and Gender: Fabrics of Power in Late Imperial China* (Berkeley: University of California Press, 1997), 269–380.

71. In 2005, I interviewed Zhu Wenqian 朱文茜, the well-known sculptor of Buddhist statues who specializes in Su School clay sculpture. She mentioned this taboo, which has been followed by female crafters since the premodern period. The interview took place at the site of Anyangyuan 安養院, where she was working on the *Thirty-Two Manifestations of Guanyin*.

72. Mann, *Precious Records*, 178–187. Yang Zhishui's research on a clay baby (*nihaier* 泥孩兒) reveals that a clay figurine in the shape of a baby had been used as a gift during the Double Seven festival since the Song dynasty. Women also prayed to Guanyin through a clay baby to grant them a child. Yang Zhishui, *Cong haiershi dao baizitu* (Beijing: Renmin meishu chubanshe, 2014), 44.

73. I am very grateful for Jill H. Casid's insight on women's things in relation to religious authority.

74. Dorothy Ko, "Epilogue: Textiles, Technology, and Gender in China," *East Asian Science, Technology, and Medicine* 36, no. 1 (January 2012): 173–174. I consider material objects a more immediate avenue to study women's life; however, I am not denouncing the value of texts. I am suggesting that we need to be aware of the nature of the text. In recent years, scholars have used tomb epitaphs as an important venue to study women's history during the medieval period. In particular, when the content and rhetorical style of epitaphs are much less restrained by Confucian discourse than similar texts produced in late imperial China, there is much more concrete information about women's religious practice. For instance, Ping Yao's extensive research on Buddhist women's epitaphs from Tang China reveal precious data about the types of scriptures women chanted and the number of icons they offered. Ping Yao, "Good Karmic Connections: Buddhist Mothers in Tang China." *Nannü: Men, Women, and Gender in China* 10, no. 1 (2008): 57–85.

75. For the discussion of *huaxian* of Buddhist deities in relation to pilgrimage sites in the Tang dynasty, see Wei-cheng Lin, *Building a Sacred Mountain: The Buddhist Architecture of China's Mount Wutai* (Seattle: University of Washington Press, 2014), 162–164.

76. Eugene Y. Wang, "Sound Observer and Ways of Representing Presences," in *Presence: the Inherence of Prototype within Images and Other Objects*, ed. Robert Maniura and Rupert Shepherd (Burlington, VT: Ashgate, 2006), 259–271. 260.

77. For the discussion of this set of images, see chapter 2.

78. Judith Butler, "Bodies That Matter," in *The Body: A Reader*, ed. Mariam Fraser and Monica Greco (New York: Routledge, 2005), 62–65.

79. Butler, "Bodies That Matter," 63.

80. Michael Taussig, *Mimesis and Alterity: A Particular History of the Senses* (New York: Routledge, 1993), 59–63.

81. For an elaborate discussion on this issue, please see chapter 4.

82. Wendi L. Adamek, "The Impossibility of the Given: Representations of Merit and Emptiness in Medieval Chinese Buddhism," *History of Religions* 45, no. 2 (2005): 136.

83. See the discussion of *baimiao* Guanyin in chapter 2.

84. William LaFleur, "Body," in *Critical Terms for Religious Studies*, ed. Mark C. Taylor (Chicago: University of Chicago Press, 1998), 37.

85. In both Confucian and Buddhist traditions, hair is considered part of the body.

86. See Ni Renji's inscription on her hair embroidery, Hong Liang, "Ming nüshiren Ni Renji de cixiu he faxiu", *Wenwu cankao ziliao* 9 (1958): 22.

87. See the discussion of merging with Guanyin in chapter 3.

88. Yuhang Li, "Oneself as a Female Deity: Representations of Cixi Posing as Guanyin," *Nannü: Men, Women, and Gender in China* 14, no. 1 (2012): 75–118.

89. Cixi's emulation of Guanyin is influenced by the Qing imperial male rulers who were considered to be the emanation of Manjusri. Qing rulers such as Qianlong had their own bodies painted as religious icons. In this process, they did not limit their representation to distinguishing physical marks but used the representation of their faces to stand in for the faces of religious icons. More specifically, with the help of Western missionary court painters, a new technique of realistic representation was incorporated into portrait and religious painting-making. In Patricia Berger's observation, this juxtaposition brings "the apparent immediacy of the imperial face with a patterned, canonical pantheon of visions." Patricia Berger, *Empire of Emptiness: Buddhist Art and Political Authority in Qing China* (Honolulu: University of Hawai'i Press, 2003), 61.

90. See the discussion in chapter 1 of the poem "Watching a Guanyin Dance" (Shi Jian, *Xicunji, Siku quanshu dianziban*).

1. DANCING GUANYIN

1. Hua Wei, "Cong Wu Zhensheng 'Taiping yuefu, Huanshen rong' kan qingdai kunju xin-bian xiaobenxi," in *Mingjia lun kunqu*, ed. Hong Weizhu (Taipei: Guojia chubanshe, 2010), 2:637–659. I thank Professor Hua Wei for calling my attention to this opera.

2. More specifically, Guanyin is garbed in a white gauze hood and robe embroidered in golden threads, wearing metal bracelets on wrists and ankles, bright red trousers, and high-heeled red embroidered shoes decorated with a phoenix head. Wu Zhensheng, *Huanshen rong*, 19a.

3. Wu Zhensheng, *Huanshen rong*, 19a–20a. In the same act, after Guanyin performs magic, Zheng Miao, the young man and his wet nurse have a conversation about the change of his sexual organ from male to female. Wu Zhensheng, *Huanshen rong*, 21b–23a.

4. Janet Gyatso, "Sex," in *Critical Terms for the Study of Buddhism*, ed. Donald S. Lopez Jr. (Chicago: University of Chicago Press, 2005), 271–291. Zhan Dan, "Xianji heliu de wenhua yiyun: tangdai aiqing chuanqi pianlun", *Shehui kexu zaixian*, no. 3 (1992): 11–17. Susanna Cahill's discussion on the cult of the Queen Mother of the West and her male and female followers in the Tang dynasty demonstrates that some parallel issues exist with the cult of Guanyin between a female deity and her gendered followers. Her study shows that under the male writers' pen, the Queen Mother of the West had complicated images as a mother, a lover, and a spiritual leader. The Queen Mother of the West might be imagined as sexual, but she was not sexualized as an object. Suzanne Elizabeth Cahill *Transcendence and Divine Passion: the Queen Mother of the West in Medieval China* (Stanford, Calif.: Stanford University Press, 1993).

5. The popularization of the eroticized Guanyin, and other stories of this kind, reached their zenith in the late-Ming era. This prompted various literary uses of the prototype Fish-basket Guanyin. Chün-Fang Yü introduces five *baojuan* or precious scrolls of the Fish-basket Guanyin from the late-Qing and early Republican period, Chün-Fang Yü, *Kuan-yin*, 427–431.

6. Yü, *Kuan-yin*, 424–425.

7. Yü, *Kuan-yin*, 427–431.

8. Yü, *Kuan-yin*, 419–438.

9. The story of Ma's wife has been recorded in various volumes. It was a popular subject in Chan poetry during the Song period. Sawada Mizuho has done extensive research on Song-era poems on Ma's Wife or Fish-basket Guanyin. See Sawada Mizuho, *Sō Min Shin shōsetsu sōkō* (Tōkyō: Kenbun Shuppan, 1982), 148–150.

10. Bernard Faure, *Faure, Bernard. The Red Thread: Buddhist Approaches to Sexuality.* (Princeton, N.J.: Princeton University Press, 1998), 282.

11. I would like to express my attitude to James Ben who called my attention to the impor-tance of *Śūtaṅgama Sūtra* in late imperial China. For a complete text of this scripture, see *Da fo ding ru lai mi yin xiu zheng liao yi zhu pu za wan xing shou lengyanjing* (hereafter *Leng yan jing*), T.19, no.945.

12. For the English translation of this episode, see *The Śūtaṅgama Sūtra* [Leng yan jing], trans. Charles Luk (London: Rider, 2011 [1966]), 2.

13. They reflect the two fundamental concepts of *se*, form and *kong*, emptiness. In other words, because form is emptiness, various transformations are possible.

14. Mei Dingzuo, *Qingni lianhua ji*, ed. Lu Lin (Hefei: Huangshan chubanshe, 1998), 1–2.

15. For instance, the tale of a monk reincarnated as the prostitute Liu Sui became popular in the late-Ming period. See "Yueming heshang du liucui," Feng Menglong, *Xingshi hengyan* (Beijing: Renmin wenxue chubanshe, 1984), 1:241–249.

16. Wang Zhideng and Zhang Chushu eds., *Wusao ji* (Harvard Yen-ching Library Collection, 1614), microfilm, juan 2, 5b–6a.

17. Guanyin's body gesture alludes to several Guanyin iconographies in the Guanyin painting manual, see Ding Yunpeng et al., *Mingdai muke Guanyin huapu* (Shanghai: Shanghai guji chubanshe, 1997), 49, 91, 113, 116, 127.

18. The couplet inscribed on the illustration reads, "圍伴着薄怯怯翡翠衾, 空倚着香馥馥黃金獸" The *feicui qin* 翡翠衾 or a quilt decorated with a pair of green kingfishers is a literary expression to denote that a lady sleeps alone when her lover or husband is away. The replacement of the quilt with a banana palm leaf further indicates unfulfilled emotion. Yuhang Li, "Female Bodies Going Bananas: Eroticism and Botanical Layers in Late Imperial China," unpublished paper, presented in the Annual Meeting of Association of Asian Studies, 2018.

19. Eric Matthew Greene, "Meditation, Repentance, and Visionary Experience in Early Medieval Chinese Buddhism" (PhD diss., University of California at Berkley, 2012), 332.

20. In the late-Ming period, scholars drew on various sources, including the classics, to address illusion. The illustration alludes to the story of *Jiaoye fulu* (蕉葉覆鹿 the banana palm leaves covering a deer) from *Liezi*, and was commonly referred to as *Jiaoye meng* (蕉葉夢 the dream of banana palm) in the Ming period. Yang Bojun, Annot. *Liezi jishi*. (Beijing: Zhonghua shuju,1979), 66.

21. In the commentary of the undressed Guanyin in chapter 49 of the *Journey to the West*, the word *huoguanyin* has the clear connotation of an illicit beauty, such as a prostitute. The comment says: "The real living Guanyin has not yet put on her clothes and jewels but wants to rescue people; if a fake living Guanyin is undressed, she only harms people" (真活觀音未梳妝就想救人, 假活觀音未梳妝只是害人). The latter half of the comment indicates that a courtesan or prostitute can do no more than seduce a man. Wu Cheng-en, *Li Zhuowi xiansheng piping xiyouji*, vols. 1792–1793, *Xuxiu siku quanshu*, (Shanghai: Shanghai guji chubanshe, 1995), chap. 49, 12a.

22. Pan Zhiheng, *Pan Zhiheng quhua*, annot. Jiang Xiaoyi, (Beijing: Zhongguo xiju chubanshe, 1988), 110.

23. Xu's father's name is unknown and is recorded only as the father of Xu Pian. He was well known for performing *dan* role type. See the entry "yueji" in Pan Zhiheng, *Luanxiao xiaopin*. Shanghai Library Collection, published in 1629., juan 樂技 2, 23a.

24. Pan, *Pan Zhiheng quhua*, 110. Xie Bi, courtesy name is Shaohua 少華, is a native of Shexian 歙縣 from Anhui Province and the author of *Jihanshu*. For the discussion of *Jinghong* dance, see Judith Zeitlin, "Music and Performance in *Palace of Lasting Life*," in *Trauma and Transcendence in Early Qing Literature*, ed. Wilt Idema, Wai-yee Li, and Ellen Widmer (Cambridge, Mass.: Harvard University Asia Publications, 2006), 467–468.

25. Xu learned calligraphy with Zhou Tianqiu 周天球 (1514–1595), *qin* with Xu Taichu 許太初, poetry with Lu Chengshu 陆成叔, and singing with Zhu Zijian. Pan, *Pan Zhiheng quhua*, 110.

26. Pan, *Luanxiao xiaopin*, juan 2, 19a.

27. By 1580, Xu Jinghong had practiced calligraphy for nearly two decades, but an inscription on an orchid painting by calligraphy teacher Zhou Tianqiu does not match Pan's praise. See her inscription in "Ming Zhou Tianqiu molan juan 明周天球墨兰卷," Guoli gugong bowuyuan bianji weiyuanhui ed., *Gugong shuhua tulu* (Taipei: Guoli gugong bowuyuan, 1994), 19:264.

28. "學琴不能操縵, 學曲不能按板, 因舍而學詩." Zhu Yizun comp., *Mingshi zong*, vol. 1460, *Yingyin wenyuange siku quanshu* (Taipei: Taiwan shangwu yinshu guan, 1983-86), *jibu*, vol.1460, juan 98, 907.

29. Apparently Pan Zhiheng also pursued Xu Jinghong 明周天球墨兰卷 and wrote several poems expressing his feeling for her. Besides "Xu Pian zhuan," also see "Dingqing shi wei Xu Feiqing fu" 定情詩為徐飛卿賦, Pan Zhiheng, *Yecheng shi, chucao* (Harvard Yen-ching Library Collection), microfilm, 16a–17a.

30. Wang Duanshu, *Mingyuan shiwei chubian*, vol. 4, *fu shang*, Qingyintang, 1667 ed. (University of Chicago Library Collection, 1667), reproduced from microfilm, 6b–7a.

31. Pan Zhiheng, *Genshichao, genshi waiji*, in *Siku quanshu cunmu congshu* (Jinan: Qilu shushe, 1995), *zi* 193–546. Yao Lü, *Lushu, Siku quanshu chunmu congshu*, zibu, zajialei, 111 (Jinan: Qilu chubanshe, 1995), *zi* 111–625.

32. Wang Zhideng, preface to *Mouye ji*, Harvard Yen-ching Library Collection. Microfilm.

33. Xu Tong, "Song Changle ling Yu Wenshu xiebing huan Jinling" 送長樂令郁文叔謝病還晉陵 ("Sending off the County Magistrate of Changle, Yu Wenshu Who Returns to Jinling on His Sick Leave"). Xu Tong, *Manting ji*, Vol. 1296 of *Yingyin wenyuange siku quanshu* (Taipei: Taiwan shangwu yinshuguan, 1983), juan 9.

34. Pan Zhiheng did not mention the location of Xu's nun's residence, but the short biography of Xu Jinghong in *Mingshi zong* indicates that it was in Lianziying 蓮子營. Zhu Yizun, *Mingshizong*, juan 98, 907. Yao Lü records that he and Cheng Ruwen tried to visit the retreat in the Wanli period, but they could not locate it. Yao, *Lushu, zi* 111–625. Since the Ming government restricted people from constructing private shrines or nunneries and conducting private ordination ceremonies, Xu Jinghong's status as a nun might have been illegal. Huang Zhangjian ed., *Mingdai lüli huibian*. (Taibei: Zhongyang yanjiu yuan lishi yuyan yanjiu suo, 1983), from the website of Zhongguo zhexueshu dianzijihua. juan 4, hulü 戶律1, huyi 戶役

35. When Guanyin was staged in religious festivals, the character combined a disguised Guanyin (*ban Guanyin* 扮觀音) and a dancing Guanyin. Yuan Hongdao indicates only the Guanyin dance in one line: "When the white-robed one claps her palms, the Guanyin dance is manifest" (Baiyi hezhang guanyin wu 白衣合掌觀音舞). Yuan Hongdao, "The Song to Welcome Spring" (Yingchunge 迎春歌,) Yuan Hongdao, *Yuan zhonglang ji*. Vol.174 of *Siku quanshu cunmu congshu* (Jinan: Qilu shushe, 1997), 718. For the plays related to Guanyin during the Ming period, see Zhou Qiuliang, "Lun gudai guanyin xi de yanchu xingtai." *Hunan gongye daxue xuebao* (*shehui kexue ban*) 3 (2010): 98–101.

36. For a study on the images of dancers in Chinese Buddhist context, see Kang Baocheng, "Mingqing shiqi de fojiao yu difangxi," in *Liangan xiqu dazhan xueshu yantaohui lunwenji* (Taipei: Guoli chuantong yishu zhongxin, 2002), 569–615. For a discussion of the practice of music and dance in Buddhist canonistic text, see Cuilian Liu, "Song, Dance, and Instrumental Music in Buddhist Canon Law" (PhD diss., Harvard University, 2014). Religious dance is a crosscultural phenomenon. For a brief introduction of the staging a divine through dance in Asia, see Mohd Anis Md Nor, "Dancing Divine Iconographies in Southeast Asia," in *Dance: Transcending Borders*, ed. Urmimala Sarkar Munsi (New Delhi, India: Tulika, 2008), 19–34.

37. *Pusa wu* had already appeared in the Tang dynasty, but it usually referred to a group dance that represented Buddhist heavenly beings. Yao, *Lushu, zi* 687.

38. Judith Zeitlin alerts us to a distinction between dance-like moves and the general idea of dance as a performer moving rhythmically to music and following a set sequence of steps. Zeitlin, "Music and Performance in *Palace of Lasting Life*," 482.

39. "人演大士, 額戴一碗, 手持兩碗為節." Yao, *Lushu*, juan 8, 687.

40. Kang, "Mingqing shiqi de fojiao yu difangxi," 581.

41. "顯現我神通廣盛," Zheng Zhizhen, *Mulian jiumu quanshan xiwen, Guben xiqu congkan chuji*, 67 (Shanghai: Shangwu yinshuguan, 1954) 24.

42. Zheng, *Mulian jiumu quanshan xiwen*, 24 a. The crane dance or *hewu* 鶴舞, for instance, existed before the Wanli period, see the entry "yuewu 樂舞" in Fang Yizhi, *Tongya*, *Siku quanshu* dianziban, juan 30, 5–968.

43. For a brief introduction of each role type, see Andrea Goldman, *Opera and the City: The Politics of Culture in Beijing, 1770-1900* (Stanford, Calif.: Stanford University of Press, 2012), 251. Xiaosu Sun points out that *renao* 熱鬧 (hot and noisy) was developed as an new aesthetic taste to stage efficacious power of divine figures in religious drama, particularly in the performance related to Princess Miaoshan. Sun, *Performing the Bodhisattva Guanyin*, 44–106.

44. Zheng, *Mulian jiumu quanshan xiwen*, 25b.

45. The best-known example is Wang Zijia (1625–1656). Wu Weiye, "Wanglang qu," *Meicun ji*. Vol. 1312 of *Yingyin wenyuange siku quanshu* (Taipei: Taiwan shangwu yinshuguan, 1983), juan 5, 12b–14a.

46. William Butler Yeats, *The Collected Poems of W. B. Yeats*, comp. Richard Finneran (New York: Collier, [1928] 1989), 217.

47. Shi Jian, *Xicunji*, *Siku quanshu dianzi ban*, juan 4, 44b.

48. For a discussion of sleeve dances in the Ming and Qing period, see Wang Kefen, *Zhongguo wudao tongzhi*, Mingqing juan (Shanghai: Shanghai yinyue chubanshe, 2010), 40–41.

49. Gu Zhengyi, *Gu Zhongfang Xinci tupu* (Peking: Peking University Library Collection), page number unknown.

50. The poet might borrow expressions from the *Romance of Western Chamber* when Yingying is first introduced as an exceptional beauty and compared with the Water and Moon Guanyin from the South Sea. Wang Shifu, *Xixiang ji*, Mao Jin, *Liushi zhong qu*, vol. 1770, *Xuxiu siku quanshu* (Shanghai: Shanghai guji chubanshe, 1995), 149.

51. Zhang Xianyi, *Wuzhi* 舞志, recorded by Yongrong, Ji Yun, et al., *Qinding siku quanshu zongmu* (Taipei: Taiwan shangwu yinshuguan, 1983), juan 39, 13a.

52. For examples of court dance in the Ming period, see the dance manuals *Lingxing xiaowu pu* composed by Zhu Zaiyu (1536–1611), *Lingxing xiaowubu*, 1596 ed. (Harvard Yen-ching Library Collection). Nicholas Standaert has provided a thoughtful discussion of the various aspects of Confucian ritual dance in the Ming and Qing dynasties. Nicholas Standaert, "The Visual Dance and Their Visual Representations in the Ming and the Qing," *East Asian Library Journal* 12, no. 1 (Spring 2006): 68–182.

53. "楊璆姬之舞氍毹, 徐驚鴻之舞觀音, 一靡其身, 而繡被千金; 一揚其腕, 而珠串十琲。能沾沾自喜, 而取媚於憐, 抑猶有慚德者耶？" "Chuyan" 初豔 in Pan, *Luanxiao xiaopin*, juan 2, 19a. Pan Zhiheng mentioned again in Yang Qiuji's biography that she leaned forward; see *Pan Zhiheng quhua*, 108. It is likely that Yang Qiuji bent forward so that people could see the elaborate embroidered patterns on the back of her outfit. Zhang Youyu who had a long-term relationship with Ma Shouzhen, also saw Xu Jinghong's Guanyin dance. See Yao Zhiyin, *Yuanming shi leichao*, vol. 884, *Yingyin wenyuange siku quanshu* (Taipei: Taiwan shangwu yinshuguan, 1983), juan 27, 25a.

54. "天身不害羞," Wu Zhensheng, *Huanshen rong*, 20a.

55. Wu Zhensheng, *Huanshen rong*, 21a.

56. Standaert, "The Visual Dance and Their Visual Representations," 68–182.

57. "鎖骨觀音變現身, 反腰貼地蓮花吐," in Wu Weiye, *Meicun ji*, juan 5, 12a.

58. Wu Zhensheng, *Huanshen rong*, 19a. Peng Xu discusses how the training of a gendered voice in the late Ming is inspiring with respect to the practices of other arts. Peng Xu, "Courtesan vs. Literatus: Gendered Soundscapes and Aesthetics in Late-Ming Singing Culture." *T'oung Pao* 100, no. 4/5 (2014): 404–459.

59. Wu Zhensheng, *Huanshen rong*, 20a. For the definitions of "*ruanwu*" and "*jianwu*," see the entry for "yuewu" in Fang Yizhi, *Tongya*, juan 30, 1a–5b, 4a–b

60. Valerie A. Briginshaw, *Dance, Space and Subjectivity* (New York: Palgrave, 2001), 77–96.

61. Pan, *Luanxiao xiaopin*, juan 2, 19a.

62. "能沾沾自喜而取媚於憐," Pan, *Luanxiao xiaopin*, juan 2, 19a.

63. "日久佳人翻作道，年深子弟或成龜," Zhang Mengzheng, *Qinglou yunyu*, in Vol.4 of *Zhongguo gudai banhua congkan erbian* (Shanghai: Shanghai guji chubanshe, 1994) 229.

64. "作孽得沒了結，借出家為收場," Zhang Mengzheng, *Qinglou yunyu*, 229.

65. Zhang Mengzheng, *Qinglou yunyu*, 229–230. To compare this work with other Buddhist women's writings from late-Ming period, see "Writing Nuns," in Wilt Idema and Beata Grant, *The Red Brush: Writing Women of Imperial China* (Cambridge, Mass.: Harvard University Asia Center, 2004), 455–470.

66. *Miaofa lianhua jing*, juan 5, T9, no. 262.

67. In the beginning of the Ming period, for instance, Jianfohui was held in Nanjing's Jiangshan Temple (Jiangshansi 蔣山寺). For the Hongwu emperor's ritual in Jiangshansi, see the entry for Song Lian's, "Jianshan guangjian fohui ji" 蔣山廣薦佛會記; Song Lian, *Song xueshi quanji*, comp. Yan Yiping, vol. 95, *Yuanke yingyin baibu congshu jicheng*, part 163 (Taipei: Yinwen yinshu guan, 1968), ji, juan 4, 2b–7b. During the Yuan period, dances such as the sixteen *tianmo* were often performed as part of *zanfo* or the eulogizing Buddhist rite. *Yuanshi*, vol. 3, *benji juan* 43, "Shundi liu," 918–919. Two songs entitled "Guanyin wu" 觀音舞 and "Huayan haihui chang wu jinzijing" 華嚴海會唱舞金字經 are included in *Yuefu qunshu*. Because some parts are missing, it is difficult to speculate how these songs were used during a Guanyin dance in *zanfo* ritual or in a Buddhist festival. *Yuefu qunshu*, juan 2. 111–113. *Jinzijing* or Golden-Character Scripture refers to a particular melody that can be used for both vocal and instrumental performance. Stephen Jones discusses the score used in the Zhihua Temple from the Qing period; Stephen Jones, "The Golden-Character Scripture: Perspectives on Chinese Melody," *Asian Music: Chinese Music Theory* 20, no. 2 (Spring–Summer 1989): 21–69.

68. For a discussion of this conflict in early Chinese Buddhism, see Liu, *Song, Dance, and Instrumental Music*, 127–142.

69. Chün-Fang Yü, *The Renewal of Buddhism in China: Chu-hung and the Late Ming Synthesis* (New York: Columbia University Press, 1981), 192–215.

70. "Wuzhe yishen xiwu" 舞者以身戲舞, Yunqi Zhuhong, *Shami lüyi yaolue*, in *Yunqi fahui*, ce 13, 4b.

71. Yunqi Zhuhong, *Shami lüyi yaolue*, 5a.

72. Timothy Brook, *Praying for Power-Buddhism and the Formation of Gentry Society in Late-Ming China* (Cambridge, Mass.: Harvard University Press, 1993), 314–315; Yuming He, *Home and the World: Editing the "Glorious Ming" in Woodblock-Printed Books of the Sixteenth and Seventeenth Centuries* (Cambridge, Mass.: Harvard University Asia Center, 2013), 245–248.

73. Kang, "Mingqing shiqi de fojiao yu difangxi," 569–615.

74. "以戲為佛事，可乎? 曰: 世間萬緣皆假，戲又假中之假也. 從假中之假而悟諸緣皆假，則戲有益無損." Cai Yi, *Zhongguo gudian xiqu xuba huibian*, 中國古典戲曲序跋彙編, 2 (Jinan: Qilu chubanshe, 1989), 1212–1213.

75. The Chan portrait-eulogy genre in the song plays with this concept. Wendi L. Adamek, *The Mystique of Transmission: On an Early Chan History and Its Contexts* (New York: Columbia University Press, 2007), 25–260.

76. Diane Apostolos-Cappadona, "Scriptural Women Who Danced," in *Dance as Religious Studies*, ed. Doug Adams and Diane Apostolos-Cappadona (New York: Crossroad, 1990) 95–108.

77. "雖復飲食，而以禪悅為味." See chapter 2 in *Weimojie suoshuo jing*, Translated by Kumārajīva. T 14, no.475. For the English translation, see *The Vimalakirti Sutra*, trans. Burton Watson from the Chinese version by Kumārajīva (New York: Columbia University Press, 1997), 33. Greene denotes the connotation and practice of *chan* in the early development of *chan* visualization. Geene, *Meditation, Repentance, and Visionary Experience*, 166.

78. Tianmo dance (tianmo wu天魔舞), Guanyin dance, and dance of Rainbow Skirt are recorded to perform during the three meals each day. Xiaoxiaosheng, *Jinpingmei*, vol. 4 (Hong Kong: Wenle chubanshe, 1976), chap. 55, 7b. For David Roy's translation, see Xiaoxiaosheng, *The Plum in the Golden Vase, or, Chin P'ing Mei*, vol. 3, trans. David Tod Roy (Princeton: Princeton University Press, 2006), 353.

79. *Tianmo wu* has been translated as the *Dance of Mara's Daughters*. See Wilt Idema, *The Dramatic Oeuvre of Chu Yu-tun (1379-1439)* (Leiden: Brill, 1985), 74. On the basis of Turfan and Tibetan texts, however, scholars have suggested that *tianmo* stands for *tianmu* 天母 (heavenly mother) or *lha mo* in Tibetan. Sometimes it is equivalent to *tiannü* 天女 or heavenly maiden. The responsibility of *tianmu* is to eulogize the Buddha or to make an offering to the blessed through dance and music. Shen Weirong and Li Channa, "'Shiliu tianmo wu' yuanliu jiqi xiangguan hanzang wen wenxian ziliao kaoshu," in Zhongguo renmin daxue guoxueyuan xiyu lishi yuyan yanjiusuo ed., *Xiyu lishi yuyan yanjiu jikan*, diwuji (Beijing: Kexue chubanshe, 2012): 325-387. In general, the *tianmo* dance was performed by sixteen dancers not just three that echo Mara's three daughters in scripture.

80. Qian Qianyi also linked *chanyue* with *tianmo* dance and *Tiannü sanhua* 天女散花 or the Heavenly Maid who scattered the flowers in Vimalakirti's room. Chen Yinke, *Liu Rushi biezhuan* (Beijing: Sanlian shudian, 2001), 811.

81. For a discussion on the liminal space in late Ming, see Timothy Brook, *The Confusions of Pleasure: Commerce and Culture in Ming China* (Berkeley: University of California Press, 1998). Late Ming painter Chen Hongshou's painting entitled "Chunti Buddha Mother" represents a deity in a theatrical space. See Yuhang Li's exhibition catalogue entry on "Bodhisattva Guanyin in the Form of the Buddha Mother in *Performing Images: Opera in Chinese Visual Culture*, ed. Judith Zeitlin and Yuhang Li (Chicago: Smart Museum of Art and the University of Chicago Press, 2014), 191–192.

82. I mainly discuss lay courtesans, but Buddhist nuns were also prostitutes. Some famous abbeys in the Jiangnan area were well-known brothels. Grant alerts us that this was rare in the late Ming. Still these monastic spaces were reimagined and exaggerated in the anticlerical discourse of the era's vernacular literature. Beata Grant, *Eminent Nuns*, 1–2.

83. Dorothy Ko, *Teachers of the Inner Chambers:* 1994), 251–261. Zeitlin, "Music and Performance in *Palace of Lasting Life*," 77.

84. The regulation of the courtesans to visit Buddhist temple needs to be further researched.

85. For the nuns' sermon, see Qian Yi (968–1026), *Nanbu xinshu*, vol. 1036, *Yingyin wenyuan ge siku quanshu* (Taipei: Taiwan shangwu yinshuju, 1983), juan 5, 9a; Sun Qi, *Beilizhi*, see the entry for "hailun sanqu zhong shi" 海论三曲中事, 3306. For the discussion of *baojuan* performance by the nuns in monastic settings in the late Qing period, see Sun, *Performing the Bodhisattva Guanyin*, 161–172.

86. Ōki Yasushi, *Chūgoku yūri kūkan: Min Shin Shinwai gijo no sekai* (Tōkyō: Seidosha, 2002), 222–223.

87. The vignettes of courtesans traveling to different temples are scattered in various literati casual jottings. For instance, Feng Mingzhen 馮夢禎, "Zhuji changyou fodian" 諸姬唱游佛殿 ("Visit Buddha Hall with Courtesans"), in *Kuaixuetang riji* (Cambridge, Mass.: Harvard Yen-ching Library Collection), juan 61 (year of jiacheng), 1 a, b.

88. Wang Zhideng, "Jinling lirenji," in Qingtiao yishi, ed., *Pinhua jian*, attached with "Maji zhuan," late Ming Sunxiu ge ed. (Guojia tushu guan Collection), 2a–6b Liu Rushi, after she married Qian Qianyi, also erected a large Thousand-handed Guanyin statue at home. Although she was already Qian's wife, in the eulogy dedicated to the statue, Qian still indicates Liu's past as coming out of the mud, but she is pure by default. Qian Qianyi, "Zao dabei guanshiyin xiangzan" 造大悲觀世音像讚 (An Eulogy for Making an Icon of the Great Compassion Repentance Guanyin), Qian Qianyi, *Chuxueji*, juan 82. For the discussion of this prose, see Chen Yinke, *Liu Rushi biezhuan*, 809–810.

89. Wang Daokun, "Zeng Xu Pianpian canchan" 贈徐翩翩參禪, in Zhang Xu 張栩, comp., *Caibi qingci*, 1624 ed. (Harvard Yen-ching Library Collection), microfilm, juan 5, 5a–7b.

90. For the process of designing the illustrations from *Caibi qingci*, see the last item on "Caibi qingci *fanli*" of this book. Zhang, *Caibi qingci*, 2b. The illustrations were carved by Huang Junqian 黃君倩(fl.1624). His name is transcribed on the first illustration, Zhang *Caibi qingci*, juan 1, 1a.

91. "千竿修竹緣朱檻, 牀頭供養奉瞿曇," See *huatu zhaiju* 畫圖摘句 (selected line for the painted illustration), under the tune title *yujiaozhi* 玉交枝; Zhang, *Caibi qingci*, juan 5, 1a, 6b.

92. Wang Daokun's set of *sanqu* is included in chapter 5, "Category of Inscribing and Dedicating" (*tizeng lei* 題贈類), which endorses certain good deeds or abilities of courtesans. In this chapter, Wang Daokun's *sanqu* poem for Xu Jinghong is the only set of songs relating to a courtesan's religious practice. Other merits that are cherished in this chapter are still typical skills and activities, such as playing *cuju* 蹴踘 ball and playing *zheng* 箏. Zhang, *Caibi qingci*, juan 5, 1a. Moreover, as the compiler of *Caibi qingci* explicitly explains: "every illustration in this book was designed based on carefully grasping the content of the lyrics." Zhang, *Caibi qingci*, "Caibi qingci fanli," 2b.

93. "我把你作優鉢羅華佛眼看," Zhang, *Caibi qingci*, juan 5, 7b.

94. Other than Guanyin, the spirits worshipped by courtesans and entertainers during the Ming and Qing dynasties vary in different regions and time periods. This long list includes baimei shen 白眉神, Guangong 关公, Hongya xiansheng 洪涯先生, Wencaishen bigan 文財神比干, Lü Dongbin 呂洞賓, Chahua laozu 插花老祖, Goulan nüshen 勾欄女神, Chunshen 春神, Wu daxian 五大仙, Husan taiye 胡三太爺 (Huxian 狐仙), Tiebanqiao zhenren xianshi 鐵板橋真人仙師, Jin Jiangjun 金將軍, Shishen 施神, Saniao laoye 撒尿老爺, Goulan tudi 勾欄土地, Jiaofang dawang 教坊大王, Yanhua shizhe 煙花使者, Zhifen xianniang 脂粉仙娘, Bainiangzi 白娘子, Zhubajie 豬八戒, Liu chijinmu 劉赤金母, and Yao ji 瑤姬. Liu Ping 劉平, "Jindai changji de xinyang jiqi shenling," in *Jindai zhongguo shehui yu minjian wenhua*, edited by Li Changli and Zuo Yuhe (Beijing: Shehui kexue wenxian chubanshe, 2007), 471.

95. Spirit of White Eyebrows is believed to be Liu Daozhi 柳盜跖, a famous thief and rebel from the Spring and Autumn period. Its iconography is similar to the Lord of Guan but with white eyebrows. He is a warlike figure holding a huge knife. For a discussion of the archetype of this spirit, see Tang Zhibo, "Mingqing wenxue zhong de baimeishen." *Minjian wenxue* (2013), 1:58–60.

96. Shen Zhou, "Baimei shen" 白眉神, *Kezuo xinyu*, vol. 135, *Shuo fu*, 1646 ed. (Harvard Yenching Library Collection), 7a.

97. See chapter 3 for further discussion of Lin Jinlan's hair embroidery. Both Lin Jinlan and Chen Shuzhen's hair-embroidered Guanyins are in the Shanghai Museum collection. A colophon on the left margin of Chen Shuzhen's work explains that Chen created this piece for her mother. I learned the information of these two from the card catalogs at the Shanghai Museum.

98. Lin Xue, *Water and Moon Guanyin*, Nantong bowuyuan, *Nantong bowuyuan wenwu jinghua* (Beijing: Wenwu chubanshe, 2005), 126, 176. More research needs to be done with respect to the authenticity of this painting. This painting was once collected by a Buddhist temple in Hangzhou. For Lin Xue's activity in Huangzhou, see Huang Shumei. "Lin Xue: yiwei mingmo mingji huajia de shengping yu yishu," in *Meishu shi yu guannian shi* VII, ed. Fan Jingzhong and Cao Yiqiang (Nanjing: Nanjing daxue shifan chubanshe, 2008), 117–137.

 99. Both Lin Jinlan and Lin Xue's creations initially ended up in temple collections. Both objects were stored in Bianlijiang yuan in Hangzhou. Lin Jinlan's hair embroidery was offered to the temple indicated in the inscription. A collector seal of *Bianlijiang yuan* appears on Lin Xue's painting. For a discussion of the Guanyin painting collection in this temple, see the conclusion of this book.

100. Li Rihua, "Ti Xue Su huali guanyin 題薛素素花里觀音" ("Inscribing on Xue Su's Guanyin among Flowers"), in Wang *Luoyu, Shanhuwang*, juan 42, 801. For English translation of this entry, see Weidner, *Views from Jade Terrace: Chinese Women Artists: 1300–1912*, 82. For a fruitful discussion of Xue Susu's artistic creation, see Daria Berg, "Cultural Discourse on Xue Susu, A Courtesan in Late Ming China," *International Journal of Asian Studies* 6 (2009): 171–200.

101. *Zhenzhuta* 珍珠塔 or *Pearl Pagoda*, a nineteenth-century *tanci* 彈詞 story, provides an example of literary imagination with respect to the miraculous power of the Thousand-handed Guanyin statue. The Guanyin enables the two gentry girls to secure their affection with their prospective husband and mother in-law. *Xiaoyi zhenji Zhenzhuta quanzhuan*, in vol.1745, *Xuxiu siku quanshu*, edited by Xuxiu siku quanshu bianji weiyuanhui, 433–457.(Shanghai: Shanghai guji chubanshe, [1849] 1995–2002), 509–526. For the discussion of this narrative and how this narrative is reappointed on a garment, see Yuhang Li "Representing Theatricality on Textile," in *Performing Images: Opera in Chinese Visual Culture* ed. Judith Zeitlin and Yuhang Li, (Chicago: Smart Museum of Art and the University of Chicago Press, 2014), 74–87.

102. Filial piety is one of the most common purposes of inscriptions by donors when a piece is intimately related to merit-making and merit transfer. Adamek, *The Mystique of Transmission*, 139–179.

103. The author of this song is unknown. *Yuefu qunzhu*, juan 4, page number is not indicated.

104. Since the Northern and Southern dynasties, "*nu* 奴" has often been used as the ending of a nickname.

105. "*Huoguanyin*" can be traced back from Yuan play texts and is adopted more frequently in the late imperial period. For instance, in act two of the *zaju* entitled *Bao daizhi zhizhan lu zhai lang* 包待制智斬魯齋郎, Zhang Gui's wife is portrayed as a sexually attractive woman and described as a living Guanyin. "Daoyou fengliu kexi huo guanyin" 倒有風流可喜活觀音, in Zang Maoxun, *Yuanquxuan*, 2 vols. (Beijing: Zhonghua shuju, 1961), 846. Pan Jinlian 潘金蓮 is referred to as *huoguanyin* because her hairstyle resembles Guanyin's. Xiaoxiaosheng, *Jinpingmei*, vol. 2, chap. 28, 6a.

106. Wai-yee Li, "The Late Ming Courtesan: Invention of a Cultural Ideal," in *Writing Women in Late Imperial China*, ed. Ellen Widmer and Kang-i Sun Chang (Stanford, Calif.: Stanford University Press, 1997), 46–73.

107. Paul Ropp, "Ambiguous Images of Courtesan Culture," in *Writing Women in Late Imperial China*, 45, ed., Ellen Widmer and Kang-i Sun Chang (Stanford, Calif.: Stanford University Press, 1997).

108. Liu Rushi provides an example of a woman who fashioned herself a Buddhist through various channels, such as transcribing Buddhist scripture, purchasing a bronze statue,

and inserting Buddhist meaning in her names. She even shaved her head after the fall of Ming. Kang-I Sun Chang 1991, 83.

109. "斂時現老僧相," in Yu Huai, *Banqiao zaji*, 11.

110. See the entry for Ma Shouzhen in *Zhongxiangci* (眾香詞 Myriad fragrances song lyrics). There is a typo in Ma Shouzhen's name in this book. Xu Shumin and Qian Yue ed. 2.

111. The Guanyin statue is indicated by her animal seat (*ni* 猊), another way to refer to the mythical animal that Guanyin rides. For a similar example, see the inscription on the eleventh manifestation of Guanyin from the *Fifty-three Guanyin Manifestations of Guanyin*, Ding Yunpeng et al.1997, 22.

112. "此高僧道者功行積歲所不能致." Xu Shumin and Qian Yue, eds., *Zhongxiang ci*, 2.

113. The golden rope and precious boat or *jinsheng baofa* 金繩寶筏 is a Buddhist term. In the *Lotus Sutra*, the Country of Leaving Filth is demarcated by a golden rope. *Baofa* 寶筏 is a metaphor for dharma, which can ferry people to the other world.

114. "姬一旦脫然超悟, 視四大為粉妝骷髏革囊盛穢, 棄之不翅敝屣, 非金繩寶筏之力.疇令蓮花生於火宅乎? 彼洛妃乘霧巫女化雲, 未離四大欲界, 惡得與姬並論哉!" Xu Shumin, *Zhongxiangci*.

115. Wang's words were later rerendered by Qian Qianyi as "burned a lamp and worshipped the Buddha, took a bath and changed her clothes, sat upright and passed away." "燃燈禮佛, 沐浴更衣, 端坐而逝." Qian Qianyi and Liu Rushi, *Liechao shiji xiaozhuan* (Shanghai: Zhonghua shuju, 1961), 765. Qian's phrases about Ma Xianglan's death were then cited by many different authors in and after his time, which further confirmed her spirituality.

116. Among the people who attended this ritual were Yunsong 雲松 from Tianjie 天界 Temple and Su'an 素庵 from Qixia 棲霞 Temple. Zhou Hui, *Xu jinling suoshi*, annot. Zhang Zengtai (Nanjing: Nanjing chubanshe, 2007), 235–237. Timothy Brook has provided an insightful discussion on how the gentry used monastic space to conduct various rituals. Brook, *Praying for Power-Buddhism and the Formation of Gentry Society*, 89–107.

117. Zhou Hui, *Xu jinling suoshi*, 235–237.

118. The complete text of *Huiyue tianren pin* can be found in several places. Wang Daokun, *Taihan fumo*, Xin'an Wang shi jia 新安汪氏家, (Harvard Yen-ching Library Collection, 1633), microfilm, juan 22, 29a–32a; Pan, *Genshichao, genshi waiji*, juan 5, 542–544; Chen Renxi, *Chen taishi wumeng yuan chuji san*, vol. 1383, *Xuxiu siku quanshu* (Shanghai: Shanghai guji chubanshe, [1633] 1995–1999), juan 12, 24b–27b; Zhou Hui, *Xu jinling suoshi*, 235–237.

119. Chen, "Shuijing an," *Chen taishi wumeng yuan chuji san*, 259.

120. Chen Renxi, *Jingkou sanshan zhi*, 1612 ed. (Harvard Yen-ching Library Collection), microfilm, juan 19, 3a,

121. Dashi or Great Being was used mainly to refer to Guanyin in late imperial China. But it could also indicate a layperson with the supernormal power of bodhisattvas, such as Vimalakīrti. Given the fact that some rhetoric in "A Chapter on the Heavenly Being Huiyue" is similar to the *Vimalakīrti Sūtra*, Wang Daokun might be alluding to both Guanyin and Vimalakīrti. I am grateful to Lu Yang for calling my attention to this connection. *Weimojie shuo jing*, translated by Kumārajīva, T14, no.475. For the English translation of this text, see *The Vimalakirti Sūtra*, trans. Burton Watson.

122. Yao Lü records that Lu Chengshu praised Xu Jinghong's light yellow skirt with a butterfly pattern (*jiadie qun* 蛺蝶裙), which was trendy in the Wanli period. Yao, *Lushu*, juan 4, 13b. 625.

123. "至則屏花鬘而衣縞素," Wang, *Taihan fumo*, juan 22, 29a.

124. For instance, a woodblock-printed image in *Yueluyi* 月露音 represents female protago-nists visiting a Buddhist temple in Tu Long's *Tanhua ji*, vol. 1, *Yuelu yin*, 103.

125. "門徒皎靈生少廣天, 與諸天人等諸天, 具諸相好, 嗜諸音樂, 習諸紛華, 皎靈猥以非夫. 容觀無冶音樂, 無所御紛華, 無所濡誠願, 一躍波流, 直登彼岸." Wang, *Taihan fumo*, juan 22, 29a.

126. Zhang Yu 張昱, "Nianxia qu" 輦下曲, "The female dancers from the West are heavenly beings" 西方舞女即天人. Zhang Yu, *Kewen laoren ji, Siku quanshu dianziban*, juan 2, 24a. In the next line, the author connects the dancer to the Tianmo dance dancer.

127. "竊聞大士契無上道, 演無上乘," Wang, *Taihan fumo*, juan 22, 29a.

128. "誤墮彼趣," Wang, *Taihan fumo*, juan 22, 29a.

129. "大士拈華微笑嚮天人言: 善哉希有! 供我優鉢羅華, 是出九品上池, 其華千葉, 葉各趺坐一佛, 法相如如其斯, 為妙色身, 即圓滿報身也, 其華或出於泥, 皭然不染, 要其高廣置之." Wang, *Taihan fumo*, juan 22, 30b.

130. "以居士身說法," Wang, *Taihan fumo*, juan 22, 31b.

131. For instance, in the colophon on the *Portrait of Wang Yuanqi*, wang yuanqi xiang 王原祁像, 渣昇(1650–1707) Zha Sheng clearly eulogizes Wang Yuanqi as the manifestation of *zaiguan shen*. *Portrait of Wang Yuanqi*, Nanjing bowuyuan collection. Wang Daokun also used the expressions of *jushi shen and zaiguan shen* to refer to himself. Wang Daokun 2004, *Taihanji*, 2403.

132. Lee Yu-min, *Guanyin tezhan*, 90–92, 199–200. Another example is a painting entitled *Guanyin of the Lotuses* by Shao Mi dated 1626. Lee, *Guanyin tezhan*, 88–89, 198–199. Lee also discusses the male and female forms of Guanyin in late imperial China. Lee Yu-min, *Fotuo xingyin* (Taipei: Guoli gugong bowuyuan, 2012), 106–107.

133. Wang Daokun mentioned Ding Yunpeng in many places in *Taihanji*. "Fomutu xiaoxu 佛母圖小序," Wang Daokun 2004, *Taihan ji*, juan 25, 543–544.

134. I thank Dorothy Ko for bringing this point to my attention. Gender ambiguity also arose as a result of late-Ming scholars' obsession with the Buddhist discourse of "unveiling duplicity." Andrea Goldman, "The Nun Who Wouldn't Be: Representations of Female Desire in Two Performance Genres of 'Si Fan,'" *Late Imperial China* 22, no. 1 (June 2001): 72.

135. "男子身中入定時, 女子身中從定起." See "Cirong ershier xian," Ding Yunpeng et al., *Mingdai muke Guanyin huapu* (Shanghai: Shanghai guji chubanshe, 1997), 44.

136. Wu Zhensheng, *Huanshen rong*, 21b–23a.

137. Wang Shizhen, "Tanluan dashi ji" and "Tanyang dashi zhuan," *Yanzhou sibu gao, xugao*, juan 66, 78.

138. Tanyangzi's icon was not only installed in Tanyang guan 曇陽觀 but also used in home worship by followers. For instance, Tu Long records that his mother juxtaposed the icon of Tangyangzi with Guanyin and other Daoist and Buddhist icons. He did not mention the media of these images. Tu Long, "Shang shoumu taifuren jiushi xu" 上壽母太夫人九十叙, in *Xizhenguan ji*, juan 11, *Tu Long ji*, ed. Wang Chaohong (Hangzhou: Zhejiang guji chu-banshe, 2012), 5:214–215. For the representation of Tanyangzi's statue and worshippers in the Tanyangguan, see the illustration in the beginning of chapter 8 in the *Xunjun xianyuan jishi* 新鐫仙媛紀事 (*Newly Carved Biographies of Immortal Women*), ed. Yang Erzeng *Xinjuan xianyuan jishi. Qiantang Yangshi caoxuan ju ed.*, 1602. Harvard Yen-ching Library Collection.

139. Judith Zeitlin, "Spirit Writing and Performance in the Work of You Tong (1618–1704)," *T'oung Pao* 84 (1998): 102–135.

140. Liang Zhi, carved, and Wang Daohui ed., *Yinjun* Ming wanli gengshu [1610], (Harvard Yen-ching Library Collection), microfilm, juan 3.

141. "baiyuexing wei Jiaoling zuo," Pan, *Genshichao, genshi waiji*, juan 5, 6b. 544.

142. Shen Defu, "Wang Nanming wen" 汪南溟文, in *Wanli yehuo bia*, vol. 3, *Yuanming shiliao biji congkan* (Beijing: Zhonghua shuju, 1959), juan 25. Ling Hong Lam's study of the concept of emotion (*qing*) in the late imperial period may help us to rethink Wang Daokun's obsession of writing long poses to envision Xu Jinghong's transcending to the heavenly realm. Lam argues that the emotion during this period was not a temporal concept indicating interiority but was fundamentally spatial, denoting exteriority. Ling Hon Lam, *The Spatiality of Emotion in Early Modern China: from Dreamscapes to Theatricality* (New York: Columbia University Press, 2018).

143. See the entry "Huiyue tianren pin" in Zhou Hui, *Xu Jinling suoshi*, 237.

144. Hu Yinglin, "Zajian wanggong tanyi wutong 雜東汪公談藝五通," *Shaoshi shanfang ji*, juan 113, *Siku quanshu dianziban*.

145. "函大士作此經以雕龍示幻, 慧月天人持此經以粉黛示幻, 錢居士書此經以筆札示幻." Chen, *Chen taishi wumeng yuan chuji san*, 255.

146. "慧月穢體乃有淨性, 無穢無淨, 亦穢亦淨, 在所轉爾, 是故摩登伽即佛弟子." Chen, *Chen taishi wumeng yuan chuji san*, 255. Tu Long commented on "A Chapter of a Heavenly Being Huiyue" in 1589. He was also involved in compiling the *Gazetteer of Potalaka Mountain* (*Putuo zhi* 普陀志). He sent a copy of the gazetteer to Wang Daokun that same year. Tu, *Tu Long ji*, vol. 12, *Tu Long jianpu*, 535.

147. The poems Wang Daokun wrote for Xu Jinghong were not included in his collection. "A Chapter of a Heavenly Being Huiyue" was added to *Taihan fumo* only in a later edition. As Zhang Ying points out, the conflict between Confucian scholars' self-discipline and the culture of pleasure was intensified in late-Ming China because of the development of commercial culture. Zhang Ying, *Confucian Image Politics: Masculine Morality in Seventeenth-Century China* (Seattle: University of Washington Press, 2017), 21.

148. Liang and Wang, *Yinjun*, juan 3. I thank Tom Kelly for calling my attention to this source.

149. Wang Daokun, "Zhaolin she ji 肇林社記," in *Taihan ji*, vol. 117–118, *Siku quanshu cunmu congshu* (Jinan: Qilu shushe chubanshe, 1997), juan 75, 1548.

150. Wang Daokun, "Wang Zhongyan zhi Xu Feiqing shu" 汪仲淹致徐飛卿書, in Pan, *Genshichao, genshi waiji*, juan 5, 193–546. A Tibetan Guanyin might refer to a bronze statue of Khasarpana (kongxing guanyin 空行觀音, another form of Guanyin in Tibetan Buddhism), sometimes recorded as Water and Moon Guanyin in Tibetan Buddhist doctrinal sources. Li Ling, "Shuiyue guanyin yu zangchuan fojiao guanyin zhi guanxi", *Meishu* 11 (2002): 50–53.

151. Pan, *Yecheng shi, chucao*, 20a.

152. Kumārajīva, *The Vimalakirti Sutra*, 86–89.

153. Pan Zhiheng wrote that he got Wang Daokun's poem from Yu Yuanzhen, the son of Xu Jinghong's deceased husband, who also helped Xu build her nun's retreat. Pan, *Genshichao, genshi waiji*, juan 5, 545.

154. "歸來早築蓮花閣, 好寫蓮花七卷經," Pan, *Genshichao, genshi waiji*, juan 5, 545.

2. PAINTING GUANYIN WITH BRUSH AND INK

1. Xu Can's birth and death dates are debated. I am convinced by Zhao Xuepei's research on this subject. Zhao Xuepei, "Guanyu nüciren xu can shengzu nian ji wannian shenghuo de kaobian." *Wenxue yichan* 3 (2004): 95–100.

2. Chen Gengsheng, comp., and Chen Dejin ed., *Haining bohai chenshi zongpu*, vol. 72–76, *Qingdai Minguo mingren jiapu xuankan xubian* (Beijing: Yanshan chubanshe, 2006), juan 27, 24a.

3. Chen, *Haining bohai chenshi zongpu*. One of Xu Can's Guanyin paintings in the National Palace Museum was created in 1684, thirteen years after she met Emperor Kangxi. It is unclear whether this painting was part of her one thousand-Guanyin painting project.

4. So far, three late-Ming courtesans—Ma Shouzhen, Lin Xue, and Xue Susu 薛素素 (fl. sixteenth to seventeenth centuries)—are recorded as being able to draw Guanyin. Yuhang Li, "Gendered Materialization: An Investigation of Women's Artistic and Literary Reproduction of Guanyin in Late Imperial China" (PhD diss., University of Chicago, 2011), 25f. Only Lin Xue has a surviving painting. For the discussion of the painting see chapter 1 in this book.

5. Li Shi, "*Mingqing shiqi guige huajia renwuhua ticai quxiang.*" *Meishu yanjiu* 1 (1995): 43–47.

6. For further elaboration on this claim, see the discussion in this chapter of *baimiao dashi* and painters who were gentrywomen.

7. Xing Cijing's birth date is unknown, but according to Sun Jiangong, Xing Cijing was probably born in the first year of Wanli era (1573) and lived until after 1640. Sun Jiangong, *Xing Tong yanjiu* (Beijing: Zhongguo wenlian chubanshe, 2006): 159–163.

8. Art historians have discussed women as patrons of Buddhist art from a wide range of aspects, such as political campaigns behind image-making, cave programing, artistic choice of iconography, motivation behind common donors, and religious communities. See Amy McNair, *Donors of Longmen: Faith, Politics, and Patronage in Medieval Chinese Buddhist Sculpture* (Honolulu: University of Hawai'i Press, 2007); Dorothy Wong, "Women as Buddhist Art Patrons during the Northern and Southern Dynasties," in *Between Han and Tang: Religious Art and Archaeology in a Transformative Period*, ed. Wu Hung (Beijing: Wenwu chubanshe, 2000), 1:535–566; Ning Qiang, *Art, Religion, and Politics in Medieval China: the Dunhuang Cave of the Zhai Family* (Honolulu: University of Hawai'i, 2004); Kate Lingley, "Widows, Monks, Magistrates, and Concubines: Social Dimensions of Sixth-Century Buddhist Art Patronage" (PhD diss., University of Chicago, 2004); Heping Liu, "Empress Liu's Icon of Maitreya: Portraiture and Privacy at the Early Song Court," *Artibus Asiae* 63, no. 2 (2003): 129–179; Hui-shu Lee, *Empress, Art and Agency in Song Dynasty China* (Seattle: University of Washington Press, 2010). With respect to the case from the Ming dynasty, see Marsha Weidner, "Images of the Nine-Lotus Bodhisattva and the Wanli Empress Dowager," *Journal of Chinese Historical Research* 35 (2005): 245–278.

9. Tang Shuyu, *Yutai huashi*, Qiantang Wangshi Zhenqitang ed., 1837 (Sun Yat-sen University Collection; accessed from Ming Qing Women's Writing Digital Library), juan 5, 3–9.

10. Women used other media, such as woven cloth, silk applique or patchwork, paper cut, and small and single sheets of printed paper cut and pasted, to make Guanyin icons in domestic space. Also see Zou Dezhong, *Huishi zhimeng*, in *Huaxue huibian* ed. Wang Chang'an (Taipei: [Publisher not identified], 1959 3a); *jian* 剪 (cut) refers to cut paper, and *tie* 貼 (to paste) refers to the use of fabric to make an applique of a figure.

11. 以為文章現世之佛法, 能文之人即現世之佛人, 善文之心, 亦現世之佛心, 金剛離一切相, 況以無色界諸天空定所持猶作男子女子相乎？Zheng Fangkun 鄭方坤 (1693–?), *Quanmin shihua, Siku quanshu dianziban*, juan 10, 28b. Li Zhi (1527–1602) has a similar argument. See his "A Letter in Response to the Claim That Women Are too Shortsighted to Understand Dao" (*Da yi nüren wei duanjian shu* 答以女人為短見书), in Li Zhi, *A Book to Burn and a Book to Keep (Hidden): Selected Writings*, ed. Rivi Handler-Spitz, Pauline Lee, and Haun Saussy. (New York: Columbia University Press, 2016), 29–33.

12. It aspires to the Buddhist concept of equality associated with the concept of *pingdeng* 平等 (equality), which the Awakening of the Great Mahayana Faith connects to being free from all form.

13. Zheng, *Quanmin shihua*, juan 10, 28a.
14. Qian Shoupu 錢守璞, "*Guan furen baimiao guanyin tu*" 管夫人白描觀音圖 ("Madam Guan's baimiao Guanyin painting"), *Xiufolou shigao* 繡佛樓詩稿, 1869 ed. (Harvard Yenching Library Collection), juan 1, 1b. For a general understanding of Chinese artists learned drawing from life and copying master models, see James Cahill, *The Painter's Practice: How Artists Lived and Worked in Traditional China* (New York: Columbia University Press, 1994), 95–105.
15. Johnston Ellen Laing, "Wives, Daughters and Lovers: Three Ming Dynasty Painters," in *Views from Jade Terrace: Chinese Women Artists 1300-1912*, ed. Marsha Weidner, Debra Edelstein, et al. (Indianapolis, IN: Indianapolis Museum of Art, 1988), 31–63.
16. Unlike Chen Shu, who was promoted by her high-ranking official sons and other male members in the family, Jin Liying was not recognized by the court. For more on Chen Shu, see the conclusion in this book.
17. See the entry "Jishi jinshi wuyun muzhiming 繼室金氏五雲墓誌銘," (The Tomb Epitaph of My Second Wife Nee Jin, Wuyun), in Wang Tan, *Wang Tan shiwen ji*, annotated by Zheng Xing, (Beijing: Renmin wenxue chubanshe, 2012), 322. For a good example of how a girl studied classics in the eighteenth century, see Susan Mann's chapter on Tang Yaoqing, Susan Mann, *The Talented Women of the Zhang Family*, 9-14.
18. Indeed, Wang Tan's concubine Qian Wan and their infant son all moved to live with Jin's family while he went on his journey to take official exams. Qian Wan was also a poet and the great-granddaughter of Qian Qianyi.
19. Wang Tan, *Wang Tan shiwen ji*, 323. When her father died, Jin and her sister buried her father close to a temple in Songtai mountain (Songtaishan 松台山 in Shaoxing). They used their own hands to close the tomb door and cover the mound with muds. She lived next to her father's tomb for a three-year mourning period. There was no spring water near the temple and the monks had to go down the hill to get water. But after Jin Liying and her sister buried their father there, a spring appeared. Jin's husband Wang Tan considered this natural phenomenon to be a response to Jin's *gegu* practice and named the spring *chuanying quan* or the Spring of Bracelet Shadow to commemorate Jin's filial behavior. Wang Tan, "Chuanying xuan 釧影泉," Wang Tan, *Wang Tan shiwen ji*, 146. For Jin Liying's own account on this spring, see the poem "Chuanying quan," in Jin Liying, *Qiuhong zhangshi yishi*, in Wang Tan, *Wang Tan shiwen ji*, annotated by Zheng Xing, Appendix I, 395–402 (Beijing: Renmin wenxue chubanshe, 2012), 399.
20. Zhu Xixiang predicted her death and was ready to go to the Pure Land, so she took a bath and went to a temple called Wuqiao nisi 烏橋尼寺 in Hejun 禾郡. She stood inside the temple with her palms together and died. The fragrance of her body lasted for several days and her body was too stiff to move, which was considered miraculous. Eventually she was buried with Dizangwang 地藏王 or Kṣitigarbha Bodhisattva. Wang Tan, *Wang Tan shiwenji*, 218.
21. She presented both paintings to her husband. Wang Tan, *Wang Tan shiwen ji*, 218.
22. Jin Liying was very successful in making profit through taking commissions from friends. Wang Tan mentioned the price of Jin Liying's painting several times in his anthology. For one example, see Wang Tan, *Wang Tan shiwen ji*, 325. Her fame even went beyond scholarly circles in the lower Yangze regions and she was admired overseas in Korea and Japan. Jin Liying once created a set of more than ten scroll paintings of Vimalakīrti and Buddhist's ten disciples, which were brought to Japan. A Japanese with a name of Changqi jiangjun 長旗將軍 even sent her a letter asking for a painting. Wang Tan, *Wang Tan shiwen ji*, 325.

23. For more on the thirty-two Guanyin manifestation, see Wang Tan, *Wang Tan shiwenji*, 169.

24. For the content of these precepts, see the entry "Bodhisattvaśīla" in Robert E. Buswell Jr. and Donald S. Lopez Jr. comps and eds. *The Princeton Dictionary of Buddhism*, (Princeton: Princeton University Press, 2014), 137.

25. Jin Liying, "Bingzhong ti yanshan tu hou" (病中題鴈山圖後, Inscribing on the Picture of Yanshan in the middle of illness), in Wang Tan, *Wang Tan shiwen ji*, 401.

26. Wang Tan, *Wang Tan shiwenji*, 222.

27. "有大士之龕五雲之殯," in Wang Tan, *Wang Tan shiwenji*, 326.

28. Wang Tan also draws such mirror images between Guanyin and his wives through referencing a name with the two characters of *guanyin*. He compared the famous woman poet Xiao Guanyin 蕭觀音 from the Liao dynasty (907–1125) with his first wife Zhu Xixiang, since the former was born on the fifth day of the fifth month and the latter died on the dame day. Hence, he refers to his first wife as Guanyin. Because both his wives died at the age of thirty-six, both married him for twelve years, both wives lived apart from him for six years and then together with him for six years, and more importantly, they both were blessed by the Buddhist rite when they died. Therefore, he implies both wives as Guanyin in his memorial poem. Wang Tan, *Wang Tan shiwenji*, 218.

29. "志篤詩書備有婦德繪大士像得慈悲三昧." Tang, *Yutai huashi*, juan 3, 2b.

30. Such as Xing Cijing, Fang Weiyi, and Xu Can discussed in this chapter. Melissa McCormick has pointed out that in medieval Japan, the monochromatic ink painting already became a shared pictorial aesthetic taste among women who created the narrative painting of the *Tale of Genji*. Melissa McCormick, "Monochromatic Genji: The *Hakubyō* Tradition and Female Commentarial Culture," in *Envisioning The Tale of Genji: Media, Gender, and Cultural Production, ed.* Haruo Shirane (New York: Columbia University Press, 2008), 101–128.

31. Tang, *Yutai huashi*, juan 3, 21b.

32. Niu Kecheng, *Secai de zhongguohua: zhongguo huihua yangshi yu fengge lishi de zhankai* (Changsha: Hunan meishu chubanshe, 2002), 68–89.

33. Helmut Brinker and Kanazawa Hiroshi, *Zen Masters of Meditation in Images and Writings*, trans. Andreas Leisinger (Zurich: Artibus Asiae, 1996), 37–45; Maxwell K. Hearn, *How to Read Chinese Paintings* (New Haven, CT: Yale University Press, 2008), 3.

34. Several women, including Fang Weiyi and Fan Jingsi 范景姒 (1601–1639), followed Li Gonglin (1049–1106), the well-known *baimiao* painter. See entry "Fanshi shihua 范氏诗画," in Wang Shizhen, *Chibei outan, Siku quanshu dianzi ban*, juan 12, 9a. The comments on Li Gonglin's painting from the Song period are helpful to understand women painters' choice of *baimiao*. Niu, *Secai de zhongguohua: zhongguo huihua yangshi yu fengge lishi de zhankai*, 174.

35. Pierre Bourdieu, *Distinction: A Social Critique of the Judgment of Taste*, trans. Richard Nice (Cambridge, Mass.: Harvard University Press, 1984), 260–317.

36. Richard Kent, "The Sixteen Lohans in the Pai-miao Style: From Sung to Early Ch'ing" (PhD diss., Princeton University, 1995), 164–174.

37. For a more in-depth discussion of this set of paintings, see Liu Shih-Lung, "Mingdai nüxing Guanyin hua yanjiu" (master's thesis, Fanhua daxue, Tapei, 2000), 129–133.

38. The study of this painting manual and its circulation among women during the Ming and Qing periods needs to be further developed. Similar model books were also available to less affluent women.

39. Huang Yuanjie's painting album is held in the collection of Liaoning Provincial Museum. More examples can be observed, including Xu Can's Guanyin painting paired with Wang Ritan 汪日葵 *King Gao's Guanyin Sutra* and Zhou Shuxi's *Zhunti Bodhisattva* paired with Heart Sūtra Wang Qu 王瞿. Fei Fanjiu, *Lichao minghua guanyin baoxiang*, collotype prints (Shanghai: Jingyuanshe, 1938) plates no.46 and no.21.

40. Male painters of Guanyin also received eulogies from other male literati. For instance, a male painter Gao Shucheng's Guanyin painting is paired with Shen Xuelin's *Heart Sutra*. Fei, *Lichao minghua guanyin baoxiang*, vol. 1. The sex of the painter and the scripture transcriber, however, are not stressed.

41. Tang Shuyu cited a late-Ming collector Wang Keyu's (1578–?) comments on Qiu Zhu's *White-robed Guanyin*. He praised Qiu Zhu's excellent skill in depicting the convex effect of the beads on Guanyin's necklace, which appeared to be realistic. It is unclear whether Wang referred to this painting. Tang, *Yutai huashi*, juan 3, 2a.

42. Wu Gen, the mother of Qian Weicheng 錢維城 (1720–1772), another woman painter from the Qian family yet less known than Chen Shu, once painted an ink outline Guanyin on the Buddha's birthday (Lunar April 8th) in 1744. Guanyin faces forward and surfs on a dragon-fish. Sudhana stands on a lotus petal. There are two unusual elements created by this woman painter. First, Wu omitted the undergarment beneath Guanyin's long robe and used the light ink lines to indicate Guanyin's belly. Although Guanyin's neck is adorned by a cloud-collar with beaded strings, the central part of her torso is exposed. The second striking feature of this painting is Guanyin's uncommon crown. Wu arranged Buddha's two disciples Ānanda and Mahākāśyapa next to the Buddha. Guoli gugong bowuyuan bianji weiyuanhui. *Gugong shuhua tulu*, vol.11, (Taibei shi: Guoli gugong bowuyuan, 1993) 87–88.

43. Xing Cijing signed the work thusly: "In the *xuan* month (September) of the year of *jiayin* in the Wanli era, the disciple of Buddha, Née Xing from the Ma family, washed her hands before painting this in the Chamber of Orchid Snow." 萬歷甲寅玄月奉佛弟子馬室邢氏沐手寫于蘭雪齋. The earliest textual record of this painting is probably in *Xingshi jiacheng* 邢氏家承 (*Xing Family Genealogy*). In the section on the Xing family's collection entitled "Hanmozhi" 翰墨志 ("Records of Brush and Ink") a handscroll painting referred to as *Guanyin* is listed. Two elements point to this connection: First, *Xingshi jiacheng* mentions that a *kaijing jie* (opening *gāthā*) is inscribed on the painting. Second, the text also describes the brushwork on that Guanyin as extremely fine. These two features certainly recall salient features of the *White-robed Bodhisattva* at the Qingdao Museum. See *Xingshi jiacheng*, "Hanmozhi 2," (reprint of 1868 ed.; Xing Tong Museum Collection, 1912), 2b–3a. This record also reports that many fake Xing Cijing paintings were circulating in Linyi when this family genealogy was composed (Qianlong period). According to this catalog, the Xing family still possessed several of Xing Cijing's paintings, and her subject matter was not limited to Guanyin. She also painted *Sanxing tu* 三星圖 (three deities), *Juanshi* 卷石 (tumbling rocks), *Baimiao Luohan tu* 白描羅漢圖 (Luohans rendered in plain line drawing). *Xingshi jiacheng*, "Hanmozhi 2," 2a–2b.

44. The current title of this painting is likely based on Xing Cijing's inscription. She first refers to the deity as White-robed Bodhisattva and later identifies her as Guanyin. Qingdaoshi bowuguan, *Qingdao shi bowuguan canghua ji* (Beijing: Wenwu chubanshe, 1991), Pl.34. This painting is also cataloged as *Baiyi Guanyin tujuan* 白衣觀音圖卷 (Handscroll Painting of the White-robed Guanyin) in *Zhongguo gudai shuhua tumu*, ed. Zhongguo gudai shuhua jianding zu (Beijing: Wenwu chubanshe, 1986–1994) 16:299.

45. The scholarship on this painting is sketchy. It is only briefly mentioned by art historian Li Shi in her discussion of the general trends in subjects in paintings by gentrywomen. Xing Cijing is classified as specializing in Buddhist painting. Li points out that the most distinctive feature of Xing's Guanyin paintings is their combination of Guanyin's image and *gāthā*. Li merely transcribed Xing's inscriptions, but does not further explain those texts. Li, "Mingqing shiqi guige huajia renwuhua ticai quxiang," 44.

46. "世傳白衣菩薩送子, 凡祈嗣者禱焉, 其靈變奇驗, 彰彰在人耳目, 未易殫述, 余今寫五像以志皈奉云爾."

47. Chün-fang Yü discusses how the White-robed Guanyin has been elided with the Child-giving Guanyin since the Ming period. See Chün-fang Yü, *Kuan-yin*, 129–133.

48. Patricia Ebrey, *The Inner Quarters: Marriage and the Lives of Chinese Women in the Sung Period* (Berkeley: University of California Press, 1993), 235.

49. Wu Hung's observation on the two types of compositional schemes in early religious art is helpful. He points out that the two types are the iconic and the episodic. Xing's handscroll represents an episodic composition in which the figures in the painting do not confront the viewer; they are self-contained without the participation of the viewer. See Wu Hung, *The Wuliang Shrine: The ideology of Early Chinese Pictorial Art* (Stanford, Calif.: Stanford University Press, 1989), 133.

50. The earliest surviving woodblock-printed edition of the *Thirty-Two Manifestations* is dated to 1622. In 1622, Fang Shaozuo 方紹祚 (active in late sixteenth to early seventeenth century) recollected the woodblock plates that were originally patronized by Cheng Dayue 程大約 (active in late seventeenth century) and who had missing plates recarved. Now ten of these woodblock plates with the format of each plate containing three images are now in the Anhui Provincial Museum collection. This set of Guanyin images was first attributed to Ding Yunpeng in 1939 by Xu Chengyao 許承堯 (1874–1946), a well-known poet, historian, and collector from Anhui. See Xu Chengyao's inscription in Ding Yunpeng et al. *Mingdai muke Guanyin huapu.* (Shanghai: Shanghai guji chubanshe, 1997), 142.

51. Shancai in Chinese literally means Virtuous Talent. He is one of the iconographic components of Guanyin. According to the *Avatamsaka* (*Hua Yan*) *Sutra*, Shancai is the son of an elder from Fu City. From the time he was nurtured in his mother's womb until he was born, all kinds of treasures spontaneously appeared in his home. As a result, he came to be known as the Virtuous Talent, Shancai. He received the teachings of Manjusri Bodhisattva, traveled to numerous kingdoms of the south, visited with fifty-three of the virtuous wise ones, and learned from them the many facets of the dharma. He also met with Samantabhadra Bodhisattva who instilled in him the inexhaustible seed of diligent practice. Shancai ultimately attained Buddhahood. His twenty-eighth trip to the southern region was to visit the Purple Bamboo Grove of Mount Putuo, where he paid homage to Avalokiteśvara Bodhisattva. In the late imperial period, because of the influence of the cult of Guanyin and various popular literatures, Shancai's visits to Guanyin were singled out as a separate iconographic component, which is commonly referred as *tongzi bai guanyin* 童子拜觀音 (pilgrim boy worshiping Guanyin). In most cases, it is easy to distinguish Shancai from a mundane boy because he is portrayed as a holy figure. He has a halo, his body is bejeweled, and flying streamers swirl around him. For a study of images of this subject, see Jan Fontein, *The Pilgrimage of Sudhana: A Study of Gandavyū Illustrations in China, Japan and Java* (Den Haag: Mouton, 1967).

52. Xing Cijing's father was Xing Ruyue 邢如約 (1512–1602). For his biography, see *Xingshi jiacheng*, 88–136.

53. He was a metropolitan graduate (*jinshi*) in 1574 and his highest post was Chief Minister of the Court of Imperial Studies. Xing Tong was a central figure in the literati world; he befriended people like Wang Shizhen, Wang Zhideng, Dong Qichang, and Tu Long. For Xing Tong's achievements in office and the arts, please see Sun, *Xing Tong yanjiu*. Most of Xing Tong's writings survive in the collection Xing Tong, *Laiqinguan ji*, ed. Shi Yiming, 28 vols. 1637 edition (University of Chicago Library Collection), microfilm.

54. Xing Cijing's biographic information can be found in Qian Qianyi and Liu Rushi, *Liechao shiji xiaozhuan*, (Shanghai: Zhonghua shuju, 1961), 2:747. For an introduction to her artistic achievements, see Grace Fong, *Herself an Author: Gender, Agency, and Writing in Late Imperial China* (Honolulu: University of Hawaiʻi Press, 2008), 91–99.

55. For the discussion of Xiing Cijing's achievement in making her own calligraphic model, see Yuhang Li, *Gendered Materialization*, 38–39, f. 33.

56. Xing's other calligraphic model entitled *Xingfuren zishu shitie* 邢夫人自述詩帖 (Calligraphic Model of Madam Xing's Self-accounted Poems) is mentioned in Bian Yongyu, *Shigutang shuhua huikao* (Shanghai: Jiangu shushe, 1921), juan 28, 43 a and b.

57. Sun Jiangong points out that after Xing married Ma, her official title changed from fifth-rank *yiren* to fourth-rank *gongren*. This proves that when Xing married Ma, Ma's fifth-rank post of *tongzhi* in Pingyang was advanced to the fourth-rank *zhifu* of Datong. Sun, *Xing Tong yanjiu*, 162.

58. As a widow, Xing Cijing is well-known for her bravery because she brought her husband's corpse back to his hometown from Guizhou (藝文志下). That journey lasted for three months and Xing wrote an extremely long prose work entitled *"Zhuibi qiantu lue"* 追筆黔途略 ("A Brief Memo of the Journey in Guizhou") to record all the turmoil she went through. See *Xingshi jiacheng, juan 10, yiwenzhi er* 藝文志, 433–447. Fong, *Herself an Author*, 93–99. Because Xing thought her husband was undervalued, she traveled to Beijing to present a memorial to the emperor, in which she pleaded for better subsidies in recognition of her deceased husband. She succeeded and her husband was granted a higher posthumous rank. That memorial, entitled *"Weifu qingxu dianshu"* 為夫請卹典疏 ("A Memorial of Asking for Subsidies for My Husband") is reprinted in *Linyi xianzhi*, vol. 5, juan 11, *Yiwenzhi xia*, 10a–12b (facsimile reprint of the 1874 edition, Xing Tong Museum Collection).

59. Madam Yang was the younger sister of Yang Wei 楊巍 (1513–1605), head of the Ministry of Civil Appointment in Beijing. The legend of her friendship with Xing Cijing was recounted in the local gazetteer and *Xingshi jiacheng* as follows: Madam Yang brought ten shelves of books with her to her husband's family. On the first day they met, she randomly picked up a book from the shelves and asked Cijing to read. To her amazement, Cijing could read the whole book without missing one word. Madam Yang then continued to test her on other books; Cijing satisfied her with all the right answers. Madam Yang was so impressed that they became very good friends and together composed poems and practiced calligraphy and painting. See *"Yangshi zhuan"* 楊氏傳, in *Neizhuan* 內傳, *Xingshi jiacheng*, juan 6.

60. Madam Yang was likely familiar with Buddhist ritual and learning because her brother Yang Wei was well known for his involvement with monastery activities and writings. In the section of the biography on Madam Yang in *Xingshi jiacheng*, an unverified source of Madam Yang is attached to her formal biography. A lady referring to herself as Yang Xinshi who was once believed to be Madam Yang, was actually the sister of another official. Zhang Guangyu from Linyi saw a stele in a White-robed Nunnery in Anzhen, on which Madam Yang's calligraphy of Guanyin sutra was transcribed. Her determination of spreading the cult of Guanyin is also fully expressed on the stele. *Xingshi jiacheng*, juan 6.

61. Xing Tong wrote biographies for his mother and his sister Xing Dazi after they passed away. For his mother Madam Wan's 萬 biography, see Xing, *Laiqinguan ji*, juan 16, 24a–29a. For his sister's biography see Xing, *Laiqinguan ji*, juan 11, 8a–11a.

62. For a study of the Ye family, see Ko, *Teachers of the Inner Chambers:* 187–218. For a study of the Fang family, see Xu Jie, "Mingmo tongcheng fangshi yu mingyuan shishe," in *Mingqing wenxue yu xingbie yanjiu*, ed. Zhang Hongsheng (Nanjing: Jiangsu guji chubanshe, 2002), 349–362.

63. Ko, *Teachers of the Inner Chambers*, 195–202.

64. "Lei chifeng ruren wangqi chenshi muzhiming" 累勅封孺人亡妻陳氏墓誌銘 ("Epitaph of [My] Departed Wife Madam Chen with Multi-conferred Ruren Title"), in Xing, *Laiqinguan ji*, juan 18, 1b–5b. It is unclear how Madam Chen sought out divination. She might have gone to the White-robed Nunnery near her home or used some text related to the cult of Guanyin. Though surviving Guanyin divinational texts were printed in 1592 by the imperial court ladies after Madam Chen passed away, they still provide a useful example of how the cult of Guanyin assimilated the popular practice of divination. Xin Deyong, "Shu shiyin ming wanli keben Guanshiyin ganying lingke," *Zhongguo dianji yu wenhua* 3 (2004): 106–111.

65. Xing, *Laiqinguan ji*, juan 18, 4a.

66. After the jade statue was moved out from Xing Tong's studio in 1824 by a local official, his memorial plaque was then placed there. "Laiqin guan fengsi ziyuan xiansheng ji" 來禽館奉祀子愿先生記 ("Record of Offering Sacrifices to Mr. Ziyuan in the Hall of Coming Bird"), *Xingshi jiacheng, yiwenzhi*, 634.

67. The third "Sitting Quietly" poem is included in Wang Duanshu, *Mingyuan shiwei chubian*, juan 6, zhengji 4, 3a. For a full translation and analysis of this poem, see Fong, *Herself an Author*, 92–93.

68. "*Chenqi fenxiang*" and "*nianfo*" appeared on the same woodblock with mark of "ju wu" 居五.

69. Transcribed from the rubbing edition of *Feifei cao*, private collection, leaf 19.

70. "形即是空, 空即是形."

71. No textual reference indicates that Xing Cijing's late nuptials were due to her resistance to marriage. Instead, *Liechao shiji xiaozhuan* provides a reason as her mother Madam Wan treasured her so much that she thought only *guiren* 貴人 (nobility) could tie the knot with her daughter. Qian and Liu, *Liechao shiji xiaozhuan*, 774. For a discussion of Xing Cijing's marriage, see Sun, *Xing Tong yanjiu*, 163.

72. Sun, *Xing Tong yanjiu*, 130–131.

73. Sun, *Xing Tong yanjiu*, 130–131.

74. I have not found the textual reference for Xing Cijing's son. This name was given by Sun Jiangong, a sclar of Xing Tong and Xing Cijing. According to Sun, Ma Shixing died when he was in his twenties and left behind two sons. Today, the offspring of Xing Cijing and her husband Ma Zheng still live in Linyi.

75. Francesca Bray, *Technology and Gender: Fabrics of Power in Late Imperial China* (Berkeley: University of California Press, 1997), 351. For a discussion of adoption an heir in the late imperial China, see Ann Waltner, *Getting an Heir: Adoption and the Construction of Kinship in Late Imperial China.* (Honolulu: University of Hawai'i Press, 1990.)

76. In the preface to Fang Mengshi's poetry collection, Fang Weiyi listed all the merits of Fang Mengshi. Also in the short biography of Fang Mengshi in *Liechao shiji xiaozhuan*, Qian Qianyi praised Fang Mengshi for finding concubines for her husband. See Hu Wenkai, *Lidai funü zhuzuokao* (Shanghai: shangwu yinshuguan, 1957), 84–85. Fang Mengshi was also recorded as being able to draw Guanyin. Tang, *Yutai huashi*, juan 3, 2b.

77. In the years after she bought a concubine for her husband, however, she gave birth to a daughter and a son. See "Xing Dazi zhuan" 刑大姊傳 (Biography of Xing Dazi), in Xing, *Laiqinguan ji*, juan 11, 8a–11a. An ink-rubbing of a stone stele carved with the "Biography of Xing Dazi" is in the collection of the Chinese National Library. *Beijing tushuguan jinshizu* ed., *Beijing tushuguan cang zhongguo lidai shike taben huibian* (Zhengzhou: Zhongzhou guji chubanshe, 1989–1991), 57:192.

78. For instance, Xing Cijing's calligraphy is well known for capturing the essence of her brother's style. Jiang Shaoshu (fl. Ming Wanli period), *Yunshizhai bitan*, vol. 11, *Zhongguo lidai meishu dianji huibian*, ed. Yu Yu-an (Tianjin: Tianjin guji chubanshe, 1997), juan 5, 84.

79. On the cover page of this sutra, besides the abbreviated title "Baiyijing" 白衣經 (White-robed Sutra), Xing Tong also inscribed, "On the fifteenth of October of the year *guisi* of the Wanli-era [1593], the follower of Buddha Xing Ziyuanfu, washed his hands and wrote, "萬曆癸巳十月望日奉佛弟子邢某子愿父沐手書." Because his second son Xing Wangcheng 邢王偁 (1592–1638) was born one year before this sutra was made, it was probably scribed to fulfill his vow. *Xingshi jiacheng, hanmozhi*, 653.

80. This explains why Xing Tong revisited this sutra a year after Xing Wangcheng was born: he probably wanted to make sure that the boy's life was stable. The second function of this sutra might be a plea for his son's longevity. One source implies that Xing Tong's calligraphic copies of Guanyin sutras in the *zhengkai* 正楷 style (standard script) were transcribed and engraved by his follower Xu Qingshi 許慶士 on the wall of the Hall of Guanyin (Guanyin tang 觀音堂) in the northwest part of Linyi. See "Xu Qingshi Guanshiyinjing ji xian taipu fashu ba" 許慶士觀世音經集先太僕法書跋 (The Late Taipu [Xing Tong]'s Calligraphic Postscript for Xu Qingshi's Guanshiyin Collection), in *Xingshi jiacheng, yiwenzhi*.

81. See the entries for "Baiyijing" 白衣經 in ["*hanmozhi yi*" 翰墨志一] and "Yufugong" 玉符公 [Xing Wangrui's posthumous name] in ["*hanmozhi er*" 翰墨志二] in *Xingshi jiacheng*, 657, 667.

82. Yü, *Kuan-yin*, 130–132.

83. According to Chün-fang Yü, selling woodblock plates of the scripture is one of the good deeds that repaid Guanyin's miraculous power. Yü, *Kuan-yin*, 134.

84. Cynthia Brokaw also points out that praying for an heir was related to the ledgers of merit- and demerit-making in the late Ming. In her discussion of the case of a physician, Yuan Huang, and his morality book *Qisi zhenquan* 祈嗣真詮 (Guide to Praying for an Heir), she notes that along with Guanyin, an esoteric goddess Zhunti was also worshipped. See Cynthia Brokaw, *The Ledgers of Merit and Demerit: Social Change and Moral Order in Late Imperial China* (Princeton, NJ: Princeton University Press, 1991), 73–75. For a recent study on Yuan Huang's relation to popular religions, see Cuong T. Mai, Cuong T. "The Guanyin Fertility Cult and Family Religion in Late Imperial China: Repertoires across Domains in the Practice of Popular Religion." *Journal of the American Academy of Religion* 87, no. 1, (March 2019) 156–190.

85. Yü, *Kuan-yin*, 130, 134. This phenomenon is not only in the *White-robed Sutra* that Chün-fang Yü discussed, but also in the miracles attached to other scriptures such as *King Gao's Guanshiyin Sutra*, which were also believed effective while praying for a child. In an 1894 edition of this sutra, the narratives of miraculously having a son are laid out as a paradigm in which the husband sponsors the printing of scriptures and the wife plays the role of receiving the son. "Guanshiyin lingyan" 觀音靈驗 ("Guanyin's Efficacy"), attached to *Gaowang Guanshiyin jing*, in *Zhongguo lidai Guanyin wenxian jicheng*, ed. Xia Jingshan and Lou Yutian (Beijing: Zhonghua quanguo tushuguan wenxian suowei fuzhi zhongxin, 1998) 3:531–546.

86. Chen Weisong, *Furen ji*, in *Haishan xianguan congshu*, Case 9, *Baibu congshu jicheng*, Series 60 (Taipei: Yinwen yinshuguan, 1967), 26a.

87. Jonathan Hay, "The Reproductive Hand," in *Between East and West in Art*, ed. Shigetoshi Osano (Cracow: Artibus et Historae, 2014), 330.

88. Chün-fang Yü found this hymn attached to *King Gao's Guanshiyin Sutra* in the Bibliothèque Nationale in Paris (Chinois 5865). She suggests that it was probably written in the late Ming since *King Gao's Guanshiyin Sutra* was widely circulated in China during this period. Yü, *Kuan-yin*, 261. For the original text, see *Gaowang guanshiyin jing*. T.85, no.2898.

89. Five such ink-rubbings have been published. Only one carved in 1640 has a different layout from the conventional top text and below image format. This rubbing is divided vertically into five parts. The top and bottom have an image of Guanyin and an *arhat*, respectively. The title *Baiyi jing* (*White-robed Sutra*) is displayed alongside the *arhat*. The complete text of the sutra occupies the three middle sections of the stele. The rubbing of this stele may have meant to be folded. See Fei, *Lichao minghua guanyin baoxiang*, pl. 154. Another rubbing of the *White-robed Sutra* can be found in this same catalog, see Fei, *Lichao minghua guanyin baoxiang*, pl. 144. For a discussion of this image, see Yü, *Kuan-yin*, 127–128. The other two are published in the catalog of the ink-rubbings collected at the National Library of China. See *Beijing tushuguan jinshizu* ed., *Beijing tushuguan cang zhongguo lidai shike taben huibian*, 7:40, 42. A newly published article reveals that Qingzhou Museum in Shandong also has an ink-rubbing of *White-robed Sutra* from a stele carved in 1613. The authors provide a detailed study of the patrons and carver of the stele. This case serves as an important example for understanding the patronizing of the stele of *White-robed Sutra* and the image of Child-giving Guanyin in Shandong during the Wanli period. Specifically, this stele was made one year earlier than Xing Cijing's painting. See Li Sen and Xu Qinghua, "Ming 'baiyi dabei wuyinxin tuoluoni jing' bei tanxi," *Zhongguo wenwuwang* (March 26, 2008).

90. This arrangement is probably confined by the convention of painting/poem paradigm; because dharani and Buddha names are not poetic verses, they were left out.

91. 無上甚深微妙法, 百千萬劫難遭遇. 我今見聞得授持, 顧解如來真實義. Here I use Chün-fang Yü's translation; Yü, *Kuan-yin*, 126.

92. 海岸孤絕處 普陀落伽山, 正法明王, 聖觀自在, 髮凝翠黛, 唇艷朱紅, 臉透丹霞, 眉彎初月, 世稱多利, 時號吉祥, 皎素衣而目煥重瞳, 坐青蓮而身嚴百福. Yü, *Kuan-yin*, 261. The translation is modified by author. In Yü's English translation, one sentence is omitted, but in the Chinese version of an article about the White-robed Guanyin, the omitted sentence is included. See Chün-fang Yü and Shi Zikan 釋自衎 trans., "Baiyi dashi songzi lai" 白衣大士送子來, *Xiangguang zhuangyan* 61 (March 20, 1989).

93. Yü, *Kuan-yin*, 261. This useful information enables us to speculate that Xing Cijing also read *King Gao's Sutra of Guanshiyin* and used it as another source for her painting.

94. 稽首大悲, 婆盧羯帝. 徒聞思備, 入三摩地. 振海潮音, 應人間世. 隨有希求, 必獲如意. I use Chün-fang Yü's translation; Yü, *Kuan-yin*, 126.

95. They are the Nanwu benshi shijia monifo 南無本師釋迦牟尼佛 (Homage to the Original Teacher Sakayamuni Buddha), Nanwu benshi a-mi-tuo-fo 南無本師阿彌陀佛 (Homage to the Original Teacher Amitābha Buddha), Nanwu baoyue zhiyan guangyin zizai fo 南無寶月智嚴光音自在佛 (Homage to Sovereign Master Buddha of Precious Moon and the Light and Sound of Wisdom Peak), Nanwu dabei guanshiyin pusa 南無大悲觀世音菩薩 (Homage to Great Compassionate Guanshiyin Bodhisattva), and Nanwu baiyi guanshiyin pusa 南無白衣觀世音菩薩 (Homage to White-robed Guanshiyin Bodhisattva). I used Chün-fang Yü's translations of these names; Yü, *Kuan-yin*, 126.

96. 似月現於九霄, 如星分於眾水, 除三災於災劫, 災變不災, 救八難於難鄉 難翻無難. The sentence Xing omitted appears between the second and the fourth colophon. The omitted part is "接接微苦, 聲察求哀" (Responding to the cries for help from people in danger). The last sentence from the original text is also deleted: "大悲大願大聖大慈, 聖白衣觀自在菩薩摩訶薩" (To the One of Great Compassion, Great Vows, Great Holiness, and Great Mercy, Adoration to the White-robed Master Perceiver Bodhisattva); Yü, *Kuan-yin*, 261.

97. Jerome Silbergeld, *Chinese Painting Style: Media, Methods, and Principles of Form.* (Seattle: University of Washington Press, 1982), 12–13; Wu Hung, *The Double Screen: Medium and Representation in Chinese Painting* (Chicago: University of Chicago Press 1996), 57–68.

98. Qingdaoshi bowuguan, *Qingdao shi bowuguan canghua ji*, pl. 34.

99. A mother's compassion is developed through different stages such as pregnancy, giving birth and raising a child. For a valuable study of the discourse of fetal development before eleventh and in relation to religious practice, see Jessey Choo, "That 'Fatty Lump': Discourses on the Fetus, Fetal Development, and Filial Piety in Early Imperial China." *Nan Nü: Men, Women and Gender in Early and Imperial China* 14, no. 2 (2012), 177–221.

 In a Confucian framework, a mother's passion toward a child is often represented through her role as an educator and a diligent textile weaver. The most representative story is that Mencius's mother relocated three times to improve her son's education. In the visual tradition, a good example is the handscroll painting entitled "Teaching Child While Weaving" by Wang Run (1756–1832) and Gai Qi (1774–1828) from the Royal Ontario Museum Collection. Another typical allegorical way to represent the compassion of mother and children is through the motif of hen and chicks.

100. The word *givenness* refers to "the quality or state of being given." Philip Babcock Gove and the *Merriam-Webster* editorial staff editors, *Webster's Third New International Dictionary of the English Language* (Springfield, Mass.: Merriam-Webster, 1981), 960.

101. See entry "*Guixiuhua* 閨秀畫" in Wang Shizhen, *Chibei outan*, juan 12, 18a.

102. Xing Cijing was lauded as a cultural hero by the people from her hometown. One record shows that after Xing passed away, someone from Linyi invited her spirit to the planchette writing (*fuluan* 扶鸞) in the last year of Kangxi 康熙 (1722). In general, during a session of planchette writing or spirit writing, one person holds a tray with sand or incense ashes and another person holds a stick. When the spirit arrives, the person who holds the stick is controlled by the spirit and writes Chinese characters in sand or incense ashes. Xing Cijing's spirit first drew a painting and then wrote a poem that was later identified as a poem from her poetry collection *Feifei cao*. Drawing on a phrase from Judith Zeitlin we can say that Xing's past became part "of a continuous present." Zeitlin explains that "the infinite repeatability of authorship becomes proof of immortality." Judith Zeitlin, "Spirit Writing and Performance in the Work of You Tong (1618–1704)," *T'oung Pao* 84 (1998): 105.

103. She simply signed the painting "Anhui Tongcheng Yao family's Fang Weiyi painted [this painting] after washing and applying perfume, at the age of seventy one" 皖桐姚門方氏維儀薰沐寫時七十有一. This painting is now in the collection of the Beijing Palace Museum.

104. Fang Weiyi's biographies have appeared in several historical records such as *Mingshi* and *Anhui tongzhi* 安徽通志. For her most complete biography, see "*Qingfenge zhuan diwu*" 清芬閣傳第五, in Ma Qichang ed., *Tongcheng qijiu zhuan*, 454–459. The narratives of her biography from different records resemble each other and all make the point that Fang was an exemplary woman.

105. Fang Weiyi, "*Weiwangren weishengshu*" 未亡人微生逑; Ma, *Tongcheng qijiu zhuan*, 455–456. During my visit to Fang Weiyi's hometown in 2010, I realized that the Fang family and Yao family's old residences are very close. There are three main family clans in Tongcheng: Fang, Yao, and Zhang. Marriages were mostly arranged among these three families. Therefore, when Fang Weiyi returned to her parents' home, she had only to move from one household to the other in the same alley. For a discussion of widow's remarriage in China, see Jennifer Holmgren, "The Economic Foundations of Virtue: Widow-Remarriage in Early and Modern China", *The Australian Journal of Chinese Affairs* 13 (Jan.1985):1–27.

106. Susan Mann points out that among the lower classes, widow remarriage was quite common, so we should study women's marriages from the perspective of different social ranks. See Susan Mann "Widows in the Kinship, Class and Community Structures of Qing Dynasty China." *Journal of Asian Studies* 46, no.1: 37–56.

107. Chinese gazetteers are local histories often complied by resident elite scholars and sponsored by the local officials. For an in-depth discussion of the production of gazetteers in imperial China, see Joseph Dennis, *Writing, Publishing, and Reading Local Gazetteers in Imperial China, 1100-1700.* (Cambridge, Mass.: Harvard University Asia Center, 2015.)

108. Liao Dawen and Jin Dingshou, eds., *Tongcheng xuxiu xianzhi* (Taipei: Chengwen chubanshe, 1975), 761–762, 947.

109. At the end of the Ming dynasty, the cult of women's purity was particularly promoted in the areas where Han culture was firmly entrenched. Anhui Prefecture, where Fang lived her whole life, is one such place. The famous philosophical school of Neo-Confucianism, which promoted female purity, dominated in Anhui. The region was well known for its chaste widows in the Ming dynasty. Carlitz suggests that the cult of female virtue was closely related to the strong lineages in Anhui, particularly Huizhou, because claiming virtuous women helped to boost the prestige of a lineage. Katherine Carlitz, "Desire, Danger, and the Body: Stories of Women's Virtue in Late Ming China." In *Engendering China: Women, Culture, and the State*, ed. Christina K. Gilmartin (Cambridge, Mass.: Harvard University Press, 1994), 101–124.

110. For a study of the Fang women's literary achievements, see Xu, "Mingmo tongcheng fangshi yu mingyuan shishe," 342–369.

111. As for Yao jiefu, see *Qianqingtang shumu*, juan 28. For Yao zhenfu, see Wang, *Mingyuan shiwei chubian*, juan 12, 6a.

112. She did not commit suicide later, because she took on the responsibility of caring for her brother's children. She also did not want to break her parents' hearts, so she decided to continue to live. Fang Weiyi, "Weiwangren weishengshu." in Ma, *Tongcheng qijiuzhuan*, 456.

113. Hu, *Lidai funü zhuzuokao*, 67. This work was recorded in Wang Shilu's *Ranzhiji zhulu*, but is no longer extant, see Yongrong, Ji Yun, et al. *Qinding siku quanshu zongmu.* (Taipei: Taiwan shangwu yinshuguan, 1983) ji 420–729.

114. Ko, *Teachers of the Inner Chambers*, 160–166.

115. In his preface to Fang Weiyi's poetry collection *Qingfeng geji* (Collection from Tower of Clear Fragrance), Fang Yizhi reveals that, like many gentrywomen in the late imperial period, Fang Weiyi regretted her gender identity and lamented the fact that women could not go beyond the domestic space. Fang Yizhi, "Qingfenge ji ba" 清芬閣集跋 (Preface for the Collection from Tower of Clear Fragrance), in *Fushan wenji qianbian* (Beijing: Beijing chubanshe, 1997), juan 2, 8a, 8b, and 9 a.

116. Fang Weiyi, "*Yu mizhi zhi shu*" 與密之侄書; Li Shi, "Fang Weiyi he tade *Guanyin tu zhou*" *Wenwu* 10 (1994): 96.

117. Ye Shaoyuan, ed., *Wumengtang ji* (Beijing: Zhonghua shuju, 1998), 540.

118. Wang, *Mingyuan shiwei chubian*, juan 12, 6a, 7b. The poem was translated by Rivi Handler-Spitz.

119. She mentions *huangkou er* 黃口兒, which refers to a little baby, and this seems to refer to the death of her infant daughter.

120. To illustrate Confucian notions of the relationship between spaces and women's expression of their religious piety, Zhou Yiqun employs a new paired opposition—hearth and temple—for these binary sacred spaces of the Ming-Qing era. Rather than focusing on the material dimension of the hearth, she lays out the Confucian discourse of ancestral rites that sanctified the domestic domain. Zhou Yiqun, "The Hearth and the Temple: Mapping Female Religiosity in Late Imperial China, 1550–1900," *Late Imperial China* 24, no. 2 (December 2003): 109–155. Fumiko Joo's research on a late Ming lawsuit over a Buddhist temple in Ningbo raises another important issue concerning how devoted lay Buddhist women, especially unmarried women, were turned into objects of ancestress worship by the family. Fumiko Joo, "Ancestress Worship: Huxin Temple and the Literati Community in Late Ming Ningbo." *Nan Nü: Men, Women and Gender in China* 16, no.1 (2014): 29–58.

121. Timothy Brook, *Praying for Power: Buddhism and the Formation of Gentry Society in Late-Ming China* (Cambridge, Mass.: Harvard University Press, 1993), 188–191.

122. Hu, *Lidai funü zhuzuokao*, 68.

123. Morten Schlütter, *How Zen Became Zen: The Dispute Over Enlightenment and the Formation of Chan Buddhism in Song Dynasty China* (Honolulu: University of Hawai'i Press, 2008), 107–109.

124. Grant, "Who Is This I? Who Is That Other? 47–86.

125. Brook, *Praying for Power*, 188–191.

126. Yü, *Kuan-yin*, 127. For the *Heart Sūtra, see Da banruo boluo miduo xinjing*, trans. Xuanzang. T5-7, no.220.

127. As Chün-fang Yü elucidates, the White-robed Guanyin and Child-giving Guanyin were indeed elided in popular religion, so "the White robed Kuan-yin (Guanyin) was as much a great meditation icon as a great fertility goddess." Because the White-robed Guanyin could bestow sons, this Guanyin could enhance women's position in the family, and she became women's protector in many ways. Although Fang Weiyi did not expect a son from Guanyin, she may have hoped that Guanyin, the fertility goddess, would help her to reach the Pure Land because the Guanyin also helps devotees to be reborn in Western Paradise. Yü, *Kuan-yin*, 245.

128. One should investigate why all of Fang Weiyi's surviving works are from her seventies.

129. It is unclear at this point who Ciyun the Chan master is. S/he was probably Fang Weiyi's contemporary.

130. For complete translation of this text, see Yuhang Li, *Gendered Materialization*, 65–66.

131. Wai-kam Ho, "White-Robed Kuan-yin (Pai-i Kuan-yin)," in William Rockhill Nelson Gallery of Art and Mary Atkins Museum of Fine Arts. *Eight Dynasties of Chinese Painting: The Collections of the Nelson Atkins Museum, Kansas City and Cleveland Museum of Art* (Cleveland: Cleveland Museum of Art, 1980), 123. As Ho points out, Zhongfeng Mingben's inscription indicates that this painting was created in Huanzhu-an in Suzhou around 1300. After two years, Mingben was invited to another monastery in Mt. Tianmu. Yongzhong remained in Huanzhu-an until his death.

132. Yukio Lippit, "Awakenings: The Development of the Zen Figural Pantheon," in *Awakenings: Zen Figure Painting in Medieval Japan*, ed. Naomi Noble Richard, and Melanie B. D. Klein (New York: Japan Society, 2007), 36.

133. "所難者吳道子一筆圓光耳." Fang Yizhi, *Xiyu xinbi* 3a, in *Tongcheng fangshi qidai yishu* (*Posthumous Writings of Seven Generations of Fang Family from Tongcheng*), ed. Fang Chang-han (1888). We do not know whether any of Wu's work survived in Fang's time or whether she saw that work, but she seriously wanted to draw Guanyin in one stroke. For a discussion of Wu Daozi's brush style, see Wen Fong, "Why Chinese Painting Is History?" *Art Bulletin* 85, no. 2 (June 2003): 263.

134. *Xuanhe huapu*, *Huashi congshu*, ed. Yu Anlan (Shanghai: Shanghai renmin meishu chu-banshe, 1963) 2:14. For a more complete discussion of Wu Daozi and his painting as performance, please see Wu Hung, "The Originals of Chinese Painting," in *Three Thou-sand Years of Chinese Painting*, ed. Yang Xin et al. (New Haven, Conn.: Yale University and Foreign Languages Press, 1997), 70–74.

135. Wu, "The Originals of Chinese Painting," 74.

136. "守其神, 專其一." Zhang Yanyuan, *Lidai minghua ji*, *Huashi congshu*, ed. Yu Anlan (Shanghai: Shanghai renmin meishu chubanshe, 1963) 1: 22.

137. Ho, "White-Robed Kuan-yin (Pai-i Kuan-yin)," 122.

138. "靜坐作觀, 久乃落筆," Fang Yizhi, *Qiyu xinbi*, 3a.

139. I thank Wendi Adamek for helping me to formulate this idea.

140. "正思惟處, 那伽定中不存一法妙契圓通, 塵塵剎剎播慈風." Translation by Wai-kam Ho, "White-Robed Kuan-yin (Pai-i Kuan-yin)," no. 97, 1221.

141. Ho, "White-Robed Kuan-yin (Pai-i Kuan-yin)," 122–123; Shane McCausland, *Zhao Mengfu Calligraphy and Painting for Khubilai's China* (Hong Kong: Hong Kong University Press, 2011), 164–166.

142. Wu Jiang, "Orthodoxy, Controversy and the Transformation of Chan Buddhism in Seventeen-Century China" (PhD diss., Harvard University, 2002), 9–16; James Cahill, "Survivals of Ch'an Painting into Ming-Ch'ing and the Prevalence of Type Images," *Archives of Asian Art* 50 (1997–1998): 17–37.

143. Beata Grant, "Little Vimalakirti: Buddhism and Poetry in the Writings of Chiang Chu (1764–1804)," in *Chinese Women in the Imperial Past: New Perspectives*, ed. Harriet T. Zurndorfer (Leiden: Brill, 1999), 286–307, 289.

144. For further discussion on sudden versus gradual attainment, please see Bernard Faure, *The Rhetoric of Immediacy: A Cultural Critique of Chan/Zen Buddhism* (Princeton, NJ: Princeton University Press, 1991), 32–52.

145. "偶一施金相, 競炙莊嚴, 即沈閣弗錄, 鄙為末技." Fang Mengshi, "Weiyi mei qingfenge ji xu 維儀妹清芬閣集序," in Shen Yixiu, comp., *Yiren si*, in *Wumengtang ji*, ed. Ye Shaoyuan (Beijing: Zhonghua shuju, 1998), 540.

146. It could refer to a statue gilded in gold. For instance see Wang Shizhen's poem on a Buddhist statue. Wang Shizhen, *Yanzhou sibugao*, juan 8, 12a, 12b.

147. This is one of the ways embroidery patterns are traced onto silk.

148. Stewart W. Holmes and Chimyo Horioka, *Zen Art for Meditation* (Rutland, VT: Tuttle, 1973), 16.

149. Chen, *Furen ji*, 6a.

150. Yü, *Kuan-yin*, 251–253.

151. Fang Yizhi, *Xiyu xinbi* 3a.

152. For other examples of this phrase used in the context to construct an ancestor shrine, see the entry "zhucitang ji" 朱祠堂記 in Lü Simian Vol.26 of *Zhu Simian quanji* (Shanghai: Shanghai guji chubanshe, 2016), 78.

153. Unlike most Buddhist women who painted only Guanyin images, Fang Weiyi also painted Luohans 羅漢 (Arhats). Based on the conventional combination of Guanyin and Luohans in the Chan Buddhist art tradition, it is not surprising that Fang chose

this theme. These two paintings are in the Anhui Provincial Museum; see Zhongguo gudai shuhua jianding zu, ed. *Zhongguo gudai shuhua tumu*, (Beijing: Wenwu chubanshe. 1986–1994), 12:211. One of these was painted for Fang Yizhi's fiftieth birthday and is published in Anhui sheng bowuguan ed., *Anhui sheng bowuguan canghua* (Beijing: Wenwu chubanshe, 2004), 87. One handscroll entitled "*Xichi da luohan tu*" 西池大阿羅漢圖 is held in the collection of the Liaoning Lüshun Museum, dated 1658, see *Zhongguo gudai shuhua tumu*, 16:355. The picture is not published. Another painting in the collection of the Beijing Palace Museum is entitled "*Jiaoshi luohan tu*" 蕉石羅漢圖. See Li, "Fang Weiyi he tade guanyin tu zhou," 96. Li claims that more than ten of Fang Weiyi's paintings have survived, but this has not been verified.

154. See the discussion of class distinction in the introduction.

3. EMBROIDERING GUANYIN WITH HAIR

1. Xuan Ding, *Yeyu qiudeng lu*, vol. 1789, *Xuxiu siku quanshu* (Shanghai: Shanghai guji chubanshe, 1995), juan 5, 42a–44a. The first half of this tale is also included in Chai E, *Fantian lu conglu* (Shanghai: Zhonghua shuju, 1936); see the entry "Faxiuji erze" 髮繡集二則 in 8 *ce*, juan 15, 15a–16a.

2. "嘉靖某甲子優婆夷女弟子葉蘋香盥沐髮繡," Xuan, *Yeyu qiudeng lu*, juan 5, 43a.

3. Xuan, *Yeyu qiudeng lu*, juan 5, 43a, 43b.

4. Susan Mann has touched on the importance of embroidering Guanyin as a symbol of women's piety in Susan Mann, *Precious Records: Women in China's Long Eighteenth Century* (Stanford, Calif.: Stanford University Press, 1997), 182–183. In a short account of hair-embroidered Guanyin images, Dorothy Ko placed the practice within a discussion of the birth of women's culture in the late Ming, Ko, *Teachers of the Inner Chambers*: 172–173. For a broader review of women and textile art, see Marsha Weidner, Debra Edelstein, et al., *Views from Jade Terrace: Chinese Women Artists: 1300-1912*. Indianapolis: Indianapolis Museum of Art (1988), 21–23.

5. Wu Hung, *Monumentality in Early Chinese Art and Architecture* (Stanford, Calif.: Stanford University Press, 1995), 24.

6. "Yaoshi rulai xiuxiang zan bing xu" 藥師如來繡像贊并序 ["The Eulogy and Preface of the Embroidered Icon of Bhaisajyaguru"], Lü Wen, *Lü Hengzhou ji*, vols. 228–229, *Yueya tang congshu* (1854), juan 9, 16a–18a.

7. Jacob Eyferth's discussion on the skill and labor involved in making rice paper in twentieth century in Sichuan helps us to have a concrete understanding of tacit knowledge of making. Jan Jacob Karl Eyferth, *Eating Rice from Bamboo Roots: the Social History of a Community of Handicraft Papermakers in Rural Sichuan, 1920-2000* (Cambridge, Mass.: Harvard University Asia Center, 2009), 25–30.

8. Robert Campany, "Notes on the Devotional Uses and Symbolic Functions of Sutra Text as Depicted in Early Chinese Buddhist Miracle Tales and Hagiographies," *Journal of the International Association of Buddhist Studies* 14, no. 1 (1991): 30.

9. Wu Hung convincingly argues that the iconography of the Buddha on this embroidery should be Fanhe Buddha not *Sakyamuni Preaching on Vulture Peak*. See Wu Hung, "Rethinking Liu Sahe: The Creation of a Buddhist Saint and the Invention of a 'Miraculous Image,'" *Orientations* 27, no. 10 (November 1996): 32–43. With respect to the date of this object, see Ma De, "Dunhuang cixiu 'Lingjiushan shuofa tu' de niandai ji xiangguan wenti." *Dongnan wenhua* 1 (2008): 71–73.

This object now is in the collection of British Museum, cat. Ch00260. For the catalog information, see Aurel Stein, *Serindia: Detailed Report of Explorations in Central Asia and Westernmost China* (Oxford: Clarendon Press, 1921), 2:851, 878, 885, 983–984; Roderick Whitfield, ed., *Xiyu meishu: daying bowuguan sitanyin soujipin* (Tokyo: Kodansha International in cooperation with the Trustees of the British Museum, 1984), pl. 1, 3:277–280.

10. Because of its huge size of 241 by 159 centimeters' the padding was made of two layers of silk and linen. The length of each stitch is about 0.8 to 1 centimeter, which is much longer than in most embroidery. Zhao Feng, *Fangzhipin kaogu xin faxian* (Hong Kong: Yishatang/fushi gongzuodui, 2007), 182.

11. Whitfield, *Xiyu meishu*, 277–280.

12. Sheng Yuyun (Angela Sheng), "Fangzhi yishu, jishu yu fojiao jifu" ("Textile Art, Technology, and Buddhist Merit Accumulations"), in *Fojiao wuzhi wenhua—siyuan caifu yu shisu gongyang* (*Merit, Opulence and the Buddhist Network of Wealth*), ed. Sarah Fraser (Shanghai: Shanghai shuhua chubanshe, 2003), 71.

13. "心識其容, 口莫能言." "Jingan xian jun xushi xiu Guanyin zan" 靜安縣君許氏繡觀音贊, Su Shi, *Dongpo quanji*, vol. 1108, *Yingyin wenyuange siku quanshu* (Taipei: Taiwan shangwu yinshuguan, 1983–1986), 1108 *ce*, 524.

14. Su, *Dongpo quanji*, 1108ce, 524.

15. This metaphoric reading of embroidery is also expressed in other authors' writings from the same period. See Bai Juyi 白居易, "Xiu amituofo zan bing xu" 繡阿彌陀佛贊并序, (A Eulogy for Embroidered Amitabha Buddha and A Preface) "xiu Guanyin pus azan bing xu" 繡觀音菩薩贊并序, (A Eulogy for Embroidered Guanyin Bodhisattva and A Preface) Bai Juyi, *Baishi changqing ji*, vol. 1080, *Yingyin wenyuange siku quanshu* (Taipei: Taiwan shangwu yinshuguan, 1983–1986), juan 39, 448.

16. "凡作佛事, 各以所有. 富者以財, 壯者以力. 巧者以技, 辯者以言", "Xiufo zan" 繡佛讚 Su, *Dongpo quanji*, juan 95, 524.

17. "Jin Shufang cixiu guanyin dashi xiang zhou" 金淑芳刺繡觀音大士像軸 (The scroll of Jin Shufang's Embroidered Icon of Guanyin dashi), 103 by 51 centimeters, Beijing Palace Museum Collection; Shan Guoqiang, ed. *Zhixiu shuhua* (Shanghai: Shanghai kexue jishu chubanshe, 2005), 140, pl. 76.

18. Dagmar Schafer has insightfully pointed out that Confucian scholars' comments on craft often left out experimental knowledge. Dagmar Schafer, *The Crafting of the 10,000 Things: Knowledge and Technology in Seventeenth Century China* (Chicago: University of Chicago Press, 2011), 132–138.

19. Dorothy Ko's in-depth discussion of the Gu school embroidery unpacks the complicated techniques used. Dorothy Ko, *The Social Life of Inkstones: Artisans and Scholars in Early Qing China* (Seattle: University of Washington Press, 2017), 120–123.

20. The Embroidery Manual was first published in 1821. Grace Fong, "Female Hands: Embroidery as a Knowledge Field in Women's Everyday Life in Late Imperial and Early Republican China," *Late Imperial China* 25, no. 1 (June 2004): 26–35.

21. Ding Pei, *Xiupu*, vol. 21, *Zhongguo lidai meishu dianji huibian*, ed. Yu Yu-an, 174–175.

22. For a fruitful discussion of the concept of *nühong* from early China to the late imperial period, see Liang Shuping, *Mingdai nühong—yi beifang funü wei zhongxin zhi tantao* (MA thesis, Guoli zhongyang daxue, 2001), 10–12.

23. Francesca Bray, *Technology and Gender: Fabrics of Power in Late Imperial China* (Berkeley: University of California Press, 1997), 256.

24. Bray, *Technology and Gender*, 183–191. By unpacking the metaphorical meanings related to the devices used in making textile, Angela Sheng insightfully points out that the

nühong is a changing discourse with respect to production, space and morality. Angela Sheng, "Women's Work, Virtue, and Space: Change from Early to Late Imperial China," *East Asian Science, Technology, and Medicine* 36, no. 1 (January 2012): 9–38. Susan Mann correctly notes that there is a hierarchical relationship among these categories of womanly works. Mann, *Precious Records*, 144–148. In the late imperial period, besides embroidery, women also produced woven icons and silk applique icons.

25. See Huang Tingjian 黃庭堅, "Liao guan shi xiu Guanyin zan" 了觀師繡觀音贊 (A Eulogy for Master Liaoguan's Embroidered Guanyin) and "Pang daoren xiu guanyin zan" 龐道人繡觀音贊 (A Eulogy for Pang daoren's Embroidered Guanyin), in Huang Tingjian, *Shangu ji*, vol. 1113, *Yingyin wenyuange siku quanshu* (Taipei: Taiwan shangwu yinshuguan, 1983–1986), 1119.

26. Dugu ji 獨孤及 composed a eulogy with a preface entitled "Guanshiyin pusa dengshen xiang zan bingxu" 觀世音菩薩等身繡像贊並序 ("Eulogy and Preface of the Life Size Embroidered Bodhisattva Guanshiyin pusa") in Dugu Ji, *Piling ji*, in *Siku congkan, jibu*, (Shanghai hanfenlou facsimile reprint of Yiyousheng ed.; Shanghai: Shanghai yinshuguan, 1929), juan 13, 11b–12a.

27. "以刺繡成文, 寫菩薩之真相." Dugu ji, "Guanshiyin pusa dengshen xiang zan bingxu", in Dugu ji, *Piling ji*, juan 13, 11b–12a.

28. It is interesting to see that this discourse was later adapted by educated women in the late imperial period in the context of fine embroidery or painting-like embroidery.

29. Yuan dynasty painter Xia Yong 夏永 (mid of the fourteenth century) is believed to have embroidered landscapes in hair. See entry "Faxiu tengwangge huanghelou tu" 髮繡滕王閣黃鶴樓圖 (The Pictures of Hair Embroidered Pavilion of Prince Teng and Yellow Crane Pavilion), in Zhu Qiqian, *Sixiu biji erjuan*, 1933, *Cixiu biji*, juan xia 39b.

30. Yi-fen Huang, "Guxiu xinkao", in *Guxiu guoji xueshu yantaohui lunwenji*, ed. Shanghai bowuguan (Shanghai: Shanghai shuhua chubanshe, 2010), 20–41.

31. There are increased mentions of embroidered Guanyin images in local gazetteers, women's biographies, and anthologies of the Ming and Qing periods.

32. *Cixiu tu* is not a systematic guideline of making embroidery like Ding Pei's *The Embroidery Manual*. For a more complete introduction of this manual, see Fong, "Female Hands," 21–46.

33. Zhang Shuying. *Cixiu tu*. In *Lüchuang nüshi*, juan 1. Ming Chongzhen edition, Harvard-Yenching Library Collection, 1b.

34. Imperial workshops and professional workshops created more types of icons. Indeed, Buddha and arhats were more popular. The subjects sixteen or eighteen arhats were often produced as an album by professional embroidery workshops, such as the Gu school embroidery from Shanghai and the imperial embroidery workshop. Shan, *Zhixiu shuhua*, pl. 2, 3. Other subjects such as *Wushisan can tuce* 五十三參圖冊, also appear in the same catalog, pl. 11.

35. Xia Lishu, et al. *Huguang tongzhi*, vol. 534, *Yingyin wenyuange siku quanshu* (Taipei: Taiwan shangwu yinshuguan, 1983–1986), shibu 292, juan 78, Zhanran 湛然, the daughter of the Minister of Defense with the last name of Mei 梅 donated her home to be used as a Buddhist shrine with the name of Xiufosi 繡佛寺, Temple of Embroidering the Buddha, which was located in Macheng County. Xia Lishu, et al., *Huguang tongzhi*, 61.

36. Kai-wing Chow, *The Rise of Confucian Ritualism in Late Imperial China: Ethics, Classics, and Lineage Discourse* (Stanford, Calif.: Stanford University Press, 1994), 211–214.

37. This phrase has different meanings depending on the gender of the practitioner. The difference exists in the usage of the word *xiu*. When used to describe the activities of a male

practitioner, *xiufo* referred to an embroidered image of Buddha for contemplation. Conversely, when the phrase was used to describe a female devotee, the adjective "embroidered" that modifies "Buddha" is commonly transformed into a verb "to embroider," to indicate the act of embroidering a Buddhist image. Yuhang Li, "Gendered Materialization", 100–102.

38. For instance, the representation of Yingying reading a letter on the tenth leaf in Mi Qiji's album *Xixiangji*, Museum für Ostasiatische Kunst Köln collection.

39. Chün-fang Yü, *Kuan-yin*, 177–178. For an example of a woman dreaming of the icon she worshipped, see Zhou Kefu, *Guanshiyin chiyanji*, vol. 7, *Zhongguo lidai guanyin wenxian jicheng*, ed. Pu Wenqi (Beijing: Zhonghua quanguo tushuguan wenxian suowei fuzhi zhongxin, 1998), 384–385.

40. Empress Renxiao was the posthumous title for Empress Xu (Xu huanghou 徐皇后). She was the daughter of the Ming Dynasty's founding member General Xu Da 徐達 (1332–1385). She selected words that encourage good deeds from Confucian, Buddhist, and Daoist teachings to complete *Daming Renxiao Huanghou Quanshanshu* 大明仁孝皇后勸善書 (*Book of Exhortation for Virtuous Deeds by the Empress Renxiao of the Great Ming*), part of the National Palace Museum Collection printed by the Ming court in 1405. For a discussion of her sister-in-law and her brother Xu Yingxu's wife's hairpin, see chapter 4.

41. Zhou Kefu, *Guanshiyin chiyanji*, 7:386.

42. Zhou Kefu, *Guanshiyin chiyanji*, 7:386–388.

43. See Hanshan Deqing, *Hanshan laoren mengyou ji*, X73, no. 1456

44. Modern scholars have used another term, *moxiu* 墨繡 (black embroidery), for this practice. But this term seems misleading, because it has also been used to refer to silk embroidery that copies the style of *baimiao* painting. Indeed, during the Qianlong period, *moxiu* was considered a substitute for *bimo* or brush and ink. See the entry for "Mingxiu dashi sanshier bianxiang yi juan" 明繡大士三十二變相一卷, *Midian zhulin*, in *Yingyin wenyuange siku quanshu, zibu* (Taipei: Taiwan Shangwu yinshuguan, 1983–1986), juan 14, 823–642, 823–643.

45. Sun Peilan thinks that, along with scripture written out in blood, hair embroidery first started in the Wu 吳 cultural area during the Song period. See Sun Peilan, "Suxiu yu fojiao wenhua (xia)", *Shanghai gongyi meishu* 1 (1994): 31. Supporting Sun's argument is a record of a young lady called Zhou Zhenguan 周貞觀 from the Song dynasty.

46. We need further research on Daoist hair embroidery and commercial hair embroidery.

47. Further research is needed on the issue of commercial hair embroidery. One Qing dynasty hair embroidery entitled "Rank Promotion" bearing the signature and seal of *Jijn tang* 繼錦堂 (Shop of Running Brocade) indicates that this embroidery was probably made at a professional workshop. Shan, *Zhixiu shuhua*, 72. Tao Jin's research on the living icons (huo ou 活偶) reveals that many statues of local deities were attached with real human hairs. At this point, it is unclear who offered the hairs to make the icons. I am very grateful for Tao Jin for sharing his unpublished field research with me.

48. Another example is the Big Belly Maitreya embroidery possibly done by a Gu school embroiderer. It is now housed in the Liaoning Museum Collection. See Piao Wenying, "Cixiu mile foxiang kao", in *Guxiu guoji xueshu yantaohui lunwenji*, ed. Shanghai bowuguan (Shanghai: Shanghai shuhua chubanshe, 2010), 210; Elizabeth Ten Grotenhis, "Bodily Gift and Spiritual Pledge: Human Hair in Japanese Buddhist Embroideries," *Orientation* (January/February 2004): 31–35.

49. It is as yet unknown whether Guan Daosheng's hair embroidery of Guanyin had any association with mortuary practice, but the direct transplanting of a person's hair to an icon's hair indicates a similar logic of regeneration.

50. For other traditions in the world, see Patrick Olivelle, "Hair and Society: Social Significance of Hair in South Asian Traditions," in *Hair: Its Power and Meaning in Asian Cultures*, ed. Alf Hilebeitel and Barbara Miller (Albany: State University of New York Press, 1998), 11–49.

51. See the entry for "*luanfa*" 亂髮 or messy hair. This is the term used for hair in Li Shizhen 李時珍 (1518–1593), *Bencao gangmu, Renbu* 人部, ed. Ming Wanli (University of Chicago Library Collection), microfilm, juan 52, 4b–7b.

52. According to the prescription, when menstruation does not flow smoothly, the woman should take hair ashes that were burned from equal amounts of women's and men's hair. Li, *Bencao gangmu*, juan 52, 4b–7b.

53. The most well-known story is that when Sakyamuni was a child, he laid down his hair on the mud for Dipankara to walk on which is a sign to predict his Buddhahood. This story is included in *Foshuo taizi ruiying benqi jing* 佛說太子瑞應本起經, T03, no.185. For the woman's long hair used for the monk to walk on, see *Fayuan zhulin*, juan 98, dunü bu 度女部, disi., T53, no. 2122.

54. "*Changfa nüren sheaf gongyang fo* 長髮女人捨髮供養佛" (Woman with Long Hair Relinquishes Her Hair to Buddha), in *Jinglü yixiang* T 53, no. 2121. The practice of women offering their hairs to temple as merit-making is still widely practiced in contemporary Hindu temples in India. Temples sell their hairs in exchange for currency. Such hairs became the main raw materials for the wig industry in other places such as China and then they were exported to America and Europe. This shows that merit-making is connected a global network of production and consumption. Emma Tarlo, *Entanglement: The Secret Lives of Hair*. (London: Oneworld, 2016.)

55. See the entry "Fa sanjian er zhe zizhang 髮三剪而輒自長" (The hair was cut off three times and they all grew back swiftly," in *Fahua lingyan zhuan*, X78 no. 1539. In the *Guang qingliang zhuan*, Manjusri also manifested as a deprived woman and sold her hair for offering. Her hair was not regained after. See the entry Pusa huashen wei pinnü 菩薩化身為貧女 (Bodhisattva transformed to a poor woman) *Guang qingliang zhuan*, T51, no.2099. For other immolations, and cutting hairs, in the *Lotus Sūtra*, see James A. Benn, "The Lotus Sūtra and Self-immolation." In *Readings of the Lotus* Sūtra, ed. Stephen F. Teiser and Jacqueline I. Stone, (New York: Columbia University Press, 2009) 107–131.

56. Nāgārjuna (Longshu), *Da zhidu lun*, trans. Kumarajiva (Jiumoluoshi 鳩摩羅什, 344–413), T25, no.1509, juan 11, 143b.

57. Reiko Ohnuma, "The Gift of the Body and the Gift of the Dharma," *History of Religions* 37, no. 4 (1998): 104.

58. Ohnuma, "The Gift of the Body and the Gift of the Dharma."

59. 毗盧遮那如來. 從初發心. 精進不退. 已不可說不可說身命為布施. 剝皮為紙. 折骨為筆. 刺血為墨. 書寫經典. 積如須彌. 為重法故. *Dafang guangfo huayan jing* 大方廣佛華嚴經, juan 40, T10, no. 293. I slightly adjusted Jimmy Yu's translation. Jimmy Yu, *Sanctity and Self-Inflicted Violence in Chinese Religions, 1500-1700* (Oxford: Oxford University Press, 2012), 43.

60. Yu, *Sanctity and Self-Inflicted Violence*, 43. Patricia Fister's discussion of a full set of bodily devotion practices, such as using skin and hair, and object making in Edo Japan encourages us to think about the interrelationship between different mediums. Patricia Fister, "Visual Culture in Japan's Imerial Rinzai Zen Convents: The Making of Objects as Expressions of Religious Devotion and Practice," in *Zen And Material Culture*, ed. Pamela D. Winfield and Steven Heine. (New York: Oxford University Press, 2017), 164–196.

61. For the dual practice of blood writing and hair embroidery, see the discussion of Zhou Zhenguan in this chapter.

62. Li Delian 李德廉 (fourteenth century), *Embroidered Lotus Sutra*, made in Zhizheng period (1341–1368), Yuan dynasty. Shanghai bowuguan, ed., *Shanghai bowuguan cangpin jinghua* (Shanghai: Shanghai shuhua chubanshe, 2004), 356–358.

63. This is a loose and general observation; as Jimmy Yu's research indicates, in modern times women followers might sometimes serve as blood providers, see Yu, *Bodies and Self-Inflicted Violence*, 50, f. 68.

64. Jimmy Yu's study on blood writing demonstrates that sometimes the practice could be life-threatening. Yu, *Bodies and Self-Inflicted Violence*, 57–58.

65. Robert Sharf, "On the Allure of Buddhist Relics," *Representations* 66 (1999), 78.

66. "大明成化庚子二月十九日信女林金蘭為脫眼疾堅誠（？）大士慈悲己身髮敬製大士神像一尊供養佛堂同千秋同識." I transcribed this inscription from the photograph of this object in the Shanghai Museum. Shanghai Museum Collection.

67. For an introduction to Ni Renji's life and artistic achievements, see Ko, *Teachers of the Inner Chambers*, 172–173. For the discussion of Ni Renji's hair-embroidered Buddha, see Hong Liang, "Ming nüshiren Ni Renji de cixiu he faxiu", *Wenwu cankao ziliao* 9 (1958): 21–22. Hong recorded the deity represented on this embroidery as Dashi (Guanyin), but the iconography and Ni Renji's own inscription suggest that it should be Amitābha Buddha or *Jieyin fo* 接引佛. Because this embroidery was made for Ni Renji's deceased parents, she apparently hoped it might help them have a better afterlife.

68. 己丑四月信女吳氏上為父母拔髮繡佛傳家供奉, Hong, "Ming nüshiren Ni Renji de cixiu he faxiu,: 22.

69. For further discussion of Defeng's inscription, see the conclusion of this book.

70. See *Bailun*, T30, no. 1569.

71. For an insightful discussion of self-burning and self-immolation in Chinese Buddhist practice, please see James Benn, *Burning for the Buddha: Self-Immolation in Chinese Buddhism*, a Kuroda Institute Book (Honolulu: University of Hawai'i Press, 2007), 8–9.

72. During the late Qing period, following the feminist movement, embroidery was even juxtaposed with footbinding as two practices that violate women's bodies. In the essay entitled "On the Harmfulness of Embroidery" Lun cixiu zhihai 論刺繡之害 the author Shangsheng discusses how making embroidery could damage women's eyes, influence their body gesture, and waste women's time. Shang Sheng 尚聲, "Lun cixiu zhihai", *Nüzi shijie* 6 (1904): 87–91.

73. Ariel Glucklich, *Sacred Pain: Hurting the Body for the Sake of the Soul* (Oxford: Oxford University Press, 2001), 6.

74. Yu, *Bodies and Self-Inflicted Violence*, 1.

75. Yu, *Bodies and Self-Inflicted Violence*, 1.

76. Yü, *Kuan-yin*, 321–347.

77. 李德廉 (fourteenth century) Yü, *Kuan-yin*, 343–344.

78. Hioki Atsuko, "The Embroidered from Human Hair and the Prayer—the Activities of a Priest Named Kunen," *Bukkyo Shigaku Kenkyu* 62 (2009): 48–69.

79. The authenticity of this embroidery needs to be further investigated. If Guan Daosheng was not its producer, at the very least it was modeled on a painting attributed to Guan. Sun Peilan transcribes the inscription as "至元己酉六月八日, 吳興趙管仲姬拜畫" and also records the seal under the inscription as "魏國夫人趙管." See Sun Peilan, *Zhongguo cixiu shi* (Beijing: Beijing tushuguan Chubanshe, 2007), 51. One problem is that there was no *zhiyuan jiyou* in the Yuan dynasty calendar, so the characters might be *zhida jiyou* 至大己酉, which is the year 1309, while Guan Daosheng was about forty-eight years old. In that case, a correct reading of the inscription would be 至大己酉六月八日,

吴兴趙管仲姬拜畫 [in the year of *zhida jiyou* on the eighth day in June, Zhao Guan Zhongji (courtesy name) from Wuxing respectfully painted [this]. The problem with this translation is that Guan Daosheng was not conferred the title *weiguo furen* until the fourth year of Yanyou 延祐 (1317). If this embroidery were actually produced in 1309, it would have been impossible for her to use the *weiguo furen* seal at that time. In the study of Guan Daosheng's bamboo paintings, Chen Pao-chen points out that the seal "*weiguo furen* Zhao Guan" appears on several fabricated Guan Daosheng bamboo paintings. See Chen Pao-chen, "Guan Daosheng he tade zhushi tu." *Gugong jikan* 11, no. 4 (1977): 67. Nonetheless, embroidery is more complicated than painting, because it is made based on a painted or printed model. Because the inscription indicates that painting dates to the year 1309, it is possible that the embroidery was based on a Guan painting done in 1309 and reproduced after Guan had attained the title. Guan Daosheng lived only two years with this title and was very sick during these two years.

80. "拆一髮為四,精細入神,宛如繪畫,不見針跡. 觀者歎為絕技." See the entry for "Wang Yuan" 王瑗, in Yang Yilun, Xia Zhirong, et al., comp., Feng Xin et al., revised in 1813, Fan Fengxie et al., reedited in 1845. *Gaoyou zhouzhi* (*Gazetteer of Gaoyou*), vol. 3, *Zhongguo fangzhi congshu*, no. 29 (facsimile reprint; Taipei: Chengwen chubanshe, 1970), juan 10 xia, 1602–1603.

81. Dorothy Ko, "Between the Boudoir and the Global Market: Shen Shou, Embroidery, and Modernity at the Turn of the Twentieth Century," in *Looking Modern: East Asian Visual Culture from Treaty Ports to World War II*, ed. Jennifer Purtle and Hans Bjarne Thomsen (Chicago: Center for the Art of East Asia and Art Media Resources, 2009), 41. For a review of the relationship between painting and embroidery before the late-Ming period, see Yi-Fen Huang, "Gender, Technical Innovation and Gu Family Embroidery in Late-Ming Shanghai," *East Asian Science, Technology, and Medicine* 36, no. 1 (January 2012): 80–84.

82. Huang, "Gender, Technical Innovation and Gu Family Embroidery," 84–85.

83. Jonathan Hay, *Sensuous Surfaces: The Decorative Object in Early Modern China* (Honolulu: University of Hawai'i Press, 2010), 91.

84. See the discussion of the record of Wang Yuan. In the case of Zhou Zhenguan who combines both blood writing and hair embroidery on the same devotional object, pricking blood from the tongue and splitting hairs by hand are juxtaposed as signs of her sincerity. Zhu Qiqian, *Nühongzhuan zhenglue*,1931, 9a–9b.

85. See entry "Zou Tao zhiqi" zhaoshi 鄒濤之妻趙氏 (Zou Tao's wife Madam Zhao) in Zhu, *Nühongzhuan zhenglue*, 20b.

86. Xuan, *Yeyu qiudeng lu*, juan 5, 43a.

87. For an example of split-hair embroidery, see a collection entitled "Rank Promotion Hair-embroidery with the Seal of 'Ji Jin Tang.' " This embroidery was also made in the Kangxi period, Shan, *Zhixiu shuhua*, 72.

88. "觀彼刀尺之微, 知其虔誠之極." See the entry for "Dinghaixian chenshi" 定海縣陳氏 in Zhu, *Nühongzhuan zhenglue*, 9a.

89. "能以髮繡大士像," see the entry for Xu Xiangping 徐湘蘋, Zhu, *Nühongzhuan zhenglue*, 23b.

90. For the cleaning process of hair, see Chen Chaozhi, "Faxiu—zhixiu yiyuan zhong de qipa." *Zhongguo fangzhi* 9 (1994): 48. For the process of softening hair with yolk, see the video of making hair-embroidered Guanyin in contemporary China, "Stitching Wisdom: Yuan Miao's Hair Yantras" (New Century Foundation, 2015), https://www.youtube.com/watch?v=bdIyeZPJAZM (accessed June 3, 2019).

91. The encyclopedia of daily life for women, *Kunde baojian* 坤德寶鑑 (*Precious Mirror of Feminine Virtues*), includes a list of the hair oils used in the eighteenth century. See the section on "Matters Related to Inner Chambers" 閨閣事宜; *wutou shexiangyou* 烏頭麝香油 and *chatou zhuyou* 搽頭竹油 are two recipes for making hair oil at home. See Zhang Lüping, comp., *Kunde baojian*, with a preface written by Sun Jingyun, dated to the forty-two years of dingyou of Qianlong (1777), ed. Yuxiutang (Harvard Yen-ching Library Collection), 4:24a, 24b. The same section also includes instructions for dyeing hair and other hair treatments.

92. The collection is now held in Baoguangsi (Baoguang si 寶光寺) near Chengdu.

93. It is unclear whether during the Ming and Qing periods, women devotees from lower classes with less training in embroidery also produced hair-embroidered Guanyin.

94. In a short biography, Qian Hui, a woman poet and artist from the mid-nineteenth century, was praised for using hair as thread to embroider images of archaic Buddhas, the Great Being, and palace beauties. Her embroideries were considered not inferior to Longmian's *baimiao*; see "Qian Hui" in Yun Zhu, comp, *Guochao guixiu zhengshiji* (Hongxiangguan ed., 1831), 8.18a.

95. Ding Yunpeng et al., *Mingdai muke Guanyin*, 67.

96. A *mogao* usually refers to an ink outline drawing on paper. It could a sketch for painting and embroidery or could function as a reference copy (*fenben*) for making painting and embroidery. Not every embroiderer drew an ink outline sketch. An embroiderer could use *fenbi* 粉筆 or chalk to draw over the lines on a *mogao*, and then could place a piece of silk over the *mogao* and press it over the silk. The outline created by the chalk powders would be transmitted onto the silk. The embroiderer then stitched an image according to the chalk-trace. Sheng Dashi, *Xishan woyou lu*, vol. 5, *Huashi congshu*, ed. Yu Anlan (Shanghai: Shanghai renmin meishu chubanshe), juan 2, 18a.

97. Li's niece Yao Dezhen 姚德貞 also helped with preparation. Shanghai bowuguan, ed., *Shanghai bowuguan cangpin jinghua*, 356–358.

98. Zhu Qiqian recorded Zhou Zhenguan's 周貞觀 story in two entries, "Zhou Zhenguan" and "Yu Ying" 俞穎, in *Nühong zhuan zhenglue*. None of his original textual sources can be verified, however. See the entries for "Zhou Zhenguan" and "Yu Ying" in Zhu, *Nühongzhuan zhenglue*, 9a–9b, 14b–15a, respectively.

4. MIMICKING GUANYIN WITH HAIRPINS

1. Yi Shizhen, comp., *Langhuan ji*, Liaoning sheng tushuguan collection, Wanli ed., *Siku quanshu cunmu congshu*, zibu, 120–88 (Jinan: Qilu chubanshe, 1995), juan xia, 12a.

2. *Langhuan ji* is usually considered a book compiled during the Yuan dynasty (1296–1368); however, its convoluted attribution of original sources have led scholars to believe that it is a forgery from the late-Ming period (sixteenth and seventeenth centuries). Luo Ning, "Mingdai weidian wuzhong xiaoshuo chutan", *Mingqing xiaoshuo yanjiu* 1 (2009): 31–47.

3. The designs on these hair accessories feature both Buddhist and Taoist subjects, such as Buddha, Guanyin, Manjusri, Marici, the Queen Mother of the West, the Eight Immortals, and immortal pavilions. With respect to the hairpins specifically carrying Buddhist motifs, Yang Zhishui links this type of object to the cult of Guanyin and to Buddhist practice on several levels: First, the hairpins featuring a Buddha image echo Guanyin's hair style; second, Yang speculates that behind this fashion lay the motive to contemplate

Guanyin via her image. Last, she insightfully points out that the hairpins with pattern of immortal pavilions from the late imperial period are reconfigurations of Pure Land imagery from the medieval period. Yang Zhishui, *Shehua zhise* (Beijing: Zhonghua shuju, 2011–2012), 2:237–257.

4. *Fanwang* refers to regional kings. They were decedents of the twenty-six sons of Zhu Yuanzhang (1328–1398), the founder of Ming dynasty; Craig Clunas, *Screen of Kings: Royal Art and Power in Ming China* (Honolulu: University of Hawaiʻi Press, 2013), 7–24.

5. Ruan Guolin, "Ming Zhongshan wang Xu Da jiazu mu", *Wenwu* 2 (1993): 63–76. Xu Yingxu was the third son of Xu Da 徐達 (1332–1385), the general who helped the Ming dynasty founder, Zhu Yuanzhang, overthrow the Mongol-led Yuan empire.

6. Xu Yingxu's epitaph indicates that his principle wife is madam Zhu; Shao Lei, "Ming zhongshan wang xu da jiazu chengyuan muzhi kaolue", *Nanfang wenwu* 4 (2013): 180. Both Xu Yingxu and his wife Madam Zhu were buried in tomb M9. The excavation report does not mention the specific location of the hairpin in Xu's tomb. Ruan, "Ming Zhongshan wang Xu Da jiazu mu," 69.

7. Tian Changying, "Jinfengguan chutu ji," *Enshi xinwenwang*, http://www.xuanen.gov.cn /goxe/minzuwenhua/2012/0508/1798.html (accessed June 1, 2017).

8. The Buddhist *Jataka Sūtra*, translated in the third century, already revealed a laywoman's desire for the bodhisattva's adornment. *Shengjing* 生經, T03, no. 154.

9. Paul Copp, *The Body Incantatory: Spells And the Ritual Imagination in Medieval Chinese Buddhism* (New York: Columbia University Press, 2014), 59–140.

10. See Lady Xiong and Empress Xiaojing's hairpins discussed in this chapter. Yang Zhishui has pointed out the six-syllable mantra in Sanskrit first started appearing at court during the Chenghua period as a result of the promotion of Tibetan Buddhism by the Chenghua Emperor. Yang, *Shehua zhise*, 2:192–221.

11. The "belief in the rewards of generous giving" is enlisted as the ninth merit by Huiyuan discussed in the Nirvāṇa-sūtra. Wendi Adamek, "The Impossibility of the Given: Representations of Merit and Emptiness in Medieval Chinese Buddhism," *History of Religions* 45, no. 2 (2005): 145.

12. 既云求我如觀音即指化身, 又云觀音功德, 我亦得之, 乃指報身, in *Guanyin yishu ji*, X35, no. 645. This citation is attributed to Jingxi Zhanran 荊溪湛然 (711–782), a leading figure in the Tiantai School.

13. *Foshuo guan wuliangshoufo jing* or *Amitāyurdhyāna sūtra*, T12, no. 365. In conventional Buddhist discourse, substance is not the nature or essence of the deity. The "marks" of the Buddha and bodhisattva used in visualization have to be ultimately realized as neither form nor formless. In the orthodox emptiness discourse, one cannot say that identity or substance is essential. They are only *upaya*—skillful means. I am grateful for Wendi Adamek for calling my attention to this issue.

14. Roman Jakobson, *Language in Literature*, ed. Krystyna Pomorska and Stephen Rudy. (Cambridge, MA: Belknap Press, 1987), 110.

15. Paul Copp insightfully points out that the "adornments of deities . . . their specific characters and positions, mark each divinity as itself." Copp, *The Body Incantatory*, 85.

16. Matthew Potolsky, *Mimesis* (New York: Routledge, 2006), 1–11.

17. Adamek, "The Impossibility of the Given," 136.

18. See the discussion of this case in the section "jewelry as a devotional medium" in this chapter.

19. *Foshuo guan wuliangshoufo jing* (*Amitāyurdhyāna sūtra*), T12, no.365. The Chinese translation of *Amitāyurdhyāna* sutra was attributed to Kālayaśas between the years 424 and 442.

20. For a recent study on the sixteen contemplations and its pictorial forms in Dunhuang, see Luo Shiping and Luo Jian, "Ziran de xinxiang: dunhuang bihua 'shiliuguan' fanying de ziranguan", *Meishu yanjiu* 4 (2015): 55–58.

21. 不遇諸禍, 淨除業障, 無數劫生死之罪. T12, no. 365.

22. In Guanyin's head halo, there are five hundred transformation buddhas who resemble Sakayamuni Buddha. Each individual transformation buddha is joined by five hundred transformation bodhisattvas, and each bodhisattva is attended by numerous heavenly beings. Then Guanyin's *urna* has countless transformation buddhas accompanied by immeasurable transformation bodhisattvas appearing in the rays. They freely alter their manifestations and fill up the worlds of the ten quarters.

23. Its height is twenty-five *yojana*, which is equivalent to a distance from several hundred to two thousand miles in modern measurement. The inconceivable size reflects the nature of a dharma body as unmanifested. *Wuliangshoufo jing*, T12, no. 365. There are different measurements of single *yojana*, from sixteen to eighty miles. Xingyun dashi et al., *Foguang da cidian*. (Gaoxiong: Foguang chubanshe, 1989), 3:2075–2076.

24. Lee Yu-min, *Guanyin tezhan*, 183–184.

25. *Wuliangshoufo jing*, T12, no. 365.

26. Antonia Finnane, *Changing Clothes in China: Fashion, History, Nation* (New York: Columbia University Press, 2008), 43–52. Rachel Silberstein's discussion on modular accessories on Chinese clothes in late imperial China and the importance of accessories provides a new way to rethink Chinese fashion system that is different from west. Rachel Silberstein, "Cloud Collars and Sleeve Bands: Fashion and Commercial Embroidery in Mid-Late Qing China," *Fashion Theory* 21, no. 3 (March 2017): 245–277.

27. *Tianshui bingshan lu*, Vol.14 of *Zhibuzu zhai congshu*, comp. Bao Tingbo (Taibei: Yiwen yinshuguan, 1966), 14:27b, 28a–28b, 32a

28. It is unclear whether these items are used for daily practice or for the afterlife.

29. Wu Renshu, *Pinwei shehua: wanming de xiaofei shehui yu shidafu* (Taipei: Lianjing chuban gongsi, 2007), 123–125.

30. Fan Jeremy Zhang, *Royal Taste: The Art of Princely Courts in Fifteenth-Century China* (New York: Scala Arts, 2015), pl. 74. For the study of imperial princes' patronages of religion, especially Daoism, see Richard Wang's book *The Ming Prince and Daoism: Institutional Patronage of an Elite* (Oxford: Oxford University Press, 2012).

31. In chapter 20 of *Jinpingmei*, we see Pan Jinlian's taste for a phoenix pattern. Li Ping-er, the newly wedded concubine, tries to follow in the principle wife's footstep. She asks Ximen Qing to take her gold wig cap to a silversmith and has one cast in the same fashion, with a Guanyin image. Xiaoxiaosheng, *Jinpingmei*, chap. 24, 4b–6a.

32. Chen Hui-Hsia's research on recycling deceased imperial women's jewelry during the Qing period further demonstrates the transformative nature of jewelry. Chen Hui-Hsia, "Qingdai gongting funü zanshi zhi liubian", *Jindai zhongguo funü shi yanjiu* 28 (December 2016): 53–124.

33. "Ming wumu she shi" 明吳母佘氏, Tang Shi comp. *Rulaixiang, Dianziban Guojia tushuguan shanben fodian, di wushier ce*, no. 8951.

34. "Ming Zhao mu Zhang ruren danian" 明趙母張孺人大年, *Tang Shi* comp, *Rulaixiang*, no. 8951

35. Burton Watson trans., *The Essential Lotus: Selections from the Lotus Sutra* (New York: Columbia University Press, 2002), 86; "The Nāga Princess," in Copp, *The Body Incantatory*, 185–186.

36. Rita M. Gross, *Buddhism After Patriarchy: A Feminist History, Analysis, and Reconstruction of Buddhism* (Albany: State University of New York Press, 1993), 70.

37. Bernard Faure, *The Power of Denial: Buddhism, Purity and Gender* (Princeton, NJ: Princeton University Press, 2003), 100.

38. Wang Tan, *Wan Tan shiwenji*, 217–218.

39. "極樂國土, 實無女人. 女既得生, 悉具大丈夫相." Yunqi Zhuhong, *Wangshengji*, 32a. In her study of female Chan masters, Beata Grant has pointed out that *zhangfu* is often used as a phrase to describe Buddhist women. Following Grant's suggestion, we could translate this sentence as "the only women who are reborn in the pure land are those who have the aspect of *da zhangfu*." Nonetheless, it is unclear whether the connotation of *da zhangfu* would be same when it is used to refer to monastic women and laywomen. In Zhonghong's statement, he refers to laywomen. With respect to this term and gender, see Beata Grant, *Eminent Nuns: Women Chan Masters of Seventeenth-Century China* (Honolulu: University of Hawai'i Press, 2009), 26–27.

40. Tu Long 屠隆, and Wang Chaohong 汪超宏, ed., "Chan jingtu" 禪淨土, *Hongbao* 鴻苞, vol. 9, *Tu Long ji* (Hangzhou: Zhejiang guji chubanshe, 2012), juan 28, 797–798. The sūtra on transforming the female form was often used in death ritual in the early period. For the discussion of this scripture, see Stephanie Balkwill, "The Sūtra on Transforming the Female Form: Unpacking an Early Medieval Chinese Buddhist Text." *Journal of Chinese Religions* 44, no.2 (2016): 127–148.

41. "只慕男身, 而不知革其女習." Yunqi Zhuhong, *Wangshengji*, 32a.

42. Yunqi Zhuhong, *Wangshengji*.

43. One of the earliest examples is the middle Binyang cave at Longmen, which was patronized by Emperor Xuanwu in the name of his deceased parents. As Amy McNair points out, effigies of the late Emperor Xiaowen and Empress Dowager Wenzhao are represented in a fairly realistic style in terms of their size, gestures, and elaborate costumes. Such a lifelike representation was meant to enable the "precise" transfer of merit to the dead. Amy McNair, *Donors of Longmen: Faith, Politics, and Patronage in Medieval Chinese Buddhist Sculpture* (Honolulu: University of Hawai'i Press, 2007), 49.

44. Buxiu baiyi si ta ji 補修白衣寺塔記, composed in the tenth year of the Xianfeng period (1860), stele, Lanzhou shi bowuguan Collection.

45. Indeed, one of the merits listed in scripture is the merit of constructing a pagoda to secure a son. *Foshuo zaota yanming gongde jing* 佛說造塔延命功德經, T19, no. 1026_

46. Please see the discussion of Fish-basket Guanyin hairpins in "Case Two: Lady Wang /Empress Dowager Xiaojing (1565–1611)" in this chapter.

47. The white jade Fish-basket Guanyin hairpin from Juxing Pagoda measures 5.4 centimeters high, 2.4 centimeters wide, and 0.6 centimeters deep. For its image and entry, see the website of the Huzhou shi bowuguan. Regarding the excavation of objects found in this tomb see Sui Quantian, "Zhejiang wuxing nanxun juxingta taji chutu yipi wenwu." *Wenwu* 3 (1982): 93. With respect to the hairpins found in the White-robed Pagoda, see Guo Yongli's research on this subject; Guo Yongli, "Ming su fanwangfei jin leisi qian baoshi baiyu guanyin zan", *Dunhuang Yanjiu* 2 (2008), 42–46.

48. Temple is home to various fertility goddesses and gods displayed in different halls, such as White-robed Guanyin Hall, Songzi cuisheng zisun san cimu gong 送子催生子孫三慈母宮, Songzi jiangjun ci 送子將軍祠, and Yanguang douzhen miao san cimu gong 眼光豆疹廟三慈母宮 (the museum has a floor plan of the temple). Patronage for constructing such a temple was often related to praying for a child or returning a favor to the spirits after successfully giving birth to a child.

49. "蕭王妃熊氏施, 伴讀姚進兼裝."

50. 崇禎五年八月初十日.

51. I would like to thank Wan Oudi, a graduate student in the Art Department at the University of Wisconsin, Madison for introducing me to the Chinese traditional filigree technique.

52. Jewelry as part of women's bodies is a cliché that was used as a trope in various romantic stories.

53. For instance, in the pagoda crypt of Tianfeng Pagoda in Ningbo, several women's silver bracelets, arm bracelets, and hairpins have been excavated and many of them bore written inscriptions. Seunghye Lee, "Framing and Framed: Relics, Reliquaries, and Relic Shrines in Chinese and Korean Buddhist Art from the Tenth to the Fourteenth Centuries" (PhD diss., University of Chicago, 2013), 186–190.

54. *Xiaoyi zhenji Zhenzhuta quanzhuan* 孝義真跡珍珠塔全傳 (1849). People believe that the story of the *zhenzhu ta* is based on the real story of a high official and native of Tongli County in Suzhou, Chen Wangdao 陳王道 (1526–1576). Fan Yanqiao, *Chayanxie* (facsimile reprints; Shanghai: Zhongfu shuju, 1934; Shanghai: Shanghai shudian, 1989), 116–17.

55. "別施金釵裝佛母, 祈靈唯願便生兒." Yu Anqi. Liuliu ge quanji, vol.143, *Siku quanshu cunmu congshu*.(Jinan: Qilu shushe, 1997), juan 37, 350.

56. On the hairpins with Buddhist images found belonged to Yan Song and his family, see *Tianshui bingshan lu*, 27b, 28a–28b, 32a. A Chŏsen dynasty scholar-official, Choe Bu 崔溥 (1454-1504) wrote that he saw a woman wearing a Guanyin crown adorned with gold and jade in the Ningbo area in 1488. Cui Pu (Choe Bu), *Cui Pu piaohai lu jiaozhu*. Annotated by Park Won-ho (Shanghai: Shanghai shudian chubanshe, 2013),164. In chapter 20 of *Jinpingmei*, the Guanyin hairpin seems imbued with the moral value of uprightness. Ximen Qing's principle wife Wu Yueniang wears a wig with Guanyin decoration in contrast to Pan Jinlian's taste for the phoenix pattern. Xiaoxiaosheng, *Jinpingmei*, vol. 2, chap. 24, 4b–6a.

57. Pu, Songling, *Xingshi yinyuan zhuan*. (Hong Kong: Zhonghua shuju, 1959), Chapter 78, 767. Lay Buddhist women often offered various decorations made of textiles to the temple. These artifacts included robes for covering the statues, banners that hang from the ceiling of the halls, shrine curtains, table covers, and mats for workshops.

58. As Mauss says, "To give something is to give a part of oneself." Marcel Mauss, *The Gift: the Form and Reason for Exchange in Archaic Societies*, trans. W. D. Halls (New York: Norton, [1925] 1990), 10. Also see McNair's discussion on Guyang Cave in *Donors of Longmen*, 49.

59. I am grateful for Dorothy Wong's comments on this issue.

60. For the "lived object," see Wu Hung, *The Art of Yellow Springs: Understanding Chinese Tombs* (Honolulu: University of Hawai'i Press, 2010), 163–173. For the "spirit object," see Wu Hung, " 'Mingqi' de lilun he shijian: Zhanguo shiqi liyi meishu zhong de guannianhua qingxiang", *Wenwu* 6 (2006): 72–81. Hui-Han Jin's research on a new type of *mingqi*, namely the miniature pewter utensils used in burial practice during the Ming period, helps us understand the shift of tomb art from elaborate mural and relief to objects. Hui-Han Jin, "Emotional Death: Tombs and Burial Practices in the Ming Dynasty 1368–1644" (PhD diss., University of Minnesota, 2017), 211–254.

61. For instance, a male hair cap, which was discovered in a Ming dynasty tomb in Chengdu, was used by the tomb occupant during his life time and was incised with four characters of xifang jingtu 西方淨土 (Western Pure Land) on its front after the person passed away. The four characters redefine this cap as an object used by the dead in his afterlife. Yang, Shehua zhise, vol.2, 130. Contemporary death ritual in Hebei province reveals that a deceased woman is often adorned by a hairpin with nine lotus flowers indicating her

rebirth in the Pure Land. Such a hairpin would fit into the category of spiritual jewelry. I thank Zhang Weisheng for sharing his field research with me.

62. This is not to say that there were no mural paintings or relief carvings from the Ming and Qing periods, but rather that the number of them and the scale of such tombs were much fewer and smaller than in previous dynasties. Wang Yudong discusses changes in decorative subjects starting from the Song and Yuan periods. Wang Yudong, "Mengyuan shiqi mushi de 'zhuangshihua' qushi yu zhongguo gudai bihua de shuailuo", in *Gudai muzang meishu yanjiu*, ed. Wu Hung, Zhu Qingsheng, and Zheng Yan, vol. 2 (Changsha: Hunan meishu chubanshe, 2013), 356. For a brief discussion of the tombs with mural paintings from Ming and Qing dynasties, see He Xilin and Li Qingquan, *Zhongguo mushi bihua shi* (Beijing: Gaodeng jiaoyu chubanshe, 2009), 445–454.

63. During the tenth century, the head, along with arms and neck, were considered the body parts that could carry the *Great Dhāraṇī of Wish Fulfillment*. Yang, *Shehua zhise*, 2:197. Paul Copp's research has demonstrated that the location of the armlet on a dead person is quite similar to the location of such an armlet on a Bodhisattva's icon. Copp, *The Body Incantatory*, 85.

64. For instance, on an official portrait of Empress Liu (969–1033) of the Northern Song, an elaborate crown displays the procession of the Queen Mother of the West, riding on a dragon accompanied by her entourage. Several scholars have speculated that, to enhance her regency, Empress Liu patronized Buddhist and Taoist art projects and was involved in reforming ancestor worship rituals at court. Her body faces the same direction as the female companions of the Queen Mother of the West and she makes similar gestures as if she is one of their number. Through this extraordinary crown on an official portrait, she tried to express her secular power via a religious icon. Hui-shu Lee, *Empress, Art and Agency in Song Dynasty China* (Seattle: University of Washington Press, 2010), 32.

65. Buddha figures as hair decoration can be traced to the Northern Song period. Emperor Renzong (1010–1063) had different sizes of tiny jade Buddhas for wearing inside his crown and hat. He explained his motivation: "I do not have the virtue, but I have been called *wansui* (ten thousand years) by many people every day. Let the Buddha receive this honor." Buddha functions as a hidden icon and serves as a substitute for the human being. The Qingshou Princess collected more than ten jade Buddhas in a small golden container that belonged to her father, the Renzong emperor. The biggest size is similar to a coin and the smallest one is like a fingernail. Qian Shizhao, *Qianshi sizhi*, Vol. 1036 of *Yingyin wenyuange siku quanshu* (Taipei: Taiwan shangwu yinshuguan, 1983), 661. From the Yuan period, in a mural painting in the Qinglong temple, we also see the representation of imperial female patrons with crowns in a procession of figures (possibly deities) standing on clouds. See the detail captioned "Imperial women and palace girls from the past" in Chai Zejun, ed., *Shanxi siguan bihua* (Beijing: Wenwu chubanshe, 1997), 219.

66. Hu Shi, *Shutan*. Printed between 1522 and 1566. *Siku quanshu dianziban*, juan 6, 12b. For a more detailed discussion, see chapter 1.

67. In another type of hairpin, the image of Amitābha Buddha is replaced by the character *fo* (Buddha), a six-syllable Sanskrit mantra, and the pictograph of Kalachakra (a time cycle or gathering of ten powerful elements), which is associated with Vajrayana Buddhism. These hairpins incised with mantras may combine both the incantation tradition and Guanyin-type hairpins. Yang, *Shehua zhise*, 2:192–221.

68. *Tianshui bingshan lu*, 27b, 28a–28b, 32a.

69. For the excavation report, see Wujin bowuguan, "Wujin Mingdai Wang Luo jiazu mu", *Dongnan wenhua* 124, no. 2 (1999): 28–36.

70. According to the *Wang Family Genealogy of Piling*, the cemetery has stone sculptures of figurines, horses, and arches. Wang Luo's tomb is the primary tomb or *zhuxue*. See "附芳茂山各房附髒合同議單," in *Piling wangshi zongpu* 毗陵王氏宗譜, Piling shientang 世恩堂 print, 1921 reprint (Changzhoushi tushuguan Collection), juan 3, 12b.

71. Wang Yu, *Wang Yu quanji*, edited by Shientang Piling wangshi, annotated by Zhu Jun. (n.d.), 1.

72. *Piling wangshi zongpu*, juan 10, 6b. Also see Wang Luo's tomb epitaph "Mingwei jiangjun zhenjiang wei zhihui qianshi wanggong muzhiming" 明威將軍鎮江衛指揮僉事王公墓誌銘, in *Piling wangshi zongpu*, juan 5, 8a–8b.

73. For Sheng Yu's biography see, Zhang Tingyu 張廷玉, comp., *Mingshi* 明史 (Beijing: Zhonghua shuju, 1974), ce 12, 4419.

74. Née Sheng's *ruren* title was honored after her son Wang Xian who became the seventh ranked official in the family. Wujin bowuguan, "Wujin Mingdai Wang Luo jiazu mu," 36.

75. Wujin bowuguan, "Wujin Mingdai Wang Luo jiazu mu," 28–29.

76. "Luogong pai shi biao" 洛公派世表, in *Piling wangshi zongpu*, juan 10, 36b.

77. *Piling wangshi zongpu*, juan 3, 3b. Compared with other family genealogies, the Wang family genealogy stresses the dress code regulations around funerary mourning.

78. Grant, *Eminent Nuns*, 4.

79. At the time, there were about nine Buddhist temples in Wujin County; see Tang Xuanqing and Fu Yingyi, *Wujin xianzhi*, Wanli edition (Changzhoushi tushuguan Collection), juan 1, 27a–94b.

80. Tang and Fu, *Wujin xianzhi*, juan 1, 27a.

81. As Sun Ji explains, *jiuji* originally referred to a bun hairstyle during the Yuan, but by Ming times, it meant a wig framed in metal wires. Sun Ji, "Mingdai de shufaguan, jiuji yu toumian", *Wenwu* 7 (2001): 62–83.

82. More expensive frames used gold wires.

83. Sun, "Mingdai de shufaguan, jiuji yu toumian," 77.

84. Marcus Bingenheimer, *Island of Guanyin: Mount Putuo and Its Gazetteers* (New York: Oxford University Press, 2016), 19–27.

85. Xu Yizhi, "Mingdai zhengju bianhua yu fojiao shengdi putuoshan de fazhan", *Xuanzang foxue yanjiu* 14 (September 2010): 36–39.

86. Bingenheimer, *Island of Guanyin*, 21–22.

87. Wujinshi bowuguan, "Wujin Mingdai Wang Luo jiazu mu," 30.

88. In a discussion of a bolt of damask with a similar *zabao* pattern excavated from the tomb of Madam Wu, wife of the Ningjing Prince in Nanchang, Zhao Feng explains that the unusual woven structure of the fabric indicates its function as *mingqi* or a spirit item. Such materials were made specifically for funerary use. Zhao Feng, *Fangzhipin kaogu xin faxian* (Hong Kong: Yishatang/fushi gongzuodui, 2002), 192.

89. For example, the Thousand Arms and Eyes Guanyin stands on a single lotus flower base with the seed pod in the middle. Lee Yu-min, *Guanyin tezhan*, pl. 8, 58.

90. The archaeologist called this object a *taobi* (陶箅). It was excavated in Jingzhou, Shishou shi, Dongzhen, Fengshan cun, in 2002. Jingzhou bowuguan, "Mingdai nüshi zhan," Exhibition, 2015.

91. Jingzhou bowuguan, "Mingdai nüshi zhan." During the nineteenth century, one of the merits of this dharani with a diagram of a pagoda is that when someone is dying, that person will be accompanied by buddhas and bodhisattvas to the Pure Land. *Foshuo zaota yanming gongde jing*, T19, no. 1026.

92. "Dongshi xiande zhi bei" 董氏先德之碑, Wang Yu, *Wang Yu quanji*, 16:248.

93. "Xueshi," Yunqi Zhuhong, *Wangsheng ji*, T51, p0146a. For an in-depth study on writing about women's burial on epitaphs, see Jessey Choo, "Shall We Profane the Service of the Dead?—Burial Divination and Remembrance in Late Medieval *Muzhiming.*" *Tang Studies* 33 (2015): 1–37.

94. Information can be found in the archive in the Changzhou Museum.

95. Michael Taussig, *Mimesis and Alterity: A Particular History of the Senses* (New York: Routledge, 1993), 115–116.

96. See Xiaojing's tomb epitaph, Zhongguo shehui kexueyuan kaogusuo, Dingling bowuguan, and Beijing shi wenwu gongzuodui, ed., *Dingling* (Beijing: Wenwu chubanshe, 1990), 1:230–232; Ray Huang, *1587, A Year of No Significance: The Ming Dynasty in Decline* (New Haven, Conn.: Yale University Press, 1981), 29.

97. Zhang, *Mingshi*, 12:3537. Xiaojing's epitaph mentions the location of her first burial site in Dongjing. Zhongguo shehui kexueyuan kaogusuo et al., *Dingling*, 1:232; Huang, *1587, A Year of No Significance*, 30–31.

98. There are, however, a few examples of laywomen being deified, such as the case of Lü Pusa.

99. For Empress Wu, see N. Harry Rothschild, *Emperor Wu Zhao and Her Pantheon of Devis, Divinities, and Dynastic Mothers* (New York: Columbia Press, 2015), 209–226. For Empress Dowager Cixi as Guanyin, see Yuhang Li, "Oneself as a Female Deity: Representations of Cixi Posing as Guanyin," *Nannü: Men, Women, and Gender in China* 14, no. 1 (2012).

100. Marsha Weidner, however, points out that the self-deification of the empress dowager may also point to political motivations in response to criticism from the court that she was too lavish in her patronage of various religious projects. Marsha Weidner, "Images of the Nine-Lotus Bodhisattva and the Wanli Empress Dowager," *Journal of Chinese Historical Research* 35 (2005): 245–278.

101. Zhang, *Mingshi*, zhuan 7, 120: 3659; Thomas Shiyu Li and Susan Naquin, "The Baoming Temple: Religion and Throne in Ming and Qing China." *Harvard Journal of Asiatic Studies* 48, no. 1 (June 1988): 131–188, here 160–161.

102. In 1616 Emperor Wanli ordered the broad distribution of a sectarian scripture that confirmed his mother's association with the Nine Lotus Bodhisattva. For a study of the *Foshuo daci zhisheng jiulian pusa huashen dushi zunjing* 佛說大慈至聖九蓮菩薩化身度世尊經 (Exalted Sutra Spoken by the Buddha on the Incarnation of the Great Compassionate and Supreme Holy Nine-lotus Bodhisattva to Save the World), see Wang Jianchuan, and Lin Wanchuan ed., *Mingqing minjian zongjiao jingjuan wenxian*, vol. 12 (Taipei: Xinwenfeng chubanshe, 1999); see Zhou Shaoliang, "Ming wanli nianjian wei Jiulian pusa bianzao de liangbu jing." *Gugong bowuyuan yuankan* 2 (1985): 37–40.

103. None of the historical references indicate the actual deification of Empress Dowager Liu. Beiping shizhengfu mishuchu, ed., *Jiudu wenwu lue* (1935), 16, pl.34. This painting was also recorded in *Rixia jiuwen kao*; the painting was created in the year of *gengchen* 庚辰 (1640). See Yu Minzhong, *Rixia jiuwen kao*, Qing Qianlong ed., dated to 1788–1795 (University of Chicago Library), juan 59, 9a.

104. For imperial women's Daoist practices, see Luk Yu-Ping's new research on the ordination scroll of Empress Zhang from Hongzhi period. Luk Yu-Ping, *The Empress and the Heavenly Masters: A Study of the Ordination Scroll of Empress Zhang (1493)* (Hong Kong: Center for Studies of Daoist Culture, Chinese University of Hong Kong, 2015), 24–32, 33–50.

105. Zhongguo shehui kexueyuan kaogusuo et al., *Dingling*, 1:198.

106. For instance, in the *Daming huidian* (*Collected Statues of the Great Ming*), the codes of dress and accessories are specified according to ritual, social rank and gender. See Li

Dongyang and Zhao Yongxian, et al. *Daming Huidian*. Shanghai: Shanghai guji chuban-she, 1995. juan 59–102.

107. *Yaoshi liuliguang rulai benyuanjing*, T14, no. 450.

108. Yü, *Kuan-yin*, 145–146.

109. Weidner, "Images of the Nine-Lotus Bodhisattva," 254–55.

110. Yan Wenqing, and Luk Yu-ping, trans., "Religious Consciousness and Beliefs in the Ming Tombs of Princes and Royal Family Members," in *Ming China: Courts and Contacts 1400-1450*, ed. Craig Clunas, Jessica Harrison-Hall, and Luk Yu-ping (London: British Museum 2016), 168–169.

111. For example, see the illustration (b) in chapter 49 from the Wu Cheng-en, *Li Zhuowu xiansheng piping xiyouji*, vol. 1792–1793, *Xuxiu siku quanshu* (Shanghai: Shanghai guji chubanshe, 1995).

112. Zhongguo shehui kexueyuan kaogusuo et al., *Dingling*, 1:198.

113. Zhou Xinhui comp., *Zhongguo fojiao banhua.* (Hangzhou: Zhejiang Wenyi chubanshe, 1996) vol. 4, pl. 233. For a careful study on the frontispieces of printed *Lotus Sutra*, see Susan Shih-Shan Huang, "Media Transfer and Modular Construction: The Printing of Lotus Sutra Frontispieces in Song China," *Ars Orientalis* 41 (2011): 135–163.

114. Wang Shancai, ed., *Zhang Mao fufu hezang mu* (Beijing: Kexue chubanshe, 2007), 25.

115. For instance, the phrase "The golden halo and magnificent canopy will receive [some-one] to return the other land" 金光華蓋, 迎還彼土, *Guan wuliangshoufo jing*, T37, no. 1753. In miraculous stories, it is often described as an auspicious omen for rebirth in the Pure Land.

116. Wu Hung, "Yinhun lingbi", in *Gudai muzang meishu yanjiu, diyiji*, ed. Wu Hung and Zheng Yan (Beijing: Wenwu chubanshe, 2011), 55–64.

117. Lee, *Framing and Framed*, 218–219.

118. Yang, *Shehua zhise*, 2: 237–257.

119. Xiaojing lay on her right side and her right hand was placed under her cap. Her left arm lay straight along the left side of her body. Her two legs were bent slightly. Her body was arranged in the same manner as the Wanli emperor's. Scholars now suggest that this posture is in emulation of either the Buddha's nirvana position or the Seven Stars of the Northern Dipper. Wang Xiuling, "Shilun ming dingling mu zhuren de zangshi", in *Shijie yichan luntan: mingqing huangjia lingqin zhuanji*, ed. Nanjing daxue wenhua yu ziran yichan yanjiusuo he xiaoling bowuguan (Beijing: Kexue chubanshe, 2004), 51–58.

120. Zhongguo shehui kexueyuan kaogusuo et al., *Dingling*, 1:25.

121. Adamek, "The Impossibility of the Given," 145–146.

CONCLUSION

1. As James Robson's study on the hand-written manuscript scriptures reveals, however, in Chinese religious practice, new printing technology never completely replaced manu-scripts. Robson, "Brushes with Some 'Dirty Truths'" 317–343.

2. "Jiu xia jiu, zhaoni yun mihua; ji zhong ji, jia xiucai baoyuan" 酒下酒, 趙尼緼迷花; 機中機, 賈秀才抱怨; Ling Mengchu, *Chuke paian jingqi*, (Beijing: Renmin wenxue chubanshe, 1991), 1:94–116.

3. This might refer to a house chapel or a meditation chamber.

4. Nun is included in the category of *sangu liupo* 三姑六婆 (Three Aunts, Six Old Ladies). It usually includes Buddhist and Daoist nuns, midwives, matchmakers, and medicine women. See Yi Ruolan *Sangu liupo*, 5–7.

5. For the moral guidance by Confucian scholar, see Lu Qi, *Xinfu pu*, *Biji xiaoshuo daguan*, 5, no. 6: 3396.

6. Wei Songshou 韋嵩壽, "Chongke Ningxiangge shiba 重刻凝香閣詩跋", in Lou Xiaoming et al., eds., *Ni Renji danchen sibai zhounian jinian wenji* (Hangzhou: Zhongguo meishu xueyuan chubanshe, 2007), 81. Ni Renji's husband was first buried next to the Longping si, see Ni's poem to commemorate her husband; Lou Xiaoming et al., eds., *Ni Renji danchen sibai zhounian jinian wenji*, 19.

7. See entry of "Jin Xingyue" in Zhu Qiqian, *Nühongzhuan zhenglue*, 22a, 22b. Zhu Qiqian cites this story from *Xiaoshanju shigao* (*Poetry Manuscript of the Little Mountain Residency*), but this reference has not been verified.

8. Zongxing et al., eds., *Zhongguo Chengdu fojiao wenhua zhencang shiji dazhan, zhanpin xuanji* ([Publisher unknown], 2005), 155.

9. The emperor's reign is not indicated in the inscription on Liding shi's embroidery, so it is difficult to speculate regarding the concrete date of this object. The two possible years are 1752 and 1872.

10. Fei Fanjiu, *Lichao minghua guanyin baoxiang*, vol. 2, collotype prints (Shanghai: Jingyuanshe, 1938).

11. For the discussion of Shen Shou's embroidery, see Ko, "Between the Boudoir and the Global Market, 48–61.

12. Fei, *Lichao minghua guanyin baoxiang*; one thousand copies were printed. Yinguang Dashi 印光大師 (1862–1940) printed this catalog again in 1939 from the same publisher. In my visit to Nantong in 2008, I was told that part of the collection in Zhaohui shenxiu zhilou was damaged during the Cultural Revolution and that the rest is in the Nantong bowuyuan. For the formation of the collection of Guanyin icons at the Bianlijiang yuan, see Zhai Hao, *Bianliyuan zhi*, vol. 13, *Zhongguo fosi shizhi huikan*, ed. Du Jiexiang, Series 3 (Taipei: Danqing tushu gongsi, 1985), 5b–8b.

13. Zhai, *Bianliyuan zhi*, 8b–9a.

14. See Shen Chengxi's colophon of Ding Yunpeng's Guanyin painting. Fei, *Lichao minghua guanyin baoxiang*, vol. 1, plate of Ding Yunpeng's Guanyin painting.

15. Fei, *Lichao minghua guanyin baoxiang*, vol. 1, plate of Ding Yunpeng's Guanyin painting.

16. Yoshihiko Amino,. "Medieval Construction of Peace and Liberty: muen, kugai and raku," *International Journal of Asian Studies* 4, no. 1 (2007): 3–14.

17. Lee Yu-min, *Guanyin tezhan*, 114.

18. Marsha Weidner, "The Conventional Success of Ch'en Shu," in *Flowering in the Shadows: Women in the History of Chinese and Japanese Painting*, ed. Marsha Weidner (Honolulu: University of Hawai'i Press, 1990), 130.

19. Gugong bowuyuan, comp., *Gugong guanyin tudian* (Beijing: Gugong chubanshe, 2012), 309.

20. Alexandra Tunstall's research on the woman textile weaver of kesi tapestry helps us to understand why silk woven material was used as a medium to reproduce a painting from the Song period. This tradition has been carried out in the court until the Qing dynasty. Alexandra Tunstall, "A Woman's Woven Painting in Literati Circles: Zhu Kerou's *Camellia*," *EASTM* 36 (2012): 39–76. Joyce Denney also points out that Yuan people believed that the weaving technique could generate a sense of "aliveness" in kesi woven portraiture. Joyce Denney, "Textiles in the Mongol and Yuan Periods," in *The World of Khubilai Khan: Chinese Art in the Yuan Dynasty*, ed. James C. Watt (New York: Metropolitan Museum of Art, 2010), 246–247.

21. In the imperial workshop, embroiderers, whether female or male, remained anonymous.

22. Zhu Qiqian, *Qing neifu chang kesi xiuxian shuhua lu*, preface by Kanduo 闞鐸 (1930), 13–14.

23. Zhu, *Qing neifu chang kesi xiuxian shuhua* lu, 13–14. Similarly, Lady Wang, the wife of the high official Jiang Bo 蔣溥, had two embroidered hanging scrolls of Guanyin and one scroll of an Arhat displayed at the Mountain Resort in Chengde and the Temporary Palace in Fengtian 奉天, today's Shenyang. Zhu, *Qing neifu chang kesi xiuxian shuhua* lu, 15.

24. Chou Wen-Shing, *Mount Wutai: Visions of a Sacred Buddhist Mountain* (Princeton, NJ: Princeton University Press, 2018), 30; see also figure 1.16.

25. Further research needs to be conducted with respect to the makers of this tapestry. The size of this *thangka* is 175 by 115 centimeters. Yu-Ping Luk, "Qing Empresses as Religious Patrons and Practitioners," in Daisy Yiyou Wang and Jan Stuart eds., *Empresses of China's Forbidden City: 1644-1912.* (Salem: Peabody Essex Museum and Washington, DC: Freer|Sackler, Smithsonian Institution, 2018), 118. The current *tangka* displayed in the Hall of Eternal Protection is a modern reproduction. The original one is in the Yonghegong storage.

26. The information is taken from the label of the object at the Palace of Eternal Protection.

27. Li, "Oneselfe as a Female Deity," 111–114.

Selected Bibliography

Adams, Doug, and Apostolos-Cappadona Diane, eds. *Dance as Religious Studies*. New York: Crossroad, 1990.

Adamek, Wendi L. "The Impossibility of the Given: Representations of Merit and Emptiness in Medieval Chinese Buddhism." *History of Religions* 45, no. 2 (2005): 135–180.

——. "The Mystique of Transmission: On an Early Chan History and Its Contexts." New York: Columbia University Press, 2007.

Alexander, Katherine Laura Bos. "Virtues of the Vernacular: Moral Reconstruction in Late Qing Jiangnan and the Revitalization of Baojuan." PhD diss., University of Chicago, 2016.

Amino, Yoshihiko. "Medieval Construction of Peace and Liberty: muen, kugai and raku." *International Journal of Asian Studies* 4, no. 1 (2007): 3–14.

Anhui sheng bowuguan 安徽省博物館, ed. *Anhui sheng bowuguan canghua* 安徽省博物館藏畫. Beijing: Wenwu chubanshe, 2004.

Apostolos-Cappadona, Diane. "Scriptural Women Who Danced," in *Dance as Religious Studies*, ed. Doug Adams and Diane Apostolos-Cappadona, 95–108. New York: Crossroad, 1990.

Bai Juyi 白居易 (772–846). *Baishi changqing ji* 白氏長慶集. Vol. 1080 of *Yingyin wenyuange siku quanshu* 景印文淵閣四庫全書. Taipei: Taiwan shangwu yinshuguan, 1983–1986.

Balkwill, Stephanie. "The Sūtra on Transforming the Female Form: Unpacking an Early Medieval Chinese Buddhist Text." *Journal of Chinese Religions* 44, no.2 (2016): 127–148.

Bailun 百論 (Treatise of the Hundred). T30, no. 1569.

Beijing tushuguan jinshizu 北京圖書館金石組, ed. *Beijing tushuguan cang zhongguo lidai shike taben huibian* 北京圖書館藏中國歷代石刻拓本彙編. Zhengzhou: Zhongzhou guji chubanshe, 1989–1991.

Beiping shizhengfu mishuchu 北平市政府秘書處, ed. *Jiudu wenwu lue* 舊都文物略. Beijing: Beiping gugong yinshuasuo, 1935.

Bell, Catherine. "Performance." In *Critical Terms for Religious Studies*, ed. Mark C. Taylor, 205–224. Chicago: University of Chicago Press, 1998.

Benn, James A. *Burning for the Buddha: Self-immolation in Chinese Buddhism*. A Kuroda Institute Book. Honolulu: University of Hawai'i Press, 2007.

——. "The Lotus Sūtra and Self-immolation." In *Readings of the Lotus* Sūtra, ed. Stephen F. Teiser and Jacqueline I. Stone, 107–131. New York: Columbia University Press, 2009.

Berg, Daria. "Cultural Discourse on Xue Susu, A Courtesan in Late Ming China." *International Journal of Asian Studies* 6 (2009): 171–200.

Berger, Patricia Ann. *Empire of Emptiness: Buddhist Art and Political Authority in Qing China.* Honolulu: University of Hawai'i Press, 2003.

Bian Yongyu 卞永譽 (1645–1712). *Shigutang shuhua huikao* 式古堂書畫彙考. Shanghai: Jiangu shushe, 1921.

Bingenheimer, Marcus. *Island of Guanyin: Mount Putuo and Its Gazetteers.* New York: Oxford University Press, 2016.

Birrel, Anne M. "The Dusty Mirror: Courtly Portraits of Woman in Southern Dynasties Love Poetry." In *Expressions of Self in Chinese Literature*, ed. Robert E. Hegel and Richard C. Hessney, 39–69. New York: Columbia University Press, 1985.

Bourdieu, Pierre. *Distinction: A Social Critique of the Judgment of Taste*, trans. Richard Nice. Cambridge, Mass.: Harvard University Press, 1984.

Bray, Francesca. *Technology and Gender: Fabrics of Power in Late Imperial China.* Berkeley: University of California Press, 1997.

Briginshaw, Valerie A. *Dance, Space and Subjectivity.* New York: Palgrave, 2001.

Brinker, Helmut, and Kanazawa Hiroshi. *Zen Masters of Meditation in Images and Writings*, trans. Andreas Leisinger. Zurich: Artibus Asiae, 1996.

Brokaw, Cynthia. *The Ledgers of Merit and Demerit: Social Change and Moral Order in Late Imperial China.* Princeton, NJ: Princeton University Press, 1991.

Brook, Timothy. *The Confusions of Pleasure: Commerce and Culture in Ming China.* Berkeley: University of California Press, 1998.

——. *Praying for Power: Buddhism and the Formation of Gentry Society in Late-Ming China.* Cambridge, Mass.: Harvard University Press, 1993.

Bryson, Megan. *Goddess on the Frontier: Religion, Ethnicity, and Gender in Southwest China.* Stanford, Calif.: Stanford University Press, 2017.

Buxiu baiyi si ta ji 補修白衣寺塔記, composed in the tenth year of the Xianfeng period (1860), stele, Lanzhou shi bowuguan Collection.

Buswell Jr., Robert E. and Donald S. Lopez Jr., comp. and ed. *The Princeton Dictionary of Buddhism.* Princeton: Princeton University Press, 2014.

Butler, Judith. "Bodies That Matter." In *The Body: A Reader*, ed. Mariam Fraser and Monica Greco, 62–65. New York: Routledge, 2005.

——. *Gender Trouble: Feminism and the Subversion of Identity.* New York: Routledge, 1999.

Cabezón, José Ignacio. "Mother Wisdom, Father Love: Gender-based Imagery in Mahāyāna Buddhist Thought." In *Buddhism, Sexuality, and Gender*, ed. José Ignacio Cabezón, 181–214. Albany: State University of New York Press, 1992.

Cahill, James. *The Painter's Practice: How Artists Lived and Worked in Traditional China.* New York: Columbia University Press, 1994.

——. *Pictures for Use and Pleasure: Vernacular Painting in High Qing China.* Berkeley: University of California Press, 2010.

——. "Survivals of Ch'an Painting into Ming-Ch'ing and the Prevalence of Type Images." *Archives of Asian Art* 50 (1997–1998): 17–37.

Cahill, Suzanne Elizabeth. "Discipline and Transformation: Body and Practice in the Lives of Daoist Holy Women of Tang China." In *Women and Confucian Cultures in Premodern China, Korea, and Japan*, ed. Dorothy Ko, JaHyun Kim Haboush, and Joan R. Piggott, 251–278. Berkeley: University of California Press, 2003.

——. *Transcendence and Divine Passion: The Queen Mother of the West in Medieval China.* Stanford, Calif.: Stanford University Press, 1993.

Cai, Yi 蔡毅. *Zhongguo gudian xiqu xuba huibian*, 中國古典戲曲序跋彙編, vol.2. Jinan: Qilu chubanshe, 1989.

Campany, Robert. "Notes on the Devotional Uses and Symbolic Functions of Sūtra Text as Depicted in Early Chinese Buddhist Miracle Tales and Hagiographies." *Journal of the International Association of Buddhist Studies* 14, no.1 (1991): 28–72.

Carlitz, Katherine. "Desire, Danger, and the Body: Stories of Women's Virtue in Late Ming China." In *Engendering China: Women, Culture, and the State*, ed. Christina K. Gilmartin, 101–124. Cambridge, Mass.: Harvard University Press, 1994.

——. "The Social Uses of Female Virtue in Late Ming Editions of Lienü zhuan." *Late Imperial China* 12, no. 2 (1991): 117–148.

Chai, Lˇ 柴萼 (1893–1936). *Fantian lu conglu* 梵天廬叢錄. Shanghai: Zhonghua shuju, 1936.

Chai, Zejun 柴澤俊, ed. *Shanxi siguan bihua* 山西寺觀壁畫. Beijing: Wenwu chubanshe, 1997.

Chang, Kang-i Sun. *The Late-Ming Poet Ch'en Tzu-lung: Crises of Love and Loyalism*. New Haven, Conn.: Yale University Press, 1991.

——. "Ming-Qing Women Poets and the Notions of 'Talent' and 'Morality.'" In *Culture and State in Chinese History: Conventions, Accommodations and Critiques*, ed. Theodore Huters, R. Bin Wong, and Pauline Yu, 236–258. Stanford, Calif.: Stanford University Press, 1997.

Chang, Kang-i Sun, and Haun Saussy, ed. *Women Writers of Traditional China: An Anthology of Poetry and Criticism*. Stanford, Calif.: Stanford University Press, 1999.

Chen Chaozhi 陳朝志. "Faxiu—zhixiu yiyuan zhong de qipa" 髮繡—織繡中的奇葩. *Zhongguo fangzhi* 9 (1994): 47–48.

Chen Gengsheng 陳庚笙, comp., and Chen Dejin 陳德錦, ed. *Haining bohai chenshi zongpu* 海寧渤海陳氏宗譜. Vols. 72–76 of *Qingdai Minguo mingren jiapu xuankan xubian* 清代民國名人家譜選刊續編. Beijing: Yanshan chubanshe, 2006.

Chen Hui-Hsia 陳慧霞. "Qingdai gongting funü zanshi zhi liubian" 清代宮廷婦女簪式之流變. *Jindai zhongguo funü shi yanjiu* 28 (December 2016): 53–124.

Chen Pao-chen 陳葆真. "Guan Daosheng he tade zhushi tu" 管道昇和她的竹石圖. *Gugong jikan* 11, no. 4 (1977): 51–84.

Chen Renxi 陳仁錫 (1581–1636). *Jingkou sanshan zhi xuanbu* 京口三山志選補. 1612 edition, microfilm in Harvard Yen-ching Library.

——. *Chen Taishi wumeng yuan chuji* 陳太史無夢園初集. Vol.1383 of *Xuxiu siku quanshu* 續修四庫全書. Shanghai: Shanghai guji chubanshe, 1995–1999.

Chen Weisong 陳維崧 (1625–1682). *Furen ji* 婦人集. In *Haishan xianguan congshu*, Case 9. *Baibu congshu jicheng*, Series 60. Taipei: Yinwen yinshuguan, 1967.

Chen Yinke 陳寅恪. *Liu Rushi biezhuan* 柳如是別傳. Beijing: Sanlian shudian, 2001.

Chen Yunü 陳玉女. "Buddhism and the Medical Treatment of Women in the Ming Dynasty: A Research Note." *Nan Nü: Men, Women Gender in Early and Imperial China* 10 (2008): 279–303.

——. "Ming wanli shiqi cisheng huangtaihou de chongfo: jianlun fodao liang shili de duichi." 明萬曆時期慈聖皇太后的崇佛: 兼論佛道兩勢力的對峙 *Guoli chenggong daxue lishi xuebao*, 23 (1997): 1–51.

Chiang Shao-yuan 江紹原. *Fa xu zhao* 髮鬚爪. Taipei: Dongfang wenhua shuju, [1926] 1971.

Chou Wen-Shing. *Mount Wutai: Visions of a Sacred Buddhist Mountain*. Princeton, NJ: Princeton University Press, 2018.

Choo, Jessey. "Shall We Profane the Service of the Dead?—Burial Divination and Remembrance in Late Medieval *Muzhiming*." *Tang Studies* 33 (2015): 1–37.

——. "That 'Fatty Lump': Discourses on the Fetus, Fetal Development, and Filial Piety in Early Imperial China." *Nan Nü: Men, Women and Gender in Early and Imperial China* 14, no. 2 (2012): 177–221.

Chow, Kai-wing. *The Rise of Confucian Ritualism in Late Imperial China: Ethics, Classics, and Lineage Discourse*. Stanford, Calif.: Stanford University Press, 1994.

Clunas, Craig. *Empire of Great Brightness: Visual and Material Cultures of Ming China, 1368-1644*. Honolulu: University of Hawai'i Press, 2007.

——. *Pictures and Visuality in Early Modern China*. London: Reaktion, 1997.

——. "Precious Stones and Ming Culture, 1400–1450." *Ming China: Courts and Contacts 1400-1450*, ed. Craig Clunas, Jessica Harrison-Hall, and Luk Yu-ping, 236–244. London: British Museum, 2016.

——. *Screen of Kings: Royal Art and Power in Ming China*. Honolulu: University of Hawai'i Press, 2013.

——. *Superfluous Things: Material Culture and Social Status in Early Modern China*. Honolulu: University of Hawai'i Press, 2004.

Clunas, Craig, Jessica Harrison-Hall, and Luk Yu-ping eds. *Ming China: Courts and Contacts 1400-1450*. London: British Museum, 2016.

Cole, Alan. *Mothers and Sons in Chinese Buddhism*. Stanford, Calif.: Stanford University Press, 1998.

Copp, Paul. *The Body Incantatory: Spells and the Ritual Imagination in Medieval Chinese Buddhism*. New York: Columbia University Press, 2014.

Cui Pu [Choe Bu] 崔溥 (1454–1504). *Cui Pu piaohai lu jiaozhu* 崔溥漂海錄校注. Annotated by Park Won-ho 朴元鎬. Shanghai: Shanghai shudian chubanshe, 2013.

Da banruo boluo miduo xinjing 大般若波羅蜜多心經 (The Great *Prajñā-pāramitā Sūtra*), trans. Xuanzang 玄奘. T5–7, no.220.

Dafang guangfo huayan jing 大方廣佛華嚴經 (Great Righteous Vast Buddha Ornamented with Flowers Scriptures). T09, no. 278.

Da fo ding ru lai mi yin xiu zheng liao yi zhu pu za wan xing shou leng yan jing 大佛頂如來密因修證了議諸菩薩萬行首楞嚴經 (The Submit of the Great Buddha, the Final Meaning of Verifications Through Cultivation of the Secret Cause of The Tathagata, and the Śūtaṅgama Sūtra of Ten Thousand Practices of All Bodhisattvas). T.19, no.945.

Daoshi 道世 (d. 683). *Fayuan zhulin* 法苑珠林 (Forest of Gems in the Garden of the Dharma). T53, no. 2122.

Dauncey, Sarah. "Bounding, Benevolence, Barter and Bribery: Images of Female Gift Exchange in the *Jin Ping Mei*." *Nan Nü: Men, Women Gender in Early and Imperial China* 5, no. 2 (October 2003): 170–202.

Davis, Richard H., ed. *Images, Miracles, and Authority in Asian Religious Tradition*. Boulder, Colo.: Westview, 1998.

Dehejia, Vidya. *The Body Adorned: Dissolving Boundaries Between Sacred and Profane in India's Art*. New York: Columbia University Press, 2009.

Denney, Joyce. "Textiles in the Mongol and Yuan Periods." In *The World of Khubilai Khan: Chinese Art in the Yuan Dynasty*, ed. James C. Watt, 243–267. New York: Metropolitan Museum of Art, 2010.

Dennis, Joseph. *Writing, Publishing, and Reading Local Gazetteers in Imperial China, 1100–1700*. Cambridge, Mass.: Harvard University Asia Center; Distributed by Harvard University Press, 2015.

Ding Licheng 丁立誠. *Xiaohuaiyi yingao* 小槐簃吟稿. Hangzhou: Qiantang dingshi jihuitang 1919.

Ding Pei 丁佩 (19th c). *Xiupu* 繡譜. In *Zhongguo lidai meishu dianji huibian* 中國歷代美術典籍彙編, ed. Yu Yu-an 于玉安, vol. 21. Tianjin: Tianjin guji chubanshe, 1997.

Ding Yunpeng 丁雲鵬 (1547–1628) et al. *Mingdai muke Guanyin huapu* 明代觀音木刻畫譜. Shanghai: Shanghai guji chubanshe, 1997.

Dong Hao 董浩 (1740–1818). *Qinding Quantangwen* 欽定全唐文. Printed in 1818. University of Chicago Library Collection.

Dudbridge, Glen. *The Legend of Miao-shan*. Oxford: Oxford University Press, 1978.

Dugu Ji 獨孤及 (726–777). *Piling ji* 毗陵集. In *Siku congkan, jibu*. Shanghai hanfenlou facsimile of the Yiyousheng edition. Shanghai: Shanghai yinshuguan, 1929.

Dunhuangwenwuyanjiusuo 敦煌文物研究所. "Xinfaxiandebeiweicixiu" 新發現的北魏刺繡. *Wenwu* 2 (1972): 54–60.

Ebrey, Patricia. *The Inner Quarters: Marriage and the Lives of Chinese Women in the Sung Period*. Berkeley: University of California Press, 1993.

Eyferth, Jan Jacob Karl. *Eating Rice from Bamboo Roots: The Social History of a Community of Handicraft Papermakers in Rural Sichuan, 1920–2000*. Cambridge, Mass.: Harvard University Asia Center, 2009.

Fahua lingyan zhuan 法華靈驗傳 (The Records of Miraculous Powers of the Lotus Sūtra). X78, no. 1539.

Fan Yanqiao 范煙橋. *Chayanxie* 茶煙歇. Shanghai: Zhongfu shuju, 1934. Facsimile reprint. Shanghai: Shanghai shudian, 1989.

Fang Yizhi 方以智 (1611–1671). *Fushan wenji* 浮山文集. *Siku jinhui shu congkan*, ji 113–474. Beijing: Beijing chubanshe, 1997.

——. *Tongya* 通雅. *Qinding siku quanshu dianziban*.

——. *Xiyu xinbi* 膝寓信筆. In *Tongcheng fangshi qidai yishu* 桐城方氏七代遺書, ed. Fang Changhan 方昌翰. 1888.

Fang Wu 方悟 ed. and Zhang Ji 張幾 illus. *Qinglou yunyu guangji* 青樓韻語廣集, 8 vols., 1631 edition, juan 5, 1a-b. The collection of National Central Library of Taiwan.

Farquhar, David M. "Emperor as Bodhisattva in the Governance of the Ch'ing Empire." *Harvard Journal of Asiatic Studies* 38, no. 1 (June 1978): 5–34.

Faure, Bernard. *The Power of Denial: Buddhism, Purity and Gender*. Princeton, NJ: Princeton University Press, 2003.

——. *The Red Thread: Buddhist Approaches to Sexuality*. Princeton, N.J.: Princeton University Press, 1998.

——. *The Rhetoric of Immediacy: A Cultural Critique of Chan/Zen Buddhism*. Princeton. NJ: Princeton University Press, 1991.

Fei Fanjiu 費範九. *Lichao minghua guanyin baoxiang* 歷朝名畫觀音寶相. Collotype prints. Shanghai: Jingyuanshe, 1938.

Fei Xiaolou 費曉樓 (1802–1850). *Fei Xiaolou baimei tu* 費曉樓百美圖. Shanghai: Shanghai guji chubanshe, 2005.

Feng Menglong 馮夢龍 (1574–1646). *Xingshi hengyan* 醒世恆言. Vol. 1. Beijing: Renmin wenxue chubanshe, 1984.

Feng Mengzhen 馮夢禎 (1548–1605). *Kuaixuetang riji* 快雪堂日記. Harvard Yen-ching Library Collection.

Fingarette, Herbert. *Confucius: The Secular as Sacred*. Long Grove, Ill.: Waveland Press, 1998.

Finnane, Antonia. *Changing Clothes in China: Fashion, History, Nation*. New York: Columbia University Press, 2008.

Fister, Patricia. "Visual Culture in Japan's Imerial Rinzai Zen Convents: The Making of Objects as Expressions of Religious Devotion and Practice," in *Zen And Material Culture*, ed. Pamela D. Winfield and Steven Heine, 164–196. New York: Oxford University Press, 2017.

Fofa jintang bian 佛法金湯編. In *Siku weishou shu jikan diwuji* 四庫未收書輯刊 第五輯, vol. 13, 561–718. Beijing: Beijing chubanshe, 2000.

Fong, Grace. "Female Hands: Embroidery as a Knowledge Field in Women's Everyday Life in Late Imperial and Early Republican China." *Late Imperial China* 25, no. 1 (June 2004): 1–58.

—. *Herself an Author: Gender, Agency, and Writing in Late Imperial China*. Honolulu: University of Hawai'i Press, 2008.

—. "'Record of Past Karma' by Ji Xian (fl. 1650s)." In *Under Confucian Eyes: Writings on Gender in Chinese History*, ed. Susan Mann and Yü-yin Cheng, 134–146. Berkeley: University of California Press, 2001.

Fong, Wen. "Why Chinese Painting Is History?" *Art Bulletin* 85, no. 2 (June 2003): 258–280.

Fontein, Jan. *The Pilgrimage of Sudhana: A Study of Gandavyū Illustrations in China, Japan and Java*. The Hague: Mouton, 1967.

Forte, Antonino. *Political Propaganda and Ideology in China at the End of the Seventh Century: Inquiry Into the Nature, Authors and Function of the Tunhuang Document*. S.6502. Naples, Italy: Istituto Universitario Orientale, Seminario di Studi Asiatici, 1976.

Foshuo baoyu jing 佛說寶雨經 (Treasure Rain Sūtra Spoken by the Buddha). Bodhiruci (Puti liuzhi 菩提流志, late 7th c.), tr. T16, no. 660.

Foshuo da a mi tuo jing 佛說大阿彌陀經 (Sūtra of the Buddha's Teaching on Amitabha). T12, no. 364.

Foshuo daci zhisheng jiulian pusa huashen dushi zunjing 佛說大慈至聖九蓮菩薩化身度世尊經 (Exalted Sūtra Spoken by the Buddha on the Incarnation of the Great Compassionate and Supreme Holy Nine-lotus Bodhisattva to Save the World). Vol. 12 of *Mingqing minjian zongjiao jingjuan wenxian* 明清民間宗教經卷文獻, ed. Wang Jianchuan 王見川 and Lin Wanchuan 林萬傳. Taipei: Xinwenfeng chubanshe, 1999.

Foshuo guan Wuliangshoufo jing 佛說觀無量壽佛經 (Sūtra of Contemplation on Buddha of Measureless Life Spoken by the Buddha). T12, no. 365.

Foshuo taizi ruiying benqi jingjuan 佛說太子瑞應本起經卷 (Sūtra of the Original Life of the Prince in Accordance with All the Good Omens Spoken by the Buddha). T03, no. 185.

Foshuo wuliangshoufo jing 佛說無量壽佛經 (Sūtra of the Buddha of Measureless Life Spoken by the Buddha). T12, no. 360.

Foshuo zaota yanming gongde jing 佛說造塔延命功德經 (Sūtra of the Merit of Building a Stupa to Prolong Life Spoken by the Buddha). T19, no. 1026.

nü shenjing 佛說傳女身經 (Sūtra on Transforming Female Form Spoken by the Buddha). T14, no.564.

Foxwell, Chelsea "Merciful Mother Kannon and its Audiences." *Art Bulletin* (2010): 326–347.

Furth, Charlotte. "Androgynous Males and Deficient Female: Biology and Gender Boundaries in Sixteenth-and Seventeenth-Century China," *Late Imperial China* 9, no. 2 (Dec. 1988): 1–31.

—. *The Flourishing Yin: Gender in China's Medical History, 960-1665*. Berkeley: University of California Press, 1999.

Gaowang guanshiyin jing 高王觀世音經 (King Gao's Guanshiyin Sūtra). T.85, no.2898.

Glucklich, Ariel. *Sacred Pain: Hurting the Body for the Sake of the Soul*. Oxford: Oxford University Press, 2001.

Goldman, Andrea. "The Nun Who Wouldn't Be: Representations of Female Desire in Two Performance Genres of 'Si Fan.'" *Late Imperial China* 22, no. 1 (June 2001): 71–138.

—. *Opera and the City: The Politics of Culture in Beijing, 1770-1900*. Stanford, Calif.: Stanford University of Press, 2012.

Goossaert, Vincent. "Irrepressible Female Piety: Late Imperial Bans on Women Visiting Temples." *Nan Nü: Men, Women, and Gender in Early and Imperial China* 10 (2008): 212–241.

Gove, Philip Babcock, and the Merriam-Webster editorial staff editors. *Webster's Third New International Dictionary of the English Language* (unabridged). Springfield, IL: Merriam-Webster, 1981.

Granoff, Phyllis. "Divine Delicacies: Monks, Images, and Miracles in the Contest between Jainism and Buddhism." In *Images, Miracles, and Authority in Asian Religious Tradition*, ed. Richard H. Davis, 55–95. Boulder, Colo.: Westview Press, 1998.

Grant, Beata. "*Da Zhangfu*: The Gendered Rhetoric of Heroism and Equality in Seventeenth-Century Chan Buddhist Discourse Records." *Nan Nü: Men, Women, and Gender in Early and Imperial China* 10 (2008): 177–211.

——. *Eminent Nuns: Women Chan Masters of Seventeenth-Century China*. Honolulu: University of Hawai'i Press, 2009.

——. "Little Vimalakirti: Buddhism and Poetry in the Writings of Chiang Chu (1764–1804)." In *Chinese Women in the Imperial Past: New Perspectives*, ed. Harriet T. Zurndorfer, 286–307. Leiden: Brill, 1999.

——. "Patterns of Female Religious Experience in Qing Dynasty Popular Literature." *Journal of Chinese Religions* 23 (1995): 29–58.

——. "The Spiritual Saga of Woman Huang: From Pollution to Purification." In *Ritual Opera, Operatic Ritual*, ed. David Johnson, 224–311. Berkeley: Chinese Popular Culture Project, 1989.

——. "Who Is This I? Who Is That Other? The Poetry of an Eighteenth-Century Buddhist Laywoman." *Late Imperial China* 15 (1994): 47–86.

——. "Women, Gender and Religion in Premodern China: A Brief Introduction." *Nan Nü: Men, Women, and Gender in Early and Imperial China* 10 (2008): 2–21.

Greene, Eric Matthew. "Meditation, Repentance, and Visionary Experience in Early Medieval Chinese Buddhism." PhD diss., University of California, Berkeley, 2012.

Gross, Rita M. *Buddhism After Patriarchy: A Feminist History, Analysis, and Reconstruction of Buddhism*. Albany: State University of New York Press, 1993.

Gu Qiyuan 顧起元 (1565–1628). *Kezuo zhuiyu* 客座贅語. Vol. 1260 of *Xuxiu siku siku quanshu* 續修四庫全書, *zibu*. 1618 ed. Shanghai: Shanghai guji chubanshe, 1995.

Gu Zhengyi 顧正誼 (fl. early 17th c.). *Gu Zhongfang Xinci tupu* 顧仲方新詞圖譜. Peking University Library Collection.

Gu, Zhongfang 顧仲方 (fl. 1575–1597). *Bihualou xinsheng* 筆花樓新聲. Printed in Wanli period (1573–1620). University of Chicago Library Collection. Microfilm.

Guanyin yishu ji 觀音義疏記 (Notes on [Zhiyi's] Elucidation of the Meaning of Guanyin). T.34, no.1729.

Guanyin Yulan Ji 觀音魚籃記. In *Guben Xiqu Congkan Erji* 古本戲曲叢刊二集. Facsimile reprint of Ming Wenlinge edition. Shanghai: Shangwu yinshuguan, 1955.

Guang qingliang zhuan 廣清涼傳 (Expanded Accounts of the Clear and Cool Mountains). T51, no. 2099.

Gugong bowuyuan 故宮博物院, comp. *Gugong guanyin tudian* 故宮觀音圖典. Beijing: Gugong chubanshe, 2012.

Guo Yongli 郭永利. "Ming su fanwangfei jin leisi qian baoshi baiyu guanyin zan" 明肅藩王妃金累絲寶石白玉觀音簪. *Dunhuang Yanjiu* 2 (2008): 42–46.

Guoli gugong bowuyuan bianji weiyuanhui 國立故宮博物院編輯委員會, ed. *Gugong shuhua tulu* 故宮書畫圖錄. Taibeishi: Guoli gugong bowuyuan, 1989–.

Gyatso, Janet. "Sex." In *Critical Terms for the Study of Buddhism*, ed. Donald S. Lopez Jr., 271–291. Chicago: University of Chicago Press, 2005.

Handler-Spitz, Rivi. *Symptoms of an Unruly Age: Li Zhi and Cultures of Early Modernity*. Seattle: University of Washington Press, 2017.

Hanshan Deqing 憨山德清 (1546–1623). *Hanshan laoren mengyou ji* 憨山老人夢游集. X73, no. 1456.

Hay, Jonathan. *Sensuous Surfaces: The Decorative Object in Early Modern China*. Honolulu: University of Hawai'i Press, 2010.

——. "The Reproductive Hand." In *Between East and West in Art*, ed. Shigetoshi Osano, 319–333. Cracow, Poland: Artibus et Historae, 2014.

He Suhua 何素花. "Qingchu shidafu yu funü: yi jinzhi funü huodong wei zhongxin." 清初士大夫與婦女以禁止婦女宗教活動為中心. *Qingshi yanjiu* 清史研究 3 (2003): 62–72.

He Xilin 賀西林 and Li Qingquan 李清泉. *Zhongguo mushi bihua shi* 中國墓室壁畫史. Beijing: Gaodeng jiaoyu chubanshe, 2009.

He, Yuming. *Home and the World: Editing the "Glorious Ming" in Woodblock-Printed Books of the Sixteenth and Seventeenth Centuries*. Cambridge, Mass.: Harvard University Asia Center, 2013.

Hearn, Maxwell K. *How to Read Chinese Paintings*. New Haven, Conn.: Yale University Press, 2008.

Hilebeitel, Alf, and Barbara Miller, eds. *Hair: Its Power and Meaning in Asian Cultures*. Albany: State University of New York Press, 1998.

Hinsch, Bret. "Confucian Filial Piety and the Construction of the Ideal Buddhist Women." *Journal of Chinese Religions* 30, no. 1 (2002): 49–75.

Hioki Atsuko. "The Embroidered from Human Hair and the Prayer—the Activities of a Priest Named Kunen." *Bukkyo Shigaku Kenkyu* 62 (2009): 48–69.

——. "Kunen and Taima Mandala Embroidered from Human Hair—The Activities of a Priest from the Early Pre-Modern Period and Their Significance." *Museum: Kokuritsu Hakubutsukan Bijutsushi* no 618 (February 2009): 19–56.

Ho, Wai-kam. "White-Robed Kuan-yin (Pai-i Kuan-yin)." In *Eight Dynasties of Chinese Painting: The Collections of the Nelson Atkins Museum, Kansas City and Cleveland Museum of Art*, 122–123. William Rockhill Nelson Gallery of Art and Mary Atkins Museum of Fine Arts. Cleveland, OH: Cleveland Museum of Art, 1980.

Holmes, Stewart W., and Chimyo Horioka. *Zen Art for Meditation*. Rutland, Vt.: Tuttle, 1973.

Holmgren, Jennifer. "The Economic Foundations of Virtue: Widow-Remarriage in Early and Modern China", *The Australian Journal of Chinese Affairs* 13 (Jan. 1985):1–27

Hong Liang 洪亮. "Ming nüshiren Ni Renji de cixiu he faxiu" 明女詩人倪仁吉的刺繡和髮繡. *Wenwu cankao ziliao* 文物參考資料 9 (1958): 21–22.

Hong Mai 洪邁 (1123–1202). *Yijianzhi* 夷堅志. Vol. 1047 of *Yingyin wenyuange siku quanshu* 影印文淵閣四庫全書. Taipei: Taiwan shangwu yinshuguan, 1983.

Hu Shi 胡侍 (1492–1553). *Shutan* 墅談. Printed between 1522 and 1566. *Siku quanshu dianziban* 四庫全書電子版.

Hu Wenkai 胡文楷. *Lidai funü zhuzuokao* 歷代婦女著作考. Shanghai: shangwu yinshuguan, 1957.

Hu Yinglin 胡應麟. *Shaoshi sanfang biji* 少室山房筆記. *Siku quanshu dianzi ban* 四庫全書電子版.

Hua Wei. "Cong Wu Zhensheng 'Taiping yuefu-Huanshen rong' kan qingdai kunju xinbian xiaobenxi." 從吳震生《太平樂府換身榮》看清代昆劇新編小本戲 Vol. 2 of *Mingjia lun kunqu*, ed. Hong Weizhu 洪惟助, 627–659. Taipei: Guojia chubanshe, 2010.

Huang, Ray. *1587, A Year of No Significance: The Ming Dynasty in Decline*. New Haven, Conn.: Yale University Press, 1981.

Huang, Shih-Shan Susan. "Media Transfer and Modular Construction: The Printing of Lotus Sutra Frontispieces in Song China." *Ars Orientalis* 41 (2011): 135–163.

Huang Shumei 黃書梅. "Lin Xue: yiwei mingmo mingji huajia de shengping yu yishu 林雪一位明末明妓畫家的生平與藝術," in *Meishu shi yu guannian shi* VII, 美術史與觀念史 ed. Fan Jingzhong 范景中and Cao Yiqiang 曹意強, 117–137. Nanjing: Nanjing daxue shifan chubanshe, 2008.

Huang Tingjian 黃庭堅 (1045–1105). *Shangu ji* 山谷集. Vol. 1113 of *Yingyin wenyuange siku quanshu*. Taipei: Taiwan shangwu yinshuguan, 1983–1986.

Huang, Yi-fen 黃逸芬. "Gender, Technical Innovation and Gu Family Embroidery in Late-Ming Shanghai." *East Asian Science, Technology, and Medicine* 36, no. 1 (January 2012): 77–129.

——. "Guxiu xinkao" 顧繡新考. In *Guxiu guoji xueshu yantaohui lunwenji* 顧繡國際學術研討會論文集, ed. Shanghai bowuguan 上海博物館, 20–41. Shanghai: Shanghai shuhua chubanshe, 2010.

Huang Zhangjian 黃漳建. ed., *Mingdai lüli huibian* 明代律例匯編. Taibei: Zhongyang yanjiu yuan lishi yuyan yanjiu suo, 1983. From the website of Zhongguo zhexueshu dianzijihua 中國哲學書電子計劃.

Huang Zheng 黃徵 and Wu Wei 吳偉, eds. *Dunhuang yuanwen ji* 敦煌愿文集. Changsha: Yuelu shushe, 1995.

Huijiao 釋惠皎 (497–554). *Gaoseng zhuan* 高僧傳. Annotated by Tang Yongtong 湯用彤. Beijing: Zhonghua shuju, 1992.

Jin, Hui-Han. "Emotional Death: Tombs and Burial Practices in the Ming Dynasty, 1368–1644." PhD diss., University of Minnesota, 2017.

Jin Liying 金禮嬴 (1772–1807), *Qiuhong zhangshi yishi* 秋紅丈室遺詩, in Wang Tan 王曇, *Wang Tan shiwen ji* 王曇詩文集, annotated by Zheng Xing 鄭幸. Beijing: Renmin wenxue chubanshe, 2012. Appendix I, 395–402.

Jingzhou bowuguan 荊州博物館. "Mingdai nüshi zhan 明代女屍展," Exhibition, 2015.

Idema, Wilt, trans., with an introduction. *Personal Salvation and Filial Piety: Two Precious Scroll Narratives of Guanyin and Her Acolytes*. A Kuroda Institute Book and Honolulu: University of Hawai'i Press, 2008.

Idema, Wilt. *The Dramatic Oeuvre of Chu Yu-tun (1379–1439)*. Leiden: Brill, 1985.

——. "The Filial Parrot in Qing Dynasty Dress: A Short Discussion of the *Yingge baojuan* [Precious Scroll of the Parrot]." *Journal of Chinese Religions*, 30 (2002): 77–96.

——. "Guanyin's Acolytes." In *Linked Faiths: Essays on Chinese Religions and Traditional Culture in Honor of Kristofer Schipper*, ed. Jan A. M. de Meyer and Peter M. Engelfriet, 205–226. Leiden: Brill, 2000.

——. "Guanyin's Parrot: A Chinese Buddhist Animal Tale and Its International Context." In *India, Tibet, China: Genesis and Aspects of Traditional Narrative*, ed. Alfred Cadonna, 103–150. Florence, Italy: Leo S. Olschki, 1999.

——. trans and with an introduction. *Personal Salvation and Filial Piety: Two Precious Scroll Narratives of Guanyin and Her Acolytes*. A Kuroda Institute Book and Honolulu: University of Hawaii Press, 2008.

——. *The Dramatic Oeuvre of Chu Yu-tun (1379–1439)*, Leiden: E.J.Brill, 1985.

Idema, Wilt, and Beata Grant. *The Red Brush: Writing Women of Imperial China*. Cambridge, Mass.: Harvard University Asia Center, 2004.

Jakobson, Roman. *Language in Literature*, ed. Krystyna Pomorska and Stephen Rudy. Cambridge, Mass.: Belknap Press, 1987.

Jian Ruiyao 簡瑞瑤. *Mingdai funü fojiao xinyang yu shehui guifan* 明代婦女佛教信仰與社會規範. Taizhong: Donghai daxue tongshi jiaoyu zhongxin, 2007.

Jiang Shaoshu 姜紹書 (fl. 1630–1650). *Yunshizhai bitan* 韻石齋筆談. Vol. 11 of *Zhongguo lidai meishu dianji huibian* 中國歷代美術典籍匯編, ed. Yu Yu-an 于玉安. Tianjin: Tianjin guji chubanshe, 1997.

Jiangxisheng wenwu gongzuodui 江西省文物工作隊. "Jiangxi nancheng ming yixuanwang Zhu Yiyin fufu hezangmu" 江西南城明益宣王朱翊鈏夫婦合葬墓. *Wenwu* 8 (1982): 16–24.

Jinglü yixiang 經律異相 (Exceptional Appearances from Sūtras and Vinaya). T53, no. 2121.

Johnson, David, ed. *Ritual Opera, Operatic Ritual*. Berkeley, Calif.: Chinese Popular Culture Project, 1989.

Jones, Amelia. *The Feminism and Visual Culture Reader*. London: Routledge, 2010.

Jones, Stephen. "The Golden-Character Scripture: Perspectives on Chinese Melody." *Asian Music: Chinese Music Theory* 20, no. 2 (Spring–Summer 1989): 21–69.

Joo, Bong Seok. "The Arhat Cult in China from the Seventh Through Thirteenth Centuries: Narrative, Art, Space and Ritual." PhD diss., Princeton University, 2007.

Joo, Fumiko. "Ancestress Worship: Huxin Temple and the Literati Community in Late Ming Ningbo." *Nan Nü: Men, Women and Gender in China* 16, no.1 (2014): 29–58.

Kang Baocheng 康保成. "Mingqing shiqi de fojiao yu difangxi" 明清時期的佛教與地方戲. In *Liangan xiqu dazhan xueshu yantaohui lunwenji* 兩岸戲曲大展學術研討會論文集, 569–615. Taipei: Guoli chuantong yishu zhongxin, 2002.

Kelly, Thomas. "Clawed Skin: The Literary Inscription of Things in Sixteenth Century China." PhD diss., University of Chicago, 2017.

Kent, Richard. "The Sixteen Lohans in the Pai-miao Style: From Sung to Early Ch'ing." PhD diss., Princeton University, 1995.

Kieschnick, John. *The Eminent Monk: Buddhist Ideals in Medieval Chinese Hagiography*. Kuroda Institute Studies in East Asian Buddhism 10. Honolulu: University of Hawai'i Press, 1997.

——. *The Impact of Buddhism on Chinese Material Culture*. Princeton, NJ: Princeton University Press, 2003.

——. "Material Culture." In *The Oxford Handbook of Religion and Emotion*, ed. John Coorigan, 223–237. Oxford: Oxford University Press, 2007.

Ko, Dorothy. "Between the Boudoir and the Global Market: Shen Shou, Embroidery, and Modernity at the Turn of the Twentieth Century." In *Looking Modern: East Asian Visual Culture from Treaty Ports to World War II*, ed. Jennifer Purtle and Hans Bjarne Thomsen, 48–61. Chicago: Center for the Art of East Asia and Art Media Resources, 2009.

——. *Cinderella's Sisters: A Revisionist History of Footbinding*. Berkeley: University of California Press, 2005.

——. "Epilogue: Textiles, Technology, and Gender in China." *East Asian Science, Technology, and Medicine* 36, no. 1 (January 2012): 167–176.

——. *Every Step A Lotus: Shoes for Bound Feet*. Berkeley: University of California Press, 2001.

——. *The Social Life of Inkstones: Artisans and Scholars in Early Qing China*. Seattle: University of Washington Press, 2017.

——. *Teachers of the Inner Chambers: Women and Culture in Seventeenth Century*. Stanford, Calif.: Stanford University Press, 1994.

——. "The Written Word and the Bound Foot: A History of the Courtesan's Aura." In *Writing Women in Late Imperial China*, ed. Ellen Widmer and Kang-i Sun Chang, 74–100. Stanford, Calif.: Stanford University Press, 1997.

LaFleur, William R. "Body." In *Critical Terms for Religious Studies*, ed. Mark C. Taylor, 36–54. Chicago: University of Chicago Press, 1998.

Lai, Whalen. "Legends of Births and the Pure Land Tradition in China." In *The Pure Land Tradition: History and Development* (Berkeley Buddhist Studies Series, no. 3), ed. James Foard, Michael Solomon, and Richard K. Payne, 174–232. Berkeley: Center for South and Southeast Asian Studies/Institute of Buddhist Studies, 1996.

Laing, Johnston Ellen. "Wives, Daughters and Lovers: Three Ming Dynasty Painters." In *Views from Jade Terrace: Chinese Women Artists 1300-1912*, ed. Marsha Weidner, Debra Edelstein, et al., 31–63. Indianapolis, IN: Indianapolis Museum of Art, 1988.

Lam, Ling Hon. *The Spatiality of Emotion in Early Modern China: from Dreamscapes to Theatricality.* New York: Columbia University Press, 2018.

Lee, Hui-shu. *Empress, Art and Agency in Song Dynasty China.* Seattle: University of Washington Press, 2010.

Lee, Seunghye. "Framing and Framed: Relics, Reliquaries, and Relic Shrines in Chinese and Korean Buddhist Art from the Tenth to the Fourteenth Centuries." PhD diss., University of Chicago, 2013.

Lee Yu-min 李玉珉. *Fotuo xingyin* 佛陀形影. Taipei: Guoli gugong bowuyuan, 2012.

——. *Guanyin tezhan* 觀音特展. Taipei: Guoli gugong bowuyuan, 2000.

Levine, Gregory P. A., and Yukio Lippit exhibition co-curators, Yoshiaki Shimizu, senior exhibition advisor. *Awakenings: Zen Figure Painting in Medieval Japan*, ed. Naomi Noble Richard and Melanie B. D. Klein. New York: Japan Society, 2007.

Li Baiyao 李百藥 (565–648). *Beiqishu* 北齐書. Beijing: Zhonghua shuju, 1973.

Li Dongyang 李東陽 (1447–1516), and Zhao Yongxian 趙用賢 (1535–1596), et al. *Daming Huidian* 大明會典. Shanghai: Shanghai guji chubanshe, 1995.

Li, Guotong. "A Research Review on the Studies of Women's History in Late Imperial China." In *Excursions in Sinology*, ed. Lee Cheuk Yin, 279–299. Hong Kong: Business Press, 2002.

Li Ling 李翎. "Shuiyue guanyin yu zangchuan fojiao guanyin zhi guanxi" 水月觀音與藏傳佛教觀音像之關係. *Meishu* 11 (2002): 50–53.

Li Miao 李淼, comp. *Guanyin pusa baojian* 觀音菩薩寶卷. Changchun: Jilin renmin chubanshe, 2001.

Li Sen 李森, and Xu Qinghua 徐清華. "Ming 'baiyi dabei wuyinxin tuoluoni jing' bei tanxi" 明白衣大悲五印心陀羅尼經碑探析. *Zhongguo wenwuwang* 中國文物网, March 26, 2008.

Li Shi 李湜. "Fang weiyi he tade *guanyin tu zhou*" 方維儀和她的觀音圖軸. *Wenwu* 10 (1994): 95–96.

——. "Mingqing shiqi guige huajia renwuhua ticai quxiang" 明清時期閨閣畫家人物題材取向. *Meishu yanjiu* 1 (1995): 43–47.

——. "Zhou Shuxi, Shuhu he tamen de dashi sanshier yingshen xiangce" 周淑禧, 淑祜和她們的大士三十二應身像冊. *Wenwu* 9 (1995): 85–87.

Li Shizhen 李時珍 (1518–1593). *Bencao gangmu* 本草綱目. Ming Wanli ed. University of Chicago Library Collection. Microfilm.

Li, Thomas Shiyu and Naquin, Susan. "The Baoming Temple: Religion and Throne in Ming and Qing China." *Harvard Journal of Asiatic Studies* 48, 1 (June 1988): 131–188.

Li, Wai-yee. "The Late Ming Courtesan: Invention of a Cultural Ideal." In *Writing Women in Late Imperial China*, ed. Ellen Widmer and Kang-i Sun Chang. Stanford, Calif.: Stanford University Press, 1997.

Li Zhi 李贄 (1527–1602). *A Book to Burn and a Book to Keep (Hidden): Selected Writings*, ed. Rivi Handler-Spitz, Pauline Lee, and Haun Saussy. New York: Columbia University Press, 2016.

Li, Yuhang. "Female Bodies Going Bananas: Eroticism and Botanical Layers in Late Imperial China." Unpublished paper, presented in the Association for Asian Studies Annual Conference, Washington DC, 2008.

——. Catalogue entry on "Bodhisattva Guanyin in the Form of the Buddha Mother in *Performing Images: Opera in Chinese Visual Culture*, ed. Judith Zeitlin and Yuhang Li. Chicago: Smart Museum of Art and the University of Chicago Press, 2014, 191–192.

——. "Communicating with Guanyin through Hair: Hair Embroidery in Late Imperial China." *Journal of East Asian Science, Technology and Medicine*, 36 (2012): 131–166.

——. "Gendered Materialization: An Investigation of Women's Artistic and Literary Reproduction of Guanyin in Late Imperial China." PhD diss., University of Chicago, 2011.

——. "Oneself as a Female Deity: Representations of Cixi Posing as Guanyin." *Nannü: Men, Women, and Gender in China* 14, no. 1 (2012): 75–118.

——. "Representing Theatricality on Textile," in *Performing Images: Opera in Chinese Visual Culture*, ed. Judith Zeitlin and Yuhang Li. Chicago: Smart Museum of Art and the University of Chicago Press, 2014, 74–87.

——. "Sensory Devotions: Hair Embroidery and Gendered Corporeal Practice in Chinese Buddhism," in *Sensational Religion: Sensory Cultures in Material Practice*, ed. Sally M. Promey, 355–375. New Haven, Conn.: Yale University Press, 2014.

Liang Shuping 梁淑萍. Mingdai nühong—yi beifang funü wei zhongxin zhi tantao 明代女紅—以北方婦女為中心之探討. Master's thesis, Guoli zhongyang daxue, 2001.

Liang Zhi 梁裘 (fl. 1573–1620.), carved, and Wang Daohui 汪道會 (1544–1613), ed. *Yinjun* 印雋. Ming wanli gengshu [1610]. Harvard Yen-ching Library Collection. Microfilm.

Liao Dawen 廖大聞 (fl. 18th c.), and Jin Dingshou 金鼎壽 (d. 1808), eds. *Tongcheng xuxiu xianzhi* 桐城續修縣志 (1827). Taipei: Chengwen chubanshe, 1975.

Lin, Wei-cheng. *Building a Sacred Mountain: The Buddhist Architecture of China's Mount Wutai*. Seattle: University of Washington Press, 2014.

Ling Mengchu 凌蒙初 (1580–1644). *Chuke paian jingqi* 初刻拍案驚奇. Beijing: Renmin wenxue chubanshe, 1991.

Lingley, Kate. "Widows, Monks, Magistrates, and Concubines: Social Dimensions of Sixth-Century Buddhist Art Patronage." PhD diss., University of Chicago, 2004.

Linyi xianzhi 臨邑縣志, facsimile reprint of the 1874 edition. Xing Tong Museum Collection.

Lippit, Yukio. "Awakenings: The Development of the Zen Figural Pantheon." In *Awakenings: Zen Figure Painting in Medieval Japan*, Greory Levine and Yukio Lippit, exhibition co-curators, Yoshiaki Shimizu, senior exhibition advisor ed. Naomi Noble Richard and Melanie B. D. Klein, 35–51. New York: Japan Society, 2007.

Liu, Cuilian. "Song, Dance, and Instrumental Music in Buddhist Canon Law." PhD diss., Harvard University, 2014.

Liu, Heping. "Empress Liu's Icon of Maitreya: Portraiture and Privacy at the Early Song Court." *Artibus Asiae* 63, no. 2 (2003): 129–179.

Liu Ping 劉平. "Jindai changji de xinyang jiqi shenling" 近代娼妓的信仰及其神靈. In *Jindai zhongguo shehui yu minjian wenhua* 近代中國社會與民間文化, ed. Li Changli and Zuo Yuhe, 469–482. Beijing: Shehui kexue wenxian chubanshe, 2007.

Liu Shih-Lung 劉世龍, "Mingdai nüxing Guanyin hua yanjiu" 明代女性觀音畫研究. Master's thesis, Fanhua daxue, Taipei, 2000.

Liu Xiang 劉向 (77–6 BC), Qiu Ying 仇英 (1498–1552) painted, Wang Geng 汪庚 (fl. early 18th c.), comp. *Huitu lienü zhuan* 繪圖列女傳. Taipei: Zhengzhong shuju, 1971.

Lopez, Donald S., ed. *Critical Terms for the Study of Buddhism*. Chicago: University of Chicago Press, 2005.

Lou Xiaoming 樓小明 et al., eds. *Ni Renji danchen sibai zhounian jinian wenji* 倪仁吉誕辰四百週年紀念文集. Hangzhou: Zhongguo meishu xueyuan chubanshe, 2007.

Lu Qi 陸圻 (1614–?). *Xinfu pu* 新婦譜. Section 5, Vol. 6 of *Biji xiaoshuo daguan* 筆記小說大觀: 3385–3406. Yangzhou: Jiangsu guangling guji keyinshe, 1983.

Lu Shihua 陸時化 (1714–1779). *Wuyue suojian shuhua lu* 吳越所見書畫錄. Preface dated to 1776. Huaiyange 懷煙閣 ed. Beijing University Library Collection.

Lü Simian 呂思勉. Vol.26 of *Zhu Simian quanji* 呂思勉全集. Shanghai: Shanghai guji chubanshe, 2016.

Lü Wen 呂溫 (772–811). *Lü Hengzhou ji* 呂衡州集. Vols. 228–229 of *Yueya tang congshu* 粵雅堂叢書.Guangzhou: Yueyatang, 1854.

Luk Yu-Ping. *The Empress and the Heavenly Masters: A Study of the Ordination Scroll of Empress Zhang (1493)*. Hong Kong: Center for Studies of Daoist Culture, Chinese University of Hong Kong, 2015.

——. "Qing Empresses as Religious Patrons and Practitioners," in Daisy Yiyou Wang and Jan Stuart eds., *Empresses of China's Forbidden City: 1644-1912*. Salem: Peabody Essex Museum and Washington D.C.: Freer|Sackler, Smithsonian Institution, 2018. 110–127.

Luo Ning 羅寧. "Mingdai weidian wuzhong xiaoshuo chutan" 明代偽典五種小說初探. *Mingqing xiaoshuo yanjiu* 1 (2009): 31–47.

Luo Shiping 羅世平 and Luo Jian 羅簡. "Ziran de xinxiang: dunhuang bihua 'shiliuguan' fanying de ziranguan" 自然的心象：敦煌壁畫十六觀反應的自然觀. *Meishu yanjiu* 4 (2015): 55–58.

Ma De 馬德, "Dunhuang cixiu 'Lingjiushan shuofa tu' de niandai ji xiangguan wenti" 敦煌刺繡 靈鷲山說法圖的年代及相關問題. *Dongnan wenhua* 1 (2008): 71–73.

Ma Qichang 馬其昶 (1855–1930), ed. *Tongcheng qijiu zhuan* 桐城耆舊傳. Hefei: Huangshan shushe, 2013..

Mai, Cuong T. "The Guanyin Fertility Cult and Family Religion in Late Imperial China: Repertoires across Domains in the Practice of Popular Religion." *Journal of the American Academy of Religion* 87, no. 1 (March 2019): 156–190.

Mann, Susan. *Precious Records: Women in China's Long Eighteenth Century*. Stanford, Calif.: Stanford University Press, 1997.

——. *The Talented Women of the Zhang Family*. Berkeley: University of California Press, 2007.

Mann, Susan, and Yü-yin Cheng. *Under Confucian Eyes: Writings on Gender in Chinese History*. Berkeley: University of California Press, 2001.

Mao Wenfang 毛文芳. *Wu, xingbie, guankan: mingmo qingchu wenhua shuxie xintan* 物, 性別, 觀看: 明末清初文化書寫新探. Taipei: Taiwan xuesheng shuju, 2001.

Mauss, Marcel. *The Gift, the Form and Reason for Exchange in Archaic Societies*, trans. W. D. Halls. New York: Norton, [1925] 1990.

McCausland, Shane. *Zhao Mengfu Calligraphy and Painting for Khubilai's China*. Hong Kong: Hong Kong University Press, 2011.

McLoughlin, Kevin. "Image and Appropriation: The Formation of Illustrated Albums of Guanyin in 17th Century Print Culture." In *The Art of the Book in China*, ed. Ming Wilson and Stacey Pierson, 159–173. London: Percival David Foundation of Chinese Art, 2006.

McNair, Amy. *Donors of Longmen: Faith, Politics, and Patronage in Medieval Chinese Buddhist Sculpture*. Honolulu: University of Hawai'i Press, 2007.

——. "Forty-Eight Buddhas of Measureless Life: Court Eunuch Patronage at the Sculpture Grottoes of Longmen." Los Angeles: UCLA Center for Chines Studies, 2007. http://www .international.ucla.edu/china/papers/mcnair_paper.pdf.

Mei Dingzuo 梅鼎祚 (1549–1615). *Qingni lianhua ji*青泥蓮花記, ed. Lu Lin 陸林. Hefei: Huangshan chubanshe, 1998.

Meulenbeld, Mark. "Death and Demonization of a Bodhisattva: Guanyin's Reformulation within Chinese Religion." *Journal of the American Academy of Religion* 84, no. 3 (September 2016): 690–726.

Miaofa lianhua jing 妙法蓮華經 (Sūtra of the Lotus Flower of the Wonderful Law), trans. Kumārajīva. T9, no.262.

McCormick, Melissa. "Monochromatic Genji: The *Hakubyō* Tradition and Female Commentarial Culture." In *Envisioning The Tale of Genji: Media, Gender, and Cultural Production*, ed. Haruo Shirane, 101–128. New York: Columbia University Press, 2008.

Midian zhulin 秘殿珠林. Vol.823 of *Yingyin wenyuange siku quanshu* 影印文淵閣四庫全書, zibu. Taipei: Taiwan Shangwu yinshuguan, 1983–1986.

Mohd Anis Md Nor. "Dancing Divine Iconographies in Southeast Asia," in *Dance: Transcending Borders*, ed. Urmimala Sarkar Munsi, 19–34. New Delhi, India: Tulika, 2008.

Mollier, Christine. *Buddhism and Taoism Face to Face: Scripture, Ritual, and Iconographic Exchange in Medieval China*. Honolulu: University of Hawai'i Press, 2008.

Morgan, David. "Introduction: The Matter of Belief." In *Religion and Material Culture: The Matter of Belief*, ed. David Morgan, 1–17. New York: Routledge, 2010.

——. "The Materiality of Cultural Construction." *Material Religion: The Journal of Objects, Art and Belief* 4, no. 2 (July 2008): 228–229.

Mostow, Joshua S., Norman Bryson, and Maribeth Graybill, eds. *Gender and Power in the Japanese Visual Field*. Honolulu: University of Hawai'i Press, 2003.

Murase, Miyeko. "Kuan-yin as Savior of Men: Illustration of the Twenty-Fifth Chapter of the Lotus Sūtra in Chinese Painting." *Artibus Asiae* 33 (1971): 39–74.

Murray, Julia. "Didactic Art for Women: *The Ladies Classic of Filial Piety*." In *Flowering in the Shadows: Women in the History of Chinese and Japanese Painting*, ed. Marsha Weidner, 27–53. Honolulu: University of Hawai'i Press, 1990.

Murthy, Viren. "The Politics of Time in China and Japan," in chapter 9 of *Oxford Encyclopedia of Comparative Political Theory*, ed. Leigh Jenko, Murad Idris and Megan Thomas. Oxford: Oxford University Press, forthcoming, 2020.

Nāgārjuna (Longshu 龍樹, d. 2nd c.). *Da zhidu lun* 大智度論 (A Commentary to the *Prajnaparamita-Sūtra*), trans. Kumarajiva (Jiumoluoshi 鳩摩羅什, 344–413), T25, no.1509.

Nantong bowuyuan 南通博物苑. *Nantong bowuyuan wenwu jinghua* 南通博物苑文物精華. Beijing: Wenwu chubanshe, 2005.

Naquin, Susan. *Peking: Temples and City Life, 1400-1900*. Berkeley: University of California Press, 2000.

Naquin, Susan, and Evelyn S. Rawski. *Chinese Society in the Eighteenth Century*. New Haven, Conn.: Yale University Press, 1987.

Naquin, Susan, and Chün-fang Yü. *Pilgrims and Sacred Sites in China*. Berkeley: University of California Press, 1992.

Natter, Jan. "Gender and Hierarchy in the Lotus Sūtra." In *Readings of the Lotus Sūtra*, ed. Stephen F. Teiser and Jacqueline I. Stone, 83–106. New York: Columbia University Press, 2009.

Ning, Qiang. *Art, Religion, and Politics in Medieval China: the Dunhuang Cave of the Zhai Family*. Honolulu: University of Hawai'i, 2004.

——. "Visualization Practice and the Function of the Western Paradise Images in Turfan and Dunhuang in the Sixth to Seventh Centuries." *Journal for Inner Asian Art and Archeology* 2 (2007): 133–142.

Niu Kecheng 牛克誠. *Secai de zhongguohua: zhongguo huihua yangshi yu fengge lishi de zhankai* 色彩的中國畫: 中國繪畫樣式與風格歷史的展開. Changsha: Hunan meishu chubanshe, 2002.

Ohnuma, Reiko. "The Gift of the Body and the Gift of the Dharma." *History of Religions* 37, no. 4 (1998): 323–359.

——. *Head, Eyes, Flesh, and Blood: Giving Away the Body in Indian Buddhist Literature*. New York: Columbia University Press, 2007.

Ōki Yashushi 大木康. *Chūgoku yūri kūkan: Min Shin Shinwai gijo no sekai* 明清中國遊里空間：明清秦淮妓女の世界. Tōkyō: Seidosha, 2002.

Olivelle, Patrick. "Hair and Society: Social Significance of Hair in South Asian Traditions." In *Hair: Its Power and Meaning in Asian Cultures*, ed. Alf Hilebeitel and Barbara Miller, 11–49. Albany: State University of New York Press, 1998.

Orsi, Robert. *Thank You, St. Jude: Women's Devotion to the Patron saint of Hopeless Causes*. New Haven, Conn.: Yale University Press, 1996.

Pan Zhiheng 潘之恆 (d. 1621). *Genshichao* 亙史鈔, *genshi waiji* 亙史外紀, juan 5. In *Siku quan-shu cunmu congshu*, *zi* 193–546. Jinan: Qilu shushe, 1995.

——. *Luanxiao xiaopin* 鸞嘯小品. Shanghai Library Collection, published in 1629.

——. *Pan Zhiheng quhua* 潘之恆曲話. Annotated by Jiang Xiaoyi 江效倚. Beijing: Zhongguo xiju chubanshe, 1988.

——. *Yechengshi chucao* 冶城詩 初草. Harvard Yen-ching Library Collection. Microfilm.

Paul, Diana. *Women in Buddhism: Images of the Feminine in Mahāyāna Tradition*. Berkeley, Calif.: Asian Humanities Press, 1979.

Peng Shaosheng 彭紹昇 (1740–1796). *Shannüren zhuan* 善女人傳, X88, no. 1657.

Piao Wenying 朴文英. "Cixiu mile foxiang kao" 刺繡彌勒佛像考. In *Guxiu guoji xueshu yantaohui lunwenji* 顧繡國際學術研討會論文集, ed. Shanghai bowuguan 上海博物館, 207–210. Shanghai: Shanghai shuhua chubanshe, 2010.

Piling wangshi zongpu 毗陵王氏宗譜, Piling shien tang 毗陵世恩堂 print, 1921 reprint, Changzhou shi tushuguan Collection.

Potolsky, Matthew. *Mimesis*. New York: Routledge, 2006

Pu Ji 普濟 (fl. early 13th c.). *Wudeng huiyuan* 五燈會元. Annotated by Su Yuanlei 蘇淵雷. Beijing: Zhonghua shuju, 1989.

Qian Qianyi 錢謙益 (1582–1664), and Liu Rushi 柳如是 (1618–1664). *Liechao shiji xiaozhuan* 列朝詩集小傳. Shanghai: Zhonghua shuju, 1961.

Qian Shizhao 錢世昭 (fl. 11th c.). *Qianshi sizhi* 錢氏私志. Vol. 1036 of *Yingyin wenyuange siku quanshu* 影印文淵閣四庫全書. Taipei: Taiwan shangwu yinshuguan, 1983.

Qian Shoupu 錢守璞 (1801–1869). *Xiufolou shigao* 繡佛樓詩稿, juan 2. 1869 ed. Harvard Yen-ching Library Collection.

Qian Xiyan 錢希言 (fl.1612). *Kuaiyuan* 獪園. Beijing University Library Collection. Digital copy is in the internet archive, http://www.archive.org/stream/02099073.cn#page/n30/mode/2up

Qian Yi 錢易 (968–1026). *Nanbu xinshu* 南部新書. Vol. 1036 of *Yingyin wenyuan ge siku quanshu*. Taipei: Taiwan shangwu yinshuju, 1983.

Qingdaoshi bowuguan 青島市博物館. *Qingdaoshi bowuguan canghua ji* 青島市博物館藏畫集. Beijing: Wenwu chubanshe, 1991.

Qiu Zhaoao 仇兆鰲 (1638–1717). *Dushi xiangzhu* 杜詩詳注. Beijing: Zhonghua shuju, 1979.

Rambelli, Fabio. *Buddhist Materiality: A Cultural History of Objects in Japanese Buddhism*. Stanford, Calif.: Stanford University Press, 2005.

Reed, Barbara E. "The Gender Symbolism of Kuan-yin Bodhisattva." In *Buddhism, Sexuality, and Gender*, ed. Ignacio Jose Cabezón, 159–180. Albany: State University of New York Press, 1992.

Robson, James. "Brushes with Some 'Dirty Truths': Handwritten Manuscripts and Religion in China." *History of Religions* 51, no. 4 (2012): 317–343.

Rothschild, N. Harry. *Emperor Wu Zhao and Her Pantheon of Devis, Divinities, and Dynastic Mothers*. New York: Columbia Press, 2015.

Ropp, Paul S. "Ambiguous Images of Courtesan Culture." In *Writing Women in Late Imperial China*, ed. Ellen Widmer and Kang-I Sun Chang, 17–45. Stanford, Calif.: Stanford University Press, 1997.

——. "Women in Late Imperial China. A Review of Recent English-Language Scholarship." *Women's History Review* 3, no. 3 (1994): 347–383.

Ruan Guolin 阮國林. "Ming Zhongshan wang Xu Da jiazu mu" 明中山王徐達家族墓. *Wenwu* 2 (1993): 63–76.

Ruch, Barbara. *Engendering Faith: Women and Buddhism in Premodern Japan*. Ann Arbor: Center for Japanese Studies at the University of Michigan, 2002.

Sawada Mizuho 澤田瑞穗. *Sō Min Shin shōsetsu sōkō* 宋明清小說叢考. Tōkyō: Kenbun Shuppan, 1982.

Schafer, Dagmar. *The Crafting of the 10,000 Things: Knowledge and Technology in Seventeenth Century China*. Chicago: University of Chicago Press, 2011.

Schlütter, Morten. *How Zen Became Zen: The Dispute Over Enlightenment and the Formation of Chan Buddhism in Song Dynasty China*. Honolulu: University of Hawai'i Press, 2008.

Schor, Naomi. *Reading in Detail: Aesthetics and Feminine*. New York, London: Routledge, 2007.

Scott, Joan. "Gender: A Useful Category of Historical Analysis." *American Historical Review* 91 (1986): 1053–1075.

——. "Gender: Still A Useful Category of Analysis?" *Diogenes* 225 (2010): 7–14.

Sha Wutian 沙武田. "Guanshiyin pusa pumenpin yu guanyin jingbian tuxiang" 觀世音菩薩普門品與觀音經變圖像. *Fayin* 3, no. 319 (2011): 47–54.

Shan Guoqiang 單國強, ed. *Zhixiu shuhua* 織繡書畫. Shanghai: Shanghai kexue jishu chubanshe, 2005.

Shang Sheng 尚聲, "Lun cixiu zhihai" 論刺繡之害, *Nüzi shijie*, issue 6 (1904): 87–91.

Shanghai bowuguan 上海博物館, ed. *Guta yizhen* 古塔遺珍. Shanghai: Shanghai shuhua chubanshe, 2014.

——. *Shanghai bowuguan cangpin jinghua* 上海博物館藏品精華. Shanghai: Shanghai shuhua chubanshe, 2004.

Shanghai bowuguan kaogu yanjiubu 上海博物館考古研究部. "Shanghai shi Songjiang qu huayang Mingdai muqun fajue jianbao" 上海市松江區華陽明代墓群發掘簡. In *Shanghai bowuguan jikan* 上海博物館集刊, 640–651. Shanghai: Remin chubanshe, 2002.

Shao Lei 邵磊. "Ming zhongshan wang xu da jiazu chengyuan muzhi kaolue" 明中山王徐達家族成員墓誌考略. *Nanfang wenwu* 4 (2013): 180–187.

Sharf, Robert. *Coming to Terms with Chinese Buddhism: A Reading of the Treasure Store Treatise*. Honolulu: A Kuroda Institute Book and University of Hawai'i Press, 2002.

——. "On the Allure of Buddhist Relics." *Representations* 66 (1999): 75–99.

Shen Bang 沈榜 (1540–1597). *Wanshu zaji* 宛蜀雜記. Beijing: Beijing chubanshe, 1961.

Shen Defu 沈德符 (1578–1642). *Wanli yehuo pian* 萬曆野獲篇. Vol. 3 of *Yuanming shiliao biji congkan* 元明史料筆記叢刊, 787–938. Beijing: Zhonghua shuju, 1959.

Shen Weirong 沈衛榮 and Li Channa 李嬋娜. "'Shiliu tianmo wu' yuanliu jiqi xiangguan hanzang wen wenxian ziliao kaoshu 十六天魔舞研究及其相關漢藏文文獻資料考述," in Zhongguo renmin daxue guoxueyuan xiyu lishi yuyan yanjiusuo 中國人民大學國學院西域歷史語言研究所ed., *Xiyu lishi yuyan yanjiu jikan* 西域歷史語言研究集刊, diwuji 第五輯, 325–387. Beijing: Kexue chubanshe, 2012.

Shen Yixiu 沈宜修 (1590–1635), comp. *Yiren si* 伊人思. In *Wumengtang ji* 午夢堂集, ed. Ye Shaoyuan 葉紹袁. Beijing: Zhonghua shuju, 1998.

Shen Zhou 沈周 (1427–1509). *Kezuo xinwen* 客座新聞. Vol. 135 of *Shuo fu* 說郛. 1646 ed., Xu juan 13, 135. Harvard Yen-ching Library Collection.

Sheng, Angela. "Women's Work, Virtue, and Space: Change from Early to Late Imperial China." *East Asian Science, Technology, and Medicine* 36, no. 1 (January 2012): 9–38.

Sheng Dashi 盛大士 (fl. 1800–1836). *Xishan woyou lu* 溪山臥游錄. Vol. 5 of *Huashi congshu* 畫史叢書, ed. Yu Anlan 于安瀾. Shanghai: Shanghai renmin meishu chubanshe.

Sheng Yuyun 盛餘韵 (Angela Sheng). "Fangzhi yishu, jishu yu fojiao jifu" 紡織藝術, 技術與佛教積福 ("Textile Art, Technology, and Buddhist Merit Accumulations"). In *Fojiao wuzhi wenhua—siyuan caifu yu shisu gongyang* 佛教物質文化—寺院財富與世俗供養 (*Merit, Opulence and the Buddhist Network of Wealth*), ed. Sarah Fraser 胡素馨, 64–80. Shanghai: Shanghai shuhua chubanshe, 2003.

Shengjing 生經 (Sūtra of the Buddha's Life). T03, no. 154.

Shenyin jiangu lu 審音鑑古錄. Vol. 1781 of *Xuxiu siku quanshu* 續修四庫全書, jibu. Shanghai: Shanghai guji chubanshe, 1995.

Shi Jian 史鑑 (1434–1496). *Xicunji* 西村集. *Siku quanshu dianziban* 四庫全書電子版.

Shinohara, Koichi. "Changing Roles for Miraculous Images in Medieval Chinese Buddhism: A Study of the Miracle Image Section in Daoxuan's 'Collected Records.'" In *Images, Miracles, and Authority in Asian Religious Tradition*, ed. Richard H. Davis, 41–188. Boulder, Colo.: Westview Press, 1998.

Silbergeld, Jerome. *Chinese Painting Style: Media, Methods, and Principles of Form*. Seattle: University of Washington Press, 1982.

Silberstein, Rachel. "Cloud Collars and Sleeve Bands: Fashion and Commercial Embroidery in Mid-Late Qing China." *Fashion Theory* 21, no. 3 (March 2017): 245–277.

Song Lian 宋濂 (1310–1381). *Song xueshi quanji* 宋學士全集. Vol. 95 of *Yuanke yingyin baibu congshu jicheng* 元刻影印百部叢書集成, compiled by Yan Yiping, part 163–202. Taipei: Yinwen yinshu guan, 1968.

Soper, Alexander. "Imperial Cave Chapels of the Northern Dynasties: Donors, Beneficiaries, Dates." *Artibus Asiae* 28, no. 4 (1966): 241–270.

Spiro, Audrey. "Hybrid Vigor: Memory, Mimesis, and the Matching of Meanings in Fifth-century Buddhist Art." In *Culture and Power in the Reconstitution of the Chinese Realm*, ed. Scott Pearce, Audrey Spiro, and Patricia Ebrey, 200–600. Cambridge, Mass.: Harvard University Asia Center, 2001.

Sponberg, Alan. "Attitudes Toward Women and the Feminine in Early Buddhism." In *Buddhism, Sexuality, and Gender*, ed. Jose Ignacio Cabezon, 3–36. Albany: State University of New York Press, 1992.

Standaert, Nicholas. "The Visual Dance and Their Visual Representations in the Ming and the Qing." *East Asian Library Journal* 12, no. 1 (Spring 2006): 68–182.

Stein, Aurel. *Serindia: Detailed Report of Explorations in Central Asia and Westernmost China*. 5 vols. Oxford: Clarendon Press, 1921.

Stevenson, Daniel. "Protocols of Power: Tz'u-Yün Tsun-shih (964–1032) and T'ien-t'ai Lay Buddhist Ritual in the Sung." In *Buddhism in Sung Dynasty China*, ed. Peter N. Gregory and Daniel A. Getz Jr., 340–408. Honolulu: University of Hawai'i Press, 1999.

Stuart, Jan. "The Face in Life and Death: Mimesis and Chinese Ancestor Portraits." In *Body and Face in Chinese Visual Culture*, eds. Wu Hung and Katherine R. Tsiang, 219–228. Cambridge, Mass.: Harvard University Asia Center, 2005.

Su Shi 蘇軾 (1037–1101). *Dongpo quanji* 東坡全集. Vol. 1108 of *Yingyin wenyuange siku quanshu* 影印文淵閣四庫全書. Taipei: Taiwan shangwu yinshuguan, 1983–1986.

Sui Quantian 隋全田. "Zhejiang wuxing nanxun juxingta taji chutu yipi wenwu" 浙江吳興南潯聚星塔塔基出土一批文物. *Wenwu* 3 (1982): 93.

Sun Chengze 孫承澤 (1592–1676). *Chunming mengyulu* 春明夢餘錄, juan 66. Vols. 868–869 of *Yingyin wenyuange siku quanshu*. Taipei: Taiwan shangwu yinshuguan, 1983–1986.

Sun Ji 孫機. "Mingdai de shufaguan, jiuji yu toumian" 明代的束髮冠, 鬏髻與頭面. *Wenwu* 7 (2001): 62–83.

Sun Jiangong 孫建功, *Xing Tong yanjiu* 邢侗研究. Beijing: Zhongguo wenlian chubanshe, 2006.

Sun Peilan 孫佩籃. *Zhongguo cixiu shi* 中國刺繡史. Beijing: Beijing tushuguan Chubanshe, 2007.

——. "Suxiu yu fojiao wenhua (xia)" 蘇繡與佛教文化 (下). *Shanghai gongyi meishu* 1 (1994): 30–31.

Sun, Xiaosu. "Performing the Bodhisattva Guanyin: Drama, Ritual and Narrative." PhD diss., Harvard University, 2017.

Tang Shi 唐時 comp. *Rulaixiang* 如來香 *Dianziban Guojia tushuguan shanben fodian*, di wushier ce, 電子版國家圖書館善本佛典第五十二冊, no. 8951.

Tang Shuyu 湯漱玉 (fl. early 19th c.). *Yutai huashi* 玉台畫史. Qiantang Wangshi Zhenqitang ed., 1837. Sun Yat-sen University Collection. Accessed from Ming Qing Women's Writing Digital Library.

Tang Xuanqing 唐玄卿 (fl. 1560), et al. *Wujin xianzhi* 武進縣志. Wanli ed. Changzhoushi tushuguan Collection.

Tang Zhibo 湯志波, "Mingqing wenxue zhong de baimeishen" 明清文學中的白眉神. *Minjian wenxue* 1 (2013): 57–62.

Taussig, Michael. *Mimesis and Alterity: A Particular History of the Senses.* New York: Routledge, 1993.

Tarlo, Emma. *Entanglement: The Secret Lives of Hair.* London: Oneworld, 2016.

Teiser, Stephen F. "Ornamenting the Departed: Notes on the Language of Chinese Buddhist Ritual Texts." *Asia Major* 22, part 1 (2009): 239–285.

Teiser, Stephen F., and Jacqueline I. Stone, eds. *Readings of the Lotus Sūtra.* New York: Columbia University Press, 2009.

Ten Grotenhis, Elizabeth. "Bodily Gift and Spiritual Pledge: Human Hair in Japanese Buddhist Embroideries." *Orientation* (January/February 2004): 31–35.

Teng, Jinhua Emma. "The Construction of the 'Traditional Chinese Women' in the Western Academy: A Critical Review." *Signs* 22 (1996): 115–151.

Ter Haar, Barend. "Buddhist Inspired Options: Aspects of Religious Life in the Lower Yangzi Region from 110–1340." *T'oung Pao* 87 (2001): 92–152.

The Essential Lotus: Selections from the Lotus Sūtra, trans. by Burton Watson. New York: Columbia University Press, 2002.

The Śūtaṅgama Sūtra [Leng yan jing], translated by Charles Luk. London: Rider. 1966 [2011]. (1966 [2011]),

Tian Changying 田長英. "Jinfengguan chutu ji." 金鳳冠出土記 *Enshi xinwenwang.* http://www.xuanen.gov.cn/goxe/minzuwenhua/2012/0508/1798.html (accessed June 1, 2017).

Tianshui bingshan lu 天水冰山錄, Vol.14 of *Zhibuzu zhai congshu* 知不足齋叢書 compelled Bao Tingbo 鮑廷博. Taibei: Yiwen yinshuguan, 1966.

Tilley, Chris, Webb Keane, Susanne Küchler, Michael Rowlands, and Patricia Spyer, eds. *Handbook of Material Culture.* London: SAGE, 2006.

Tu Long 屠隆 (1543–1605) *Tu Long ji* 屠隆集. Ed. Wang Chaohong 汪超. Hangzhou: Zhejiang guji chubanshe, 2012.

Tunstall, Alexandra. "A Woman's Woven Painting in Literati Circles: Zhu Kerou's *Camellia*." *EASTM* 36 (2012): 39–76.

Volpp, Sophie. *Worldly Stage: Theatricality in Seventeenth-Century China.* Cambridge, Mass.: Harvard University Press, 2011.

Waltner, Ann. *Getting an Heir: Adoption and the Construction of Kinship in Late Imperial China.* Honolulu: University of Hawai'i Press, 1990.

——. "T'an-Yang-Tzu and Wang Shih-chen: Visionary and Bureaucrat in the Late Ming." *Late Imperial China* 8, no. 1 (June 1987): 105–127.

Wang Cheng-hua. "Nuren, wupin, yu ganguan yuwang: Chen Hongshou wanqi renwuhua zhong Jiangnan wenhua de chengxian" 女人, 物品與感官慾望: 陳洪綬晚期人物畫中江南文化的呈現. *Jindai Zhongguo funushi yanjiu* 近代中國婦女史研究 10 (December 2002): 1–57.

——. "Material Culture and Emperorship: The Shaping of Imperial Roles at the Court of Xuanzong (r. 1426–1435)." PhD diss., Yale University, 1998.

Wang, Daisy Yiyou and Stuart, Jan eds., *Empresses of China's Forbidden City: 1644–1912*. Salem: Peabody Essex Museum and Washington D.C.: Freer|Sackler, Smithsonian Institution, 2018.

Wang Daokun 汪道昆 (1525–1593). *Taihan fumo* 太函副墨, 22 juan. Xindu Wang shi jia 新都汪氏家,1633. Harvard Yen-ching Library Collection. Microfilm.

——. *Taihan ji* 太函集. Vols. 117–118 of *Siku quanshu cunmu congshu* 四庫全書存目叢書. Jinan: Qilu shushe chubanshe, 1997.

——. *Taihan ji* 太函集. Annotated by Hu Yimin 胡易民 and Yu Guoqing 余國慶. Hefei: Huangshan shushe, 2004.

Wang Duanshu 王端淑 (1621–1701?). *Mingyuan shiwei chubian* 名媛詩緯初編. Qingyintang 清音堂. 1667 ed. University of Chicago Library Collection. Reproduced from Microfilm.

Wang, Eugene Y. *Shaping the Lotus Sūtra: Buddhist Visual Culture in Medieval China*. Seattle: University of Washington Press, 2005.

——. "Sound Observer and Ways of Representing Presences." In *Presence: the Inherence of Prototype within Images and Other Objects*, ed. Robert Maniura and Rupert Shepherd, 259–271. Burlington, VT: Ashgate, 2006.

Wang Kefen 王克芬. *Zhongguo wudao tongzhi* 中國舞蹈史, Mingqing juan 明清卷. Shanghai: Shanghai yinyue chubanshe, 2010.

Wang Luoyu 汪砢玉 (1587–?). *Shanhuwang* 珊瑚網. Vol. 818 of *Yingyin wenyuange siku quanshu* 影印文淵閣四庫全書. Taipei: Taiwan shangwu yinshuguan, 1983.

Wang Qilong 王起隆 (fl.1650), comp. Preface to *Jingangjing xinyilu* 金剛經新異錄. X87, no. 1633.

Wang, Richard. *The Ming Prince and Daoism: Institutional Patronage of an Elite*. Oxford: Oxford University Press, 2012.

Wang Shancai 王善才, ed. *Zhang Mao fufu hezang mu* 張懋夫婦合葬墓. Beijing: Kexue chubanshe, 2007.

Wang Shifu 王實甫 (1260–1336), *Xixiang ji* 西廂記, Mao Jin 毛晉 (1599–1659), *Liushi zhong qu* 六十種曲. Vol. 1770 of *Xuxiu siku quanshu*, 146–203. Shanghai: Shanghai guji chubanshe, 1995.

——. *Huizhenji* 會真記. Vol. 3 of *Shanben xiqu congkan* 善本戲曲叢刊, ed. Wang Qiugui 王秋桂. 1611 ed. Taibeishi: Taiwan xuesheng shuju, 1984.

Wang Shizhen 王世貞 (1526–1590). *Yanzhou sibu gao, xugao* 弇州四部稿, 續稿. Vols. 1279–1287 of *Yingyin wenyuange siku quanshu*. Taipei: Taiwan shangwu yinshuguan, 1983.

Wang Shizhen 王士禛. *Chibei outan* 池北偶談. *Siku quanshu dianzi ban* 四庫全書電子版, preface by Wang Shizhen in 1691.

Wang Shucun 王樹村, ed. *Guanyin baitu* 觀音百圖. Guangzhou: Lingnan meishu chubanshe, 1997.

Wang Tan 王曇 (1760–1816). *Wang Tan shiwen ji* 王曇詩文集, annotated by Zheng Xing 鄭幸. Beijing: Renmin wenxue chubanshe, 2012.

Wang Xiuling 王秀玲. "Shilun ming dingling mu zhuren de zangshi" 試論明定陵墓主人的葬式. In *Shijie yichan luntan: mingqing huangjia lingqin zhuanji*, ed. Nanjing daxue wenhua yu ziran yichan yanjiusuo he xiaoling bowuguan, 51–58. Beijing: Kexue chubanshe, 2004.

Wang Yu 王偁 (1424–1495). *Wang Yu quanji* 王偁全集, ed. Shientang Piling wangshi 世恩堂毗陵王氏, annotated by Zhu Jun 朱雋. (n.d.)

Wang Yudong 王玉冬. "Mengyuan shiqi mushi de 'zhuangshihua' qushi yu zhongguo gudai bihua de shuailuo" 蒙元時期墓室的 "裝飾化" 趨勢與中國古代壁畫的衰落. Vol. 2 of

Gudai muzang meishu yanjiu, 古代墓葬美術研究 (第二輯), ed. Wu Hung, Zhu Qingsheng, and Zheng Yan, 339–357. Changsha: Hunan meishu chubanshe, 2013.

Wang Zhengshu 王正書. "Shanghai pudong ming lushimu jishu" 上海浦東明陸氏墓記述. *Kaogu* 6 (1985): 540–549.

Wang Zhideng 王穉登 (1535–1612), comp., and Zhang Qi 張琦 (fl.1498–1515), ed. *Wusao ji* 吳騷集. 1614 ed. The collection of National Library of Taiwan.

——. *Wusao ji sijuan* 吳騷集四卷, The collection of National Central Library of Taiwan.

——. *Mouye ji* 謀野集. Harvard Yen-ching Library Collection. Microfilm.

Wardell, Anne E., and James C. Y. Watt. *When Silk Was Gold: Central Asia and Chinese Textiles*. London: Abrams, 1997.

Weimojie suoshuo jing 維摩詰所說經 (*The Vimalakirti Sūtra*.) Translated by Kumārajīva 鳩摩羅什. T 14, no.475.

——. *The Vimalakirti Sūtra*. Translated by Burton Watson from the Chinese version by Kumāra-jīva. New York: Columbia University Press, 1997.

Wei Shou 魏收. *Weishu shilao zhi* 魏書釋老志. Beijing: Zhonghua shuju, 1974.

Weidner [Haufler], Marsha. "The Conventional Success of Ch'en Shu." In *Flowering in the Shadows: Women in the History of Chinese and Japanese Painting*, ed. Marsha Weidner, 123–156. Honolulu: University of Hawai'i Press, 1990.

——. "Images of the Nine-Lotus Bodhisattva and the Wanli Empress Dowager." *Journal of Chinese Historical Research* 35 (2005): 245–278.

——. *Views from Jade Terrace: Chinese Women Artists: 1300-1912*. Indianapolis: the Indianapolis Museum of Art, 1988.

——. "Women in the History of Chinese Painting." In *Views from Jade Terrace: Chinese Women Artists 1300-1912*, by Marsha Weidner, Debra Edelstein, et al. 113–29. Indianapolis, IN: Indianapolis Museum of Art, 1988.

Weidner, Marsha, and Patricia Ann Berger. *Latter Days of the Law: Images of Chinese Buddhism 850-1850*. Lawrence: Spence Museum of Art, University of Kansas, 1994.

Winfield, Pamela D. and Heine, Steven. *Zen and Material Culture*. New York: Oxford University Press, 2017.

Whitfield, Roderick, ed. *Xiyu meishu: daying bowuguan sitanyin soujipin* 西域美術: 大英博物館斯坦因搜集品. Vol. 3. Tokyo: Kodansha International in cooperation with the Trustees of the British Museum, 1984.

Widmer, Ellen. "The Rhetoric of Retrospection: May Fourth Literary History and the Ming-Qing Women Writer." In *The Appropriation of Cultural Capital: China's May Fourth Project*, ed. Milena Dolezelova-Velingerova and Oldrich Kral, 193–225. Cambridge, Mass.: Harvard University Asia Center, 2001.

Widmer, Ellen, and Kang-I Sun Chang, eds. *Writing Women in Late Imperial China*. Stanford, Calif.: Stanford University Press, 1997.

Wong, Dorothy. "Guanyin Images in Medieval China, Fifth and Eighth Centuries." In *Bodhisattva Avalokiteśvara (Guanyin) and Modern Society: Proceedings of the Fifth Chung-Hwa International Conference on Buddhism*, ed. William Magee and Yi-hsun Huang, 255–302. Taipei: Drama Drum, 2007.

——. "Women as Buddhist Art Patrons During the Northern and Southern Dynasties." In *Between Han and Tang: Religious Art and Archaeology in a Transformative Period*, ed. Wu Hung, 535–566. Vol. 1. Beijing: Wenwu chubanshe, 2000.

Wu Cheng-en 吳承恩 (1506–1582). *Li Zhuowu xiansheng piping xiyouji* 李卓吾先生批評西遊記. Vols. 1792–1793 of *Xuxiu siku quanshu*. Shanghai: Shanghai guji chubanshe, 1995.

Wu Gaobin 吳高彬, ed. *Yiwu wenwu jingcui* 義烏文物精萃. Beijing: Wenwu chubanshe, 2003.

Wu Hung. *The Art of Yellow Springs: Understanding Chinese Tombs.* Honolulu: University of Hawai'i Press, 2010.

——. *The Double Screen: Medium and Representation in Chinese Painting.* Chicago: University of Chicago Press, 1996.

——. " 'Mingqi' de lilun he shijian: Zhanguo shiqi liyi meishu zhong de guannianhua qingxiang." 明器'的理論和實踐—戰國時期儀禮美術中的觀念化傾向. *Wenwu* 6 (2006): 72–81.

——. *Monumentality in Early Chinese Art and Architecture.* Stanford, Calif.: Stanford University Press, 1995.

——. "The Originals of Chinese Painting." In *Three Thousand Years of Chinese Painting*, ed. Yang Xin et al., 70–74. New Haven, Conn.: Yale University and Foreign Languages Press, 1997. 70–74.

——. "Rethinking Liu Sahe: The Creation of a Buddhist Saint and the Invention of a 'Miraculous Image.' " *Orientations* 27, no. 10 (November 1996): 32–43.

——. "Shengqi de gainian yu shijian" 生器的概念與實踐. *Wenwu* 1 (2010): 87–96.

——. *The Wuliang Shrine: The Ideology of Early Chinese Pictorial Art.* Stanford, Calif.: Stanford University Press, 1989.

——. "Yinhun lingbi" 引魂靈璧 In *Gudai muzang meishu yanjiu, diyiji* 古代墓葬美術研究, 第一輯, ed. Wu Hung and Zheng Yan, 55–64. Beijing: Wenwu chubanshe, 2011.

Wu Hung, and Katherine R. Tsiang, eds. *Body and Face in Chinese Visual Culture.* Cambridge, Mass.: Harvard University Asia Center, 2005.

Wu Jiang. "Orthodoxy, Controversy and the Transformation of Chan Buddhism in Seventeen-Century China." PhD diss., Harvard University, 2002.

Wu Renshu 巫仁恕. *Pinwei shehua: wanming de xiaofei shehui yu shidafu* 品味奢華: 晚明的消費社會與士大夫. Taipei: Lianjing chuban gongsi, 2007.

Wu Weiye 吳偉業 (1609–1672). *Meicun ji* 梅村集. Vol. 1312 of *Yingyin wenyuange siku quanshu* 影印文淵閣四庫全書. Taipei: Taiwan shangwu yinshuguan, 1983.

Wu Youru 吳友如 et al., illustrators, Zheng Qiming 張奇明, ed. *Dianshizhai huabao: Daketang ban* 點石齋畫報大可堂版. (Shanghai: Shanghai huabao chubanshe, 2001)

Wu Zhensheng 吳震生 [Wu Ketang 吳可堂] (1695–1769). *Huanshen rong* 換身榮, in Wu Zhensheng 吳震生, *Taiping yuefu yugou shisan zhong* 太平樂府玉勾十三種, shisi juan 十四卷, Li E 厲鶚 preface dated to 1752, vol.1, Zhongguo guojia tushuguan collection.

Wujin bowuguan 武進博物館. "Wujin Mingdai Wang Luo jiazu mu" 武進明代王洛家族墓. *Dongnan wenhua* 東南文化 124, no. 2 (1999): 28–39.

Wuliangshoufo jing 無量壽佛經 (Sūtra of the Buddha of Measureless Life). T12, no. 365.

Xia Jingshan 夏荆山, and Lou Yutian 婁玉田 eds. *Zhongguo lidai Guanyin wenxian jicheng* 中國歷代觀音文獻集成. Beijing: Zhonghua quanguo tushuguan wenxian suowei fuzhi zhongxin, 1998.

Xia Lishu 夏力恕 (fl. 18th c.), et al. *Huguang tongzhi* 湖廣通志. Vol. 534 of *Yingyin wenyuange siku quanshu* 影印文淵閣四庫全書. Taipei: Taiwan shangwu yinshuguan, 1983–1986.

Xia Shufang 夏樹芳 (fl. 1573). *Faxizhi* 法喜志. Preface dated to 1608. University of Chicago Library Collection. Microfilm.

Xiaoxiaosheng 笑笑生. *Jinpingmei* 金瓶梅. 1695 ed., photographic reprint. 8 vols. Hong Kong: Wenle chubanshe, 1976.

——. *The Plum in the Golden Vase, or, Chin P'ing Mei.* 5 vols. Trans. David Tod Roy. Princeton, N.J.: Princeton University Press, 1993–2013.

Xiaoyi zhenji Zhenzhuta quanzhuan 孝義真跡珍珠塔全傳. Vol. 1745 of *Xuxiu siku quanshu* 續修四庫全書, 433–457. Shanghai: Shanghai guji chubanshe, [1849] 1995–2002.

Xin Deyong 辛德勇. "Shu shiyin ming wanli keben Guanshiyin ganying lingke" 述石印明萬曆刻本觀世音感應靈課. *Zhongguo dianji yu wenhua* 中國典籍與文化 3 (2004): 106–111.

Xing Cijing 邢慈靜 (1568?–after 1640). *Zhishi jitie* 之室集帖. Woodblocks, Xing Tong Ji'nian guan Collection.

——. *Zhishi jitie* 之室集帖. Ink-rubbing edition, private collection.

Xing Tong 邢侗 (1551–1612). *Laiqinguan ji* 來禽館集, ed. Shi Yiming 史以明. 28 vols. 1637 ed. University of Chicago Library Collection. Microfilm.

Xingshi jiacheng 邢氏家承. 1912 reprint of 1868 edition. Xing Tong Museum Collection.

Xingyun dashi 星雲大師 et al. *Foguang dacidian* 佛光大辭典. Gaoxiong shi: Foguang chubanshe, 1989.

(Xinzeng) baimei tushuo (新增) 百美圖說. Shanghai: Shanghai shuju, Qing Guangxu 13 [1887].

Xiuying baojuan 秀英宝卷. Vol. 18 of *Minjian baojuan* 民间宝卷, ed. Zhongguo zongjiao lishi wenxian jicheng bianzuan weiyuanhui 中國宗教歷史文獻集成編纂委員會. Hefei: Huangshan shushe, 2005.

Xu Jie 許結. "Mingmo tongcheng fangshi yu mingyuan shishe" 明末桐城方氏與名媛詩社. In *Mingqing wenxue yu xingbie yanjiu*, ed. Zhang Hongsheng 張宏生, 349–362. Nanjing: Jiangsu guji chubanshe, 2002.

Xu Sufeng. "Lotus Flowers Rising from the Dark Mud: Late Ming Courtesans and Their Poetry." PhD diss., McGill University, 2007.

Xu Shumin 徐樹敏 (fl. late 17th c.), ed. and comp. *Zhongxiang ci* 眾香詞. 1690 ed., photolithographic reprint. Shanghai: Dadong shuju, 1934.

Xu Shuofang 徐朔方. *Wang Daokun nianpu* 汪道昆年譜. Vol. 4 of *Xu Shufang ji* 徐朔方集, 1–103. Hangzhou: Zhejang guji chubanshe, 1993.

Xu Tong 徐熥 (fl. 1588). *Manting ji* 幔亭集. Vol. 1296 of *Yingyin wenyuange siku quanshu* 影印文淵閣四庫全書. Taipei: Taiwan shangwu yinshuguan, 1983.

Xu, Peng. "Courtesan vs. Literatus: Gendered Soundscapes and Aesthetics in Late-Ming Singing Culture." *T'oung Pao* 100, no. 4/5 (2014): 404–459.

Xu Yizhi 徐一智. "Mingdai zhengju bianhua yu fojiao shengdi putuoshan de fazhan" 明代政局變化與佛教聖地普陀山的發展. *Xuanzang foxue yanjiu* 玄奘佛學研究 14 (September 2010): 25–88.

Xuan Ding 宣鼎 (1832–1880). *Yeyu qiudeng lu* 夜雨秋燈录. Vol. 1789 of *Xuxiu siku quanshu* 續修四庫全書, 247–428. Shanghai: Shanghai guji chubanshe, 1995.

Xuanhe huapu 宣和畫譜. Vol. 2 of *Huashi congshu* 畫史叢書, ed. Yu Anlan 于安瀾. Shanghai: Shanghai renmin meishu chubanshe, 1963.

Yan Wenqing, and Luk Yu-ping, trans. "Religious Consciousness and Beliefs in the Ming Tombs of Princes and Royal Family Members." In *Ming China: Courts and Contacts 1400–1450*, ed. Craig Clunas, Jessica Harrison-Hall, and Luk Yu-ping, 163–169. London: British Museum, 2016.

Yan Yaozhong 嚴耀中. "*Muzhi jiwen zhong de tangdai funv fojiao xinyang*." 墓誌祭文中的唐代婦女佛教信仰 In *Tang song nvxing yu shehui* 唐宋女性與社會, ed. Deng Xiaonan 鄧小南, 467–492. Shanghai: Shanghai cishu chuban she, 2003.

Yang, Binbin. *Heroines of the Qing: Exemplary Women Tell Their Stories*. Seattle: University of Washington Press, 2016.

Yang Bojun 楊伯峻. Annot. *Liezi jishi* 列子集釋. Beijing: Zhonghua shuju,1979.

Yang Erzeng 楊爾曾 (fl. 1612), ed. *Xinjuan xianyuan jishi* 新鐫仙媛紀事. *Qiantang Yangshi caoxuan ju ed.*, 1602. Harvard Yen-ching Library Collection.

Yang Yilun 楊宜崙 (fl. 1773), Xia Zhirong 夏之蓉 (1697–1784), et al., comp. Feng Xin 馮馨 (fl. early 19th c.) et al., revised in 1813; Fan Fengxie 范鳳諧 et al., reedited in 1845. *Gaoyou*

zhouzhi 高郵州志. Vol. 3 of *Zhongguo fangzhi congshu* 中國方志叢書, no. 29. Facsimile reprint. Taipei: Chengwen chubanshe, 1970.

Yang, Zhishui 揚之水. *Cong haiershi dao baizitu* 從孩兒詩到百子圖. Beijing: Renmin meishu chubanshe, 2014.

——. *Gushiwen mingwu xinzheng* 古詩文名物新証. Beijing: Zijincheng chubanshe, 2004.

——. *Shehua zhise* 奢華之色. 3 vols. Beijing: Zhonghua shuju, 2011–2012.

Yao Lü 姚旅 (?–1622). *Lushu* 露書, *Siku quanshu chunmu congshu* 四庫全書存目叢書, zibu, zajialei, 111. Jinan: Qilu chubanshe, 1995.

Yao, Ping. "Good Karmic Connections: Buddhist Mothers in Tang China." *Nan Nü: Men, Women Gender in Early and Imperial China* 10 (2008): 57–85.

Yao Zhiyin 姚之駰 (fl. mid 18th c.). *Yuanming shi leichao* 元明事類鈔. Vol. 884 of *Yingyin wenyuange siku quanshu* 影印文淵閣四庫全書. Taipei: Taiwan shangwu yinshuguan, 1983.

Yates, Robin D. S. *Women in China from Earliest Times to the Present: A Bibliography of Studies in Western Languages.* Boston: Brill, 2009.

Ye Shaoyuan 葉紹袁 (1589–1648) ed. *Wumengtang ji* 午夢堂集. Beijing: Zhonghua shuju, 1998.

Yeats, William Butler. *The Collected Poems of W. B. Yeats.* Compiled by Richard Finneran. New York: Collier, 1989.

Yi Ruolan 衣若蘭. *Sangu liupo: mingdai funü yu shehui de tantao* 三姑六婆: 明代婦女與社會的探討. Taipei xian banqiaoshi: Daoxiang chubanshe, 2002.

Yi Shizhen 伊世珍, comp. *Langhuan ji* 瑯嬛記. Vol 120 of *Siku quanshu cunmu congshu* 四庫全書存目叢書, zibu. Jinan: Qilu chubanshe, 1995.

Yongrong 永瑢 (1744–1790), Ji Yun 紀昀 (1724–1805), et al. *Qinding siku quanshu zongmu* 欽定四庫全書總目. Taipei: Taiwan shangwu yinshuguan, 1983.

Yu Anlan 于安瀾, ed. *Huashi congshu* 畫史叢書. Shanghai: Shanghai renmin meishu chubanshe, 1963.

Yu Anqi 俞安期. *Liuliu ge quanji* 翏翏閣全集, vol.143, *Siku quanshu cunmu congshu* 四庫全書存目叢書. (Jinan: Qilu shushe, 1997).

Yu, Anthony C. *The Journey to the West.* Chicago: University of Chicago Press, 1977–1983.

——. *State and Religion in China: Historical and Textual Perspectives.* Chicago: Open Court, 2005.

Yü, Chün-fang. *Kuan-yin: The Chinese Transformation of Avalokiteśvara.* New York: Columbia University Press, 2001.

——. "Ming Buddhism." In *The Cambridge History of China.* Vol. 8, *Ming Dynasty (1368–1644)*, part 2, ed. Denis Twitchett and Frederick W. Mote, 893–952. Cambridge, Cambridge University Press, 2008.

——. *The Renewal of Buddhism in China: Chu-hung and the Late Ming Synthesis.* New York: Columbia University Press, 1981.

Yu Huai 余懷 (1616–1696). *Banqiao zaji* 板橋雜記. Nanjing: jiangsu wenyi chubanshe, 1987.

Yu, Jimmy. "Bodies and Self-Inflicted Violence in Sixteenth and Seventeenth China." PhD diss., Princeton University, 2008.

——. *Sanctity and Self-Inflicted Violence in Chinese Religions, 1500–1700.* Oxford: Oxford University Press, 2012.

Yu Minzhong 于敏中 (1714–1779). *Rixia jiuwen kao* 日下舊聞考. Qing Qianlong edition, dated to 1788–1795. University of Chicago Library Collection.

Yuan Hongdao 袁宏道 (1568–1610). *Yuan zhonglang ji*, vol.174 of *Siku quanshu cunmu congshu* 四庫全書存目叢書, 718. Jinan: Qilu shushe, 1997.

Yuding quantangshi 御定全唐詩, Kangxi (r. 1662–1772). Vol.1423 of *Yingyin wenyuange siku quanshu* 影印文淵閣四庫全書. Taipei: Taiwan shangwu yinshuguan, 1983.

Yuefu qunshu 樂府群書, manuscript, late Ming period. 4 vols. Harvard Yen-ching Library Collection. Microfilm.

Yun Zhu 惲珠 (1771–1833), comp. *Guochao guixiu zhengshiji* 國朝閨秀正始集. Hongxiangguan ed., 1831.

Yunqi zhuhong 雲棲袾宏 (1535–1615). *Shamen lüyi yaolue* 沙門律義要略, in *Yunqi fahui* 雲棲法彙, vol.13. Nanjing: Jinling kejingchu, 1897.

———.*Wangsheng ji*往生集, in *Yunqi fahui* 雲棲法彙, vol.16. Nanjing: Jinling kejingchu, 1897.

Zang Maoxun 臧懋循 (1550–1620). *Yuanquxuan* 元曲選. Beijing: Zhonghua shuju, 1961.

Zeitlin, Judith. "Music and Performance in *Palace of Lasting Life*." In *Trauma and Transcendence in Early Qing Literature*, ed. Wilt Idema, Wai-yee Li, and Ellen Widmer, 454–487. Cambridge, Mass.: Harvard University Asia Publications, 2006.

——. " 'Notes of Flesh': The Value of the Courtesan's Song in Seventeenth-Century China." In *The Courtesan's Arts: Cross-Cultural Perspectives*, ed. Martha Feldman and Bonnie Gordon (2006): 75–99.

——. *The Phantom Heroine: Ghosts and Gender in Seventeenth-Century Chinese Literature*. Honolulu: University of Hawai'i Press, 2007.

——. "The Pleasure of Print: Illustrated Songbooks from the Late Ming Courtesan World." In *Gender in Chinese Music*, ed. Rachel Harris, Rowan Pease, and Shzr Ee Tan, 41–65. Rochester: University of Rochester Press, 2013.

——. "Shared Dreams: The Story of the Three Wives' Commentary on *The Peony Pavilion*." *Harvard Journal of Asiatic Studies* 54, no. 1 (June 1994): 127–179.

——. "Spirit Writing and Performance in the Work of You Tong (1618–1704)." *T'oung Pao* 84 (1998): 102–135.

Zeitlin, Judith, and Yuhang Li, eds., *Performing Images: Opera in Chinese Visual Culture*. Exhibition Catalogue. Chicago: Smart Museum of Art and University of Chicago Press, 2014.

Zeng Huixian 曾惠仙. "Xu Can zuopin kaoshu" 徐燦作品考述. *Jiuzhou xuelin* 九州學林 5, no. 4 (Winter 2007): 235–246.

Zhai Hao 翟灝 (d. 1788). *Bianliyuan zhi* 辯利院志. Vol. 13 of *Zhongguo fosi shizhi huikan*, ed. Du Jiexiang 杜潔祥. Series 3. Taipei: Danqing tushu gongsi, 1985.

Zhan Dan 詹丹. "Xianji heliu de wenhua yiyun: tangdai aiqing chuanqi pianlun 仙妓合流的文化意蘊: 唐代愛情傳奇片論." *Shehui kexu zaixian*, no. 3 (1992): 11–17.

Zhang Chao 張潮 (1650–1709), comp. *Yu Chu xinzhi* 虞初新志. *Xuxiu siku quanshu* 續修四庫全書, vol.1783, 168–481. Shanghai: Shanghai guji chubanshe, 1995.

Zhang, Fan Jeremy. *Royal Taste: The Art of Princely Courts in Fifteenth-Century China*. New York: Scala Arts, 2015.

Zhang Lüping 張履平 (fl. 18th c.), comp. *Kunde baojian* 坤德寶鑑. Preface by Sun Jingyun 孫景運, dated to the forty-two years of dingyou of Qianlong (1777), Yuxiutang 逎修堂 ed. 9 vols. Harvard Yen-ching Library Collection.

Zhang Mengzheng 張夢徵 (fl.17 th C.) *Qinglou yunyu* 青樓韻語, in *Zhongguo gudai banhua congkan erbian*, 中國古代版畫叢刊二編 vol. 4. Shanghai: Shanghai guji chubanshe, 1994.

Zhang Shuying 張淑英 (dates unknown, before or early Ming period). *Cixiu tu* 刺繡圖. In *Lüchuang nüshi* 綠窗女史, juan 1. Ming Chongzhen edition, Harvard-Yenching Library Collection.

Zhang Tingyu 張廷玉 (1672–1755) et al.. *Mingshi* 明史. Beijing: Zhonghua shuju, 1974.

Zhang Xu 張栩 (fl. early 17th c.), comp. *Caibi qingci* 彩筆情辭, 1624 ed. Harvard Yen-ching Library Collection. Microfilm.

Zhang Yanyuan 張彥遠 (815–907). *Lidai minghua ji* 歷代名畫記. Vol. 1 of *Huashi congshu* 畫史叢書, ed. Yu Anlan 于安瀾. Shanghai: Shanghai renmin meishu chubanshe, 1963.

Zhang Ying. *Confucian Image Politics: Masculine Morality in Seventeenth-Century China*. Seattle: University of Washington Press, 2017.

Zhang Yu 張昱 (fl.14th. C.). *Kewen laoren ji* 可聞老人集. *Siku quanshu dianziban* 四庫全書電子版.

Zhang Zhao 張照 (1691-1745). *Shengping baofa* 昇平寶筏. *Guben xiqu congkan* jiuji zhisi 古本戲曲叢刊九集之四. Shanghai: Zhonghua shuju, 1964.

Zhao Feng 趙豐. *Fangzhipin kaogu xin faxian* 紡織品考古新發現. Hong Kong: Yishatang/fushi gongzuodui, 2002.

Zhao Xuepei 趙雪沛. "Guanyu nüciren xu can shengzu nian ji wannian shenghuo de kaobian 關於女詞人徐燦生卒年及晚年生活的考辨." *Wenxue yichan* 3 (2004)· 95–100, 160.

Zhao Shiyu 趙世瑜. *Kuanghuan yu richang: Ming Qing yilai de miaohui yu minjian shehui.*狂歡與日常明清以來的廟會與民間社會. Beijing: Shenghuo-Dushu-Xinzhe sanlian shudian, 2002.

Zheng Fangkun 鄭方坤 (fl. 1729). *Quanmin shihua* 全閩詩話. *Siku quanshu dianxiban* 四庫全書電子版.

Zheng Zhizhen 鄭之珍 (1518–1595). *Mulian jiumu quanshan xiwen* 目連救母勸善戲文. *Guben xiqu congkan chuji*, 67. Shanghai: Shangwu yinshuguan, 1954.

Zhongguo gudai shuhua jianding zu 中國古代書畫鑑定組, ed. *Zhongguo gudai shuhua tumu* 中國古代書畫圖目. Beijing: Wenwu chubanshe, 1986–1994.

Zhongguo shehui kexueyuan kaogusuo 中國社會科學院考古所, Dingling bowuguan 定陵博物館, and Beijing shi wenwu gongzuodui 北京文物工作隊, eds. *Dingling* 定陵. 2 vols. Beijing: Wenwu chubanshe, 1990.

Zhou Hui 周暉 (fl. late 16th c.). *Xu jinling suoshi* 續金陵瑣事. Annotated by Zhang Zengtai. Nanjing: Nanjing chubanshe, 2007.

Zhou Ji 周楫 [Zhou, Qingyuan 周清源] (fl. early 17th c.). *Xihu erji sanshisi juan* 西湖二集三十四卷, *Xihu qiuse yijuan* 西湖秋色一卷, juan shou,7. The collection of National Central Library of Taiwan.

——. *Xihu erji* 西湖二集. Shanghai: Beiye shanfang, 1936.

Zhou Kefu 周克復. *Guanshiyin chiyanji* 觀世音持驗記. Vol.7 of *Zhongguo lidai guanyin wenxian jicheng* 中國歷代觀音文獻集成. Beijing: Zhonghua quanguo tushuguan wenxian suowei fuzhi zhongxin, 1998.

Zhou Qiuliang 周秋良. *Guanyin bensheng gushixi lunshu* 觀音本生故事戲論述. Beijing: Zhongguo xiju chubanshe, 2008.

——. "Lun gudai guanyin xi de yanchu xingtai" 論古代觀音戲的演出形態. *Hunan gongye daxue xuebao (shehui kexue ban)* 3 (2010): 98–101.

Zhou Shaoliang 周紹良. "Ming wanli nianjian wei Jiulian pusa bianzao de liangbu jing" 明萬曆年間為九蓮菩薩編造的兩部經. *Gugong bowuyuan yuankan* 2 (1985): 37–40.

Zhou Xinhui 周心慧. ed., *Zhongguo fojiao banhua* 中國佛教版畫 Hangzhou: Zhejiang *Wenyi chubanshe*, 1996.

Zhou Xisheng 周西生 comp. *Xingshi yinyuan zhuan* 醒世姻緣傳. Hong Kong: Zhonghua shuju, 1959

Zhou, Yiqun. "The Hearth and the Temple: Mapping Female Religiosity in Late Imperial China, 1550–1900." *Late Imperial China* 24, no. 2 (December 2003): 109–155.

Zhu Qiqian 朱啟鈐 (1871–1964). *Cunsutang sixiulu erjuan* 存素堂絲繡錄二卷. Cunsutang 存素堂, 1928.

——. *Nühongzhuan zhenglue* 女紅傳徵略. Cunsutang 存素堂, 1931.

——. *Qing neifu chang kesi xiuxian shuhua lu* 清內府藏緙絲繡線書畫錄. Preface by Kanduo 闞鐸, dated to 1930.

——. *Sixiu biji erjuan* 絲繡筆記二卷. Wubingge 無冰閣, 1933.

Zhu Yizun 朱彝尊 (1629–1709) comp. *Mingshi zongzh* 明詩綜. Vol. 1460 of *Yingyin wenyuange siku quanshu* 影印文淵閣四庫全書. Taipei: Taiwan shangwu yinshu guan, 1983–86.

Zhu Zaiyu 朱載堉 (1536–1610). *Lingxing xiaowubu* 靈星小舞譜. 1596 ed. Harvard Yen-ching Library Collection.

Zongxing 宗性 et al., eds. *Zhongguo Chengdu fojiao wenhua zhencang shiji dazhan, zhanpin xuanji* 中國成都佛教文化珍藏世紀大展展品選集. Chengdu: Zhongguo chengdu fojiao wenhuazhan zuweihui, 2005.

Zou Dezhong 鄒德中 (fl. late 15th c.). *Huishi zhimeng* 繪事指蒙. In *Huaxue huibian* 畫學彙編, ed. Wang Chang'an 王暢安. Taipei: [Publisher not identified], 1959.

Zou Yi 鄒漪 (fl. early 17th c.), comp. *Qizhen Yecheng* 啟禎野乘. Vol. 62 of *Mingdai zhuanji congkan* 明代傳記叢刊. Taipei: Mingwen shuju, 1991.

Index

Page numbers in *italics* indicate figures.

Née Sheng, *150*, 162–170, 166, *167*, 250n74
Née Xiong. *See* Xiong (Lady or Née).
Née Xu, 162–170, *169*
Nelson-Atkins Museum of Art, 78, *79*
neng (expert ability), 136
Neo-Confucianism, 2, 234n109
ni (animal seat), 220n111
"*Nianfo*" ("Chanting Buddha") (Xing Cijing),
 83
Nine-lotus Bodhisattva, 173
Nine Lotus Bodhisattva, 251n102
Ni Renji, 242n67, 252n6; burial in Longping
 temple (Longping si), 197, 252n6; with
 hairpin, *165, Wushi xianzu tuce* (An Album
 of the Ancestors from Wu Family), 163,
 165, *165;* hair embroidery and, 124, *125*,
 128, 137, 141, 242nn67–68
"*Nishuo qihuo*" (*A Nun Explains Seven Puzzles*)
 (Fang Weiyi), 96–97
Northern Qi (550–577) period, 4
nosebleeds, 118
Nun Explains Seven Puzzles, A ("*Nishuo qihuo*")
 (Fang Weiyi), 96–97
Nunneries: discourse of 13, 98, 196, 230n64,
 comparing to brothel, 208n37; "entering
 a nunnery," 40; Guanyin nunnery: 6, 19,
 82–83, 147, 156, 163, 196, 229n60; private
 nunnery: restriction by the state,
 215n34, Xu Jinghong, 215n34,
nuns, in *sangu liupo* category, 252n4
nügong, 113
nühong, 113, 238n24

objectification, with talent, 206n8
Ode on Dancing, An (Yongwu), 35, *36*, 37
One Hundred Treaties (*Bailun*), 124
opera: *chunqi*, 30, 34; enlightenment and,
 42; Mulian, 33–34
ornaments, hair, 154–156. *See also* hairpins

pain: non-verbalized pain, 124; ritualized,
 127; self-inflicted, 123–128; wound/pain
 from gegu practice, 64
painters: courtesan painters, 199; male
 painter's resistance 7–8; following male
 masters: 11, 19, 63, Ding Yunpeng, 19, 53,
 78, *139;* Li Gonglin, 19, 226n34; Qiu Ying,
 68,72; Wu Daozi, 67, 100, 102; following

female master, Guan Daosheng, 63;
 painter's gender identity and Guanyin's
 gender identity, 11; painter and his or
 her social role, 63–64; patriarchy and
 women, 11, 19; women as both painters
 and embroiderers 53; professional
 female painters, 64–66, *65,* 100, 225n22;
 Ten Thousand-handed Guanyin and
 professional woman painter; 66; women
 painters in eighteenth and nineteenth
 century, 64–66, 72, 200. *See also*
 courtesan; gentrywomen, as painters
painting, 19; embroidery and, 110; gender
 and, 63–64; gentrywomen and, 59–66;
 gongbi technique, 64; iconography and,
 47; scriptural text in, 86–90; writing and,
 62, male masters, 102; *See also baimiao*
 style
pagoda: building a pagoda, 156, 247n45;
 dharani blanket with a pagoda, 250n97;
 ink-rubbing of a relief and, 98; offering
 to the crypts in pagoda, 5, 156–158, *157,
 158,* 160, 247n47, 248n53; pearl pagoda,
 as an artifact, 159, as *tanci* performance,
 159, 220n101; stupa as design on jewelry,
 177
Palace of Eternal Protection, 254n26
Pan (Madam), 92
Pan Zhiheng, 31–32, *33*, 37, 39, 41; with
 dancing deity materialized, 57; Wang
 Daokun and, 223n153
Pang daoren, 239n25
paper: ink and, 22–23, 59, 61, 86; rice, 64, 67,
 102, 237n7
parrots, 6, 66, 166
patriarchy: Confucianism and, 3; gender
 politics and, 7, 11; scholarship and, 7;
 sexuality and, 7; women painters and,
 11, 19
patrons: of temples, 247n48; women as
 Buddhist art, 224n8
Pearl Pagoda, The, 159
Peony Pavilion, 7
Perceiver of Sounds. *See* Guanyin
peril, hairpins eliminating, 177–185
pewter utensils, 248n60, 249n62
phoenix, 40, 159, 213n2, 246n31, 248n56
Piaojing (*Classic of Whoring*), 40